James Tissot

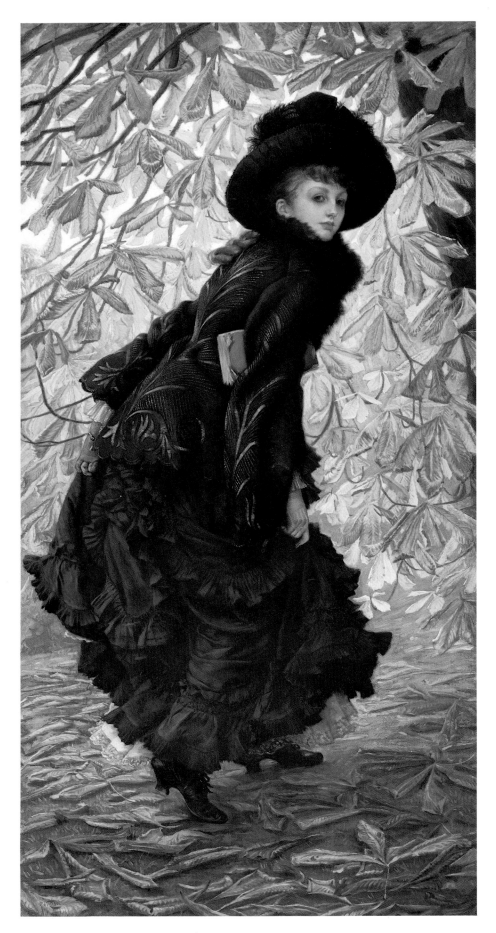

Frontispiece: *October*, Montreal Museum of Fine Arts. Cat. 99

James Tissot

Edited by

Krystyna Matyjaszkiewicz

ABBEVILLE PRESS · PUBLISHERS · NEW YORK

Front Cover: *The Amateur Circus (Circus Lover)*. 1883–5.
Oil on canvas, 58 × 40¼ in. (147.3 × 101.8 cm.).
Museum of Fine Arts, Boston, Juliana Cheney Edwards Collection.

Back Cover: *Self-Portrait*. Mid 1860s.
Oil on panel, 19⅝ × 11⅞ in. (48.9 × 28.8 cm.).
The Fine Arts Museums of San Francisco; Mildred Anna Williams Collection.

Library of Congress Cataloguing in Publication Data
James Tissot.
 Bibliography: p.
 Includes index.
 1. Tissot, James Jacques Joseph, 1836–1902 – Addresses,
essays, lectures. I. Matyjaszkiewicz, Krystyna.
N6853.T47J3 1984 709′.2′4 84-18542
ISBN 0-89659-516-1

First Abbeville Press edition, 1985.
ⓒ 1984 Barbican Art Gallery

Printed in Great Britain by Balding + Mansell Limited.

Acknowledgements

I would like to thank in particular Michael Wentworth and Jane Abdy for their kindness and their generous, unstinting support throughout this project; Willard Misfeldt and Michael Wentworth for sharing the fruits of their research; Ian Thomson, Harley Preston, Malcolm Warner and Jessica Rutherford for contributing their research as essays. In addition, I would like to thank the following for assistance: Philip Bailey; Margaret Christian, Christie's Old Master Picture Dept.; Peter Day, Keeper of Collections, Chatsworth; Rosemarie Ellcock, Oxford University Press; Richard Green; Ralph Hyde, Keeper of Prints and Maps, Guildhall Library; Mrs E. A. Lee; Alison Mark; Roy Miles; Alice Munro-Faure, Sotheby's Picture Dept.; Clyde Newhouse; Robin Paisley; Nicola Smith, Guildhall Library; Irene Pollock, Guildhall Library; Sotheby Parke Bernet Inc., New York; Guy Stair Sainty; and Christopher Wood. I would also like to thank John Hoole and the Barbican Art Gallery staff for their wholehearted support and assistance, and lastly Jacek, who has borne the encroachment of Tissot on our lives with loving patience and understanding, and without whose encouragement the task would have been far more difficult and less enjoyable.

K.M.

Contents

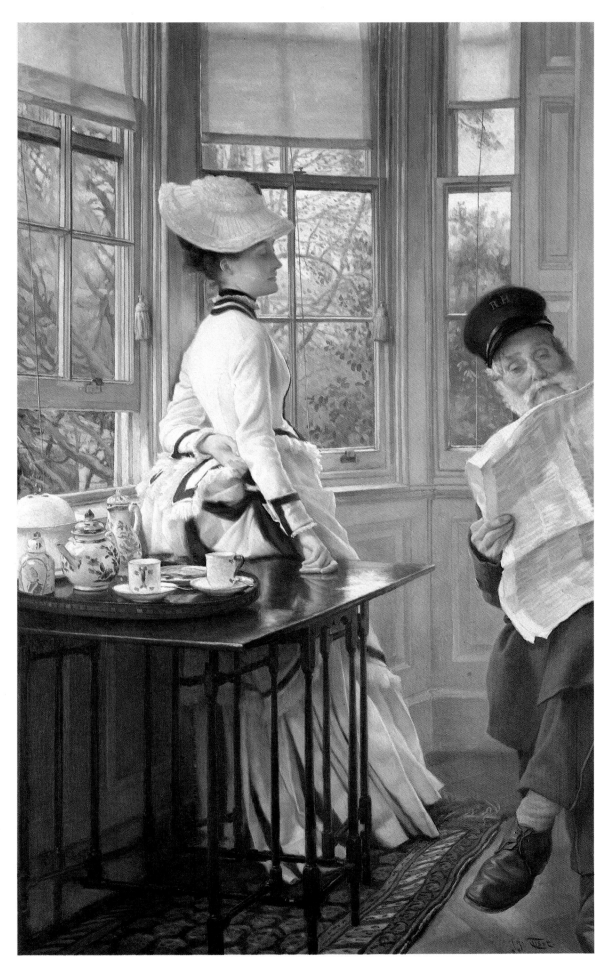

1. *Reading the News*
private collection.
Cat. 68.

Preface

For a large public gallery in Britain to have mounted a Tissot exhibition thirty to forty years ago would have been regarded as totally eccentric; to do it now seems perfect in terms of both popular and scholarly interest. James Tissot's work has seen a dramatic return to favour in recent years, accompanied by an increase in demand for his pictures and, therefore, an increase in their value. Such popularity was easily granted to the more overt, moralizing pictures of the Pre-Raphaelites and Victorian genre painters, work that can be seen to have social purpose and high moral fibre, but this favour has only grudgingly been allowed to return to Tissot. For many years – the nadir of his importance from the scholarly point of view must have been the 1940s and 1950s – his paintings were regarded as the epitome of late Victorian, vacuous and decadent society portrayal. As he, a foreigner working mostly in England, did not fit into any easy art-historical category or grouping, he was dismissed from consideration. Only now, with hindsight, can we see his work as that of the well-placed, yet detached observer, intent upon producing work that was both marketable and a reflection of the society that surrounded him; his was a poignant comment, which culminated in the telling, society scenes of the *Femme à Paris* series.

The change of attitude towards Tissot's work mirrors the extraordinary fluctuation of favour and rejection that he experienced in his own lifetime. As is recounted elsewhere in this book, he achieved a meteoric rise in Paris in the 1860s and again in London in the following decade. This rapid success brought him wealth and social standing but it ultimately exposed him to the dangers of changing fashion, leaving him in later years artistically isolated and increasingly recluse-like, the painter of religious themes, an artist in the Wilderness.

This gallery cannot yet claim any distinction in the resurrection of long overlooked yet worthy artists, but *James Tissot* follows the success of the Matthew Smith exhibition and precedes our plans to organize shows about Gwen John and Cecil Beaton, two figures who in very differing ways have, too, been overlooked or disregarded by the British art establishment and are, consequently, in need of re-appraisal.

In our efforts to mount this exhibition, Barbican Art Gallery is most indebted to the many lenders who, in parting with their own much loved property, have provided essential help. Similarly, we would like to thank the Peter Stuyvesant Foundation for its valuable sponsorship, which enables the gallery to publicize the exhibition to a proper extent. *James Tissot* could not have happened without such assistance.

Further vital help has been given by the Arts Council of Great Britain and much advice and encouragement has come from the contributors to the exhibition catalogue, not least Sir Michael Levey, who agreed to allow his *Antique Collector* article to be used as our introduction. Krystyna Matyjaszkiewicz has been an irreplaceable support over the last two years, and her effort and application have been central to the development of the exhibition. The staff of Phaidon Press have also been invaluable in their patience and support, so enabling this catalogue production to run smoothly.

John Hoole
Curator
Barbican Art Gallery

1

The Ambiguous Art of Tissot

SIR MICHAEL LEVEY

Numbers in margin refer to catalogue entries.

Tissot's art is today enjoying a well-deserved revival: in the sale-room, among scholars, through articles, books and exhibition catalogues, and with the general public. As an artist Tissot is probably better and more seriously appreciated than at any time since his death in 1902.

His paintings, especially those done during his London years from 1871 to 1882, are easy enough to like. Competently painted in a typically nineteenth-century style of unrigorous naturalism, they are chiefly scenes of leisured social life in a middle-class milieu, avoiding extremes of poverty or wealth as their style avoids extremes of academic studio finish or Impressionist, *plein-air* freedom of handling. Well may they seem fitted to complement in pictorial terms the world of Trollope, as is demonstrated by the effective use of them as covers for several of the current Oxford University Press *World's Classics* series of the Palliser novels (even though strict pedantry would point out that Trollope's social level there is far more aristocratic than anything Tissot ever attempted).

Rarely do Tissot's scenes tell an overt story or anecdote but there is plenty of human observation and gently human emotion, the focus of which tends to be a woman or women. Elegantly rather than ostentatiously dressed, though very much *dressed*, costumed, encased in clothes that seem at once plumage and armour, women occupy a prominent yet uncertain place – disturbing, even perhaps provoking, men more than, apparently, feeling much themselves. Or, rather, the nature of their feelings is ambiguous. So tastefully and carefully does Tissot adorn them – in clothes that seem to have been in some cases his own property – that at first glance many of his paintings have a mere fashion-plate charm. The striped black and white dress, the pleated white dress with ribbons of pale yellow, are modelled in variations again and again, always with a keen eye for pattern, fall of material and disposition, with almost audible rustling, of fan-like folds. Black and white clothes, in particular, excite and exercise Tissot to produce some of his most memorable effects: lessons in restrained costume which owe more, probably, to his French background than to the garish reality of Victorian middle-class fondness for bottle-green and magenta.

Yet fascinated as Tissot clearly was by female fashion, and undemandingly enjoyable as are the resulting paintings, it would be wrong to assume there is little more to his art. For all its patent charm and its mild hints of social humour and flirtation, it has underneath remarkably disturbing elements, with a nearly obsessive mood compounded of languor and isolation and sheer yearning. Women are, from first to last, the carriers of this mood, experiencing it and causing it, its victims as well as its propagators. They are weak, yet appealing in their weakness, whether genuinely weakened by ill-health or by the social convention that requires them to seek a man's steadying hand, for example, as they clamber aboard a ship. They and their pretty plumage must be protected in aviary-like settings of enclosed gardens and under awnings and parasols. Yet these fragile creatures, with their paraphernalia of trailing flounces, shawls and muffs, not only cast a potent spell over men but seem often to do so half against their will. How bored they are with their role. To escape from the burden of being attractive, of causing emotional stress, might be supposed the chief feeling with which, in painting after painting,

they gaze beyond the spectator. One may think of some of Trollope's liveliest heroines, less unconventional than Ibsen's, but still pining for the freedom enjoyed by men.

Even in the scenes of social life Tissot touches a nerve of unease. In the *Ball on Shipboard* 66 (Colour Plate 25) it is noticeable that hardly any dancing is to be seen. Mainly we are shown women sitting or standing around in pairs or trios or quartets, having to talk among themselves, while the most prominent female figure, in the foreground, turns away to look in our direction, hoping for some incident or arrival – a partner perhaps – to interrupt her isolation and boredom. Despite the bright flags and the distant band, and the intended air of conviviality, being on board ship has its imprisoning aspect. Unease is made more apparent in paintings like *The* 70 *Concert* (Colour Plate 6). There a female violinist (and it seems typical of Tissot that the performer is female) stands, patiently waiting to perform in a fashionable music-room still animated by people talking, taking their seats and crowding into the restricted space. Tissot's own original title for the composition ironically underlines the point: *Hush!* Perhaps the most familiar of these paintings is *Too Early* (Colour Plate 7) where social awkwardness and social 65 isolation openly form the theme. Marooned in the centre of the highly-polished ballroom floor a group of guests, an elderly man with three women, suffer from the gaffe of arriving so promptly that their hostess is still settling music with the musicians, and two servants, peering round the door, grin at their discomfiture. As usual with Tissot, the appurtenances are of considerable elegance (the setting Adam-style revival), as are the women's bare-shouldered, evening toilettes, but all this serves only to sharpen the painful embarrassment. We are perhaps meant to think, rather cruelly, that guests with so little social flair can never fit into the level of society they have, for this one (first, and last?) evening attained.

If in this composition the bones of the subject obtrude too obviously, almost tritely, there are others where the ambiguities are more subtle, concerned with something deeper than social unease, suggesting serious psychological uncertainty. Boats and rivers are favourite locations for such scenes. It has often been said that in these Tissot was influenced by Whistler's use of the Thames and Thames-side: and in formal terms that is true enough. For Tissot, however, the appeal seems to lie as much in the opportunity for symbolism. The river or sea runs like the tide of life. Embarking and disembarking, and being on board ship, inevitably suggest the transient. Women may be present as a temporary break, a diversion from the proper business of nautical existence. The ship leaves port, leaving the women behind. Beyond the horizon lies the experience the voyage will bring.

In the almost too symbolically apt location of Gravesend (the name probably struck his foreign ear more forcibly than it does a native's), Tissot evolved a strange composition, treated in etchings as well as paintings, where a girl gazes out from a landing-stage across the widening 58 river, herself under the gaze of two men. Her detached figure, abstracted, its back resolutely turned on them, is closer in every sense to us, the spectators. Her mood and her isolation are what intrigue us. She stands as any of the lonely, frustrated girls of nineteenth-century fiction, often married off for one cause or another to the wrong man. What she is gazing at is not shown: but we all know the sensation of watching our own lives flow by when gazing at a river flowing by. Among examples in fiction, the long reverie-monologue of Bella Wilfer in *Our Mutual Friend*, looking out with her father over the Thames at Greenwich, is characteristic. She imagines 'all sorts of voyages', on impossible ships with impossible husbands, releasing her from the barren reality of near-forced engagement to a man presumed dead.

The girl who is the focal point of Tissot's Gravesend composition is being scrutinized by an 58 elderly man and a younger, though mature man, accompanied by an indifferent boy: making up three generations of males. Only in the finished painting of the subject (Colour Plate 8) are 57 the two men (both now in naval uniform) openly proprietorial, one presumably the father, the other presumably the fiancé. Their own anxious-seeming colloquy represents one mood, created partly by the girl's. And something even more ambiguous of the same kind is conveyed in *The Last Evening* (Colour Plate 14), a shipboard scene of imminent parting. 55

55 Again, the woman is the figure closest to us, reclining passively with something of an invalid air, occupying a good deal of the foreground. Only her tartan rug relieves the sombre black and white tonality of her costume and the painting generally. While her ship's mate lover stares fixedly at her, she is lost, staring into space. In turn the couple come under the eye of the middle-aged captain, listening to the old man who is the woman's father. The third generation, pert but pre-adolescent, seeing love as just amusing, is present in the young girl who pops up, in effect eavesdropping on both groups. The lovers' situation may be as tangled as the criss-cross mass of rigging that fills the background, but it all hangs on the woman's attitude, more listless, it would appear, than urgent or distressed. The last evening has something almost fatally final about it. What seems strongest is a mood of unequal or unsatisfied feelings. It is as if the situation of a last evening has not so much created them as brought them painfully to light.

That this mood of something unsatisfied, of yearning and of transience was not adopted by Tissot merely to titillate and pleasingly puzzle his English audience is confirmed by considering his earlier work. Taken altogether, the emotional weight on lonely, vaguely suffering women points to a definite sense in Tissot of what in life their lot tends to be. Equally noticeable is his fondness for certain seasonal effects, autumnal ones above all. Mood and season go together in one of his earliest paintings (of 1858) called with deceptive blandness *Promenade dans la neige*, 'A Walk in the Snow' (whereabouts unknown). A married couple are pacing arm in arm through a winter landscape, emotionally far apart, virtually divorced in thought as their gazes diverge. He looks into the distance; she stares down dreamily at the footprints in the snow, as though tracking a lost lover. Years later in London, Tissot painted another incongruous couple, not medieval, as had been the earlier pair, but modern, perambulating in Regent's Park on a
107 wintry day: *The Warrior's Daughter* (City of Manchester Art Galleries).[1] There, beside the wheeled chair of an old man, walks a beautiful young woman with almost insolent detachment — exactly as Edith Granger walks beside her aged mother's chair in *Dombey and Son*.

Before Tissot turned to modern subjects, he had found inspiration significantly in the story
1, 2, 3 of Marguerite, the simple girl loved and led into sin by Faust, yet redeemed at death. Goethe had added this incident to his version of the legend, and Tissot may have become familiar with it through Gounod's opera, first performed in Paris, in 1859. The tragedy of Marguerite, young, alone and seduced because of her beauty, prefigures Tissot's typical heroine, in art and, to some extent, also in life.

In or around 1876 Tissot met a hauntingly pretty Irish divorcee, Mrs Newton, born Kathleen Kelly. Then aged 22, she had been married at 17, separated speedily from her husband on confessing a liaison and was the mother of two illegitimate children. She went to live with Tissot in his St. John's Wood house and there she died of tuberculosis at the age of 28. She became the main figure in his art: in photographs, etchings and paintings. It is she who walks
132, 123 so proudly in *The Warrior's Daughter*. Elsewhere she lounges on a lawn or in a hammock; she
111, 110 waits for the ferry or watches beside the river while 'Tissot' writes with his stick in the gravel 'I love you'. Increasingly, she just gazes out apathetically, her eyes seeming to grow more huge and blank with the onset of illness, her slim waist taking on a tragic aspect as the disease consumes her.

There has been a natural tendency to see Tissot's art markedly coloured, if not changed, by his relationship with Mrs Newton. True as that is in literal terms, the deeper truth is perhaps that her isolated, sub-scandalous situation, combined with the very appeal that had caused it, answered something in Tissot's own nature. She had been envisaged already, as it were, walking with her husband in the snow.

We know her death distressed Tissot, but of her attitude to him we are totally ignorant. Tissot never married, and his character was found baffling by contemporaries. It is as though he hardly had a pronounced or coherent character. From the first Mrs Newton's languor, even her illness, may have attracted Tissot. She embodied transience. And she must have been only too well aware of how little happiness her beauty had brought her. If she found tranquillity with

Tissot, it was only an interlude. No enchanted garden, no amount of drapery, could protect her from a terribly early death. Each summer might be her last.

Too aptly, though doubtless without premonition, did Tissot have her pose for a composition, both etched and painted, entitled *October* (Frontispiece). At first glance her undulating, chic-clad figure breathes an almost saucy allure. She is caught stepping delicately among strewn chestnut leaves, glancing over her shoulder at the spectator and lifting her skirts to reveal a lacy flounce of petticoat. It might be the cover of the autumn number of some modish or mildly risqué magazine. Yet the face we confront is quite impassive. The spark of sex is generated less by the woman than by her clothes. And she is stepping into a fluttering curtain of autumn foliage, its branches writhing around her, suggesting a future at once suffocating and sterile. 99

Comparable autumnal effects had been introduced by Tissot into earlier costume paintings, perhaps ironically when the subject was a young girl flirting provocatively with an older man, and certainly symbolically when the subject was an agonised parting of lovers, as in *Les Adieux* 42 (Fig. 12). Most striking of all perhaps was his use of autumn to invest and set the scene for a commissioned portrait of the widowed Empress Eugénie with the Prince Imperial, shown amid 71 fallen leaves in the grounds of their English country home. He was the ideal choice of artist. The subject might have come from his imagination. A sad, black-veiled widow, still beautiful, appears with her uniformed son. Parting is adumbrated. The man must go off. The woman remains to mourn. When one considers that the mother here was destined in fact to lose the son within a few years, Tissot seems the more percipient.

In *Les Adieux*, for all the fancy costumes and the keepsake sentiment, there is a tang of real 42 atmosphere. The chill, misty day and the hard, high barrier of the iron railings play their part in emphasizing the pain of the lovers, though no explanation of what severs them is given. Yet once again the compositional onus is on the girl. We are with her, inside the garden gate, sharing her sufferings. The man will depart – his horse's ghostly head looms up as a reminder – but the girl will be constant, tenacious as the ivy growing at the base of the wall. Unlike, say, Millais' *Black Brunswicker* or *A Huguenot* (Fig. 11), compositions which may have loosely influenced Tissot, *Les Adieux* fails deliberately to tell an anecdote. Its concern is with a mood, a typical mood of the artist's. Love in the sense of attraction between man and woman is a sustained theme of Tissot's, but seldom does he show it as certain or happy. And always it seems to come back to what the woman feels.

After Mrs Newton's death and his return to Paris, Tissot started an ambitious series of paintings on the theme of women, of all ranks, in urban society: *La Femme à Paris*. In these crowded compositions, the woman stands out, oddly isolated, sometimes seeking outside the canvas for the spectator, and psychologically alone. It was a bridesmaid, not a bride, Tissot 171 painted for the series. An elegantly-dressed woman, engaged in seeing the bride off in a carriage for the honeymoon, is all animation at the moment; but soon she will be left, among the passers-by, in her finery, on the damp pavement of a Parisian street, by herself.

Perhaps we shall never grasp exactly what it was Tissot was trying in his art to convey. Perhaps he was never himself quite clear. Yet what is unmistakable is that under the leisured air and the fashionable clothes, and the slightly contrived charm, lurks an almost bitter sensibility. It is this quality which marks him off from the purveyors of costume-pieces and problem paintings and makes his art so far from trivial. To that extent he may reasonably be linked to Trollope, the novelist he has come posthumously to illustrate. There too we encounter an art that proves unexpectedly serious, for all its lightness and apparent simplicity. One frail, strange chance connects them. It was from a real Irish landed family that Trollope took the name he gave his English ducal family; and from that family came the serving officer who seduced Mrs Newton and fathered her first child: the Pallisers.

This article first appeared in *Antique Collector*, June 1984.

2

James Tissot: 'cet être complexe'

MICHAEL WENTWORTH

Few painters can have benefited more than James Tissot from the revisionist attitude of a new generation of art historians towards the painting of the nineteenth century. His pictures have become the objects of an admiration and study, which has taken tangible form in the homage of the sales room; his person the subject of an almost irresistible psychological speculation; and even his unfortunate mistress shows all the signs of an incipient cult figure. Indeed, Tissot, the man, no less than Tissot, the artist, seems almost more attractive to modern taste than he was to that of his own time. His neurotic character and confused emotional life are compellingly contemporary; they suit our idea of the artist rather nicely, and like the highly personal narrative tone of his pictures, invite conjecture. Tissot has been supplied with a modern *persona* as brooding and overcast as the skies in his pictures, and each, to a real degree, has taken on the emotional colour of the other.

There is plenty of evidence to justify the approach. Tissot was a complex being, and for him life and art were interwined to a point where they often become a single aesthetic, autobiographical, and psychological thread. Yet if we do attempt to separate Tissot, the man, from Tissot, the artist, it seems most profitable to try and discover something of how he appeared to his contemporaries, without the emotional colour that hindsight and modern prejudice have freely applied, and set that appearance as a foil to our own view.

Tissot's character must have seemed far less neurotic to his contemporaries than it does to us. Edmond de Goncourt noted particular complexities in one of his generally malicious entries about the painter in his *Journal* (see p. 17); and Dr Blanche speaks with professional authority of Tissot as highly-strung and of a nervous temperament – a diagnosis surely intended to explain the doctor's own puzzled distaste at Tissot's participation in the Commune.[1] But, for the most part, his contemporaries dwell on his sharp business sense, his good, if somewhat heavy, manners, and his immaculate wardrobe – leaving vagaries of character unspoken and perhaps unnoticed. Sometimes, their remarks carry a barb, for Tissot appears distressingly like Lizzie Eustace in *The Eustace Diamonds* in that it was admitted by his friends, and also by his enemies – 'who were in truth the more numerous and active body of the two' – that he had 'done very well' for himself.

Degas gives us our first full-length view of the man in his great portrait of the late 1860s (Fig. 1). It offers a series of paradoxes, which delineate the character of his friend with the same accuracy that he brings to the depiction of his features. Impeccably turned out, as he appears in photographs of that time (Fig. 2), Tissot might be a *boulevardier* who has happened into an artist's studio: although the pictures that surround him offer an accurate index of his artistic interests at the time, none is identifiably from his hand, and he seems without artistic commitment beyond a taste for studio visits, common enough among men of fashion in Second Empire Paris. By the time the portrait was painted, Tissot was a highly successful painter and his art had made him rich. It had allowed him to build a luxurious house in the avenue de l'Impératrice and to move freely in the *beau-monde*. He cultivated a style of sober elegance and high fashion with something, perhaps, of the melancholic pose of Romanticism and a tart modernity, which Degas has captured to perfection.[2]

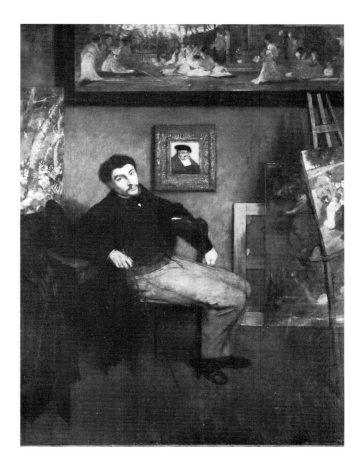

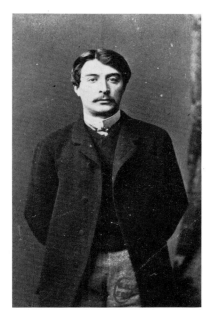

Fig. 2. *Carte de visite* photograph of Tissot.
c. 1865–8. Paris, Bibliothèque Nationale

Fig. 1. Edgar Degas. *James Tissot in
an Artist's Studio. c.* 1868. New York,
The Metropolitan Museum of Art, Rogers
Fund 1939

If we attempt to read the portrait in terms of character (dangerous, perhaps, but irresistible when faced with Degas's insights), the remote superiority of the dandy begins to give way to something less assured but more personal, and a disturbing mood begins to colour the atmosphere. The body, with its strong diagonal thrust, appears unstable and constricted. Seemingly without passion, the eyes – which Goncourt would later compare to those of a dead fish – follow us questioningly, aloof but somehow suppliant, and Tissot, tense as a coiled spring beneath his superficial langour, appears somehow trapped by the grid of pictures, which represent his own career. He is almost literally up against the wall of the studio, and only precipitate action seems sufficient to free him from his own lethargy. We are left with the unsettling feeling that Tissot may suddenly bolt, leaving the studio empty.

It is not unlikely that Degas, with his natural intuition and sense of character, has seized on elements in both Tissot and his art to give a true portrait of the man. With tact and affection, Degas is at pains to confirm Tissot's public pose as a dandy and *boulevardier*, but he allows us to glimpse beneath the surface to the troubled world of anxieties and contradictions that marked the man himself and formed the basis of his art.

His sitter was probably 32 years old and had been in Paris for twelve years. He had been brought up in Nantes and given a thoroughly religious education. His father, born in the Franche-Comté near the Swiss border, was practical, rich, and self-made, with little taste for the arts. His mother, a Bretonne, was religious, and religion fused easily with mysticism and the supernatural in Brittany. The young man's decision to become a painter was not met with enthusiasm, but he was not absolutely prohibited, and went to Paris at the age of nineteen to study with Lamothe. Little is known of his early years there. Although he met Whistler and Degas soon after his arrival and lived above Alphonse Daudet, who later wrote a fictionalized memoir of the time in *Le Petit Chose*, Tissot remains a shadowy figure. Daudet later suggested

that he was deeply religious, his head filled with dreams of imaginary cathedrals to decorate, and his first pictures hint that his religious upbringing had somehow come into unhappy conflict with his new life. He would not have been the first well-brought-up young provincial to receive a sentimental education in the City of Light – like the heroes of Balzac and Flaubert. His first work, a little portrait of his mother, looks out at us with the questioning eyes we later recognize in Degas's portrait of her son, and its companion at the Salon of 1859, *Promenade dans la neige*, already equated emotion and season, a snowy landscape and a lovers' quarrel. In the works that followed, the legend of Faust and Marguerite provided both the spiritual dilemmas and a type of heroine that remain constants in his work.

1, 2

Often dismissed on artistic grounds, a fate that their beautiful design and colour hardly warrant, these pictures read remarkably well in terms of character and point very clearly to autobiographical concerns. *Voie des fleurs, voie des pleurs* (Fig. 39), a moral tale whose title in translation, 'Path of Flowers, Way of Tears', seems to indicate a personal spiritual conflict, contains what is surely a self-portrait in the despairing young man at the centre, and *Départ du fiancé* (whereabouts unknown), with its passive heroine and Tissot himself as her betrothed, is, beneath its narrative superstructure, simply the first of his full-dress renderings of those partings like *Les Adieux* and *The Last Evening*. The early pictures have already that bitter taste of transience and estrangement that gives his work its unmistakable tone.

42, 55

As the decade closed, moral dilemmas gave way to modern genre, and with it came the great artistic and social success, which is reflected in Degas's portrait. Tissot's pictures take on a brittle, worldly elegance, which is far removed from the mute anguish of earlier works and if his stylish widows and arch *soubrettes* hint at deeper things, they are seldom allowed to show. Tissot also preferred an untroubled public face. In the earliest of his straightforward self-portraits (Fig. 3), a picture roughly contemporary with the Degas, he opts less for revelation than for charm, and gazes out with a confidence, which may be somewhat belied by a raised hand, which protects him as much as his air of detached amusement. (It must be simple coincidence, but how telling, that he repeats the gesture, although ritualized, in the self-portrait (Fig. 7) that he painted to finish his illustrations to the New Testament; surrounded with the paraphernalia of a funeral, he bids his readers goodbye.) The Franco-Prussian War brought an end to this happy existence. Brave during the Siege of Paris, Tissot, perhaps in anxiety about his house or from offended patriotism, then associated himself with the Commune, and when it collapsed amid furious reprisals, was forced to flee. Crossing to London, he set about building his shattered career in another country.

Tissot, the artist as business man and dandy, emerges even more clearly against a foreign background. In 1874, Edmond de Goncourt considered Tissot's second successful career in his *Journal*: 'Today, Duplessis told me that Tissot, that plagiarist painter, has had the greatest success in England. Was it not his idea, this ingenious exploiter of English idiocy, to have a studio with a waiting room where, at all times, there is iced champagne at the disposal of visitors, and around the studio, a garden where, all day long, one can see a footman in silk stockings brushing and shining the shrubbery leaves?'[3] Despite the sarcastic remark about the shrubberies, the rest was true enough. Tissot had set himself up in a big house in St. John's Wood, and until the arrival of Mrs Newton and her children turned the place into a nursery a few years later, the champagne must have flowed as the pictures sold, with gratifying ease.

When the fastidious Berthe Morisot visited London, she was invited to see the wonders for herself. In her letters home, she tells her mother and sister that Tissot 'lives like a king' from the sale of his pictures – those brooding 'early London works' we so much admire – which she describes briskly as 'very pretty things that sell well'. Describing her host, she suggests a touching desire to please in his compliments about her work (which she suspects he has probably never seen) and characterizes him as 'very nice, very decent – but a little vulgar' (although *everyone* probably seemed a little vulgar next to Berthe Morisot). Tissot's English friend Louise Jopling remembered him as 'a charming man, very handsome, extraordinarily

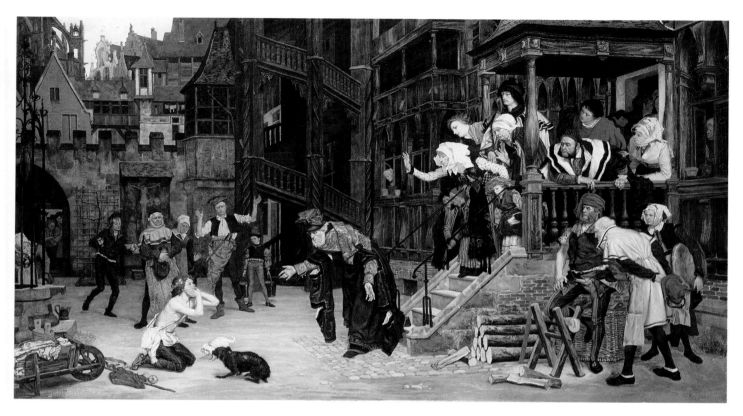

2. *Le Retour de l'enfant prodigue*, Manney collection. Cat. 5.

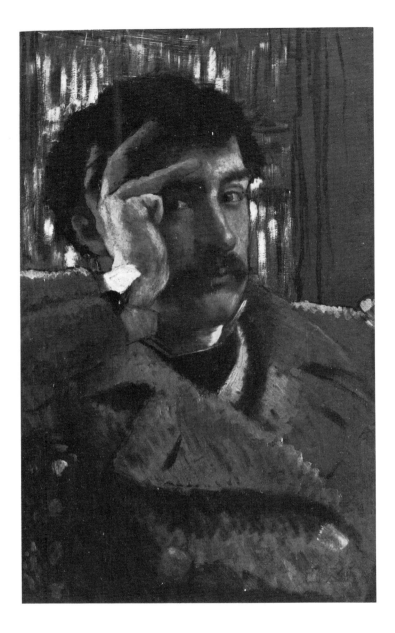

like the Duke of Teck, or rather the Prince, as was then his title', and her comparison to that popular prince may be taken as the highest of compliments. She then turns her attention to Tissot's wardrobe, and says with obvious relief that there was 'nothing of artistic artlessness either in his dress or demeanour'. Other biographers took up the themes with equal enthusiasm as the *cher maître* of the Bible illustrations gave interviews to the press. Clifton Levy described him, with an unintentional irony that would have pleased Degas, as 'a gentleman who might be anything respectable', and G.P. Jacomb-Hood, who saw him on board a ship to Alexandria in 1896, noted his reserved elegance and remarked that he was 'gloved and groomed as if for the *boulevard*'. After Tissot's death, George Bastard found that his reserved British manner had been as reassuring as the English cut of his clothes.[4]

In his own time, Tissot was clearly considered a successful gentleman-painter *par excellence* – a type more common then, and more admired than now. Today, the bland surface of his career appears less consistent. As with Degas's portrait of the man, it begins to shift as we study it and occasionally cracks to reveal the anxieties and contradictions lurking beneath. It almost appears that Tissot set out to wilfully destroy the structures he had so patiently and so successfully built. A decade of work in Paris was destroyed when he suddenly decided to throw in his lot with the Commune, and friends and patrons scattered in horror; his English career was compromised when he took up publicly with Kathleen Newton – an idyll doomed from the

start, if they but knew it, by her cruel malady – and then abandoned when he left London following her death; the failure of *La Femme à Paris* led to spiritualism, less suspect then, but also to the Bible, and a last success.

During the years of calm, Tissot's laconic social pose must have given the impression that he was lacking in temperament, an impression which can only have been strengthened by his hard head for business. Yet it was clearly more than a pose. In his life, as in his pictures, there is a sense of strain beneath the listless surface, and, pressed too closely by circumstance, it sometimes erupted with devastating effect. Was he perhaps laconic because it was the surest means of maintaining emotional control? Obsessive, apprehensive, superstitious and alienated on some deep level, how often his houses, his wardrobe, and his successes must have seemed the flowers covering the void, some kind of talisman to protect him from the doubt and isolation that lurked below. There was long to be an intransigent conflict between the impermanence and estrangement that drew him and the fear of it, which had to be assuaged by the permanence of houses, clothes, and success.

'Tissot, this complex being,' Edmond de Goncourt wrote in his *Journal* in 1890, 'a blend of mysticism and phoneyness, laboriously intelligent, in spite of an unintelligent skull and the eyes of a dead fish, passionate, finding every two or three years a new *appassionnement* with which he contracts a little new lease on his life.'[5] It is a portrait that complements, and completes, that of Degas some twenty years earlier.

In his own time, Tissot was considered a professional who practised his craft with hard-headed dedication and considerable skill. His hand, though dextrous, was heavy – as Goncourt found his intelligence: 'a little slow, serious and thoughtful, grasping with difficulty the fugitive subtlety of rapid shades of meaning'.[6] The product, however, sold well. A letter to a collector from the young artist, written in the early 1860s, suggests high fees and youthful arrogance: 'Sir, Several proposals have been made by serious collectors to buy my work'. Berthe Morisot was not alone in her astonishment at Tissot's English prices in the 1870s: Degas's letters are filled with them and John Singer Sargent is said to have referred to him sarcastically as 'a dealer of genius'. Later, Tissot himself would estimate his English earnings at 1,200,000 francs. In the 1890s, the marketing of the Bible illustrations would bring in sums which made the earnings of the past appear trifling: a million francs in reproduction rights in France alone, $100,000 in entrance fees during the American tour, $60,000 from the sale of the illustrations to the Brooklyn Institution.[7]

Like any good businessman, and like most of his artist friends, Tissot was anxious to suit his product to the market. The notion of the artist as a being obedient to his own development alone – or of art as an enclosed world with its own laws outside those of general society – would have struck him as ludicrous. Supported by the rigorous craft of his academic training, he was quite willing to court public approval, recasting his narratives and refocusing his aims. As a result, his art appeared complex and his talent anything but homogeneous to his contemporaries. It was more consistent than it appeared, bound together by what François Thiébault-Sisson described as truth and archaeology – a feeling for character and place phrased in the most precise terms – but as it continually shifted in external style and subject his contemporaries grew impatient and confused.[8] If we are to believe Edmond de Goncourt, his art, no less than his life, was sustained by those shifts, the *appassionnements* that gave him a short new lease on life and make his career read like an index of the developments that marked the second half of the century; brief, but potent, enthusiasms for Northern painting, Naturalism, Pre-Raphaelitism, Japonism, Impressionism and Aestheticism. To modern observers, this makes Tissot appear interestingly prophetic; to his contemporaries, these passions were regarded as sure signs of a lack of individual temperament and a tendency towards pastiche. As a result, he was often accused of plagiarism. Writing to his mother from Venice to describe his new pastels, Whistler once predicted: 'Tissot, I daresay, will try his hand at once.'[9] It was a sentiment shared by many.

Indeed, his relations with other artists were clouded by his passions if not by his desire to succeed and what seems to have been a disagreeably flinty ability to ignore the claims of friendship in the process. His friendship with Whistler, perhaps the oldest of his friends, was allowed to flounder when Tissot refused to testify on his behalf in the Whistler-Ruskin trial in 1877, presumably because Tissot did not want to compromise his standing by a public declaration of Whistler's artistic ability in the courts. His friendship with Degas came to an equally unhappy end when Tissot sold two pictures Degas had once given him for reasons that, however inexplicable, can hardly have been financial and today still appear quite gratuitously insulting.[10] When his own interests were involved, Tissot seems to have been without sentiment. In the middle 1970s, when Tissot had just begun to consider printmaking as a lucrative sideline to his painting, the printmaker Marcellin Desboutin – grand, impecunious, and the close friend of Tissot's friends Degas, Manet, and de Nittis – also considered the English market, only to find his search for patronage compromised by Tissot's slander of his work in London. 'I am astonished', Desboutin wrote to Mme de Nittis, 'that the good Monsieur Tissot has honoured me with his malevolence.'[11]

On the other hand, Tissot was on good terms with Manet and they travelled to Venice together in 1875. Tissot bought Manet's *Blue Venice* (Shelburne, Vermont, The Shelburne Museum) soon after, and back in London hung it in St. John's Wood and did his best to interest English dealers in Manet's work.[12] He also bought a picture from Pissarro after it had been refused at the Royal Academy, to help him through the difficulties of exile in London.[13] Perhaps Tissot's friendships can be summarized, as Tissot himself was by a contemporary, as 'prodigious when he found it expedient, and ever prudent'.[14]

Prudence might also be said to be the guiding principle of his career as an artist. He was a bundle of anxieties and contradictions, but he had all the strength of character needed to keep them in line and make them work for him. Precious little time can have been spent in reflection, self-pity, or regret. If anything is truly remarkable about Tissot, it is not that he was neurotic, but that he successfully made his neuroses play so positive a part in a long and successful career. Indeed, a considerable part of the modern fascination for him lies in how he applied his own troubled feelings to his otherwise often standard works, for it is now customary to consider his pictures almost entirely in terms of their sense of emotional strain and psychological conflict. But was this always so? One would be hard-pressed to substantiate the approach in any contemporary reviews of his pictures, which dwell on narrative and technique rather than psychological content. Should one assume that the neurotic edge was simply ignored? Or was it invisible? In no other aspect does the gulf between modern appreciation of his work and that of his contemporaries appear as great. Considering Tissot's English pictures in 1902, a critic as perceptive as Thiébault-Sisson found them not neurotic, but laboriously 'sincere', and 'intensely English in tone'. Was what is now considered subtle then considered ineptitude? 'His brush was never light enough, his drawing never swift enough to express the Frenchwoman in her restless activity . . . powerless in the presence of the Parisienne . . . he had not much hesitancy as to the Englishwoman, whose grace is more robust and less bewildering.'[15]

Tissot practised his craft with dedication and hard work. Quite probably it is his remarkable energy that distinguishes him as a person. He painted about 300 pictures, not including oil sketches and similar works; made about ninety etchings, drypoints, and mezzotints; took up *cloisonné* enamel and sculpture with ambition and aptitude; and in his last years produced his illustrations to the Bible with all the dedication, study, and travel the task required. As an artist, he continually extended himself to the very limits of his ability. If his *appassionnements* steered him a crooked course, each was taken up with an enthusiasm that never faltered. The last of the Bible illustrations were begun with all the energy that marked his passion for Leys and Japan.

Energy run wild may at least partially explain Tissot's nearly obsessive interest in the duplication of his work as he grew older. There are few replicas of pictures in the 1860s – *Un Déjeuner* (whereabouts unknown) and its near duplicate are the only pair actually located today –

3. *L'Escalier*, private collection. Cat. 22

Fig. 4. J.M. Brydon,
architect. *Studio for James
Tissot Esqre, Grove End
Road*. The *Building News*,
15 May 1874

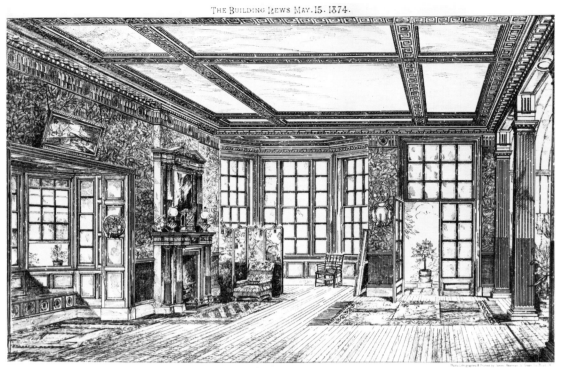

STUDIO FOR JAMES TISSOT ESQRE. GROVE END ROAD.
J . M . BRYDON . ARCHITECT.

44 and in the early 1870s his replicas, like that of the left hand figure in *Bad News* (Colour Plate 26),
are more accurately described as variations, but by the end of the decade replicas had become
the rule and large exhibition pictures were reproduced in smaller oil versions intended for a
collector's market, in watercolours, and in etchings, with a relentlessness that perhaps goes
beyond simple practical commercialism.

Tissot's working method was consistent to his aims, and was the solid product of his Parisian
training as an artist. He took a direct line from studies and oil sketches to the finished picture,
and if it proved a success, followed it with replicas and reproductions. It was a process that left
little room for experimentation, trial, and error, but it was entirely practical and there were few
false steps. Among the gouache studies for pictures of the early 1870s, for example, only a few
are without a picture for which they directly served. Two drawings, a study for *The Return from
60 the Boating Trip* (Colour Plate 4) and a study of a young woman (USA, private collection) that can
now be associated with the 1874 Royal Academy picture *Waiting* (whereabouts unknown) have
only recently left the ranks of the unassociated drawings, and others will surely follow.

Fundamentally without imagination, as Tissot's contemporaries noticed in increasing
numbers as the Bible illustrations appeared, his working method was well-suited to his artistic
aims. An insistence on visual truth was ideal in combination with his energy and patience in the
creation of modern genre pictures and seldom played him false until he blundered on to the
sublime in the Bible illustrations. Like Courbet, Tissot wanted to see something before he
painted it (and whether he *did* see the ranks of the seraphim as he later claimed is another
question). We can be sure that what we see in his pictures was documented with precision; those
of the 1870s, for example, reflect the physical setting of his studio at Grove End Road
(Fig. 4).[16]

More interesting, and clearly related, is Tissot's repetition of costume and setting from
picture to picture, creating, perhaps unintentionally, little series which describe various
passions. Sometimes costumes are even repeated within the same picture, taking on a magical
sense of double exposure, but whether this repetition was simply a matter of convenience, a by-

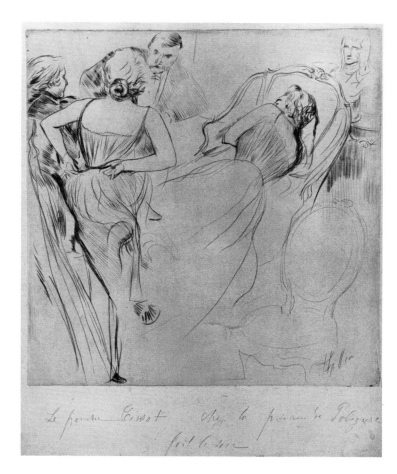

Fig. 5. Paul Helleu. *Le Peintre Tissot chez la princesse de Polignac. c.* 1895. Drypoint, with pencil additions. Private collection

product of photography itself, or an artistic concern of the kind that fascinated Degas remains a matter of conjecture. In that, the original title of the picture now called *In the Conservatory* (whereabouts unknown) might prove invaluable in providing the key to Tissot's intention. It is given a narrative hinge by its 'twins', but the quality of Muybridge about it may not be coincidental. Tissot was less than honest when he said the titles of his pictures were 'not intended to express anything'.[17] Julian Treuhertz's discovery that the original title of the picture at Manchester long known as *The Convalescent* is in fact *The Warrior's Daughter* is proof enough to the contrary : all confusion has disappeared with the proper title and the picture itself is fraught with marvellous new complexities and meanings.[18]

107

The emotional cataclysm of the death of Mrs Newton in 1882 seems to have brought Tissot's professional and personal life to some kind of head. For the only time, Edmond de Goncourt found Tissot emotionally convincing and was obviously moved by the reality of his grief when Tissot arrived in Paris a week after her death. The ambitious series *La Femme à Paris* occupied him for the next three years and was a failure when it was exhibited at the Galerie Sedelmeyer in 1885. It is artistically complex and determinedly eccentric in its approach, although much of it is familiar if we look more closely, but it is also somehow a little half-hearted and mechanical. While he worked on the series, Goncourt tells us that Tissot courted the tight-rope walker who appears in one of the pictures and became engaged to Louise Riesener, adding a floor to his house with touching enthusiasm in anticipation of his marriage, until the lady caught sight of his portly silhouette as he removed his overcoat and changed her mind. Both episodes like *La Femme à Paris* itself, can be read as desperate remedies against grief, or as quick forgetfulness. Some ten years later, Helleu, who, all things considered, might have been kinder, told Edmond de Goncourt about a little drypoint he had made of Tissot, his 'concupiscent eyes fixed on a woman's décolletage'.[19] But for its size, he might have been describing his large *Le Peintre Tissot chez la princesse de Polignac* (Fig. 5).

165–172

177

The world gave way to the Bible in 1885 when Tissot, at work on *Musique sacrée* (whereabouts unknown ; the last of the *Femme à Paris* series, which represented a society woman

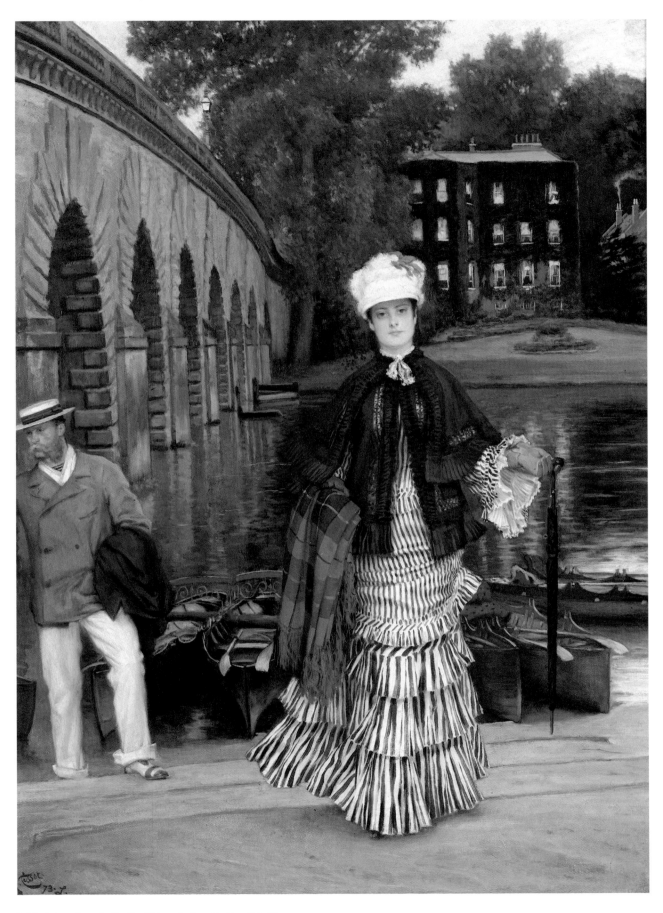

4. *The Return from the Boating Trip*, private collection. Cat. 60

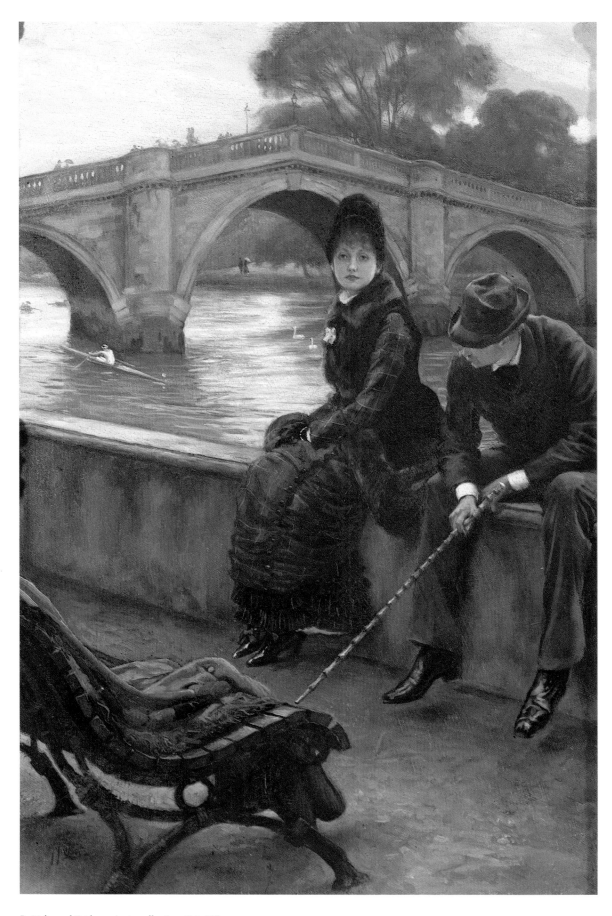

5. *Richmond Bridge,* private collection. Cat. 110

singing a duet with a nun in the choir loft of a church), returned to the church of St. Sulpice to soak up local colour and make a sketch for the setting. During mass, Tissot found himself joining in the devotions, and as the Host was raised, he had a vision of Christ the Comforter. His vision lingered between him and his work: attacked by a fever, he fell sick and when he recovered, painted his vision. Or so he said, perhaps a little too often, to the press.

181, 184 From that day forth, he could no longer return to his former worldly subjects, yet felt unworthy to touch upon the 'real' Jesus. To render himself worthy, he undertook to illustrate the life of Christ. The Old Testament followed, and before he had done, three trips to the Holy Land and fifteen years of labour had made him a figure of international importance – not artistic importance, perhaps, but a key figure in that strange religious revival in the eighties and nineties, which tinted the *fin de siècle* with the iridescent colour of its equivocal faith, half St. John in the wilderness, half Sarah Bernhardt in Byzantium.

Tissot's illustrations must be assessed apart from his other work, and perhaps even by a different, non-artistic, set of standards. They were intended to be as exact as the illustrations in a scientific text book, and their success or failure as works of art took second place to his attempt to document physical realities: that is how they were judged by his contemporaries, and that is how he wanted them to be judged. The Bible was to be rendered whole. Archaeology and truth, illuminated by the bright lamp of faith, was to restore the rights 'filched' from it, as he said, by generations of artists interested only in form and colour. He set about his task exactly as he had set about his Leysian Fausts and Thames-side idylls – by gathering the data about type, costume, and setting; when something more intangible was required, he supplemented reality with the results of his experiments in the occult. Mrs Newton had materialized at a séance to his complete satisfaction, another vision that was reproduced for public consumption, and her gauze draperies and shining lights are to be encountered in numerous more sacred contexts.

142 But tied, however willingly, to his text, Tissot reduced himself to an illustrator, and so limited the part his own gifts could play in the creation of the series. He had previously illustrated the Goncourts' *Renée Mauperin* as a family tragedy in which he and Mrs Newton were photographed in some kind of macabre charade of their own future; modern life was what he did best, and there were, after all, only ten episodes to deal with. The task may have proved more congenial than we know and may well have turned his attention towards illustration itself. The Bible required hundreds, ultimately thousands, of illustrations, and the task must have grown a bit tedious – if appearances aren't deceiving – when it was mired down in the minor prophets or parables without particular visual appeal. Only death could finally still his hand, and halt the illustrations issued forth by the score.

The world gave way to the Bible, and what a stroke of practical genius it was, catapulting him into the ranks of *chers maîtres* (Fig. 6), with a force sufficient to last the rest of his life. Humourless pomposity flows like the waters of Eden in his remarks: he described the enormous task of the Bible illustrations to Cleveland Moffett as 'not labour, but prayer'.[20] He rhapsodized about his visions and his château with pious fluency, but he did it with all the skill of a revivalist preacher or a confidence man, and it is difficult not to admire him for it in terms of theatre, if nothing else (Fig. 7). The world was ready for the Tissot Bible, and Tissot, the businessman, was ready for the world.

Whether it was piety and pure faith, or hard-headed practicality and a public pose can be debated: there were contemporaries convinced of both, and it seems likely that it was a mixture of the two. Tissot's contemporaries also considered his Bible his most significant work and it overshadowed his earlier *mondaine* works; there modern taste demurs.

Faith has always been assumed to have made him blunder. Perhaps the answer is more complex. Faith, together with spiritualism and fame, had brought freedom. The real failure of the Bible illustrations lies less in his mistaken belief in the power of truth and archaeology to tackle the sublime, than in some internal slackening of the anxiety, yearning, and estrangement that had given his earlier work such potent force. Inner peace had removed the mainspring of

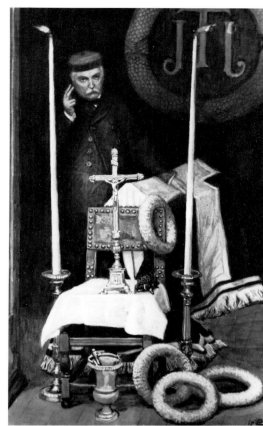

Fig. 6. Photograph of Tissot. *c.* 1895. Private collection

Fig. 7. *Portrait of the Pilgrim. c.* 1886–94. New York, the Brooklyn Museum

his art. The old method remained – truth and archaeology for anyone – but the electric charge of personality that had shocked them out of the ordinary was gone. The Bible illustrations are tedious as archaeology and flawed as truth, but had he continued to paint 'vulgar society', might not the results, if less distasteful, have been much the same? Tissot, perhaps, had simply ceased to be an artist. The energy and enthusiasm that sparked his talent had transformed themselves into other means of expression; certainly he still had plenty of both for spiritualism, travel, publicity, high-living, and one hopes, 'the inconceivable joy in his faith' he had described to a disgusted Degas.[21]

Tissot's art was forgotten in the rush to modernism, but in a new age when artistic intelligence and sure craft again have the power to surprise and delight, he has returned to the forefront in a way that would have astonished his contemporaries. That he has emerged as an *artist* is entirely owing to what he dedicated his life to doing – making pictures, and he would be the first now, as he was in his own lifetime, to resent biographical explanation. That his life is ultimately as irrelevant as it is fascinating is a true measure of his success.

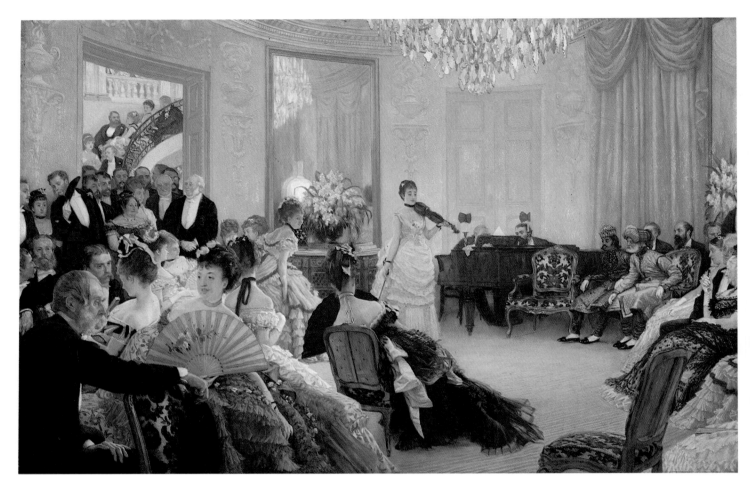

6. *Hush!*, City of Manchester Art Galleries. Cat. 70

7. *Too Early*, Guildhall Art Gallery, London. Cat. 65

3

Comic and Aesthetic: James Tissot
in the Context of British Art and Taste

MALCOLM WARNER

Sometimes obvious, more often understated or ambiguous, the spirit that animates Tissot's art at its best is the spirit of comedy. Not that he was a caricaturist, or a fine-art cartoonist. Nothing could be further from his intentions than trying to make us laugh by exaggerating to the point of deformity or by cracking illustrated jokes. His style is so dead-pan that he may not make us laugh at all, just smile without quite knowing why. It is comic in the true sense because it is observant and naturalistic, drawing attention to human foibles and vanities as part of a

65 believable picture of society. Looking at a work such as *Too Early*, it is easy to understand why Tissot has so often been written off as merely photographic. So complete is his rendering of the crystal chandelier, the shiny floor and the flouncy dresses, that we forget we are looking at a painting and enter into the humour of the situation as if it were real, as if we were seeing it as directly as the two amused servants peeking round the door in the background. Tissot's comic world is apparently without signposts; we seem to find the humour for ourselves and there is great pleasure of recognition to be gained when we do.

Too Early is one of his more overtly comic pieces. The embarrassingly punctual guests, shuffling their feet and wondering where to look and what to do with their hands, are ridiculous because they have made a social mistake. (Tissot later used virtually the same central group to represent a family of gauche provincials in his series *La Femme à Paris*.[1]) But there is a deeper comedy to the situation, which is that they, their hostess, the guests yet to come, probably we the spectators too, should abide by the absurd conventions that make arriving too early so uncomfortable. Here, and in his other pictures of the middle classes at leisure, Tissot ever so gently portrays their social life as an elaborate ceremony in which the main object is to

66, 70 wear the right clothes and behave correctly. In *The Ball on Shipboard* and *Hush!* (Fig. 8), the parties are in full swing but no-one seems to be enjoying themselves. They are all too concerned to appear nonchalant — and the impending concert in *Hush!*, designed to bring an artistic touch to the evening, is quite clearly a bore. The only guests showing much interest are the two Indians on the right, and then perhaps more out of curiosity than love of the violin.

80 Only occasionally does the humour broaden, as in *The Gallery of HMS Calcutta* (London, Tate Gallery), where the French pun on Calcutta, 'quel cul tu as!', refers us to the curvaceous forms of the young woman in the centre. The lines of the ship's architecture and furniture bend as if in sympathy and appreciation. Elsewhere, Tissot can be just wilfully strange, as when he includes

66 four pairs of women wearing identical dresses in *The Ball on Shipboard*. It is an enchanting touch worthy of Buñuel, but what does it signify? Are they four pairs of twins? Or have four pairs of women arrived at the ball not too early this time but (the worst of all socialites' nightmares) wearing the same outfits, quite by chance? Is Tissot wryly likening fashion to a uniform? His intentions are sometimes tantalizingly concealed. But the general flavour of his comedy is fairly clear. He just lightly and with a straight face teases the people he depicts, much as he and Carlo

52 Pellegrini teased the eminent Victorians they drew for the magazine *Vanity Fair*.

The tradition of comic painting in Britain begins of course with Hogarth. Tissot's work invites comparison with Hogarth; he surely knew as much and so did his audience. Both artists deal in the painstaking observation of the dress and carriage of their day, manners, customs and

 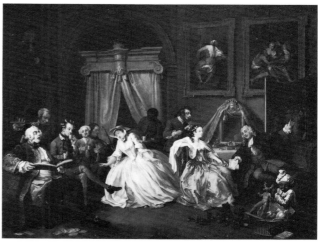

taste, especially in interior decoration. Both think in theatrical terms, creating stage-like spaces for their characters and stressing *mise-en-scène* and descriptive detail at the expense of formal considerations. The point of their work lies in what they show rather than the way they design their compositions or handle their brushes. Tissot is at his most obviously Hogarthian in his series *The Prodigal Son in Modern Life* (Nantes, Musée des Beaux-Arts), which is an updating of *A Rake's Progress*. But in less specific ways all his views of British life are an updating of Hogarth, especially the Hogarth of *Marriage à la Mode*. Defining what they have in common and the differences between them is a useful way of understanding Tissot's position in British art.

First of all, both Hogarth and Tissot are painters of modern life; they highlight those facts of contemporary life that make it different from life in the past. Their characters wear the latest fashions, inhabit fashionably decorated interiors and live their lives *à la mode*. Their favourite territory is the city, where things change most quickly. As far as their professional standing was concerned, both fell foul of academic prejudice, particularly the hierarchical view of subject-matter that placed religious, mythological, allegorical and historical subjects above the depiction of real life and which encouraged the artist to aspire to the ideal, to represent things as they ought to be, rather than as they ever are. Hogarth attacks this notion in the examples of so-called 'high art', shown as the corrupt taste of corrupt people, that he includes in the background of works such as *The Countess's Morning Levée* (Fig. 9). The hierarchy still held sway in Tissot's time but there were more voices raised against it, particularly in France, where the case for *le peintre de la vie moderne* was made eloquently by Baudelaire, and pictures of an insistent, sometimes deliberately provocative modernity were painted by Courbet, Manet, Tissot's friend Degas and the Impressionist group. These had their British counterparts in works by the Pre-Raphaelites and Whistler, as well as stylistically more conservative artists such as W.P. Frith.

Hogarth called *A Rake's Progress* and *Marriage à la Mode* his 'modern moral subjects'. Tissot's work can hardly be called 'moral' except in the sense that it records contemporary mores. As far as morality is concerned, it generally has little or nothing to say. Tissot is capable of moral pronouncements on a high, abstract level, as in his dance-of-death picture *Voie des fleurs, voie des pleurs* (Fig. 39) and the projected allegorical series *The Triumph of Will*, but he does not raise the same issues when down among real people of his own time. The nearest he approaches the modern moral subject is in *The Prodigal Son in Modern Life* but that is a biblical parable of timeless relevance put into modern terms to make it come alive for a modern audience, which is a different thing from art that is critical of contemporary society. Hogarth stands at the head of a tradition of British modern-life painting that portrays society in a way that invites moral judgment and usually condemnation. The Countess at her levée is allowing herself to be charmed by her smooth-talking lawyer into making an assignation with him for the purpose of adultery and this, according to Hogarth, is typical of modern marriage, marriage *à la mode*, cynically conceived for financial and social advantage. It is a moral tract for his times.

Fig. 8. *Hush! (The Concert)* c. 1875. City of Manchester Art Galleries

Fig. 9. William Hogarth. *Marriage à la Mode IV: The Countess's Morning Levée.* c. 1743. London, National Gallery

85

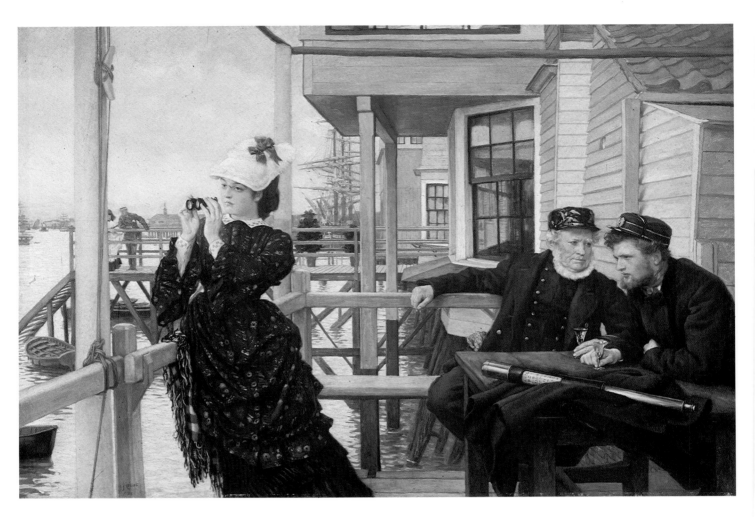

8. *The Captain's Daughter*, Southampton Art Gallery and Museums. Cat. 57

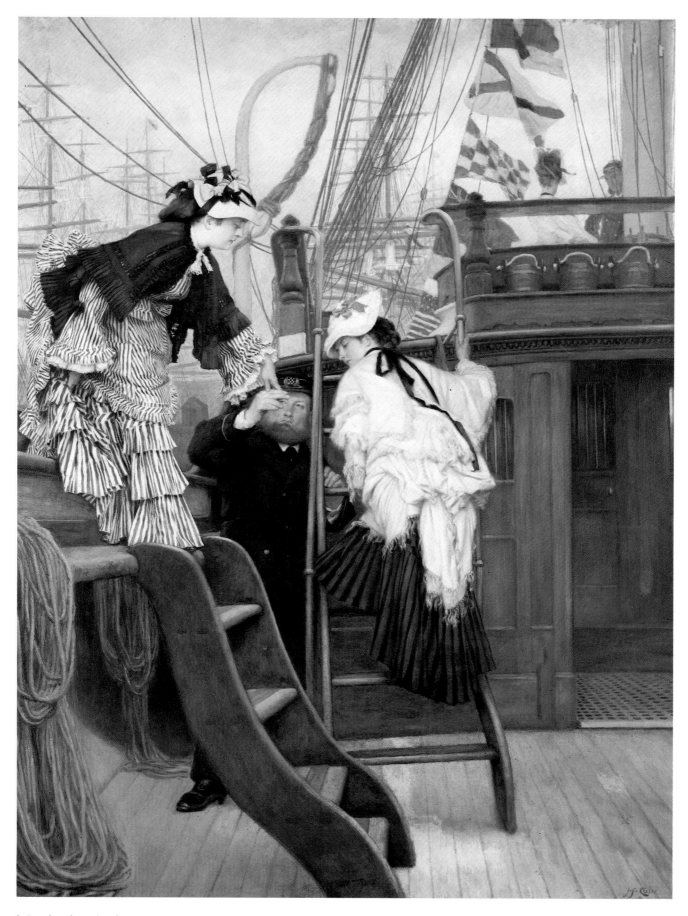

9. *Boarding the Yacht*, The Hon. P.M. Samuel. Cat. 64

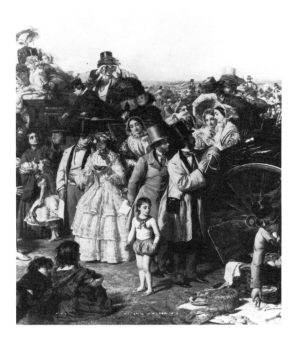

Fig. 10. William Powell
Frith. *The Derby Day*
(detail). 1856–8. London,
Tate Gallery

There was a Hogarth revival in the 1850s and 1860s led by Holman Hunt with *The Awakening Conscience* and continued in pictures by Ford Madox Brown, Augustus Egg, R.B. Martineau and others. A 'Hogarth Club' was formed in 1858 with Hunt and Brown among its members. Tissot's work seems even more amoral alongside the earnest, sermonizing efforts of these men than they do alongside pictures by Hogarth because they are addressed to more or less the same society. He is closer in spirit perhaps to more moderate artists working in the Hogarthian tradition, such as David Wilkie and Frith. Yet even an ostensibly jolly scene such as Frith's *The Derby Day* (Fig. 10) still draws attention to aspects of the subject that seem to demand a moral response, however shallow and commonplace that response might be. We notice how the wealthy racegoers, some of them frittering away large sums of money on gambling, are contrasted with the poor entertainers, gypsies and beggars around them. We home in on incidents such as the hungry child acrobat being distracted in mid-performance by the sight of a servant spreading out a sumptuous picnic for his masters.

The British modern-life painters usually couched their social comments in narrative terms. The moral is the moral of a story. Indeed, British art in general aspired to the condition of story-telling. Millais's *A Huguenot* (Fig. 11) began life as a picture simply of lovers whispering by a garden wall. Acting on the advice of his friend Holman Hunt and his own acute knowledge of public taste, Millais finally gave his lovers a moral dimension and a very specific narrative context. The full title as printed in the Royal Academy exhibition catalogue was *A Huguenot, on St. Bartholomew's Day, Refusing to Shield Himself from Danger by Wearing the Roman Catholic Badge*, and there was a passage from a history book to go with it. This was the kind of popular costume-piece that Tissot set out to imitate in *Les Adieux* (Fig. 12), one of the first pictures he sent to the Royal Academy exhibition shortly after settling in London. It fitted the bill as far as its general theme of love in adversity was concerned, and in its picturesque period details. But there is no clear narrative line. For all we know, the situation raises no big issues whatsoever; and the lovers' story is unexplained. The finality of 'adieux', the dead leaves and the scissors (for severance) suggest that they are parting for ever. But why? And what is the significance of the ivy, which is normally a symbol of dependence or eternal life?

The ambiguity of *Les Adieux* is characteristic of Tissot. Hogarth, Frith and Millais (at least in *A Huguenot*) spell out the stories in which their characters are involved with maximum clarity, using carefully chosen incidents, appropriate gestures and facial expressions, and easily legible symbolism. Hogarth's seductive lawyer is enticing the Countess to come with him to a masked

42

ball, and gestures debonairly towards a picture of such a ball on the screen. The Countess responds with a knowing look, and in the foreground a laughing boy points to a figurine of Actaeon, whose horns foretell the cuckolding of the Countess's husband. It is impossible to read Tissot's paintings in this way. He prefers to keep us guessing. His titles rarely help: indeed, he made a point of not giving too much away in them and occasionally changed them as if they were of no consequence. We gain an insight into what he intended us to make of his ambiguities from his plan to have the etchings after the series *La Femme à Paris* accompanied by stories written by various authors inspired by the pictures. *La Menteuse*, which shows a young woman in a finely decorated interior holding some flowers and parcels, was provided with a story by Alphonse Daudet about an artist's mistress who comes home with gifts she claims are from people to whom she is giving piano lessons.[2] Only after her death does the artist discover she has been lying to him. In much the same way as Daudet did, though not quite so elaborately perhaps, Tissot surely wants us always to speculate about what stories his characters might be involved in. If narrative content can be latent, optional and largely the invention of the specatator, then his work is narrative – but that is hardly what most British artists would have understood by the term.

Tissot was by no means alone in avoiding the easily legible storyline. Being seen not to depend on narrative, or 'subject' in the way the Victorians used the word, was virtually a condition of membership of the British avant-garde. The reaction against subject, which can be called the 'Aesthetic Movement' for want of a better term, began with Millais's *Autumn Leaves* and his other mood-paintings of the later 1850s and was carried on by Whistler, Rossetti, Burne-Jones, Albert Moore and others in the 1860s. Their paintings are static and self-contained, suggesting not a story arrested at a telling moment but a mood, usually of languor, wistfulness and sensuality. Their purpose is not to be true or good but to be beautiful. The emphasis is on form more than description, on colour especially, and in the case of Whistler, on brushwork. Whistler was the most militant campaigner against subject and was fond of making didactic analogies between painting and music. If music can be an arrangement of notes that do not represent anything nor tell a story, why should painting not be a subjectless arrangement of

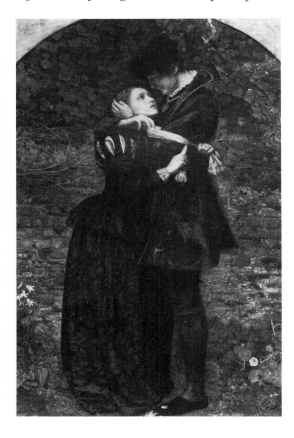

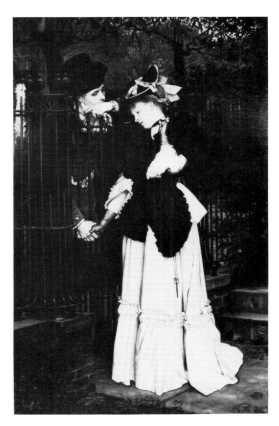

Fig. 11. John Everett Millais. *A Huguenot.* 1851–2. Makins Collection

Fig. 12. *Les Adieux.* 1871. Bristol City Art Gallery

Fig. 13. James McNeill
Whistler. *The White Girl.*
1861–2. Washington, D.C.,
National Gallery of Art

Fig. 14. *Les Deux Soeurs:*
portrait (The Two
Sisters). 1863. Paris,
Musée d'Orsay

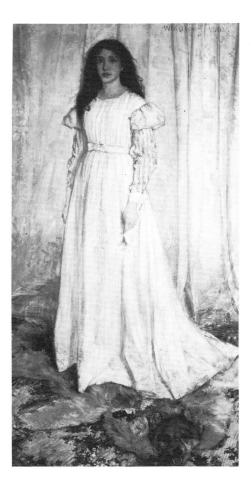

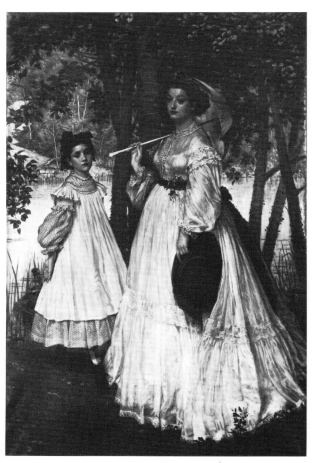

colours and be just as effective? Tissot showed he was aware of the Millais-Whistler tendency in British art as early as 1863 with *Les Deux Sœurs* (Fig. 14), a 'symphony in green' derived from the work Whistler called his 'Symphony in White, No. 1', *The White Girl* (Fig. 13).

The painting that tells a story generally uses facial expressions to help do so. The works of Hogarth and Frith are full of physiognomic signs that tell us what people are like, what they are thinking and what they are feeling. Artists of the Aesthetic Movement rejected storytelling, and facial expression with it, feeling that if a face were too strongly stamped with character or affected by emotion, this would distract attention from its beauty, which was the main object of the exercise. *The White Girl* belongs to a vast sisterhood of dreamy, impassive females who stare blankly out at us, and beyond us, from British paintings of the 1860s and 1870s. So does the young woman in the striped dress in the left foreground of *The Ball on Shipboard*, Kathleen Newton in pictures such as *The Warrior's Daughter*, and indeed most of Tissot's female characters. His reasons for adopting this 'look' are typically complex. He undoubtedly shared some of the artistic concerns that led Whistler and others to subjectlessness and expressionlessness, although they obviously never possessed him as completely as they possessed, say, Albert Moore. Then in a work such as *The Ball on Shipboard*, lack of expression is part of the comic point of the scene: the party is all finery and no fun. But then again, amongst the kind of people Tissot depicts, 'aesthetic' impassivity was actually the fashionable look.

It often is. Most people think that impassivity becomes them, that it brings out any beauty there may be in their features and makes them look more interesting as well. There are good reasons for this. When we look at faces, whether in real life or art, we inevitably look for clues to the thoughts and feelings behind them. When an expression is definite, a broad grin for example, we register its meaning quickly and it is unlikely to hold our attention for long. But a

14

66
107

66

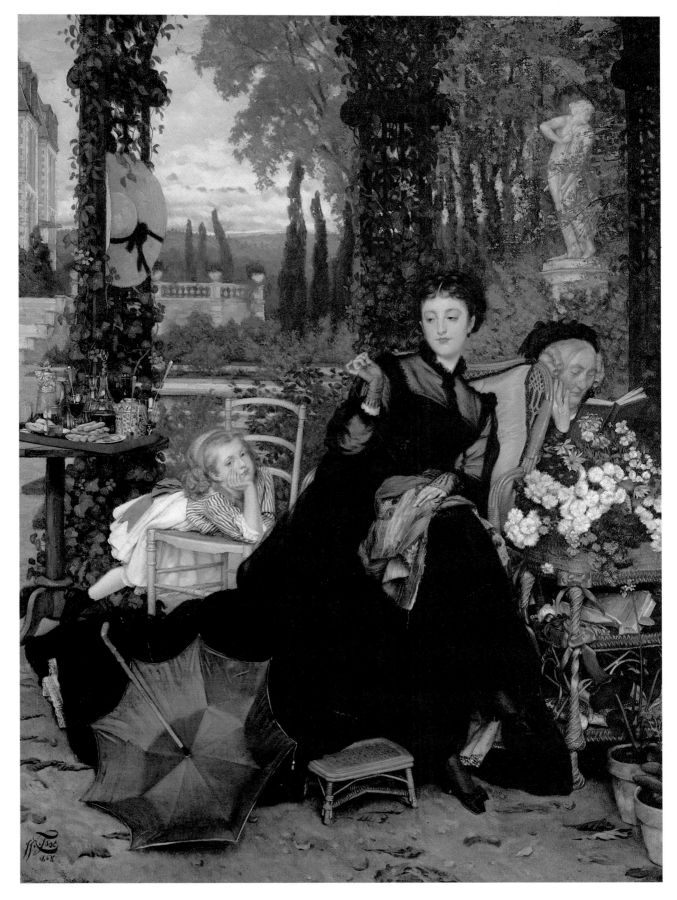

10. *Une Veuve*, Manney collection. Cat. 18

blank stare keeps us guessing and inventing, and what we read into the face is far more interesting and attractive than what we can read so easily in a broad grin or any other marked expression. It suggests unconcern with the banal realities of everyday life, deep thought and a touch of melancholy, which has long been a most fashionable state of mind to appear to possess. Today it is often assumed by pop stars but it has been the hallmark of image-conscious people for centuries. Its ambiguity offers obvious advantages to the artist, especially when concerned with a group composition. Wherever two or three expressionless people are gathered together, we are all quite prepared to believe that there is something 'psychological' going on between them. Tissot constantly plays on our suggestibility in this respect, quite ingeniously and quite legitimately too.

When the people wearing this look are also wearing the most fashionable, expensive clothes and seen in the most luxurious settings, it takes on an extra meaning. The chic set who inhabit Tissot's pictures appear to be quite at home with wealth and beauty and quite unimpressed. Their evident indifference makes them all the more attractive. They are glamorous, because they take their superiority for granted. The guests at *The Ball on Shipboard* are quite un-selfconscious about the 'other ranks' looking on from a respectful distance at the back. Both groups know their place. The picture would make a perfect advertisement for the couturier who made the women's dresses, not only because it displays them to best advantage (sometimes from two different angles), but also because it shows them as a must among the fashionable elite. Magazine and television advertisements now sell everything from holidays to chocolates on the implication that they are passports to the in-crowd. Of course, Tissot's object was not to sell dresses. But he did want to sell paintings, which he did with quite outstanding success because they are such good advertisements for themselves. 'Buy us', they seem to say, 'and it will show the world that you know style when you see it.'

Tissot's scenes of fashionable life were intended for people who could identify themselves with the characters he depicts and who bought them as they might buy idealized portraits of themselves. When he made actual portraits and 'specimens' to attract commissions (Fig. 15), he gave his sitters the same immaculate dress, opulent surroundings and impassive looks as the people in his social scenes; the latter stand in the same flattering relation to middle-class society as his portraits do to the individuals they represent. This is the fundamental difference between Tissot and Hogarth. No-one bought Hogarth's pictures and engravings because they believed or wished themselves to be like the characters the artist describes. Tissot's buyers did exactly that. So it is not surprising that he should avoid serious criticism and moralizing. Few people buy pictures to be told off by them. And the avoidance of any definite narrative helped his audience to imagine themselves into the glamorous company Tissot portrays, far more than if some specific story about specific characters were taking place.

In other words, Tissot was in the business of creating a stylish self-image for the wealthy, art-buying middle-classes. The early Victorian period had seen the patronage of art in Britain pass from the aristocracy to the new men of the age, rich industrialists, largely from the North of England. These were the patrons and collectors on whom the Pre-Raphaelites depended. Most of the pictures they bought embodied the values they cherished: truth, work, duty, abstinence and family life. By the 1870s, when Tissot was in London, a disturbingly hedonistic attitude had begun to rear up in the very homes of these self-made men, fostered among their children and grandchildren by the privileged upbringing and education that their family's wealth provided for them. Hogarth portrays wealth as corruptive. Frith, the early Victorian, warns against its misuse, especially gambling, and advocates philanthropy. Tissot concerns himself not at all with the morality of wealth, merely with the question of how best to flaunt it – and in this he struck a chord in the hearts of many wealthy people of his time.

These were the generation who felt nostalgic for the elegance, pleasure and *savoire-faire* that had supposedly characterized life before the Industrial Revolution, who decorated their homes with eighteenth-century paintings and furniture and created a rococo revival in art and

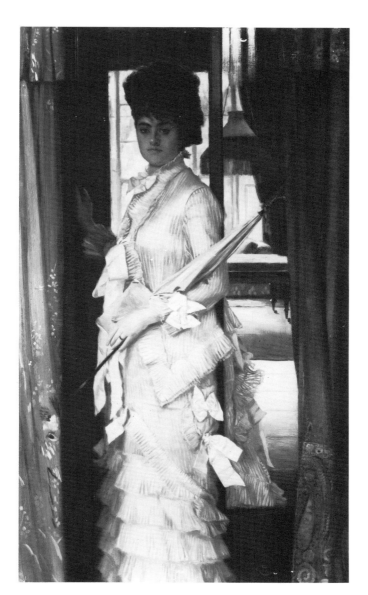

Fig. 15. *A Portrait (Miss Lloyd)*. 1876. London, Tate Gallery

architecture. It was a fairly natural offshoot of the Aesthetic Movement. In pictures such as *Les Adieux*, Tissot catered to the taste for things eighteenth-century in an obvious way. But there is a fashionably rococo air about many of his modern-life works too. *Too Early* and *Hush!* are set in eighteenth-century-style interiors and the elegant social gatherings they show might well touch off memories of Watteau. With just a hint of irony, Tissot's works suggested to his nineteenth-century audience how they might behave in an eighteenth-century manner; or, to put it another way, they suggested to his middle-class audience how they might behave in an aristocratic manner. They are modernized *fêtes galantes*.

65, 70

The refinement of Tissot's comedy is utterly in keeping with the sophisticated world his pictures evoke. His art could not afford to be caricatural or judgemental, which would have seemed bad manners, or worse, small-mindedness. But if it contained a little teasing irony and wit, so much the better. Being part of the *beau monde* is by no means incompatible with the ability to observe it with amused detachment; on the contrary, this is the mark of the true dandy. Tissot himself adopted the persona of the dandy: he was the man of the world; he had seen everything and been impressed by nothing except the vanity of it all. Being a Frenchman in London society made him all the more believable and attractive in the part. At their most effective, his pictures had his audience identifying themselves simultaneously with the characters depicted and with the artist. When they saw the comedy in them, they could flatter themselves that they had achieved the ultimate sophistication of smiling at sophistication itself. Tissot's is a fashionable comedy, tempered by aestheticism and perfectly fitted to its time.

11. *Colonel Frederick Gustavus Burnaby,* National Portrait Gallery, London. Cat. 30

12. *La Soeur aînée*, D.C. Dueck. Cat. 124

4

Tissot: his London Friends and Visitors

JANE ABDY

James Tissot lived almost permanently in London between May 1871 and November 1882. He was one of a number of French artists, who for reasons political or economic, found London a convenient artistic home. Goncourt describes them as 'cette nouvelle genération de peintres, gagneurs d'argent et à cheval sur Paris et Londres'. Unlike many of his friends, who were literally visitors, Tissot loved England, and had an Anglomania so great that he had anglicized his Christian name as early as 1859, and was mistaken in the early 1870s by Jacques Emile Blanche, albeit then a boy in his teens, for an Englishman.

It is impossible for us now to imagine the difference between London and Paris in the 1870s: Paris was a city of brilliant light and long boulevards, London was still the London of Dickens. The oft quoted remark of Tissot to Goncourt that he loved England because of the 'odeur du charbon de terre' and his nostalgic references to 'ces pluies comme il en fait à Londres et ou la chassée était un lac' were highly idiosyncratic statements from a Frenchman. Most foreign visitors were appalled by the filth of the capital, smothered but not hidden by pea-soup fogs, and de Nittis attributed his bronchitis largely to the fatigue he suffered from 'les demi journées passées en Angleterre à peindre dans le brouillard'. Sarah Bernhardt, arriving in 1879, found it a dismal city, and bewailed 'dust and grime and black with greasy dirt; those flower sellers at the corner of the streets, with faces sad as the rain and bedraggled feathers in their hats and lamentable clothing; the black mud of the streets; the low sky. The funereal mirth of drunken women hanging on to men just as drunken; the wild dancing of dishevelled children round the street organs as numerous as omnibuses. All this caused an indefinite suffering to a Parisian.'

Tissot explained to Edmond de Goncourt that he found in London *la bataille de la vie*. Tissot liked change and challenge; indeed, without the various upheavals of his life, he might have ossified into a Salon painter of predictably annual output. Yet Tissot's career in England was not a struggle, but an immensely successful campaign, and during his twelve years there his lot lay in pleasant places. In this he was greatly aided by his friend, Thomas Gibson Bowles. When Tissot first arrived in London in May 1871, he was the guest of Bowles at Cleeve Lodge in Hyde Park Gate. Bowles was a man of great enterprise: he had founded *Vanity Fair* in 1868, and had commissioned from Tissot some of the coloured cartoons, which were such a successful feature of the magazine, from 1869. He had also commissioned the indolently elegant portrait of Captain Burnaby (London, National Portrait Gallery), one of Tissot's most wholly successful works. Bowles had accompanied Tissot on his forays as a *tireur* during the siege of Paris, when Bowles, always intrepid, rushed over as war correspondent for the *Morning Post* and sent back his despatches by carrier pigeon. The drawings by Tissot were the basis for the illustrations in Bowles's book on the siege. For some time Tissot lived with Bowles at Cleeve Lodge, and doubtless the cartoons he made helped him financially, and the introductions of Bowles eased his social path.[1] Bowles was blithe, debonair and very handsome; he knew everybody in the London social and literary worlds and his affection for Tissot eased the *bataille de la vie* in a way few artists enjoyed.

Many memoirs of the time refer to Tissot as a sociable man, a charming man, 'of genial temperament', and 'very hospitable'. In 1982 a small enamel plaque came on the art market,

28

30

34

which had been in Tissot's house in the Doubs and was among the effects of his heiress and
niece, Jeanne Tissot (Fig. 38).[2] It is dated 1886 and inscribed:

M. Jopling		J.E. Millais
	F. Pils	
G. du Maurier		J. Whistler
	W. Eglinton	
Phil Morris		Alma-Tadema
	Robert	
Sir J. Benedict		Seymour Haden
	N. Hemy	
M. Montalba		R. Macbeth

Miss Alma-Tadema told James Laver that she visited Tissot's house in Paris and saw there a
plaque bearing the names of his English friends, which was to be incorporated in a large
cloisonné enamel mantelpiece. This plaque may have been one of many, for the London list is by
no means complete, and there might have been others to commemorate his Parisian comrades.
Such as it is, the plaque is a testament to Tissot's sociability and the artistic circles in which he
liked to move. The letters of Alan Cole refer to 'a capital small dinner' with Tissot and Whistler,
eaten off blue and white porcelain, at which they discuss art and Balzac. Mrs Jopling recalls the
hospitality of 17 Grove End Road: 'delightful were the dinners he gave'.

Mrs Jopling's name comes first, which must have pleased her greatly. Tissot lost touch with
her completely when he left London in 1882, and she imagined him to have become a Trappist
monk, so little did he maintain contact with his English friends. It is natural that Tissot should
have liked Mrs Jopling; she was attractive, bright and brave. Louise Jopling was dedicated to
art in a way perhaps not warranted by her talent, but on several occasions, despite her three
marriages, she literally had to earn her living by her pictures, which sold quite well. As she had
been trained in Paris, Tissot would have found her especially sympathetic. She had studied
with Charles Chaplin but her works show none of his gliding brush strokes, and nor did she
heed his counsel to 'Ne vous occupez du titre. En Paris cela est inutile, quand la peinture est
bonne. Laissez les titres, et la description du sujet aux Anglais, qui ne comprennent
absolumment rien d'art' (whereas Tissot loved *titres*).[3] Mrs Jopling's fluent French must have
been welcome to Tissot, for it is unlikely that many of his English friends were linguists. Clara
Montalba had also trained in France, where for four years she was a pupil of Isabey. Later she
was a Grosvenor Gallery painter, where she exhibited views of Venice. Tissot's friendship with
Whistler and Seymour Haden is too well known for comment. It is interesting that Charles
Napier Hemy is included in the plaque. The career of Hemy was triply linked with Tissot's. As a
boy he was deeply religious and joined the Dominicans, who sent him to a monastery at Lyons.
At the age of 21 he left the order and went to Antwerp to study under Baron Leys. Two of his
anecdotal pictures of the early 1870s are less spirited versions of Tissot's *Portsmouth Dockyard* 83
(Colour Plate 16) and *Histoire ennuyeuse* (New York, private collection). Hemy's painting later 49
became repetitive and he was a Victorian precursor of Montague Dawson, but a view of
Limehouse painted in 1911 (Fig. 16) shows the picturesque lure of the Thames dockside that had
so intrigued Tissot in *The Three Crows' Inn*. 58

Many of the artists on the list were members of the Arts Club in Hanover Square, which
Tissot joined in 1873 and did not resign from until 1884. It was the second home of official
English art; banquets were given there for newly elected Royal Academicians. Mr Jopling (who
also drew for *Vanity Fair*), Phil Morris, du Maurier, Millais, Whistler, Seymour Haden and
Macbeth were all members. So was Sir Jules Benedict, the composer and conductor who is
portrayed as the pianist in Tissot's picture *Hush!* (Fig. 8), and Carlo Pellegrini, the 'Ape' of 70
Vanity Fair. The club provided a welcoming base for London visitors; on the upper floors there
were bedrooms for members to stay. Heilbuth was a member from 1870 to 1890 and de Nittis

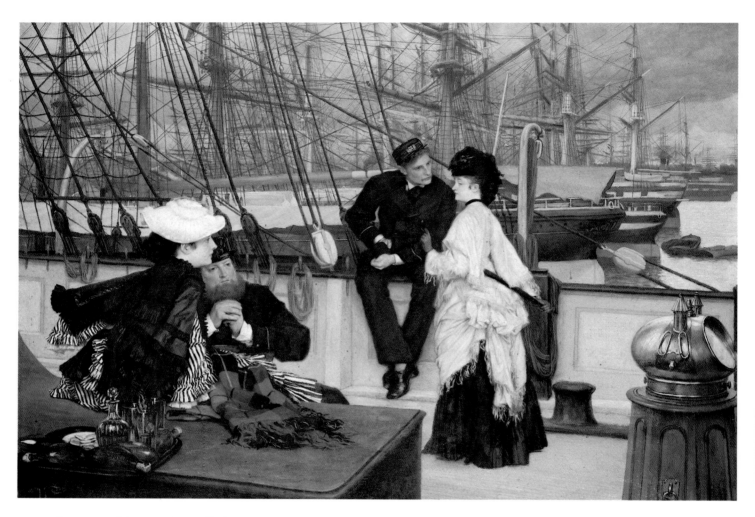

13. *The Captain and the Mate,* private collection. Cat. 61

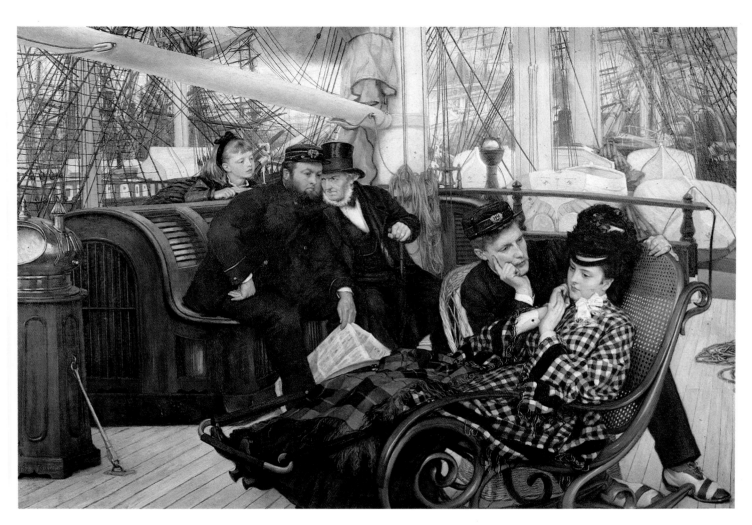

14. *The Last Evening*, Guildhall Art Gallery, London. Cat. 55

from 1876 to 1878. 'J'ai vu Tissot au Club, il a été très jantil [sic], très aimable', wrote de Nittis to his wife Leontine in Paris in March 1875.[4]

Tissot and de Nittis were excellent friends. It is possible that Tissot lent to the young painter and his wife his house at 63 avenue du Bois, while he was in London. It was through Marsden, one of Tissot's dealers, that de Nittis tried to sell some of his paintings in London. He took lodgings in Tissot terrain in 1876 at 77 Boundary Road, and in the next year, near by in Wellington Road. Michael Wentworth is of the opinion that de Nittis made a portrait of Mrs Newton.[5]

The experiences of de Nittis in London and Scotland were not happy and they show, in contrast, to what a remarkable and easy degree Tissot assimilated himself to English life and to English artistic society. The problem of language was acute. 'Tu sais bien la gène d'un voyage ne parlant pas la même langue', he wrote in his halting French to his wife. The climate was miserable; 'Il y a un froid de loup', he wrote from Edinburgh in May, and he found London cloaked in a 'brouillard noir', which only allowed him to paint for a few hours a day. He was always hard up: he had difficulties with his patrons, the Knowles, and his Paris dealer, Goupil, kept him on a pitiful retainer of 18,000 francs a year, about £400, with first option on most of his pictures. Tissot, that 'dealer of genius' as Sargent called him, was selling pictures for £900 a time early in the 1870s.

Yet of all those 'peintres, gagneurs d'argent', de Nittis, a painter of genius, alone reveals a London through foreign eyes. *Piccadilly* (1875; Fig. 17), just by the crossing to Park Lane Hotel and with Coutts Bank beyond, is transformed into a vivacious thoroughfare in which the charming 'Parisiennes' bonneted and booted, cross the street with *joie de vivre*, and the bustle of the traffic becomes lively. Perhaps the most interesting of his London paintings is Trafalgar Square (1878; Fig. 18), which shows the square as a whole panorama, a vast piazza. De Nittis was influenced by Boldini's spectacular *Place Pigalle*, which he saw in London in 1875. The picture is given a restless vitality by the procession of people walking across the front of the picture like a frieze, or like the border of a tapestry. De Nittis's view of the Bank of England is less successful, portraying the agitation but not the excitement of city life, and his static view of St. Paul's shows his palette and his humour had yielded to the grey climate.

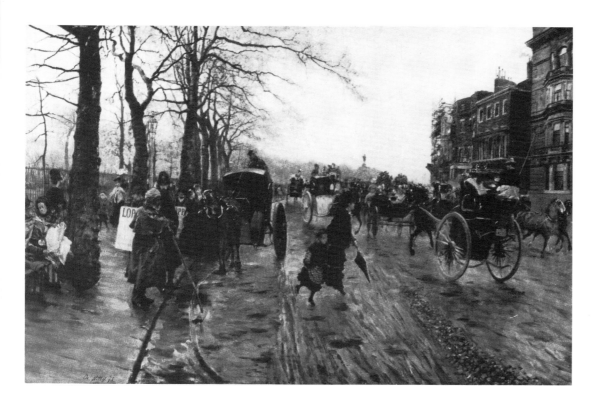

Fig. 17. Giuseppe de Nittis. *Piccadilly*. 1875

De Nittis and Heilbuth both pose in the doorway of Tissot's *Hush!* (1875). They were 70 Grosvenor Gallery painters like Tissot, who had exhibited his pictures there since its opening in 1877, when 'the glamour of fashion was over it' (Mrs Jopling). Heilbuth was a German, who divided his time between London and Paris. He made pictures pretty as sugared almonds and his favourite subject was elegant women in summer garments. His art was unaffected by London; his charming pictures look much the same whether they are at Bagatelle or by the Thames (Fig. 19). Bastien-Lepage was another of the peripatetic painters. His most famous work in his portrait of Sarah Bernhardt in creams, silver and gold, which was in the Salon of 1880. In 1879 he visited the actress when she was in London with the *Comédie Française* and, according to de Nittis, sought her help in gaining a commission to paint the Prince of Wales. Bastien-Lepage painted some beautiful landscapes of the Thames; he came to love England, and visited every year until his death from cancer in 1884. His pictures of street vendors, and his land-scapes depicting French peasants, greatly influenced Clausen and the English realist painters.[6]

Jacques Emile Blanche, friend of Proust and all society, found in England a second home. He first came here as a boy in the 1870s for annual visits. In his memoirs he recalls seeing Tissot, going at times on excursions with him, Helleu and Boldini to Sydenham, where they watched

Fig. 18. Giuseppe de Nittis. *Trafalgar Square*. 1878

Fig. 19. Ferdinand Heilbuth. *Bagatelle*. Whereabouts unknown

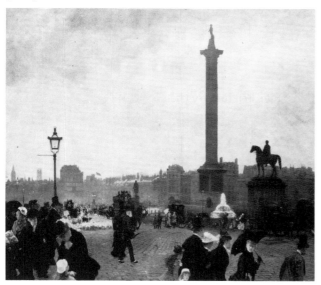

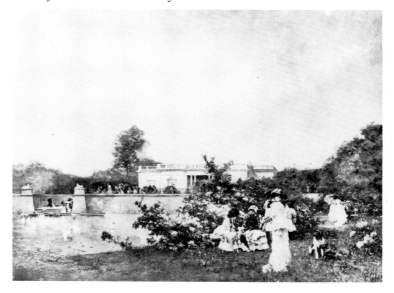

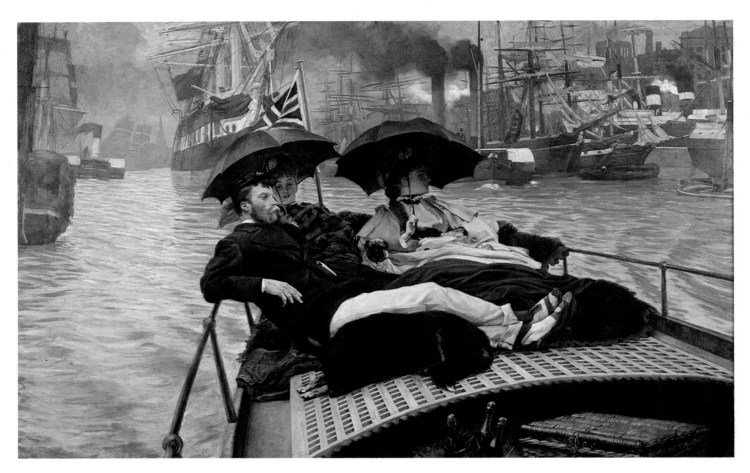

15. *The Thames*, Wakefield Art Gallery and Museums. Cat. 81

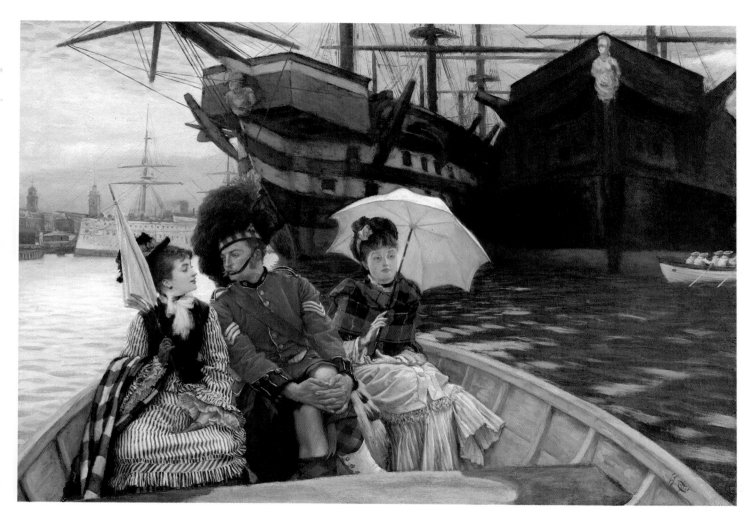

16. *Portsmouth Dockyard,* Tate Gallery, London. Cat. 83

the fireworks and ate indifferent dinners. (Foreign painters suffered from Victorian cuisine; Blanche talks dismissively of mock turtle soup, cold salmon and cucumber, and strawberry cream. De Nittis and Pellegrini always insisted on cooking their own pasta.) His memoirs are notoriously unreliable. He was a social man, a diner-out, and obviously could not resist telling a good story, whose embellishments became the authorized version. His greatest patrons were Mrs Saxton Noble and her daughter Lady Gladwyn, who was painted as a child by Blanche, knew him well, and admits that this engaging man had a preference for his own fiction to others' fact. Blanche, highly gifted, was an extraordinarily uneven painter, for his art bears the imprint of the last picture he had looked at, now a Gainsborough, now a Daniel Gardner, now a Lavery, now a Manet. The canvas illustrated here (Fig. 20), which he painted in 1882 when he was staying with the Besnards in their house in Ovington Square, shows most greatly the imprint of Tissot. The housemaid pouring out the tea looks out of the picture and stares at the spectator in the fashion of so many of Tissot's models. The female figures in the background have the languor one associates with St. John's Wood, yet their aesthetic dress would have had little interest for Tissot, the lover of tiny waists and frills that cost a fortune.

In one of his letters from London, Jules Claretie talks of *Tissoteries*, a good enough description for the highly costumed extravaganzas of Tissot and his friends. How did these itinerant painters affect English art? They were not in harmony with either the Pre-Raphaelites and their followers, or the realist painting of the Camden Town Group. There are various contemporary instances of their direct inspiration. Atkinson Grimshaw, who exhibited once at the Grosvenor Gallery in 1878, obviously much admired both Tissot and de Nittis. The processional frieze of *Trafalgar Square* is repeated in his masterpiece *Leeds Bridge* (1880). His ravishing *Autumn Regrets* (Fig. 21), painted in 1882, the year of Mrs Newton's death, shows a

Fig. 20. Jacques Emile
Blanche. *A London
Interior*. 1882. London,
Bury Street Gallery

figure as elegant as Kathleen herself. The model is sitting on one of the marble benches that Alma-Tadema was to install in Tissot's garden, and the yellowing chestnut leaves that curtain the picture are reminiscent of the falling leaves which veil the portrait of Empress Eugénie and her son at Chislehurst painted by Tissot in 1874.

The most lasting influence of Tissot on English painting has not been what I think he would have wished. Towards the end of the 1860s and in the early 1870s he made a number of pictures set in a hazy late Louis XVI period, where ladies wear large bonnets and vast striped taffeta skirts draped in bunches at the back, and their lovers have tricorne hats. The keynote of these pictures hovers from the nudge and wink provocation of *Un Déjeuner* to the more English sentiment of *Les Adieux*, such a success in England that it was printed as a steel engraving. Tissot ceased to paint 'costume pieces' about 1875, but he had set a precedent which the English found delightful. Halliday's *Dorothy*, a girl in a Directoire bonnet, was the success of the Academy in 1873. The paintings of Marcus Stone are Tissot's *scènes galantes* made respectable (Fig. 22). The subject is always a love story or as his biographer, Alfred Baldry, describes it, subjects that 'make the widest appeal to all sorts and conditions of men and women, . . . idyllic compositions full of tender expression, subtle domestic dramas in which love would always be found playing the leading part'. His pictures are perfectly proper family viewing. A wistful romance has replaced the more explicit approaches of Tissot, and tea served from bone porcelain is the appropriate refreshment, while Stone's beloved cats are the only chaperones necessary. He established a pseudo-Regency era as the age of happy love, and the English garden of his home the ideal setting for a lover's romantic proposal. This theme was taken up by Heywood Hardy and in the twentieth century it has found literary fulfilment in the bucks and beaux of Miss Cartland and Miss Heyer, and in particularly decorative tins of toffees.

Tissot's own sad English love story changed the tenor of his paintings, for from the time of his meeting with Kathleen Newton he painted little but the story of himself and his mistress. His romantic interlude at Grove End Road has often been regarded as an episode apart, like the love affair of Proust's hero, Swann. This is not wholly true. We know so little of Tissot's life that his previous romantic attachments remain untold. We know he loved pretty women – Helleu's wicked etching of Tissot eyeing a pretty woman at Mme de Polignac's (Fig. 5) is a cruel tease. In his relationship with Kathleen Newton, Tissot was seen to be following many of the English artists of his time in choosing a mistress who was of equivocal social position, and of delicate health. (The characteristic red hair was added later : at least two portraits of Mrs Newton have been overpainted so that her hair is Rossetti red, with a false *crinière* of curls on her brow ; cleaning has revealed the true pale brown hair, and a severer coiffure.[7])

Much myth surrounds the history of Mrs Newton, for we know little except the inaccurate rumours of the time and the latter-day romanticized stories that her niece, Miss Hervey, told to

Fig. 21. Atkinson Grimshaw. *Autumn Regrets*. 1882. Whereabouts unknown

Fig. 22. Marcus Stone. *The First Cloud*. Whereabouts unknown

42

177

134

Miss Marita Ross in 1947.[8] Kathleen Kelly was born in 1854; her mother died when she was a child, and at the age of 16 she was sent out to India, that celebrated marriage market, to stay with her brother, an officer in the Indian army. He had already told Dr Isaac Newton, a recently widowed doctor in the Indian Civil Service, of his pretty sister, and a marriage was obviously envisaged. However, Kathleen on the voyage out fell in love with a Captain Palliser: 'It is true I have sinned once, and God knows I love that one too deeply to sin with any other.' She was duly married to Dr Newton but ran away from him almost literally at the church door. She returned to Captain Palliser, by whom she soon became pregnant. He seems to have abandoned her, for Dr Newton paid for her voyage back home, and in December her daughter, Muriel Mary Violet, was born at her father's house in Conisborough. Kathleen was sent to live with her sister, Mrs Hervey (whose husband was also said to be in the Indian army) and her four children at Hill Road, just round the corner from Tissot. Kathleen Kelly was a naive and romantic young girl when she was sent out to India. She was probably swept off her feet when Tissot, the famous Parisian painter, fell in love with her in 1875 or 1876. She was his constant model, patient and passive, and his Galatea. Tissot chose her clothes and dressed the Irish colleen like a Parisienne. Her elegant, frail form is very different from the cossetted, corseted models of *Calcutta*, two years before. A child was born in 1876, Cecil George, and we do not know whether it was Tissot's, though in the tender way he depicted him in many portraits it seems probable. It is worth remarking that Mrs Newton's two children lived with Mrs Hervey; they were visitors to Grove End Road, not inhabitants, and their visits usually occurred at the hour of tea.

131

Mrs Newton was consumptive; her illness probably dictated a quiet life. In the first years of the relationship, she and Tissot visited Paris together and made excursions he recorded to Richmond, Greenwich and Brighton. She probably had no desire for a social life and preferred the gentle domesticity of her home. Mrs Jopling writes that she herself was no longer invited to Grove End Road and knew nothing of Mrs Newton except she heard that Tissot was involved in an affair with a married woman. J.E. Blanche wove a tall story about her being imprisoned in the house, and being spotted by Helleu by chance; the story is patently untrue, moreover Helleu did not visit London for the first time until 1884, two years after the death of Mrs Newton. Probably the couple confined their circle to old friends, sympathetic to their social dilemma. Miss Hervey remembered Whistler being a visitor to the house. She also recalled meeting Oscar Wilde, at that time everyone's favourite guest and mentioned in the first chapters of many memoirs. The story seems unlikely, but not impossible, for in 1882 de Nittis entertained Oscar Wilde to dinner in Paris.

What Tissot's work tells us about Mrs Newton is that he was obsessed by her gentle beauty and made her the subject of almost every painting for the six years of their liaison. Miss Hervey said that they were deeply in love, and this is borne out by Tissot's despairing attempts to find her again through mediums and seances after her death, when he continued to paint her for two or three years as if she were still alive.

In his loneliness he turned to spiritualism. In the spring of 1885 he met in Paris the young
152 medium, William Eglinton. Eglinton's name occupies the central place in the plaque of friendship, which was made the following year. At the time of the meeting Eglinton was 28; for some years he had been practising automatic writing with hidden slates.[9] On a more ambitious level he had two 'guides', 'Joey' and 'Ernest'. For some time his clients came from the dingier of the respectable suburbs, Hendon, Finchley, Potters Bar, and one envisages hopeful journeys on the omnibus. Then bored society ladies also 'took him up' and he began a career in Mayfair. His sitters included the Duchess of Manchester, Lord Stanhope, Lord Crawford, Lord Poltimore, Oliver Montagu and those enquiring 'Souls', George and Percy Wyndham and Lady de Grey. In 1884 he had a meeting with Gladstone, which lent him much respectability. That year Eglinton purchased his own house in New Quebec Street. Before then, Farmer confesses that the failure rate of his seances was two in five; once installed in his own rooms, doubtless with elaborate apparatus Eglinton's success rate rose to 80% and in the two years of 1884 and 1885 he gave

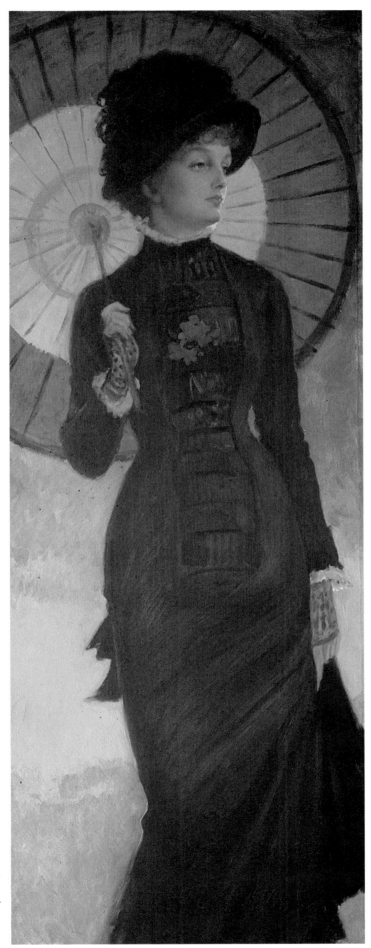

17. *La Dame à l'ombrelle (Mme. Newton),* Musée Baron Martin, Gray. Cat. 103

over 600 seances. When he met Tissot in Paris in February 1885, he suggested that he come to London for a 'regular course of investigation'. Photographs of Mrs Newton could be studied, preparations made. After some preliminary seances, Ernest led in the materialization of Mrs Newton, who gazed at Tissot with great sweetness, kissed him and held his hand tenderly for some moments. The deception was complete.

As a token of his gratitude, Tissot made an etching of Eglinton as the frontispiece for *Twixt Two Worlds*. The medium is holding his slates for automatic writing; he looks intelligent and keen. Farmer points out that Tissot tried to capture the expression of Eglinton in a trance, which indeed differs greatly from the solid and porky person elsewhere portrayed in the book. Tissot also celebrated the occasion with his last mezzotint, *Apparition médiunimique*, showing Ernest guiding Mrs Newton and throwing a light on her familiar features. Ernest is dressed in what seems to be a robe for a hot climate and Mrs Newton is heavily swathed in white concealing draperies.[10] Tissot made impressions of the print in different colours, perhaps to convey the illuminations of Eglinton's house, and also an oil painting of the scene, now missing. The clothes worn by Mrs Newton are similar to those in Tissot's biblical illustrations, which he started a year later, and it is clear that he regarded her appearance as proof of her existence in another world because he turned part of his studio into a room whereby he tried to summon up again her spirit from the deep.

151

The visit to Eglinton was not Tissot's last to London: Anna Alma-Tadema records him visiting her father in 1896 and seeing his old home transformed into a magnificent red brick residence with rooms in the Pompeian style, and marble benches in the garden on which posed the 'Roman' ladies. Only Tissot's colonnade copied from the Parc Monceau remained, then to be pulled down in 1947 to make way for garages. But Tissot's links with London belonged to the past; he lost touch with his English friends. De Nittis had died in 1884, at about the same time as the Grosvenor Gallery began to decline. Tissot's constant friends were now the Daudets and Helleu, whom he introduced to Edmond de Goncourt. He regarded Helleu as his artistic heir, and gave him the diamond tool with which Helleu made his graceful drypoints. Helleu, too, loved England, and one of his favourite sitters was Miss Sydney Bowles, the beautiful daughter of Tissot's old friend, who now became his friend too. But Helleu's England is that of beautiful women, Mayfair and yachting at Cowes, and Edwardian elegance rather than Victorian drama and *la bataille de la vie*.

5

London Years: the Dissemination of the Image

HARLEY PRESTON

The factors which have contributed to the dramatic revival of enthusiasm for the once-neglected art of J.J. Tissot are many and diverse. One of them must surely arise from his ability to project images which stimulate the imagination and cling to the memory with exceptional tenacity. The works of the English period (1871–82), for example, might appear at first sight to offer a dispassionate portrayal of the life and manners of a certain segment of Victorian society, sometimes felt to be 'vulgar' or 'not quite nice' by the artist's critics of superior moral tone. Such a social charade was, however, for all its ostensible authenticity, a highly synthetic simulacrum, a series of human still-lifes of posed models and studio costumes. Through skilful artifice – the dexterity and brilliance which Ruskin admitted – Tissot evoked a convincing world of enchanting puppets in simulated recreation, of animated lay-figures resplendent in the finery of modish costume and millinery, depicted in paintings of intense, rich colour, technical finesse and glossy surface.

Having perfected his authoritative and fully realized compositions with seeming effortlessness, Tissot sometimes tried variations, but more frequently proliferated these finalized images, little altered in basic formal elements, through his own important print *oeuvre* in the media of etching or drypoint or, most frequently, in that combination of the two which had become a standard technique for the *peintre-graveur* since the first golden age of etching in the seventeenth century. Leaving aside an experimental colour print, which the artist, ever susceptible to novelty, agonized over interminably in the last decade of his life,[1] he also executed four large mezzotints, presumably under the initial influence of England, where specimens of the *manière noire* had been produced in quantity and were to be assiduously collected.

149, 151

What is often termed the 'etching revival' aroused an increasing enthusiasm in France from the mid-century amongst major masters, smaller talents and adventurous amateurs. By 1862 the *Société des Aquafortistes* had been founded, and in England the older and more modest Etching Club had encouraged original work, including that from the Pre-Raphaelite circle. The surgeon, etcher and expert Sir Francis Seymour Haden (1818–1910; brother-in-law of Whistler, friend of Tissot) proselytized on behalf of the technique, and collected the latest French prints. Another apologist, P.G. Hamerton (1834–91), long a resident of France and dubious about Tissot's 'modernism', went so far in his zeal as to claim that print collectors were harder to please than buyers of paintings and that original graphics avoided 'the baneful influence of vulgar patronage'.[2]

The French master-printer, Auguste Delâtre (1822–1907) crossed to London in 1859 (having just printed Whistler's *French Set*) and was back again in 1863 to teach at South Kensington. He, in turn, trained Frederick Goulding (1842–1900), the outstanding British craftsman who was to pull most of Tissot's editions. In 1859 Whistler had commenced etching his major *Thames Set*, published in London the year of Tissot's arrival, and which was to provide the crucial stimulus for him.

Whether or not Tissot was influenced by Seymour Haden,[3] he did not commence etching in

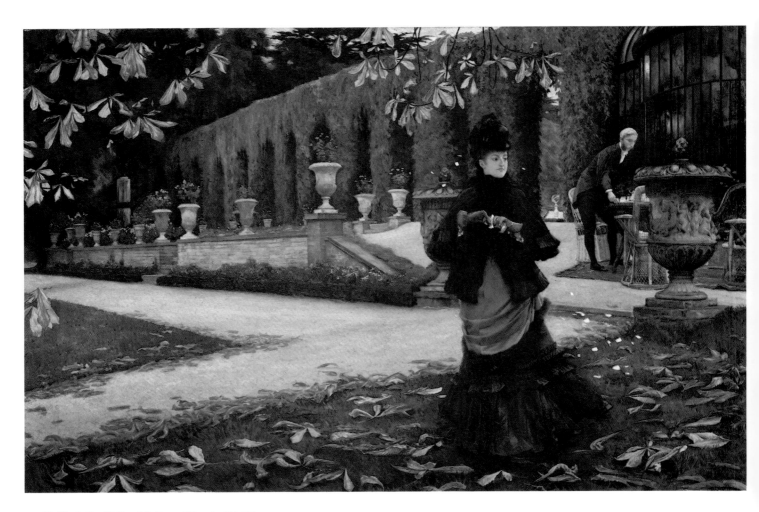

18. *The Letter*, National Gallery of Canada. Cat. 97

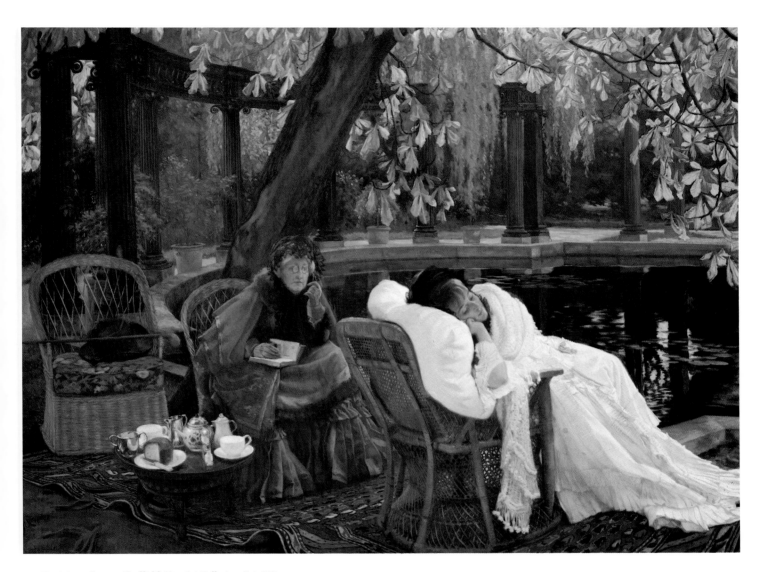

19. *A Convalescent*, Sheffield City Art Galleries. Cat. 195

London, for prior to his enforced emigration he had already produced five little-known, freely-handled portraits which accord entirely with the technical and stylistic assumptions of the artists within the ambit of the etching revival and which are appealingly direct and spontaneously involved with the medium although, in the light of virtuosity to come, slightly hesitant and awkward.

Quantitatively at least, the climax to Tissot's graphic expression coincided with, or derived from, his troubled London idyll with its notable financial successes and his compulsive and tragic *affaire du coeur* with Kathleen Newton. The traditional antithesis to the original artist's print conceived exclusively in terms of a chosen medium and its particular visual effects, was established by the commercial reproductive engraving taken, frequently, from a popular painting, made by specialist craftsmen in a variety of rather impersonal techniques and run off to subscribers in enormous editions as a print for the wall rather than the portfolio. Tissot's paintings were reproduced as steel engravings several times, and he could not have been unaware of the market for such productions destined for customers at the other end of the aesthetic spectrum to Hamerton's discerning connoisseur of fine prints.

43, 48

During the decade from 1875, the majority of Tissot's own prints relate more or less directly to existing pictures and fall somewhere between the original creation and a very superior form of quasi-reproductive engraving, designed, in its many refinements of technique, to imply something of the tonality and chiaroscuro of oil painting. They must be accorded the status of original artist's prints, however, for Tissot translated his clarified, polished final statements totally from one medium to the other. In historical context, his dependence on existing compositions should not be considered singular in kind so much as degree. To a much more varying extent the subjects of paintings or drawings recur in the original prints of his great contemporaries, Millet, Daubigny, Jongkind, Pissarro and Degas, while many of Manet's prints, in a range of modern graphic media, dazzlingly reflect his paintings in differing guise.

Such re-interpretation of fixed designs demanded that basic forms were both generalized and stylized into monochrome linear patterns, the traditional outlines, hatchings and cross-hatchings of the *intaglio* processes, where brushed modelling was schematized into parallel or sinuously undulating traces, which are at times of great textural delicacy. Tissot quickly understood the veiling and softening role of light burr on the characteristic drypoint *ductus*, and relied particularly on Goulding's ability to calculate *retroussage* in his printing to obtain a juicier result through the halations of withdrawn ink film which frequently shroud a sharply etched skeletal linearity. Tissot's drawing style, his preference for ovoid faces, tentacular arms, insectile digits, is modified by the deftness and control of his handling of etching needle and drypoint and the subtle range of effect in his threads, webs and meshes of line and the gently scratched drypoint shading of features and figures, hair and costume, skies and clouds. There remains at this purely manipulative level of technical expression, something intriguingly mysterious, which lingers after the initial confrontation with the subject, which is often blatant, sometimes startling. Under the closest scrutiny, area by area, line by line, the prints abound in innumerable passages of richly sensuous, abstract beauty.

In his 1978 *catalogue raisonné* of Tissot's prints, Michael Wentworth described eighty-four engraved subjects and reproduced painted sources for about half of these. Since then further paintings that formed the basis for prints have surfaced,[3] including one that is worth describing here through its slightly atypical nature.[4] This picture (Fig. 23) was the manifest source for one

90

of Tissot's earliest and most attractive engraved *japoniste* subjects, the *Matinée de printemps* dated in the plate to 1875 (Fig. 24).[4] The drypoint formed part of the artist's first exhibit at the Dudley Gallery in the Egyptian Hall, Piccadilly, as a contribution to their fourth exhibition of 'Works of Art in Black and White', described as an etching and priced at ten guineas. The reviewer in the *Athenaeum* of 17 June 1876 noticed it in terms that were to stay with the artist in England, as 'M. Tissot's Spring Morning (56), intensely vulgar, but "clever" enough for the public it appeals to'. Perhaps this assessment encapsulates something of the artist's London

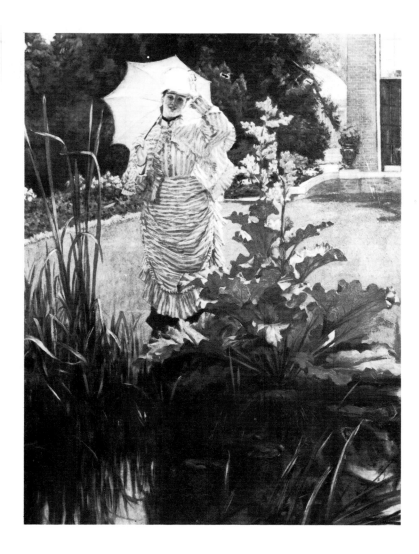

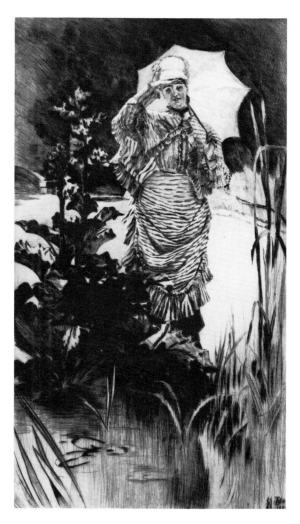

success, although the following year the derogatory epithet was transferred by Ruskin specifically to his subject-matter.

Lacking the high sentimentality, the elaborate detail and (for the moment) the moralizing and anecdotal titillation of many of his British contemporaries, Tissot, the artist of *la vie moderne*, has posed a model, as if in an intimate family snapshot, in the vertical format of a Chinese or Japanese hanging scroll. She wears one of the artist's favourite striped summer dresses, which he used again in later works. Her bonneted head is haloed by a pale, light-transmitting parasol — a *motif* exploited to different effect by such artists as Courbet, Boudin, Manet, Monet and Renoir. She holds up one hand to shade her eyes, seeming to glance indifferently past a splendid flowering rhubarb plant (*rheum undulatum*) — it will appear again in *The Widower* (Sydney, Art Gallery of New South Wales) — which is surrounded by flag irises and reeds which lend themselves readily to an orientalising arrangement. The design is reversed in printing which indicates that the drypoint was taken directly from the painting, being the image of the oil scratched on the copper plate in the same sense.

This is one of the earliest instances where the artist has engraved from his own painted version, indeed, possibly the first, since *Une Convalescente* is based on a detail only from the painting in the Sheffield Art Gallery, and oils that relate to *Le Châpeau Rubens* and *A la fenêtre* are not so far known. Uncharacteristically, however, the drypoint is a revision of the painting. The format has been rendered even taller and narrower, more *kakemono*-like, by the reduction

Fig. 23. *Matinée de printemps* (A Spring Morning). *c.* 1875. Private collection

Fig. 24. *Matinée de printemps* (A Spring Morning). 1875. Drypoint. Private collection

93

87

50, 51

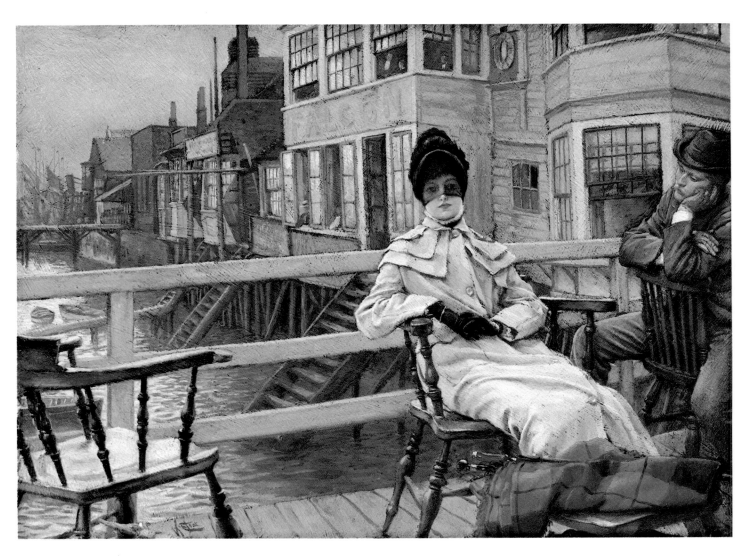

20. *Waiting for the Ferry*, Samuel A. McLean. Cat. 111

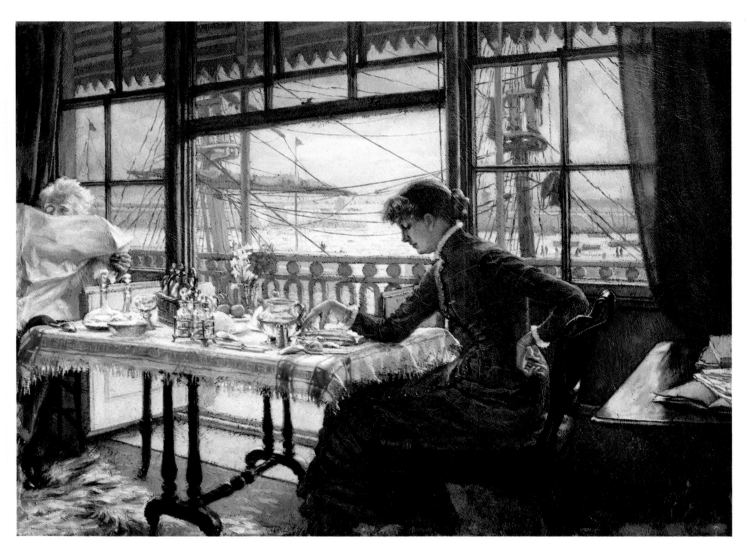

21. *Room Overlooking the Harbour,* private collection. Cat. 77

of the original composition to one side, along the line of the vertical wall of Tissot's house to the rear. The background of trees, shrubs, flower beds and pot plants has been darkened and to a large extent neutralized in a Japanese manner, and rendered in broad, sweeping slashes of the drypoint, which also simplify the foreground reeds, grasses and lily pads, whose varying accumulations of burr add much to the incisive richness of texture. The character of the line is immediately reminiscent of the showier drypoints Paul Helleu was to draw with the diamond point. It is not surprising to discover not only that Tissot used such a diamond point made for him in London, rather than one of hardened steel, but that he subsequently gave it to Helleu.[6]

Tissot does not appear to have promoted the sale of his prints as derivations from exhibited paintings by any unsubtle juxtaposition, and only rarely displayed them together. Visitors to the Royal Academy in 1876 might have noted that the painting entitled *The Thames* (Wakefield Art Gallery), a somewhat critically maligned picture, was accompanied by the etching that successfully re-interprets it; an impression of the etching was also sent to the Paris Salon of the same year. *Spring (Specimen of a Portrait)*, possibly the picture exhibited here, or conceivably, a larger version of it, appeared at the Grosvenor Gallery in 1878, where it was reviewed in detail, along with the associated etching *Printemps*. Otherwise, London's gallery visitors might have needed good visual memories to relate print to painting. The generally well-received *The Widower* had been included in the controversial inaugural exhibition of 1877 at Sir Coutts Lindsay's sumptuous new Grosvenor Gallery, while the etching and drypoint *Le Veuf* was available that· year at the Dudley Gallery at a price of twelve pounds. The composition of another painting, which had accompanied *The Widower*, *Portsmouth Dockyard*, etched as *Entre les deux mon coeur balance*[7], did not appear at the Dudley Gallery until a year later, offered at nine guineas. A year also intervened between the presentation of the painting *Croquet* (Ontario, Art Gallery of Hamilton), shown at the Grosvenor Gallery in 1878, and the print of the subject, which appeared in a Dudley 'Black and White' show of 1879, with impressions on sale at six guineas. The sequence may be slightly different in the case of *Emigrants*. It would seem that the smaller replica of a larger prime version may have been that displayed at the Grosvenor Gallery in 1879.[8] Both are dated by Wentworth to a period of some six years earlier than this, but such evidence is insufficient to suggest that the painting re-emerged to add marketable impact to the etching which was to be seen at the Dudley Gallery in 1880 for seven guineas.

On a scale more minute than the proliferation of virtually identical multiple original prints was the traditional repetition of painted subjects in the form of version, variant and replica. The many bourgeois art collectors of the age provided ample scope for placing autograph replicas of large, popular or individually admired paintings that had already been commissioned or sold prior to general exposure. Tissot's painted *oeuvre*, still in the process of being draw from long seclusion through increasing curiosity and spiralling saleroom prices, is not yet comprehensively established, while the provenance of many paintings remains unclarified. The sequence of the various versions is therefore to some extent speculative.

Although Tissot does not seem to have succumbed uncritically in his London years to what the French sometimes saw as a national fetish for the medium itself, watercolour repetitions exist from the outset of his public career, for example the medievalizing *Marguerite à la fontaine* of 1861, and may be found spasmodically at later intervals up to the time of the biblical illustrations when watercolour and gouache became his predominant media.[9] Perhaps the watercolour replica of *Quiet* (private collection) might have been prompted by the unavailability to an admiring patron of his Royal Academy exhibit of 1881. A clue may lie in the existence of a version of *Le Confessional*, 1865, the oil painting (Southampton Art Gallery) exhibited at the Salon of the following year. The watercolour replica was purchased by George Lucas for the great collection of nineteenth-century art of William T. Walters of Baltimore.[10] Was this commissioned specially or did it already exist as a speculative commodity?[11]

The oil replicas, in contrast, present some diversities of scale. One category is represented by two similarly sized versions of *July (Specimen of a Portrait)*, which the artist also titled *Seaside*.

81
82
101
102
93
16
121
137
3
134
16

Mrs Newton is shown seated before a window with a view of Ramsgate lighthouse and wearing the white, flounced muslin summer dress with yellow ribbons (suggestive of Whistlerian *décor*) depicted in *Spring* and many other paintings. One of these versions (New York, private collection) seems to have been that lent by the artist to the Grosvenor Gallery in 1876.[12] If this remained unsold, it is mildly perplexing to find its replica (Ohio, private collection) which, if a modern sale catalogue entry represents fact, was obtained from the artist in London and which should be classed as a variant since the sitter's hairstyle has been altered at some time to one that is less tightly groomed.[13]

Smaller replicas, however, exist for some of Tissot's best known subjects of the 1870s, amongst them *London Visitors* (Milwaukee, Layton Art Gallery) which reflects the large painting in the Toledo Museum of Art, Ohio (R.A. 1874),[14] *Emigrants* (New York, private collection) and *October*, the monumental first version being in the Montreal Museum of Fine Arts. The same institution once possessed the larger version of *Emigrants* — a composition revealing, perhaps, a slight twinge of Tissot's social conscience for this nineteenth-century social predicament. The picture has been mutilated by being cut down below the level of the nearest ship's yard arm, destroying its steep narrow verticality.[15] To these published examples may be added the more recently located small replica of *The Widower*.[16] 99

The high, meticulous finish of such pictures rules out the likelihood of their being considered as sketches, for Tissot's oil studies are broadly handled in thick pigment and such a texture would make them difficult to re-work, on the precedent of some of the Pre-Raphaelite studies subsequently coloured for sale after their initial function had been fulfilled. *Emigrants*, *October* and *The Widower* were all repeated closely in graphic form, but *London Visitors* has only its setting in common with the etching and drypoint of 1878, *Le Portique de la Galerie Nationale à Londres*.[17] It is even less easy to consider these little paintings as *maquettes* for etchings, assuming that the large pictures may have left the studio. Close comparison of photographs does not endorse such a view, and, even with an artist as compulsively industrious as Tissot, such intricately elaborated models would involve unnecessarily laborious preparation. 114

The best explanation for the existence of such small, signed replicas remains the obvious one. Following many of his contemporaries, Tissot must have produced paintings at a lower price than those of the large *machines* exhibited at the Royal Academy or the Grosvenor Gallery, specifically to attract private collectors of smaller means or less adventurous commitment. That such a demand existed or could be fostered may be documented in the Dudley Gallery exhibitions of 'Cabinet Pictures in Oil', which were held regularly from the year of Tissot's arrival. Understandably Tissot did not participate in their annual watercolour shows, but he commenced showing prints in their 'Black and White' exhibitions in 1876, offering on one occasion a pen and ink drawing of the Trafalgar Tavern, Greenwich: this may be the study for the etching, now in the Fogg Museum of Art.[18]

Tissot contributed to the twelfth exhibition of cabinet pictures in 1878 with a painting entitled *Revêrie* for which he asked £206; presumably this was a replica of a picture for which an oil sketch is known (London, private collection). In the thirteenth Dudley Gallery exhibition of 1879 he included a painting called *Quiet*, priced at £105 (the title being that of his 1881 Royal Academy exhibit) and, slightly more costly, *The Warrior's Daughter* at £125.[19] These Dudley Gallery shows did not, on the whole, contain work by artists of Tissot's stature, and most of the prices fell within the range of the more substantial exhibition watercolours. With his commercial instincts, Tissot must have rapidly followed the existing tradition of painting such cabinet pieces either for exhibition or for private sale.[20] Despite the social sequestration of the house and studio at 17 Grove End Road through the liaison of the painter and a divorcee, it is possible that 'vulgar' clients may yet have visited to sip iced champagne and view small painted replicas alongside Tissot's sample set of framed and priced prints which remained intact in France until dispersal in 1982.[21] 126

107

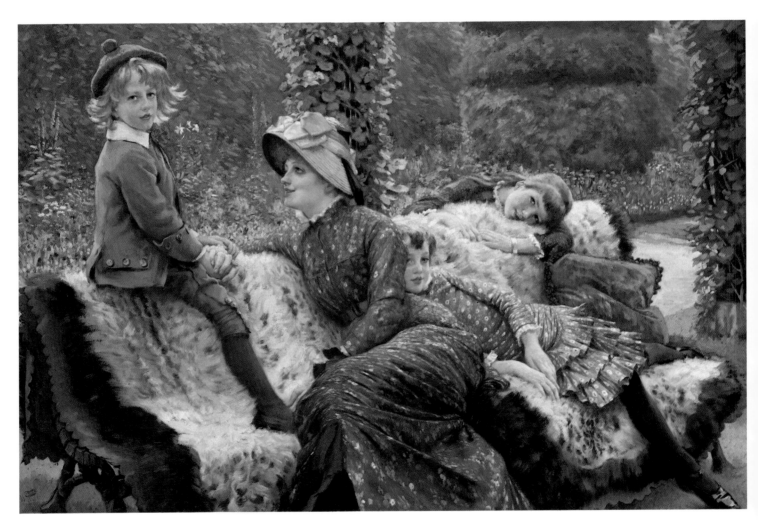

22. *Le Banc de jardin,* private collection. Cat. 148

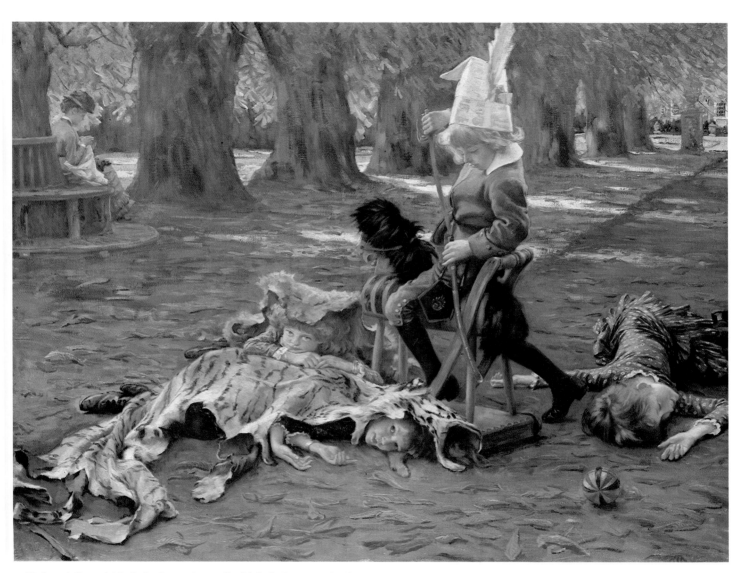

23. *Le petit Nemrod*, Musée des Beaux-Arts et d'archéologie, Besançon. Cat. 147

6

Costume in Tissot's Pictures

KRYSTYNA MATYJASZKIEWICZ

It is difficult to look at Tissot's pictures without noticing what the people in them are wearing. The costumes vie for attention to such an extent with the still lifes of glass and china, with the furniture, flora, and the backgrounds of architecture or rigging, that these 'props' almost become the *raison d'être* of the paintings. Some of Tissot's contemporaries criticized his pictures for this. Today, however, their popularity is because of the appeal both of that carefully selected clutter of late nineteenth-century life and of the peaceful and idyllic view of the past the scenes evoke. The paintings also provide a rich source of information of dress and society for today's historians; James Laver made a correct assumption, in concluding his early biography of Tissot, that the artist was 'assured of his immortality, if not in the History of Art, at least in *l'histoire des moeurs*', as most books on nineteenth-century costume or society published over the last forty years illustrate at least one of Tissot's pictures.[1]

Tissot's interest in costume no doubt began at an early age. His parents were both in the fashion trade: his father was probably a wholesale linen-draper and his mother had run a hat-making company, together with her sister, Arsène, before she married.[2] In this milieu, Tissot would have come to know the minutiae of costume and fashion, texture and variety of fabrics, and the coloured fashion plates which disseminated so widely the images of fashion's current ideal. From the point of view of costume, his *oeuvre* can roughly be divided into two groups: those pictures that use historic or foreign costume and those that depict contemporary dress.

It was perhaps natural for a young, unsure painter to turn first to historic dress, which could swathe a figure, mask anatomical inaccuracies, and lend immediate intrinsic interest and theme to a picture. The hesitant *Promenade dans la neige*, among Tissot's first Salon exhibits of 1859, shows two figures in historic dress, roughly based on German and Flemish fashions of the early sixteenth century. The choice was inspired by Tissot's admiration for the historical paintings of the Belgian Henri Leys, whose mature works – which Tissot would have known from prints and seen on exhibition in Paris – drew on the art of Dürer, Holbein, Cranach the Elder and Cranach the Younger, and their German and Flemish contemporaries.[3] The costumes are very simple, probably borrowed studio 'props', with minimal decorative additions. An early version of *The Dance of Death* (1859, whereabouts unknown) shows a marked increase in decorative detail and Tissot's second, Salon version of the subject (Fig. 39), painted after a visit in 1859 to Leys's studio in Amsterdam, is a positive orgy of slashed and patterned clothes, with plenty of drapes and pleats. None of the costumes in either version has the substance or conviction of made-up garments but a number of the costumes, based closely on German sixteenth-century fashions, show that Tissot studied sixteenth-century sources at first hand, in particular woodcuts (probably in the print room of the Bibliothèque Nationale) and also paintings and reproductive prints or photographs after them. He seems to have been particularly impressed by the richly slashed costumes of the German *Landsknecht* (see Fig. 39, left and centre) and later had one such garment made up.

Tissot would have seen the costume 'props' in use by Leys and other history painters such as Meissonier, and by 1860 appears to have built up a small stock of such garments, probably made up to his own designs.[4] These are re-used in different combinations for his Faust and other

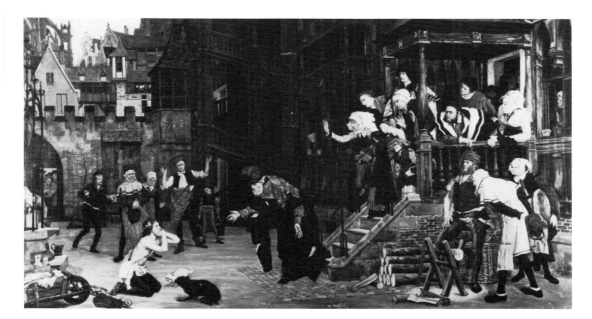

'medievalizing' paintings and include embroidered skirts, aprons, bodices, and sleeves, cloaks, caps and coifs, coats and shoes. Some, like the chemises and starched coifs, are close to sixteenth-century originals. Others misinterpret construction or use: the German shoulder cape with standing collar becomes a bodice in Tissot's interpretation, and decorative under-sleeves, slashed at the elbow, become detached tubes, almost like fingerless gloves; two similar enormous cloaks, worn by the father of the Prodigal Son and by Marguerite, oddly have two extra openings down their overlong sleeves, possibly imitating false sleeves. Cloaks or loose swathes of fabric were draped over parts where items were missing or difficult to paint. Tissot would also appear to have utilized theatrical or second-hand costumes of much later date when necessary (Fig. 25).

 It is interesting to note that Tissot does not appear to have made significant use of costume pattern books like Bonnard's *Costume Historique* and Vecellio's *Clothes Ancient and Modern*, which were an important source for nineteenth-century history painters on both sides of the Channel.[5]

 Following a visit to Venice in 1862, Tissot had painted a Carpaccio-inspired *Départ de l'enfant prodigue à Venise*, with compositional elements and costumes derived from *The Legend of St. Ursula* in the Accademia, Venice.[6] But the sumptuous fabrics and costumes of High Renaissance Venetian painting made a deeper impression on his art, for Tissot extended his repertoire to include Italian and French-inspired later sixteenth-century garments. He acquired a limited range of such costumes, more likely borrowed than specially made up, which included a lady's gown, man's doublet, trunk hose, jerkin, tall-crowned hat and bonnet, and boy's jerkin, trunk hose and jacket. These garments were used in different combinations, together with cloaks and accessories, for a number of pictures during the mid 1860s (Fig. 26).

 Tissot was indulging in the sheer fun of dressing-up. He was not attempting to paint factual historical re-creations, and costume was given limited support from other 'props'. As well as sixteenth-century dress, Tissot used mid-eighteenth-century costume in at least two pictures during 1864–5, and painted several incorporating kimonos and other Japanese items which he was avidly collecting at this time.[7] Japanese costume, however, was not particularly understood until his later portrait of Prince Akitake Tokugawa (1868), whom he tutored for a while, and *The Prodigal Son in Modern Life: In Foreign Climes*, whose geishas are clearly based on Japanese representations.[8]

 Tissot continued with historical costume pictures while painting others in modern dress.

1, 2, 3
4, 5, 6

5

7

153a

Fig. 26. *Le Rendez-vous.*
c. 1867. Whereabouts
unknown. Reproduced
from Tissot's photograph
albums (I/41)

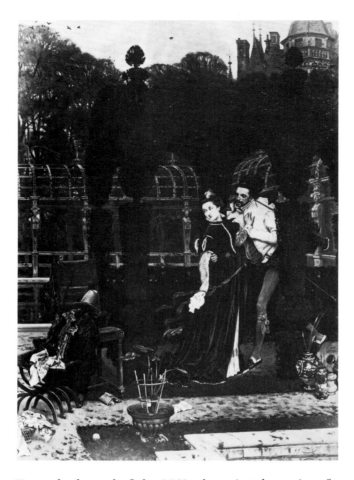

Towards the end of the 1860s, he painted a series of comedians in sixteenth- to eighteenth-century garb.[9] He also painted a number of more frivolous genre pictures in late eighteenth-century dress, whose pretty girls, love themes and veiled immorality were inspired by the works of Moreau le Jeune, Boilly and Debucourt. Tissot and his contemporaries may have thought that he was painting Directoire dress (that is of the late 1790s). In fact, the costumes are generally based on those of the late 1780s, modified to suit current taste, and bear little resemblance to those of true '*incroyables* and *merveilleuses*' – the 'punks' of the 1790s – except

26 for the red coat, with caped collar and large buttons, and the chin-high cravat, which appear in most of the pictures. Tissot probably obtained the coat, tricorne and embroidered waistcoat (Fig. 27) second-hand, perhaps from a theatrical costumiers (from whom he could also have borrowed the soldier's costume and fitted coat in *Un Souper sous le Directoire* (Baroda, Museum and Picture Gallery) and had several dresses and a beribboned hat made up, possibly adapted from fancy dress (eighteenth-century inspired costumes were popular for fancy dress balls at this time).[10] The black hat with striped ribbons is teamed either with a white dress and matching ruffle-edged fichu, or with a combination of one of two striped gowns and skirts, one gown

27 having long sleeves and a buckled belt, the other elbow-length sleeves with contrast cuff and collar, worn with a flimsy muslin fichu. Any attempt at a 1780s silhouette is marred by the lack of characteristic 'pouter pigeon' kerchief, puffed out at the breast, and crown of fluffed-out, wavy, slightly powdered hair. The cashmere shawl, though not correct for the 1780s, is surely inspired by that in Ingres's portrait of *Madame de Senonnes*, which Tissot had copied at some time in his native Nantes.[11]

In the 'Directoire' pictures (as in those of contemporary life), Tissot pays greater attention to detail than previously, carefully depicting a titillating ankle, with embroidered stockings and dainty shoes, or frothy petticoats and net gloves. He also added other appropriate 'props' – eighteenth-century china, silver and glass – to give a unified re-creation of his view of that era.

When he came to England, Tissot's eighteenth-century costume pictures were modified to suit English taste. He studied paintings of the late 1770s and 1780s by Reynolds, chiefly through

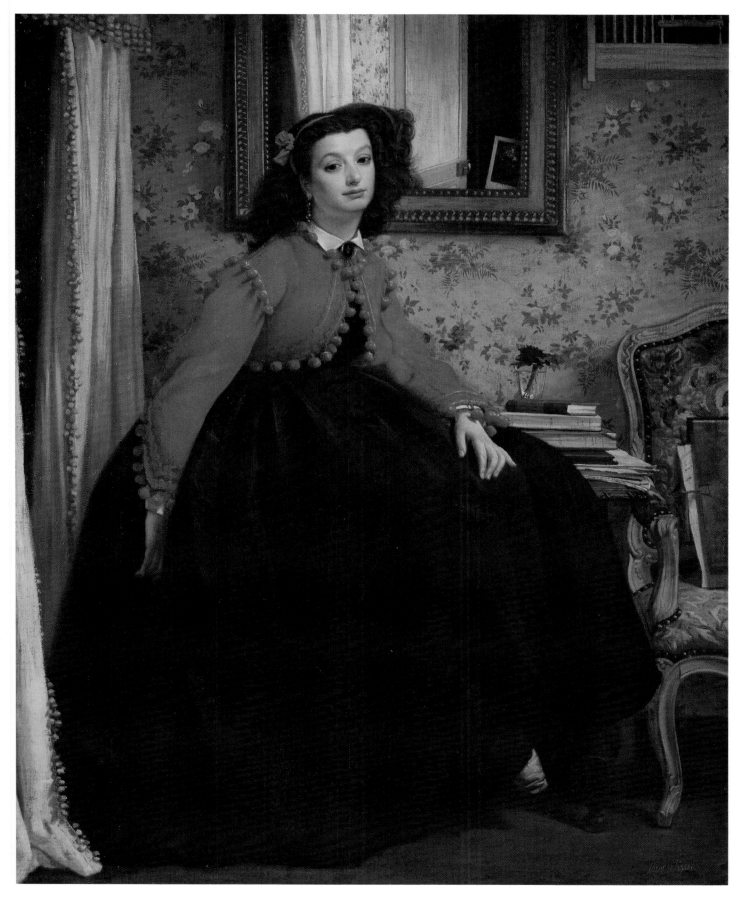

24. *Mlle L. L . . . (Jeune Femme en veste rouge)*, Musée d'Orsay, Paris. Cat. 13

Fig. 27. *Partie carrée.*
c. 1870. Whereabouts
unknown

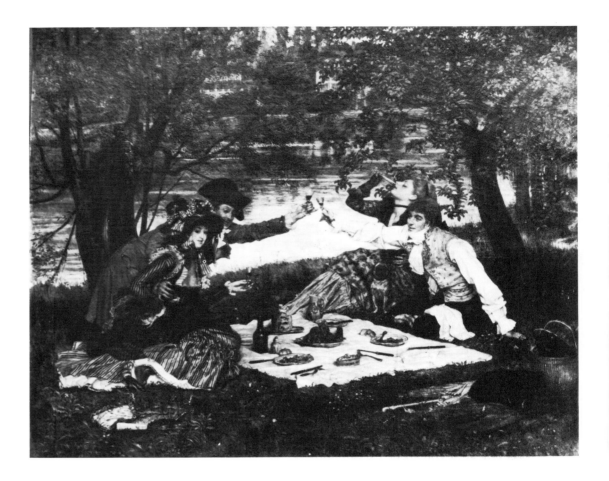

46 engravings (which he would have known before in France), but no doubt also at the Royal
Academy's Reynolds exhibition of 1872; at least one study after a Reynolds picture is known
(London, Tate Gallery). This interest may have been fostered by his friend, Millais, but was also
supported by the revival of taste for eighteenth-century clothes, paintings and the decorative
arts. Popular eighteenth-century fancy dress costumes were encroaching on real fashion:
'Watteau' *robes de chambre* were worn and fabrics with 'Pompadour flowers' or 'Dolly Varden
chintzes' were widely available, while 'Manon Lescaut' mantles, 'Watteau bows', 'Dubarry'
costumes and 'Louis Quinze' puffs were all the rage.[12] A gown like that on the left in *Bad News*
44 (Colour Plate 21) could easily have been made up to a similar pattern as used for modern 'Dolly
Varden' costumes. Contemporary fichus and hats copied eighteenth-century ones, so there was
no problem in obtaining authentic-looking 'props'. Similarly, in the furniture, silver, pottery
and porcelain, revivals and copies mix happily with eighteenth-century originals.[13] Again,
Tissot could have obtained breeches, tricorne and dresses from a costumier, only having items
like the mob-cap made up if necessary, based on those in the pictures by Reynolds and his
contemporaries.

181–5 Tissot's later religious illustrations can also be classed as costume pictures, for he based them
on studies of contemporary Jews and Arabs, believing that their garb had remained unchanged
since the days of Christ. He made numerous drawings and photographs on his trips to the Holy
Land (most of which are now lost), paying careful attention to what was worn by different races,
and gained considerable fame for his 'archaeological' portrayal of life in the Holy Land.

Since the 1930s, Tissot has become better known as an illustrator of late nineteenth-century
fashions. 'No other contemporary has left so complete a record of the time, nor has managed to
do so with such a grace or such amazing devotion to truth and detail . . . down to the last button,

the tiniest little frill, the tilt of the bonnet', wrote Edward Knoblock in 1933.[14] Indeed, Tissot's meticulous rendition of fashionable toilettes is a rich mine of information for today's costume historians (if fraught with occasional pitfalls for the unwary).

Tissot exhibited his first modern life pictures at the Salon of 1864. Portraiture and his experience of historic costume proved useful for depicting contemporary society and dress. *Mlle L.L. . . . (Jeune Femme en veste rouge)* (Paris, Musée d'Orsay) is a highly accomplished fashionable 'portrait', which assimilates the influence of Ingres and the informal pose and clothes' display of contemporary fashion plates and photographs. The sitter wears a fashionable 'Zoave' bolero, popular in the early 1860s, with the bobble-fringe trimming often used during the 1860s and 1870s, also seen here decorating the curtains. The sitter was a professional model and the clothes were probably her own, chosen by Tissot to give the portrait a striking appearance. The careful depiction of costume details, jewellery, hairstyle and house interior, together with the use of a mirror as a compositional device, reveal Tissot's close study of portraits by Ingres.

In terms of costume painting, Tissot had much in common with Ingres, for both positively revelled in the detailed rendition of fashionable clothes. Tissot found no constraint in painting sitters in modern dress, unlike many predecessors and contemporaries who thought modern dress ugly and preferred the 'timeless' dress of past epochs, especially for portraiture.[15] With Degas, Manet and the Impressionists, Tissot was drawn to the images of contemporary society in photographs, fashion plates and magazine illustrations, which dealt with subject matter not usually found in 'higher' art forms and provided new viewpoints and compositional solutions.[16] Fashion plates, for example, showed numerous variants of people in contemporary dress within everyday settings – in the park, visiting, at the seaside, or in town – as well as showing how to depict contemporary dress to advantage. Tissot was equally attracted to fashion plates by the 'keepsake' quality of the fashionable beauties depicted in them and tried to reproduce this in his modern life pictures, no doubt recognizing a ready market among those accustomed to such popular images.

Les Deux Soeurs, Tissot's second modern life Salon picture, owes setting, pose and detail to the idiom of the fashion plate. As in *Mlle L.L. . . .*, Tissot has refrained from using an obvious profile which would emphasize the triangular crinoline of the mid-1860s, preferring to underplay the fashionable outline of his figures. This feature remains prevalent in his later modern life compositions. Similar pairs of figures were used in contemporary fashion plates to show different costumes or variants, and also to show the same costume from two points of view. Throughout his career, Tissot adopted this compositional device in his modern life pictures.

Early paintings like *Le Confessional* (Fig. 41), *La Confidence* (Salon 1867) and *Les Patineuses* (1869, whereabouts unknown) reveal Tissot's reliance on the keepsake idiom to create saleable modern life pictures whose subjects were merely excuses for showing attractive, fashionably-dressed women.[17] Some pictures were more successful than others: the elaborate, trained dresses in *La Confidence* are somewhat ill-suited to the subject of a walk by the river, but *Les Patineuses* could almost be a fashion plate advertisement for skating dress. In the search for novelty, few garments were repeated, Tissot no doubt relying on hired clothes and those belonging to the models themselves.[18]

By the late 1860s, Tissot felt more confident to experiment with variations on a similar theme. He acquired some contemporary clothing 'props', which, like items from his growing collections of objets d'art, were used in a number of pictures on different models from 1867/8 to 1869. Two outfits, an informal morning gown and a visiting or promenade toilette, occur separately or together in variations of the 'Girl at Home' and 'Visiting Girlfriend', themes prevalent in the paintings of the Belgian, Alfred Stevens, whose work Tissot greatly admired. The morning gown appears in at least four pictures.[19] It offers considerable decorative potential, with its small ruffles at neck and cuffs, and the cape collar, sleeves, train and hem

13

14

16

22, 19

22

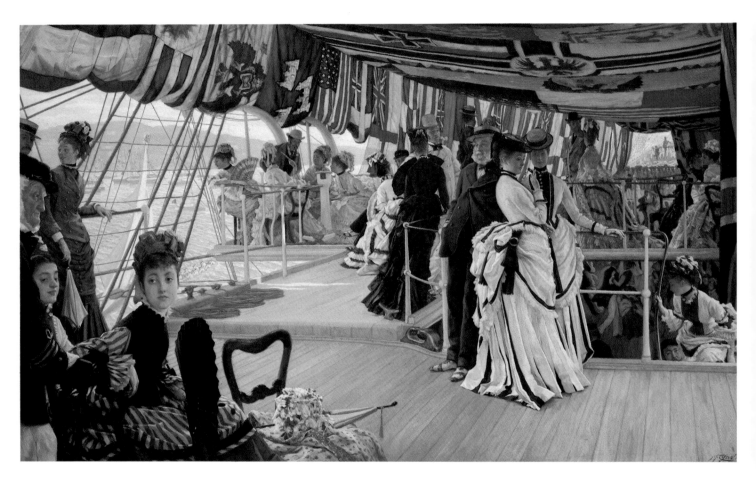

25. *The Ball on Shipboard,* Tate Gallery, London. Cat. 66

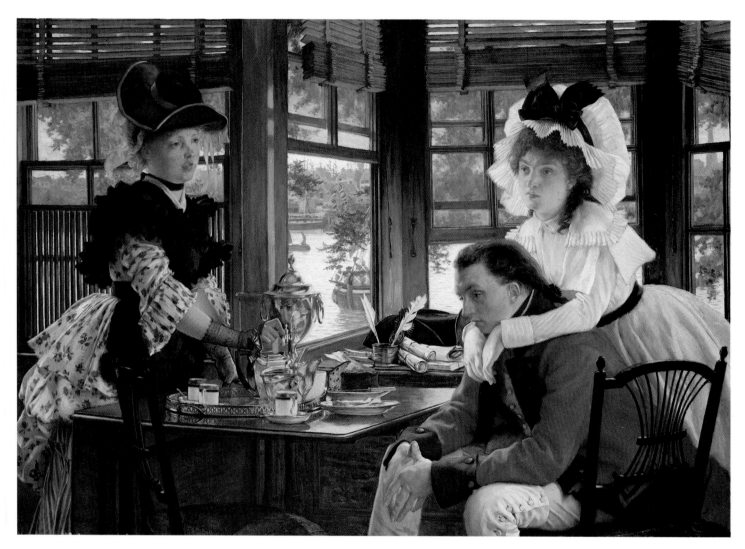

26. *Bad News*, National Museum of Wales, Cardiff. Cat. 44

Fig. 28. *Study of a Girl.*
c. 1869. Birmingham City
Art Gallery

edged with fine red piping and bobble-fringe trimming (Colour Plate 3). The visiting toilette allowed for slight variants: the complete outfit, consisting of a tunic and matching cape with darker weave border and fur edge, worn with a skirt with deep pleated flounce, a matching fur muff and a feather-trimmed hat, is depicted in a small pencil study (Fig. 28), but is seen without the hat and muff in *Le Goûter* (private collection) and without the optional cape in *Jeunes Femmes regardant des objets japonais* (Cincinnati, private collection).[20] The skirt was also used elsewhere with a different tunic.

19

Tissot had developed a successful formula for the re-use of the same costumes in different pictures through slight variation of pose or accessories. Several studies made at one or more sittings could be utilized within different contexts for a number of compositions, simply changing a face or accessory where needed. This allowed considerable scope when novel compositions were in great demand and Tissot developed it to a fine art while he was in England. The repetition of certain items of clothing allows many of Tissot's undated pictures to be grouped within a year or two of one another, when considered together with theme and setting, as most costume 'props' were periodically discarded and replaced.

Tissot was very selective in what he chose to portray. He had a distinct preference for checks, stripes and pleats (as seen before in his choice of eighteenth-century dress in France). It is probable that his interest in Japanese prints had made Tissot more aware of the graphic potential of patterns on clothes and the way in which folds and curves could be suggested two-dimensionally through sharp breaks and alterations of pattern direction or edge trimming.

Equally, checks, stripes and pleats were an ideal vehicle for the display of virtuoso painting technique, which would also have appealed to Tissot.

Several paintings and related studies of *c*. 1871–3, including *The Last Evening* (Fig. 29), show a black and white check tunic, trimmed with wide black ribbon and edged with a fringe, with wide pagoda sleeves, apron front and pannier back (the latter's fullness emphasized by a matching sash, seen best in *The Thames* (London, private collection)), worn over a black skirt with pleated flounce. In *The Thames* and a small gouache study, a bobble-fringe shawl is worn over the shoulders, the type of home-made knitted garment that is frequently described but rarely depicted.[21] The shawl adds textural interest and appears again in *On the Thames, a Heron* (Minneapolis Institute of Art), worn by the companion of a girl in the check tunic (who herself wears a short jacket), and in *A Convalescent* (Colour Plate 19), *c*.1876.[22] The red plaid shawl of *The Last Evening* occurs many times, even as late as the Kathleen Newton 'departure' pictures of *c*. 1881–2, a favourite 'prop' like the rocking chair. A similar grey plaid shawl is used throughout the 1870s.

Two grey and white striped tunics feature in a number of similarly dated pictures. A vertically striped one, with black buttons down the front and black ribbon trimming, appears in *The Ball on Shipboard* (Colour Plate 25) and in *London Visitors* (Ohio, Toledo Museum of Art), both exhibited in 1874, as well as an early *Waiting for the Ferry* (Louisville, J.B. Speed Museum).[23] The colourful striped shawl used in *London Visitors* appears again in *The Morning Ride* (New York, private collection).[24] A second tunic with vertical stripes on bodice and matching cape, and horizontal ones on apron front, provides a striking decorative feature in a painting and two prints of *c*.1875 (Figs. 23 and 24), appearing again in *Holyday* (Colour Plate 18) and *Waiting for the Train* (Dunedin Public Art Gallery, New Zealand).[25]

A finely striped, *mille raies* black and white dress appears in at least four pictures *c*. 1873–4, when very fashionable, worn with a black mantle and cape. It is still used as late as 1876–7, with the addition of a waistcoat in *Portsmouth Dockyard* (Colour Plate 16) worn elsewhere over the vertically striped tunic. This type of use over several years is seen again with the white pleated muslin dress with yellow bows, which features in *A Portrait (Miss Lloyd)* (Fig. 15), *Holyday* and *Ramsgate*, all 1876, and continues to be used until 1878.

Less obviously decorative items were also re-used. The cream tunic with fringe trimming seen in *The Captain and the Mate* (Colour Plate 13) appears in *Waiting for the Train*, while a fur-edged matching mantle and cape, worn with pleated flounce skirt, appears on both younger

55

95
111
96

66

90, 91, 96

60

83

75
79

61
95

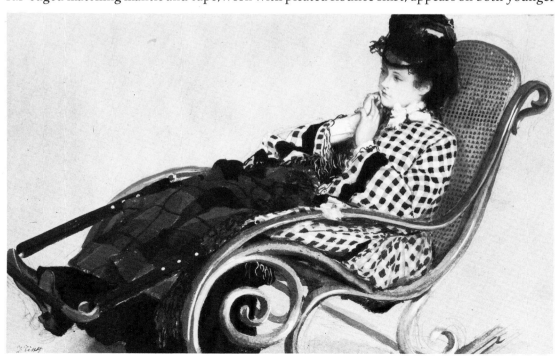

Fig. 29. *Study for 'The Last Evening'. c.* 1873. Northampton, Mass., Smith College Museum of Art

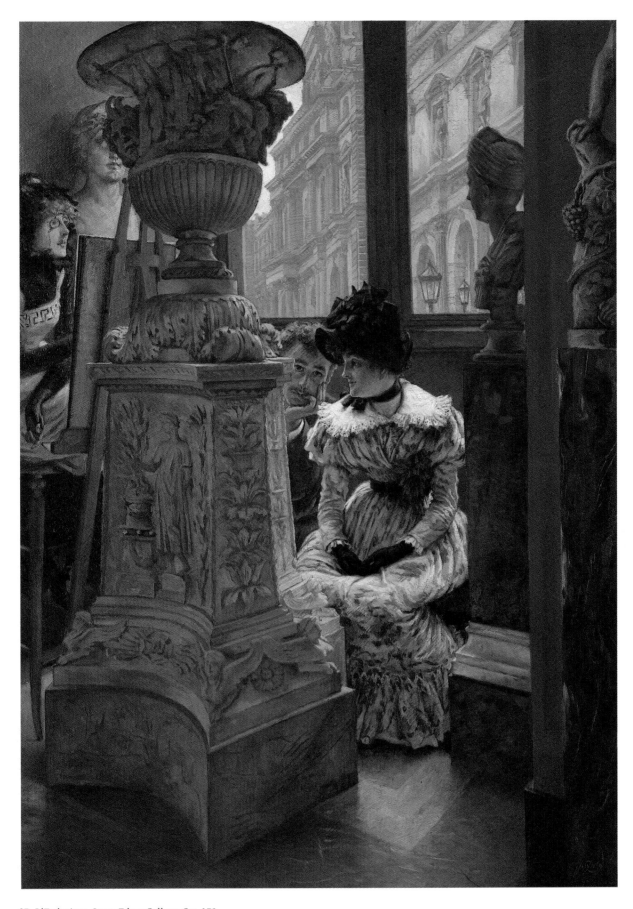

27. *L'Esthetique,* Owen Edgar Gallery. Cat. 173

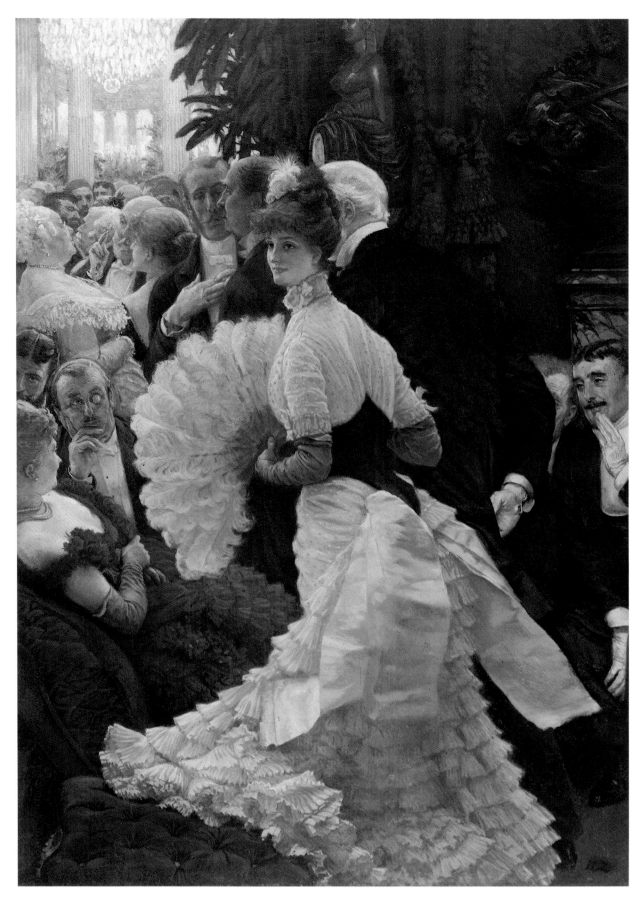

28. *L´Ambitieuse (La Femme à Paris)*, Albright-Knox Art Gallery, Buffalo. Cat. 165

and older models. Bonnets and hats can feature when the height of fashion, as with the striped boater of *Waiting for the Ferry* and *Waiting for the Train*, or can be re-used over several years, like parasols and shawls. This may well parallel real use, for a summer promenade or garden hat

60 like that in *The Return from the Boating Trip* (Colour Plate 4), though popular *c.* 1872–4, might well have continued in normal use for many years and its appearance in pictures as late as 1876 might not have been seen as an anomaly.

It is true that fashion as actually worn lags behind fashion as advocated by trendsetters in fashion plates and magazines. Tissot's pictures provide a useful record of the former, though his re-use of 'props' over more than two or three years is an artistic expedient rather than a desire for a true reflection of what was currently worn. They show his taste and his preferences: even

65 in pictures which look like the record of an occasion, Tissot is highly selective. *Too Early* (Colour Plate 7), for example, shows the vapoury muslin and tarlatan ball dresses rather than the heavier moire or grosgrain silks that were equally popular at the time. Tissot's friends posed for

70 *Hush!* (Colour Plate 6), in their own or borrowed clothes, the pink dress in the centre having
66 appeared before in *Too Early*. *The Ball on Shipboard* is likewise a studio ensemble, juxtaposed on a separately-studied setting (as with most of Tissot's pictures). The wide range of 'up to the minute' fashions, whether hired, borrowed or bought, is perhaps the most ambitious array in any of Tissot's pictures. Only the centre dress, seen from the back, and the green dress on the balcony, are 'one-off' items (though unknown paintings containing them may well appear). The grey double-breasted jacket worn by the figure on the left, fashionably imitating men's dress and worn with matching buttoned tunic, skirt and hat, appears again in *London Visitors*; the

68 striking white and blue-black toilette, repeated right of centre, is worn in *Reading the News* (Colour Plate 1), though with the favourite garden hat rather than the ultra fashionable man's boater; the pink dress with contrast plastron bodice front, which seems to 'walk' through *The Ball on Shipboard* (appearing no less than four times) is seen again in *In the Conservatory* (whereabouts unknown), as is the pale blue dress from the balcony, which becomes the centrepiece of *The Bunch of Lilacs* (private collection).[26] As in all of Tissot's pictures, men decidedly 'play second fiddle', wearing casual dress which could be 'props' or their own.

The repetition of figures in the same costume within the same pictures is certainly deliberate, for Tissot could have drawn on a number of other 'props' in his current wardrobe. He may have intended the repetition to suggest movement, inspired by the images of Muybridge. But, as mentioned before, it is also a perfectly acceptable convention used in fashion plates to show clothes from several points of view.

With the advent of Kathleen Newton, certain aspects of costume in Tissot's pictures altered. At first, he dressed her in some of his 'props' or depicted her in the type of toilettes he liked to

101 paint, with plenty of crisp pleats and decoration. Soon, however, Kathleen Newton's own taste and style become apparent. She had the ideal figure for fashions of the late 1870s and early 1880s, 'neither too thin nor too stout; tall, but yet not too tall to be graceful'.[27] Her wardrobe was limited but stylish, with a distinct preference for the slim 'Princess' line. The black dress,

99, 124 with gathered front crossed by tabs, the floral-sprigged dress, with gathers down the centre and
134 bow at the hem, worn with a pleated underskirt (Fig. 30), the scoop-necked pale blue summer
139 dress, the caped coat – all are among clothes that reappear frequently in ever-changing variations. The children of Kathleen and her sister, Mary Hervey, cavort through the pictures,

148 progressing from baby to mini-adult clothes.

Tissot's flair for painting costume died to a certain extent with Kathleen Newton. Whether he simply lost interest in fashion, or merely disliked the exaggerated *tournures* of the early 1880s is uncertain, but his portrayal of fashions in several of the *Femme à Paris* series reflect only his own preferences for frothy pleats and were criticized for being out of date. The clothes in *La*

170 *Mondaine* (Toronto, Mr and Mrs Joseph M. Tanenbaum), for example, could just as well be
165 those of the mid and late 1870s, while *L'Ambitieuse* (Colour Plate 28) was ridiculed for the model's outdated dress: 'She can't aspire to being described as elegant, wearing one of those

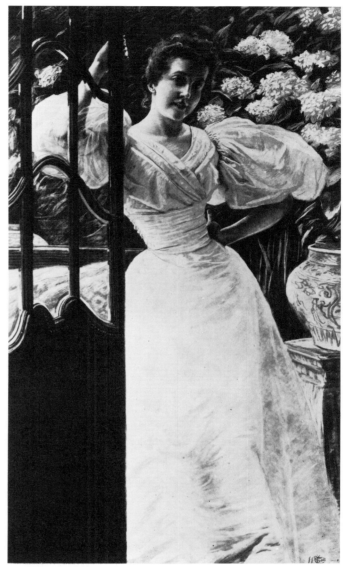

dewy gowns that you wish would finish but never do, of antiquated cut, without any bustle but with a pointed black girdle like those worn twenty years ago.'[28]

Other pictures in the series are more successful in portraying contemporary dress, while *L'Ésthetique* (Colour Plate 27), one of two paintings for a projected series of *L'Étrangère*, suits dress admirably to the subject: the model wears a floral gown with puffed leg-of-mutton sleeves and fall collar characteristic of Aesthetic dress.

In France, Tissot continued to do portraits of fashionable society (mostly in pastel) while working on his religious illustrations. The portraits record fashionable dress at the turn of the century, though they show a bias towards simpler patterns and plain fabrics (Fig. 31). There are photographs of some of them in Tissot's albums, but many were not recorded and all but a few remain untraced: it is hoped that more will gradually come to light so that Tissot's *oeuvre* will also provide useful evidence for the study of *Belle Époque* dress.

Fig. 30. *La Soeur aînée* (The Elder Sister). *c.* 1881. Whereabouts unknown. Reproduced from Tissot's photograph albums (III/31)

Fig. 31. *A portrait.* 1895. Whereabouts unknown. Reproduced from Tissot's photograph albums (IV/34)

7

Tissot's Cloisonné Enamels

JESSICA RUTHERFORD

On 12 May 1882 an 'Exhibition of Modern Art by J.J. Tissot' opened at the Dudley Gallery in the Egyptian Hall, Piccadilly. The exhibition, 'arranged after Parisian fashion, with tapestries and other furniture "de luxe"', included paintings, etchings and a group of over twenty *cloisonné* enamels' (see Appendix to this Chapter).[1] The catalogue claimed that all these enamels, many with intricate bronze mounts, were 'designed, modelled and executed by the Artist's own hand'.[2] Although his work in enamel and bronze forms a fascinating aspect of Tissot's career, it remains an area in which few documented facts have yet emerged.

One can only speculate as to why in the late 1870s Tissot became interested in the craft of *cloisonné* enamel; he was one of the earliest collectors of Japanese art in France and undoubtedly his own personal collection included Japanese and Chinese *cloisonné* enamels.[3] His admiration for Japanese metalwork might have been an initial source of inspiration; but more likely he was inspired by the enamels of Lucien Falize, Ferdinand Barbedienne and Christofle and their elaborate exhibits at the 1878 Paris exhibition. In the context of French enamellers there was little innovatory about Tissot's products; as M. Josse noted in 1883, Tissot was in fact emulating the achievement of the French craftsmen working fifteen years previously.[4]

Tissot's withdrawal from London society into a life of domesticity with Mrs Newton and her children at Grove End Road would have allowed him the time to study and practise the intricate technique of *cloisonné* enamelling. Whether he received instruction or was completely self-taught (as is implied in the Dudley Gallery catalogue) is unknown; the technical process itself was emphasized in the Dudley Gallery exhibition by the inclusion of a number of trial pieces illustrating the progress of his experiments in the medium. The catalogue stressed the craft aspect: 'The composition of opaque enamels for *cloisonné* work on metal, such as are here employed, has always been a carefully kept trade secret; and it was only after numerous experiments that the artist could produce the flux and tints required for his palette He is still working with a view to augment the resources already at his command.' Tissot's mastery of the craft with neither the help of professional craftsmen, nor using commercial enamels, was appreciated both sides of the Channel.[5] In England, however, it was admired rather more than the results: 'It is something in these days to have re-invented such a process as that of *cloisonné* enamel; and though M. Tissot's work in this medium can scarcely be described as beautiful it is undoubtedly interesting and noteworthy.'[6]

Tissot's attempt to assuage the criticism of the subject matter of his work as 'trivial' or 'vulgar' found expression in the heavy-handed symbolism of *The Challenge*, exhibited at the Grosvenor Gallery in 1877 as part of a projected series called 'The Triumph of Will'.[7] In similar vein he conceived the large-scale monument in silvered bronze and enamel entitled *Fortune* (Appendix, no. 71 and Fig. 32) and two pillar vases decorated with enamelled serpents with bronze mounts formed of serpents entwining human figures (Besançon, private collection, Appendix, nos. 72 and 73). The mounts of the pillar vases are reminiscent of Frederick Leighton's influential *Athlete Wrestling with a Python*, which was shown at the Royal Academy in the same year as the Grosvenor Gallery exhibition. *Fortune*, designed as a life-size monument or fountain, is heavy with symbols of Patience, Time, Ambition and Love; formally linking the

Fig. 32. Sculpture, *Fortune*. Silvered bronze and *cloisonné* enamel.
Paris, Musée des Arts Décoratifs

two globes on the back of the tortoise (Patience) are writhing and entwined pythons; the base is inscribed 'tout vient à point pour qui sait attendre'. This allegorical work, the centrepiece of the exhibition, required a lengthy caption of explanation in the catalogue. It received however, little praise from some English critics: 'elaborate but far from impressive' declared the *Magazine of Art*.[8] M. Josse, reviewing the same exhibition in Paris, thought it could be regarded as one of the best modern *cloisonné* enamels.[9] The result of Tissot's brief excursion into 'high art' is laboured and awkward; more successful are the decorative pieces incorporating familiar subject matter.

One vase (Appendix, no. 78, Fig. 33 and Colour Plate 30) entitled *Children in a Garden*, is an amalgam of two of Tissot's Grove End Road paintings of Mrs Newton and her children: *Croquet* (*c.* 1878; Ontario, Art Gallery of Hamilton) and *The Gardener* (*c.* 1879, Fig. 69). Two of the four enamel side panels depict variants of the two seated children in the background of *Croquet*; the third shows the girl standing holding a mallet also taken from *Croquet*, and the fourth Mrs Newton with a parasol from *The Gardener*. A round vase (whereabouts unknown, Appendix, no. 76) entitled *On the River* possibly derives from one of the Thames boating paintings and can be identified with the vase referred to in the *Academy* as 'depicting young ladies in boats'.[10] Apart from *jardinières* and vases (Fig. 34), the exhibition also included three trays and five teapots. Two of the teapots (Appendix, nos. 81 and 85) are clearly of Japanese inspiration in shape and decoration, similar in type to the Japanese export wares sold at Liberty's in the 1880s (Fig. 35).[11]

One of the most accomplished extant pieces is the *jardinière* (Fig. 36 and Colour Plate 29) now in the collection of Brighton Museum and Art Gallery, which can be identified with no. 74 in the

158
121

160

157

Fig. 33. Vase, *Children in a Garden. Cloisonné* enamel on copper. Paris, Musée des Arts Décoratifs

Fig. 34. Vase. *Cloisonné* enamel on copper. Paris, Musée des Arts Décoratifs. This vase and the one shown in Fig. 33 were purchased direct from the sale of Tissot's estate.

Fig. 35. Two teapots. *Cloisonné* enamel on copper

Dudley Gallery catalogue: 'An Oval Jardinière. *Lake and Sea*. Bronze mounted with female figures kneeling on monsters' heads'. The exquisitely moulded mounts were also used on the *jardinière*, no. 75, entitled *The Cave and the Pool* (whereabouts unknown). Particularly intriguing are the similarities between the *jardinière Lake and Sea* and a sixteenth-century Chinese *jardinière* (Fig. 37) formerly in the David-Weill collection, now in the Musée des Arts Décoratifs. The similarity in overall shape, the bronze mounts and feet and the subject matter of the *cloisonné* enamel panels are too striking to be merely coincidental. The reverse panel, with figures seated in a landscape, might have suggested to Tissot the appropriateness of adapting the scenes from his Grove End Road paintings to enamel vases.

It has recently been established that this rare and important Chinese *jardinière* formed part of Tissot's own collection. Mme Howard-Johnston, the daughter of Paul Helleu, a painter and close friend of Tissot, remembers that when Tissot died her father went to the Château de Buillon to collect a Chinese *jardinière* that had been stolen from the Imperial Palace during the Chinese revolution. Helleu bought the *jardinière* from Tissot's estate and later exchanged it for a work of art with M. David-Weill. Mme Howard-Johnston has confirmed that the *jardinière* in the Musée des Arts Decoratifs is the same one her father acquired from Tissot's collection.[12]

The Chinese *jardinière* is clearly the source for *Lake and Sea*; Tissot's seascape in enamel with sloping rocky landscapes, clusters of trees and rooftops closely resembles its Chinese model. The handles formed of gilt-bronze maidens, kneeling on exquisitely moulded monster heads reminiscent of Japanese lion dogs, derive from the handles of the Chinese *jardinière*, formed of gilt-bronze lions standing on lion heads.

The pieces in the Dudley Gallery exhibition were marked with Tissot's monogram J.J.T., but no founder's marks are apparent. The catalogue claims that all the works in bronze and enamel were executed by the artist's own hand. Tissot would have designed and perhaps modelled the elaborate bronze mounts, but undoubtedly they would have been cast by a professional bronze founder. The quality of the casting suggests that they were made in France, by a firm such as Christofle or Barbedienne, accustomed to casting art bronzes for decorative pieces.

Tissot was admired for his technical skill and for having revived the art of *cloisonné* enamel, but the subject matter was little to English taste. The *Academy* considered his enamels to be 'an extraordinary memorial of his patience, ingenuity and skill of hand' but they did not think that

Fig. 36. *Jardinière, Lake and Sea*. Gilt bronze and *cloisonné* enamel. Brighton, Royal Pavilion, Art Gallery and Museums. This side shows the view of the sea.

'representations of sea and sky and young ladies in boats are suitable for *cloisonné* work, nor do we think that flat sided vases imitating red brick walls and ivy are good art: but there is no doubt about the originality of the design and boldness and beauty of the colour, even though the works attract us little in other respects.'[13]

All Tissot's pieces were for sale, but none appears to have been sold in England, nor commissions placed; the complete collection returned with Tissot to Paris in November that year. The majority of the pieces so far traced remained in Tissot's possession and were either sold at the sale following his death or kept by members of Tissot's family.

The Dudley Gallery exhibition was the first significant showing of modern *cloisonné* enamels in England. It was noted, or briefly reviewed, by many journals including the *Magazine of Art*, the *Academy*, the *Portfolio*, the *Illustrated News*, and the *Artist and Journal of Home Culture*. The links between the subject matter of his enamels and his paintings suggest Tissot began experimenting in the medium in about 1877–8, so predating the work of the only known English craftsman working in *cloisonné* enamel at this time, Clement Heaton. The firm of Elkington's had produced *cloisonné* enamels in the 1870s, which were admired by Christopher Dresser in *Principles of Decorative Design* (1873). The revival of interest in all aspects of enamelling amongst artists and craftsmen occurred in the late 1880s and 1890s, led by Alexander Fisher, Henry Wilson and Nelson Dawson. It is perhaps surprising, given the emphasis on technical processes in the Dudley Gallery exhibition, that Tissot's *cloisonné* enamels had such little apparent influence on English craftsmen.

After the death of Mrs Newton in the autumn of 1882, Tissot returned to Paris and reopened his house in avenue du Bois. He tried to re-establish his position as an artist with an exhibition in March the following year at the Palais de l'Industrie. The exhibition included all the *cloisonné* enamels exhibited at the Dudley Gallery, catalogued in the same order. M. Josse had seen the

Fig. 37. Chinese *jardinière*. Sixteenth century. Gilt bronze and *cloisonné* enamel. Paris, Musée des Arts Décoratifs. This *jardinière* formed part of Tissot's own collection in the 1870s.

29. *Oval jardinière – Lake and Sea,* Brighton Royal Pavilion, Art Gallery and Museums. Cat. 157

30. Vase *'en gaine'* – *Children in a Garden,* Musée des Arts Décoratifs, Paris. Cat. 158

Fig. 38. Plaque inscribed
with names of Tissot's
friends, dated 1886.
Cloisonné enamel on
copper

London showing and claimed that it was his suggestion that they should be shown to art-loving Parisians.[14] The enamels were exhibited again (in the same order) at the Galerie Sedelmeyer in April/June 1885 with an additional group of eight knife-rests of various designs, not previously exhibited.

Tissot continued to work in this medium in Paris, though in a less ambitious manner designing mostly small objects and plaques. Lord Ronald Sutherland Gower visited Tissot in his Paris studio in February 1888 and noted in his diary 'He [Tissot] has remarkable and rare talent; he works in *cloisonné* enamel, as well as in all sorts of painting materials.'[15] The Alma-Tademas also visited Tissot in Paris; Miss Anna Alma-Tadema remembered that Tissot 'showed them an enormous *cloisonné* mantelpiece which he was constructing, decorated with Arabic verses and the names of English friends, among which Alma-Tadema was moved to find his own'.[16] This could explain the purpose of the enamel plaque (Fig. 38) which is inscribed with the names of Tissot's English friends and associates within burning brands.[17] Possibly the mantelpiece also included the slab for a chimney piece exhibited at the Dudley Gallery (Appendix, no. 89). The inscribed plaque, dated 1886, and other pieces which have come to light, indicate that Tissot continued to work in this medium throughout the 1880s and perhaps early 1890s.[18]

Perhaps Tissot retained a certain sentimental attachment to his enamels and their associations with Mrs Newton and Grove End Road. In need of spiritual comfort he turned to the Catholic Church and spiritualism. Edmond de Goncourt recalled a visit to Tissot's house in 1890 where in a special room hung *L'Apparition médiunimique*, Tissot's artistic record of the apparition of Mrs Newton during a seance in 1885. In the waning light of evening Tissot showed him a piece of rock crystal and an enamel tray 'qui servent a des evocations, ou l'on entend, assure-t-il (Tissot) des voix qui se disputent'.[19]

APPENDIX
List of Known Exhibited Works

A. *The Dudley Gallery 1882*

71. FORTUNE – A Work in Bronze & Cloisonné Enamel. The Goddess, no longer balancing herself upon her revolving wheel, is seated at ease upon our globe, and raises the bandage from her eyes in order the better to discern her favourites. Beneath her feet, Time, typified by the months on the Zodiac, is flying. Patience, the principle of all success, and the true basis of all fortune, is represented by the tortoise; whilst the two leading impulses of man, Selfishness and Sympathy, are represented by the types of Ambition and Love. The Motto, 'Wait and Win', in various languages – French, German, Russian, Hebrew, Arabic and Latin – runs round the base.
The intention of the Artist is to adapt this Work to a life size monument or fountain.

72. PILLAR VASE – Black Serpents on a yellow-ground, supported by Bronze Serpents entwining human figures.

73. PILLAR VASE – Turquoise-blue; the similar bronze base.

74. AN OVAL JARDINIERE – Lake and Sea. Bronze-mounted with female figures kneeling on monsters' heads.

75. JARDINIERE, with Square Panels – The Cave and the Pool. Bronze-mounted with female figures on monsters' heads.

76. ROUND VASE – On the River.

77. ROUND VASE – 'Semis de fruits'.

78. VASE 'EN GAINE' – Children in a garden.

79. VASE 'EN GAINE' – Palms on a yellow ground.

80. VASE 'EN GAINE' – The Old Brick Wall.

81. TEA POT – Blue.

82. TEA POT – Yellow.

83. TEA POT – Rose and blue.

84. TEA POT – Parti-coloured.

85. TEA POT – White and green.

86. TRAY – The 'Fiord'.

87. TRAY – Autumn Leaves.

88. TRAY – Arabesque Work.

89. SLAB, for a chimney piece.

90. THE ARTIST'S MONOGRAM – Trial-piece in the new sealing-wax red, and turquoise-blue.

91. TRIAL PIECES – A series showing the progress of the Artist's experiments.

B. *Additions to Sedelmeyer Exhibition 1885*

21. Eight knife rests of various designs.

The author would particularly like to acknowledge the generous help and encouragement received from Michael Wentworth and also thank Jane Abdy and Professor W.E. Misfeldt for information kindly given.

8

Tissot as a Religious Artist

IAN THOMSON

Tissot has been an enigma, as much to many of his contemporaries as to subsequent generations. The strands of his nature that give continuity to his work, and explain the complexity of his controlled emotion and creative urge, are now being re-discovered. One is tempted to ask: how many Tissots were there, jostling within the same character – *flâneur*, chameleon, portraitist, nautical artist, painter of secular and anecdotal themes, exponent of *l'histoire des moeurs*. But at a deeper level all the evidence points to an artist capable of understanding the abstract in terms of allegory and metaphysics, able to see the poetry in ballads, feel the conflicts in Goethe's re-written legend of Faust, submerge the spiritual when stressing the material seemed more favourable and popular, and yet capable of responding to religious impulse when the moment came. Son of a devout Catholic family, he gave little public evidence of any religious conviction in his mid-career for a decade and a half, only to end up as a 'returned prodigal' illustrating the Bible. How justified was the Professor of Moral Philosophy at the Catholic Institute in Paris in describing him virtually a theologian, even

181, 184 comparing Tissot's four volumes, two of the *Life of Christ* and two of the *Old Testament*, with the *Summa Theologica* of Thomas Aquinas?[1]

We need to identify the phases of Tissot's career during which he focused on religious subjects, and to assess his motives and the sincerity of his images. His earliest work was a remarkable blending of autobiography, a certain bourgeois sentimentalism, family allegiance, Jesuit schooling, Gothic medievalism derived from Baron Leys, and ambition. Religion, in terms of spirituality, morality, worship, and temptation, were never far from Tissot's mind at this time.

Among his first Salon exhibits, shown in 1859, were two *peintures à la cire*, *Saint Jacques-le-Majeur et Saint Bernard* and *Saint Marcel et Saint Olivier* (whereabouts unknown).[2] These four names, associated with the Abbaye at Buillon, near Besançon, and his own family, suggest the protection of guardian-angels over the estate that Tissot's father had bought when Jacques Joseph was a boy of nine, and which he was eventually to inherit. St. Jacques was his own patron saint; St. Bernard of Clairvaux, born not far from Buillon, relates to the ancient Cistercian foundation on the family estate; Marcel was the name both of Tissot's father and elder brother; Olivier was his younger brother.

At the Salon of 1861 Tissot exhibited his *danse macabre*, *Voie des fleurs, voie des pleurs* (Fig. 39), a skit on the frivolity of life and the finality of death. Silhouetted on the rim of the earth in a casual procession, led by musicians and tailed by Death, figures emblematic of human existence – flirtation, lasciviousness, violence, drunkenness and pomposity – stroll down the slippery slope of life. His own satisfaction with this whimsical, capricious allegory is conveyed in the signature 'JACOBUS TISSOT pinxit 1860'. Such moral fantasies were frequent in the Salons of the Second Empire: one thinks of Hamon's *The Human Comedy* (Compiègne, Musée National du Château) at the Salon of 1852, and Glaize's *Misery the Procuress* (Rouen, Musée des Beaux-Arts), also shown in 1861. Tissot, like his contemporaries, equivocated between the picturesque and the high-minded.

This 'thread of life in a period piece' is contemporary with Tissot's major series of paintings

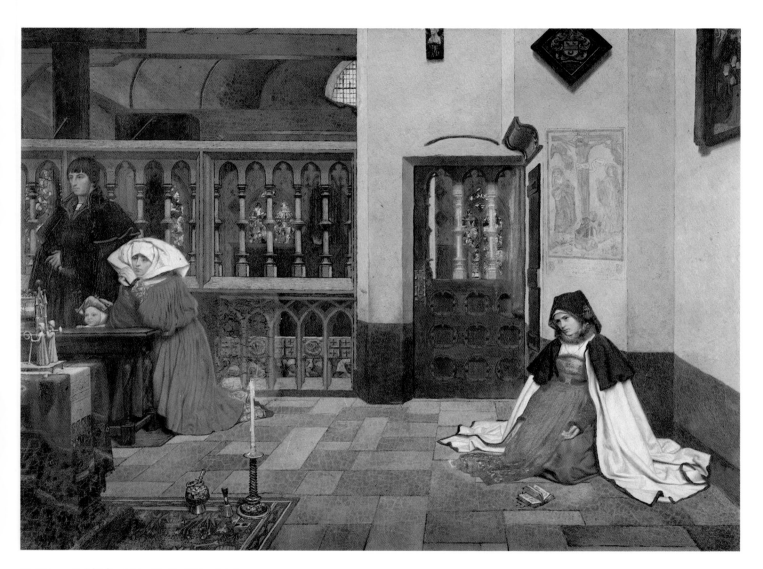

31. *Marguerite à l'église*, Major Martin Gibbs. Cat. 1

Fig. 39. *Voie des fleurs, voie des pleurs* (Path of Flowers, Way of Tears). 1860. Rhode Island School of Design, Museum of Art

on the legend of Faust, several of which were also exhibited in the 1861 Salon. Again, the theme was not novel. Delacroix had produced a series of seventeen Faust lithographs, and Goethe had expressed his admiration for these designs when they were published in 1828. Ary Scheffer, too, had preceded his usual production of religious images with paintings on the Faust theme. Tissot's treatment of the story, however, played down the central moral issues to concentrate on the psychological nuances of Faust's courtship with Marguerite. He was also able to indulge in his current addiction to the Gothic stimulated by his admiration for Leys. The spark that prompted Tissot to attempt his series may well have been the première of Gounod's opera, *Faust*, in Paris on 19 March 1859. What we see in Tissot's series is an understanding of personal torment. His compassionate nature was at one with Marguerite's desolation, sorrow, and loneliness, with all the focus on her defencelessness, the victim of temptation and treachery.

In Act II, Faust sees Marguerite coming out of church, and offers to accompany her. Dare she accept the advances of a gallant stranger? She declines him, and Tissot catches it all in his *Rencontre de Faust et de Marguerite* (Fig. 40). Many of the pictures represent Marguerite by herself, often in church, detached, pensive and perplexed. Tissot's success was in conveying the moral tension in her life.

How much Tissot owed to his older contemporary, Jules-Elie Delaunay (1828–91), who at Madame Tissot's instigation had helped to introduce her son to a studio and the art world in

1

2, 3

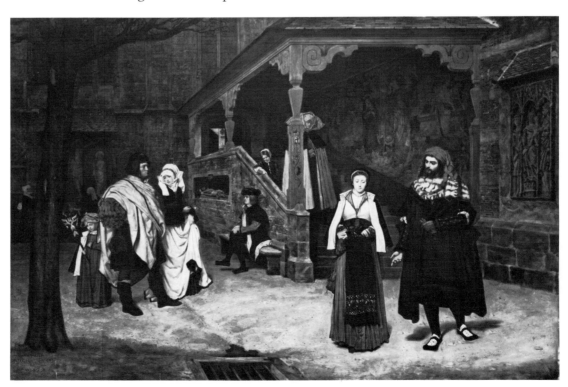

Fig. 40. *Le Rencontre de Faust et de Marguerite* (The Meeting of Faust and Marguerite). 1860. Paris, Musée d'Orsay

Paris, has yet to be determined, but Delaunay's religious interest may have had some impact. Delaunay's important *Communion of the Apostles*, 1861 (Nantes, L'Hôpital S. Jacques), is contemporary with this phase. The small etching of a priest (Paris, Bibliothèque Nationale), surely another friend of this period, is doubtless a token of his Catholic allegiance. Below Tissot's monogram and above the date 1860, is a cross. Its juxtaposition to Tissot's initials cannot be dismissed as being without some significance.

 Mystery surrounds another Tissot picture in this early period. Painted in 1860, the scene is in a side chapel, with several figures identifiable from the Faust series. But the central figure in the foreground has nothing to do with the portrayals of Faust. Standing by a pillar, present with a dozen worshippers in rapt devotion, he is yet disassociated from them in his own concentration; he bears every resemblance to Luther, who figured prominently in the work of Henri Leys in Antwerp, whence Tissot had recently returned. Reproduced in 1861 in a Bingham photograph it is entitled *Les Vêpres*, which certainly conveys the atmosphere of the setting and would offset any controversial Protestant notions in Catholic France. But the similarity to Luther is unmistakable. A painting of that title by Tissot was exhibited, not with the Faust pictures in the 1861 Salon, but on its own at the Société des Amis des Arts exhibition at Limoges in 1862. It seems almost certain that this is the painting that gradually changed in title to *Young Luther in Church* (Leeds Exhibition, 1868), to *Luther's Misgivings* by 1886, and then to *Luther's Doubts* by the time it entered the collection of the Art Gallery in Hamilton, Ontario. Whether it derives from the influence of Leys, or even reflects Tissot's own 'second thoughts' about religion and life, it smacks more of a passing Reformation reconstruction than an essential incident in the Faust series. In *Les Vêpres* Tissot made no overt comment of Luther's theological dilemmas; rather he trusted his skill in physiognomy to depict critical doubt.

 After the emotional months of 1861 — the death of his mother, the completion of the Faust series, the success at the Salon, the return of the body of Napoleon I to Paris and its re-burial in the Invalides — Tissot needed a total change of scene, and travelled to North Italy. In a letter to Degas from Venice he declared that he had taken up the theme of the Prodigal Son. The dramatic content of the parable generated two remarkable, but contrasting, pictures. Tissot himself admitted that the Carpaccio-derived *Le Départ* was 'un peu pédant'. Set in Venice, the left half of the Venetian *Le Départ* (whereabouts unknown) is detailed bustle and activity, the son leaving his luxurious home.[3] The right half is sun and light playing on beautiful buildings beside the placid surface of the lagoon, as a ship awaits to sail for the open sea — Tissot's first (accidental) shipping scene. *Le Retour de l'enfant prodigue* (New York, Manney collection) is an elaborate scene in a street or courtyard, in the Leysian idiom, with the destitute son on his knees beseeching the forgiveness of his father who comes to him ready to embrace. *Le Départ* and *Le Retour* were exhibited in the 1863 Salon and together the pair satisfied important ambitions. They proved Tissot's calibre as a painter of historical genre subjects and his ability to orchestrate mood and emotion by gesture and expression. Whereas in the Faust series he had only tackled the more worldly and metaphysical half of the story's polarity of temptation and redemption, in the *Prodigal Son* canvases Tissot was prepared to complete the parable, to balance greed and pride with forgiveness and compassion.

 Two years later, in a striking painting of *The Confessional* (Fig. 41), a foot is to be seen in a frame at the top left hand corner of the canvas, perhaps the prodigal son at the moment of contrition. Tissot combines wit and narrative, churchiness and aloofness, as a well-to-do lady moves her *prie-dieu* with gentle dignity from the confessional while cocking an ear to catch the opening words of the next penitent.

 The modern life scenes on which Tissot was increasingly to concentrate did not allow him the scope, as his early paintings had, to include morally significant concepts, and the chic success of his career no doubt put such thoughts behind him. For the next fifteen years there is a total absence of any pictures relating to a religious subject until the *Prodigal Son in Modern Life* series appeared in the Dudley Gallery Exhibition in 1882.[4] In this series, Tissot managed to combine

Fig. 41. *The Confessional.*
1865. Southampton Art
Gallery

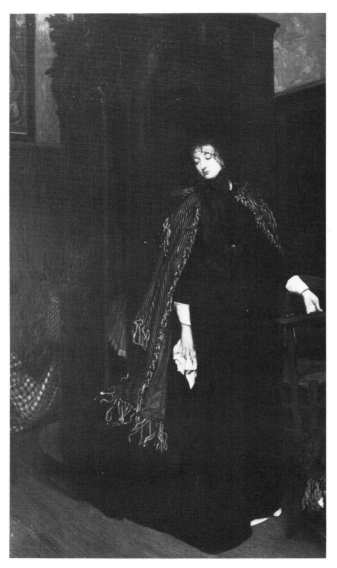

153d

his expertise as a modern genre painter with the effective treatment of a biblical subject by representing the characters in contemporary costume. The most impressive of these four pictures is, once more, the *Return* where a ship, newly arrived, is unloading its cargo of pigs and passengers at a wharf. The father, presumably a merchant (for the departure scene is in a comfortable house at the dockside), is there to meet the ship. The son, now a vagabond, rushes to his father, falls on his knees, and they grasp each other devotedly. The scene is one of pathetic, but rapturous reunion, with the other son looking on disdainfully, movingly realistic. It marked his return to a religious theme after a secular interlude of a decade in England, 1871–82.

Whether James Tissot was a lapsed or practising Catholic during his time in England is not known. His *œuvre* gives little hint in any direction. But his liaison with Mrs Kathleen Newton from about 1876 till her death in November 1882 raised all manner of religious questions. She, the young divorced wife of a doctor in India, was a Catholic also. In the climate of the times, and in view of the strict rules and conventions of the Church, any contemplation of marriage was probably considered out of the question. Nevertheless, there is no doubt whatever that Kathleen Newton's death of tuberculosis at the early age of 28 devastated his previous happiness, prompted his immediate return to France, and subjectively induced a reappraisal of his personal life.

For nearly four years Tissot struggled to regain a lost reputation in France. The exhibition of 102 of his works at the Palais de l'Industrie in 1883 was not the great success he had hoped

for. His series of fifteen large paintings, *La Femme à Paris*, exhibited in early 1885, also failed to electrify the viewing public or appeal to the critics. A relatively brief incursion into spiritualism, in an attempt to re-encounter Kathleen Newton, met no lasting satisfaction.

Then, out of the blue, comes Tissot's own account of a dramatic experience. Entering the Church of St. Sulpice in Paris, 'more to catch the atmosphere for a picture than to worship . . . I found myself joining in the devotions, and as the Host was elevated and I bowed by head and closed my eyes, I saw a strange and thrilling picture.'[5] Tissot painted his vision, and it was well described by the painter Meissonier: 'Two miserable creatures, a man and woman, almost imbecile with suffering and poverty, stand among the ruins. The invisible Saviour has drawn near. He is clothed in a shining golden cope, but He throws it open before the miserable pair . . . and, as if to console them, to encourage them to endure and suffer, He shows them His divine and martyred body.'[6]

Meissonier knew the painting as *The Ruins of the Cour des Comptes* (1885; whereabouts unknown).[7] Tissot had, thus, placed his figures in the wreckage of Paris's central law-courts, razed to the ground during the suppression of the Commune in May 1871. His painting can perhaps best be interpreted as Christ giving comfort to the people in the midst of destruction and decay. As usual, Tissot's choice of subject was shrewdly synchronized with current preoccupations. In the wake of the Commune, Parisian buildings took on symbolic significance; Meissonier himself had given his canvas *The Ruins of the Tuileries* (1871; Compiègne, Musée Nationale du Château) an ideological edge, and the Church of the Sacré Coeur, under construction during the 1880s, was conceived as a symbol of national penitence.

The impact of Tissot's vision in the Church of St. Sulpice induced a new vocation, and he felt compelled to illustrate the account of the *Life of Christ* in the Gospels. His declared objective was to try to recapture the atmosphere, customs and topography of the Holy Land and reconstruct an impression of Christ's impact upon the people of His time. He set off on his fiftieth birthday, 15 October 1886, travelling first to Egypt, which captivated him, and then on to Palestine, by which time his journey had become a personal pilgrimage. His work was a race against time, for 'the data still existing . . . will . . ., in these days of the invasion of the engineer and the railway, disappear before the irresistible impulse of the aggressive modern spirit,' as he wrote in his Introduction to the *Life of Christ*.

181

In the Holy Land he steeped himself in ancient customs and traditions, made countless sketches, complete with details as to colouring, and notes about historical incidents and associations. He read assiduously and enquired constantly from scholars and local authorities as to the verification of sites, endeavouring to be careful to discriminate between authentic, traditional and less reliable sites, and to be more thorough than other nineteenth-century artists who had worked in Palestine before him. He returned in March 1887 loaded with material to illustrate the *Life of Christ*, and more convinced than ever of the need to do it. His stance was that of a traditionalist: Christ was both human and divine. To this two-fold conviction he remained true and his work must, therefore, be judged by the ambition and intentions he set himself. Tissot was well aware both of the problems as an artist and of the scepticism he would encounter from others.

Tissot introduced himself as a religious painter to the French public by exhibiting his *Prodigal Son in Modern Life* series at the Exposition Universelle in Paris in 1889, and was promptly awarded a gold medal. In early 1894 the first 270 pictures for the *Life of Christ*, out of a final total of 365 illustrations, were shown in the Salon du Champ-de-Mars. Edmond de Goncourt wrote that crowds welcomed the pictures with enthusiasm, including a good number of priests. On 30 July 1894 Tissot was created a Chevalier of the Legion of Honour. The French edition of the *Life of Christ* was published by Mame et Fils of Tours in two volumes, in 1896–7. It had taken two years for Tissot to supervise the reproductions, and he had examined each plate as it was produced at Lemerciers in Paris. The earliest copies of the de luxe first edition were sold at 5000 francs each.

153
182

In England the publishers were Sampson Low, Marston & Co. The Latin text of the Gospel passage was on the left-hand column of each page with the English text in the right-hand column alongside. Copious notes, relating to theological exegesis or geographical explanation, costumes, customs or traditions, interspersed the text to the astonishment of countless readers, who expected this of no artist. Tissot dedicated the English edition, dated 15 October 1897 Abbaye de Buillon, to W.E. Gladstone, four times Prime Minister of Great Britain. In London, after the painful criticism of former years, the drawings and paintings of the *Life of Christ* in an exhibition in the Lemercier Gallery met with a warm reception. The illustrations, largely by virtue of their realism, proved acceptable to Catholics and Protestants alike, in an age when there was frequently little love lost between them.

Some of the finished illustrations of the *Life of Christ* are still unquestionably moving, others repugnant to our taste today; some successful in composition and appeal, others far-fetched and disappointing. As with his earlier work his pictures are best when they involve realism and narrative, and are least worthy when he contrives to convey mysticism and supernatural power. In general, the face of Christ is strong and tranquil, human yet sublime, in command of each situation. Only when we reach the events of Holy Week and the Passion do the paintings often become uncomfortably poignant, but so were the events. *What our Saviour Saw from the Cross* is one of his most novel and imaginative scenes. Every eye looks up at the Cross, but no cross or figure of Christ is seen. Rather, Christ beholds the crowd below, in their varying attitudes of grief, taunt, and amazement.

It is crucial to see Tissot's religious images within their cultural and ideological context, for at the turn of the century Catholicism was a live political issue in France. The French philosopher-theologian, J.E. Renan (1823–92), sent to Syria on an archaeological expedition by Napoleon III in 1860, had written his *La Vie de Jésus* while in Palestine shortly afterwards. Published in 1863, it magnified the simple charm of Jesus as an itinerant preacher, denied any supernatural being or redemptive element, and caused a storm throughout France and beyond. Hard on the heels of Darwin's *The Origin of Species*, 1859, it served to inculcate doubts as to the literary and scientific value of the biblical records, and encourage a rampant atheism and anti-clericalism that blended well with emergent Republicanism. By contrast, Tissot's theological orthodoxy began to assure his recognition in Catholic circles once the news of his work became known.

In 1893 the Archbishop of Rheims, Cardinal Langénieux, in his role as Papal Legate, paid a visit to Patriarch Piavi in Jerusalem to initiate conversations between the Vatican and the Eastern Orthodox Churches. Who better than Tissot to be commissioned to document the occasion in a painting for which a place had already been reserved in the Baptistry of Rheims Cathedral? The picture was exhibited at the Salon du Champ-de-Mars in 1897, but is now lost.

Tissot was also commissioned to paint a vast mural of the *Head of Christ*. With the arms of Christ outstretched to welcome, embrace and bless, the painting filled the enormous curved apse above the high altar in the Dominican Convent Church in the rue Faubourg St. Honoré in Paris. The figure symbolized Christ as the Head of the Church, emphasized humanity without diminishing his divinity, and gave Tissot the satisfaction of 'monumentality', an offering to the Catholic Church. It was dedicated in a notable ceremony in the church on 3 December 1897. Tissot's work in the 1890s was, thus, seen by the ecclesiastical authorities as an ally of the Catholic *Ralliement* against Republican anti-clericalism.

Toying with the imagery of French militarism and national resurgence, Tissot showed himself alert to the other powerful current of contemporary conservatism, the jingoistic call for *revanche* against the Prussians. By the 1890s Tissot was an accredited painter of the French 'right'. Indeed, as the *Life of Christ* volumes approached publication Tissot was momentarily tempted to embark on a series of paintings on the story of Joan of Arc, rapidly becoming a cult in the 1890s. He was also tempted to paint Napoleon I, to replace Ingres's *The Apotheosis of Napoleon* which had been destroyed by fire in the Hotel de Ville in Paris in 1871. Putting these temptations behind him, however, he set off in 1896 on his third trip to the Holy Land, having

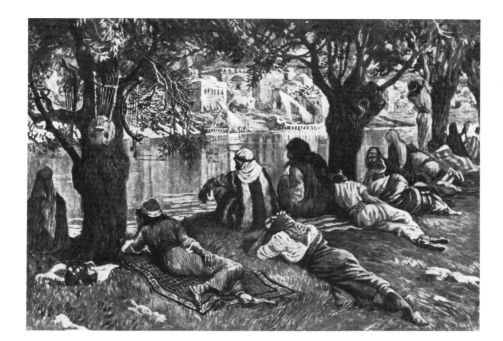

Fig. 42. *By the Waters of Babylon* from the *Old Testament*

now determined to illustrate the *Old Testament*. The drama of the Bible had prevailed over the lure of patriotism.

Tissot's *Old Testament* volumes had 400 illustrations, concentrated mostly in the historical books, but also including some of the Psalms and the Prophets. The outcome was patchy; some were dramatic, inspired, convincing; others, suffered from the inevitability of attempting too much too quickly. What is astonishing, however, is the dexterity with which Tissot could switch from distant landscapes to indoor scenes, from people to animals, from measured diagrams to decorative letters, from the pageantry of history to individual types. *By the Waters of Babylon* (Fig. 42; Psalm 137), is splendid in composition, atmosphere and detail. It conveys resignation to circumstance, narrative, naturalism, and imagination, and confirms Tissot as good a draughtsman as a colourist.

By 1902 the 400 Old Testament pictures were well under way, with 200 completed. But suddenly illness struck him, and Tissot died at Buillon on Friday, 8 August 1902. *The Times* of London, on Monday, 11 August, bursting on every page with glowing accounts of the coronation of the King-Emperor Edward VII in Westminster Abbey on Saturday, 9 August, found room on the Court Circular page for a sizeable tribute to M. James Tissot, 'the painter of the "Life of Jesus"'. He was buried in the private chapel at Buillon, which he loved.

The *Old Testament* volumes appeared in 1904, six artists of Tissot's own choosing being brought in to complete the work for publication using Tissot's sketches. The last illustration in the *Life of Christ* is a self-portrait, entitled *Portrait of the Pilgrim* (Fig. 7). Sad and forlorn at the age of 60, Tissot stands behind a chair, surrounded by the symbols of the Jewish and Christian faiths, with his right hand lifted to shoulder level, half in farewell, half in blessing, and, looking at us, appended the words:

<div align="center">

'Ye who have read these volumes written for your
benefit and have perhaps been moved by what
they contain, as ye close them, say this
prayer for their author: Oh God, have
mercy on the soul of him who
wrote this book, cause Thy
light to shine upon him
and grant to him
eternal rest.
Amen.'

</div>

184

Notes

1. The Ambiguous Art of Tissot

1. Following the observations of Julian Treuherz in the catalogue of the exhibition, *Some Masterpieces from Manchester City Art Gallery*, David Carritt Ltd., June–July 1983 (no. 27). He suggests convincingly that the painting, previously known as *The Convalescent*, is identifiable with one described in the *Athenaeum*, 27 November 1879: 'a battered old officer riding in a bathchair and attended by a young lady, who is not always under her father's eye'.

2. James Tissot: 'cet être complexe'

1. de Goncourt, Edmond and Jules, *Journal: memoires de la vie littéraire* 26 January 1890; Blanche, J.E., *Portraits of a Lifetime*, ed. and tr. Walter Clement (New York; 1938), p. 25.
2. See Reff, Theodore, 'The Pictures Within Degas's Pictures', *Metropolitan Museum Journal*, 1 (1968), pp. 125–6, and the 'Introduction' in Providence/Toronto 1968, n.p., for excellent and complete studies of the artistic and psychological implications of the portrait.
3. Goncourt, 3 November 1874.
4. Morisot, Berthe, *Correspondence de Berthe Morisot*, ed. Denis Rouart (Paris; 1950), p. 89; Jopling, Louise (Mrs Jopling-Rowe), *Twenty Years of My Life* (London; 1925), p. 60; Levy, Clifton Harvey, 'James Tissot and his Work', *New Outlook*, 60 (1898), p. 954; Jacomb-Hood, G.P., quoted in Laver 1936, p. 62; and Bastard, George, 'James Tissot', *Revue de Bretagne*, vol. XXXVI (November 1906), p. 276.
5. Goncourt, 26 January 1890.
6. Thiébault-Sisson, François, 'J.-James Tissot', *Les Arts*, 9 (October 1902), p. 4.
7. Letter in the Musée de Gray; Sargent quoted in Laver 1936, p. 33; Bastard op. cit., p. 265.
8. Thiébault-Sisson op. cit, p. 4.
9. Letter in the Whistler collection, University of Glasgow.
10. See Wentworth 1984, p. 58, n. 51: since publication, Ronald Pickvance has been kind enough to bring to my attention the fact that Tissot owned a second Degas, which was also sold to Durand-Ruel at the same time in the nineties: *La Dame aux jumelles* (I.431, *c*. 1865; Dresden, Museum of Modern Art), or 'Lyda', whose identity remains a mystery, but whom Mr Pickvance – and I – would like to connect with the woman who appears in several of Tissot's pictures at the time, as, for example, the 1864 Salon picture, *Mlle L. . .L. . .* (Paris, Musée d'Orsay). For Degas's four drawings of 'Lyda' see Pickvance, Ronald, *Degas, 1879*, catalogue of exhibition organized by the National Galleries of Scotland and the Edinburgh Festival Society, in collaboration with the Glasgow Museums and Art Galleries, 1979, no. 2.
11. Letter in the de Nittis Foundation, Barletta.
12. See the letter quoted in Cachin, Françoise, et. al., *Manet*, an exhibition organized by the Grand Palais, Paris, and the Metropolitan Museum of Art, New York, 1983, under the provenance for no. 148.

13. See Wentworth 1984, p. 58, n. 51.
14. Bastard op. cit., p. 278.
15. Thiébault-Sisson op. cit., p. 4.
16. The illustration, after a drawing exhibited at the Royal Academy, was described as 'the interior of the studio, a part of the additions recently completed at the house of Mr. Tissot – the well-known French artist – in Grove End-road [sic], from the designs and under the superintendence of Mr. J.M. Brydon . . . As will be seen from the drawing, it is a large apartment, amply lighted, principally from the north and east. The whole of one side (the right in the view) is open to a large conservatory, from which it is separated by an arrangement of glass screens and curtains. The floor is laid with oak parquet, and the walls are hung with a kind of tapestry cloth of a greenish blue colour.' *Building News*, 1874 p. 526. I am indebted to Jessica Rutherford for bringing this illustration to my attention.
 Brydon later worked on the additions to the Château de Buillon: see catalogue entry for the *Château de Buillon*.
17. de Lostalot, Alfred, 'James Tissot', *Society of French Aquarellists* (Paris; 1883), p. 376.
18. See 'The Ambiguous Art of Tissot', note 1.
19. Goncourt, 9 January 1894.
20. Moffett, Cleveland, 'J.J. Tissot and His Paintings of the Life of Christ', *McClure's Magazine*, 12 (March 1899).
21. See Halévy, Daniel, *My Friend Degas*, ed. and tr. by Mina Curtis (Middletown, Conn., 1964), p. 95.

3. Comic and Aesthetic

1. Wentworth 1984, pl. 189.
2. For *La Menteuse*, Wentworth 1984, pl. 184.

4. Tissot: his London Friends and Visitors

1. He made twenty-two cartoons in 1871, eight in 1872, nine in 1873.
2. See p. 84. Also among her effects was a drawing of herself as a young woman by Paul Helleu.
3. Jopling, Louise. See 'Cet être complexe', note 4.
4. Pittalunga, Mary, and Piceni, Enrico, *Giuseppe de Nittis*. Milan, 1963.
5. Wentworth 1978, p. 206 and Fig. 48h.
6. Particularly *Pas Mèche*, now in National Gallery of Scotland.
7. *July* (Ohio, private collection) and *Quiet* (London, private collection).
8. For a full account of Mrs Newton see: Ross, Marita, 'The Truth about Tissot', *Everybody's Weekly* 15 June 1946, pp. 6–7; Brooke, David S., 'James Tissot and the "Ravissante Irlandaise"', *Connoisseur*, May 1968, p. 7.
9. Farmer, John, *Eglinton: Twixt Two Worlds*, London, 1886.
10. Ernest was also fluent in Hindustani.

5. London Years: the Dissemination of the Image

1. The colour print is *La Promenade*, c. 1890–5. Wentworth 1978, W. 88.
2. Hamerton, P.G., *Etching and Etchers*, London 1868, p. 29.
3. Laver suggested that he might have been a pupil of Seymour Haden's: see Laver 1936, p. 28.
4. Three other recently discovered paintings, which relate in varying degree to prints, are the panel *En plein soleil* (New York, private collection; Wentworth 1984, colour plate IV) and, rather more closely, two paintings exhibited here, *Spring (Specimen of a Portrait)* and *Le Banc de jardin*. Further paintings are recorded in photographs in Tissot's albums and are referred to in the appropriate catalogue entries.
5. New York, private collection; Sotheby's Belgravia, 23 March 1981 lot 67. Reproduced in colour in *Art at Auction: The Year at Sotheby's 1980–81*, London 1981, p. 60.
6. Paris, Bibliothèque Nationale, *Helleu*, 1957, p. 18, cat. 121. I am grateful to Michael Wentworth who drew my attention to this catalogue, which confirmed my casual observation of 20 years past.
7. The etching was also titled 'How Happy could I be with Either', following the song from *The Beggar's Opera*.
8. Wentworth 1984, p. 104.
9. This was presumably for the practical reason of assisting in the compulsive, incessant production of these works under the stimulus of his religious conversion.
10. Wentworth 1984, p. 56, pl. 33. William T. Walter's collection was rich in nineteenth-century art as well as other areas.
11. Such a commercial aspiration would appear to underlie the watercolour replicas of the famous set of four paintings of *The Prodigal Son in Modern Life* (Nantes, Musée des Beaux-Arts, also etched) which accompanied the oils at the Dudley Gallery exhibition of 1882.
12. Wentworth records an inscription as *J.J. Tissot à l'ami E. Simon en bon souvenir* and points out that the dedicatee was the Director of the Paris Theatre Ambigu, 'to whom Tissot must have given it in the mid-eighties'. Unless it had been bought back rapidly prior to 1883 (when it was exhibited at the Palais de l'Industrie) the artist must have retained it.
13. Wentworth 1978, Fig. 35b. Sale Parke Bernet, Los Angeles, 22–3 May 1972 lot 260 (illustrated), from the Fansworth Estate, Deedham, Mass., 'Acquired from the artist in London, by a member of the Fansworth family'.
14. Wentworth 1978, Fig. 40c; Wentworth 1984, pl. 106.
15. Wentworth 1978, Fig. 45e.
16. British Rail Pension Fund. Sotheby's Belgravia, 1 October 1979 lot 41 (illustrated). Reproduced in colour in *Art at Auction: The Year at Sotheby's 1979–80*, London 1980, p. 65. Oil on canvas (40.5 × 23 cm); deriving closely from the Sydney painting (118.1 × 77.3 cm) the subject reveals a cool, restrained response to British Victorian preoccupations with mortality.
17. The setting is a telling view up the National Gallery's west steps to the portico and spire of St. Martin-in-the-Fields. A first state of the print indicates conclusively that from the outset the foreground figure was not to be the blue-coat schoolboy of the paintings, but Kathleen Newton as a fictive art student in familiar costume, clasping a folio.
18. Wentworth 1978, Fig. 36c.
19. This seems to be the subject known as *The Convalescent*, of which one version is in the Manchester City Art Gallery: see 'The Ambiguous Art of Tissot', note 1.
20. The question of Tissot's use of a studio assistant remains uninvestigated. Besides taking photographs, he could conceivably have participated in the larger paintings or in the

production of replicas, perhaps to be re-touched and signed by the artist.
21. These were sold at Sotheby's, London, 17 June 1982 lots 271–302.

6. Costume in Tissot's Pictures

1. Laver 1936, p. 65.
2. Misfeldt 1971, p. 13: Tissot's father gave his occupation as *négotiant* (merchant) when registering the birth of his first three sons and *marchand de nouveautés* (linen-draper) when registering the fourth (Municipal Records, Nantes). A merchant was simply a wholesale dealer, so it is likely that he became a wholesale linen-draper, purchasing cloths made of flax and hemp, and 'shawls, printed calicoes, muslin etc' from merchants and manufacturers for resale to retail linen-drapers and for export, a highly profitable business, booming 'beyond all precedent or calculation' in 1824: *The Book of English Trades and Library of the Useful Arts . . .*, new enlarged edition, printed for Sir Richard Phillips & Co., London 1824, pp. 226–31.
Wentworth 1984, p. 10 quotes Bastard's description of Mme Tissot as a *fabricante de chapeaux*, a hat-maker as opposed to a milliner (*modiste*). Until the latter half of the nineteenth century, the former made predominantly men's hats while the latter made bonnets and other 'confections' for women, combining this with dressmaking in the provinces. If Bastard was correct, it is more likely that Mme Tissot and her sister ran a hat-making company than were hat-makers themselves. Misfeldt op. cit. describes the two sisters as 'partners in a company dealing in women's fashions', but gives no further evidence.
3. Leys also painted fifteenth- and seventeenth-century scenes. For the importance of Leys in the nineteenth century, the impact of his art on Tissot and the reaction of critics to Tissot's 'imitations', see Wentworth 1984, pp. 24–32, 34, 36–7, 42.
4. For Meissonier's use of costume 'props' see Lethève, Jacques, *Daily Life of French Artists in the Nineteenth Century*, tr. Hilary E. Paddon. New York, 1972, p. 72.
5. See Smith, Roger, 'Bonnard's *Costume Historique* – a Pre-Raphaelite Source Book', *Costume, The Journal of the Costume Society*, VII 1973, p. 28–37; Ormond, Leonée, 'Dress in the Painting of Dante Gabriel Rossetti', *Costume*, 8 1974, pp. 26–9; Strong, Roy, *And when did you last see your father? The Victorian Painter and British History*, London 1978.
6. Unlocated; Wentworth 1984, pl. 16.
7. The two pictures using eighteenth-century costume, recorded in Tissot's photograph albums, depict a man in mid-eighteenth-century coat and waistcoat, breeches, buckled shoes and tricorne. For the Japanese dress, see Wentworth 1984, pp. 68–72 and pls. 55 and 56.
8. For the portrait of Prince Akitake Tokugawa, see Wentworth 1984, pl. 54.
9. ibid. pp. 75–6, pl. 63 *Sixth Comedian*; Laver 1936, pl. XII, *First Comedian*; *Second Comedian* sold Sotheby's 14 November 1973, lot 27.
10. e.g. 'Costumes for Fancy Balls', The *Queen*, 1 January 1870. See also Stevenson, Sara, and Bennett, Helen, *Van Dyke in Check Trousers: Fancy Dress in Art and Life, 1700–1900*, Scottish National Portrait Gallery, 1978.
11. Wentworth 1984, pl. 28.
12. e.g. The *Queen*, 18 May, 6 July and 3 August 1872; The *Englishwoman's Domestic Magazine*, July 1872.
13. Discussed in Brooke 1969.
14. Introduction to Leicester Galleries 1933 catalogue, p. 3.
15. See Ormond op. cit.; Stevenson and Bennett op. cit.; Ribeiro,

Aileen, 'Some evidence of the influence of dress of the seventeenth century on costume in eighteenth-century female portraiture', *Burlington Magazine*, December 1977; Nevinson, John, 'Vandyke Dress', *Connoisseur*, vol. 157, November 1964: also Reynolds's comments in the *Discourses*, particularly VII 1776.

16. See Roskill, Mark, 'Early Impressionism and the Fashion Print', *Burlington Magazine*, June 1970; Isaacson, Joel, *Monet: Le Déjeuner sur l'herbe*, London 1972, pp. 45–51 and notes 70–3.
17. For *La Confidence*, see Wentworth 1984, pl. 31; painting cut down, sold Christie's New York. For *Les Patineuses*, see Misfeldt 1971, Fig. 39.
18. The dress and model on the right in *Les Deux Soeurs* appear in *Le Printemps* (Salon 1865, unlocated; Wentworth 1984, pl. 30) where the same model is also shown in a bolero and skirt which are worn in a small portrait dated 1863, recorded in Tissot's photograph albums.
19. *Mélancolie* (unlocated, Misfeldt 1971, Fig. 46); *L'Escalier* (private collection); *Jeunes Femmes regardant des objets japonais* (London, private collection; Wentworth 1984, colour plate II); *Jeunes Femmes regardant des objets japonais* (Cincinnati, private collection; Wentworth 1984, pl. 59).
20. The outfit also appears in *Rêverie* (Pennsylvania Academy of Fine Arts, Philadelphia; Wentworth 1984, pl. 50) and a painting of a girl beside a confessional recorded in Tissot's photograph albums, Fig. 43.
21. For *The Thames*, see Wentworth 1984, pl. 75. The small gouache study is in the Art Gallery of New South Wales, Sydney.
22. The former Wentworth 1984, pl. 90.
23. For *London Visitors* see Wentworth 1978, Fig. 40c; for *Waiting for the Ferry*, see Wentworth 1984, pl. 111.
24. Wentworth 1978, pl. 100.
25. Wentworth 1984, pl. 98.
26. ibid. pls. 107 and 137.
27. The *Englishwoman's Domestic Magazine*, April 1876.
28. *La vie parisienne*, quoted in Wentworth 1978, p. 304.

7. Tissot's Cloisonné Enamels

1. The *Portfolio* 1882, Art Chronicle, p. 115.
2. *An Exhibition of Modern Art by J.J. Tissot – The Prodigal Son in Modern Life; Paintings, Etchings and 'Émaux Cloisonnés'*, Dudley Gallery, London 1882, p. 30.
3. Wentworth, Michael: 'Tissot and Japonisme' in *Japonisme in Art: An International Symposium*, gen. ed. Chisaburo Yamada, Tokyo: Committee for the Year 2001, 1980 pp. 127–46.
4. *Revue des Arts Décoratifs*, 1882–3 'L'art Japonais à propos de l'exposition organisée par M. Gonse', letter from M. Josse, pp. 329–38; p. 335.

5. See note 4.
6. The *Magazine of Art* 1881–2, Art Notes p. XXXIV.
7. Wentworth 1984, p. 137 for a description of *The Challenge*, taken from the review in *The Times* of the Grosvenor Gallery exhibition, 1 May 1877. The painting is in a French private collection.
8. See Note 6. The reviewer did consider that the teapots were 'pretty enough'.
9. See Note 4.
10. The *Academy*, 27 May 1882, p. 384.
11. The vases were sold at Sotheby's Monte Carlo, 15–16 June 1982, lots 835 and 836.
12. This information from Mme Howard-Johnston was conveyed to me by Jane Abdy. I am very grateful to Jane Abdy for her help in establishing the fact that the Chinese *jardinière* did actually form part of Tissot's collection. David-Weill acquired the *jardinière* from Helleu prior to 1925 as it is illustrated in *L'Amour de L'Art* January 1925, in 'L'Art Chinois dans la collection David-Weill' by H. D'Ardenne de Tizac, pp. 24–9.
13. See note 10.
14. See note 4.
15. Gower, Lord Ronald Sutherland, *Old Diaries*, London 1902, p. 63.
16. Laver '36, p. 60.
17. The plaque was sold at Sotheby's Monte Carlo, 15–16 June, lot 834.
18. The Tissot scholar, Professor W.E. Misfeldt, has in his collection two enamel plaques made in Paris by Tissot which might have been designed as part of the mantelpiece. One, dated 1886, is similar in overall design to the plaque inscribed with the names of Tissot's friends; the second piece appears to be a section of a decorative border. Another plaque, with a design inspired by Egyptian art, dated 1888, was sold at Sotheby's Monte Carlo, 15–16 June 1982, lot 837.
19. Goncourt, op. cit., vol. iii, p. 1118, entry for 1 February 1980. The tray referred to could be one of the three exhibited at the Dudley Gallery nos. 86–8; it might of course be a Japanese enamel.

8. Tissot as a Religious Artist

1. Preface to the *Old Testament*, M. De Brunoff et Cie, Paris 1904.
2. The former illustrated Misfeldt 1984, Fig. 4.
3. Wentworth 1984, pl. 16.
4. The possible exception was Tissot's short-lived attempt to get back to allegory in the *Triumph of Will* in 1877, but this was not directly religious.
5. Levy, C.H., 'James Tissot and his work', *New Outlook*, quoted in Wentworth 1984, p. 172.
6. Greard, V.S.O., *Meissonier*, London 1897, p. 176.
7. Wentworth 1984, pl. 196.

Notes on essay contributors

Sir Michael Levey is Director of The National Gallery, London.

Michael Wentworth collaborated on the 1968 Providence/Toronto *James Tissot* exhibition and wrote the *catalogue raisonné* of Tissot's prints that accompanied the 1978 Minneapolis exhibition. He has written numerous articles on Tissot and a major study of the artist, which was published in March 1984 by Oxford University Press.

Malcolm Warner writes and lectures on nineteenth-century art. A popular booklet by him on Tissot was published by the Medici Society in 1982.

Jane, Lady Abdy has long been fascinated by Tissot and has stimulated the resurgence of interest in Tissot's work in Britain.

Harley Preston is Curator of Prints and Drawings at the National Maritime Museum, London. He has published a number of articles on nineteenth-century painting and on Tissot.

Krystyna Matyjaszkiewicz is Assistant Keeper at Barbican Art Gallery, has worked on eighteenth- and nineteenth-century painting and costume, and has selected the Tissot exhibition.

Jessica Rutherford is Keeper of Applied Art at Brighton Art Gallery and Museum, about whose collections she has published various studies.

Ian Thomson, Chaplain of All Souls College, Oxford, frequently lectures on Tissot and has published a number of articles on the artist in recent years.

CATALOGUE

Titles are generally those given by Tissot to works exhibited during his lifetime, with other accepted titles and Tissot's alternative English titles in parentheses, also in italics. When English equivalents were not given by Tissot, translations have been provided in brackets. The size is in inches, followed by the centimetre equivalent. The abbreviations, t.r./t.c./t.l./b.r./b.c./b.l./r.c./l.c., are, respectively, top right/top centre/top left/bottom right/bottom centre/bottom left/right centre/left centre. Under REF., W., B. and T. refer to print catalogues by Wentworth, Béraldi and Tissot. Under EXH. and LIT., only relevant exhibitions and major published references are included, and for abbreviations, see Bibliography.

1. *Marguerite à l'église* [Marguerite in Church]. 1860. (Colour Plate 31).

Major Martin Gibbs.

Oil on panel, $26\frac{1}{2} \times 36$ (67.3 × 91.4). Signed & dated b.l.: *J.J. Tissot 1860*.

PROV.: Purchased from the Goupil Gallery in 1879 for £315 by Henry Martin Gibbs, grandfather of the present owner.

EXH.: Goupil Gallery 1860; Sotheby's, New Bond Street, *Treasured Possessions*, a loan exhibition in conjunction with the Historic Houses Association, 1983–4 (61).

LIT.: Misfeldt 1971, pp. 38, 40, 42 & fig. 7; Wentworth 1984, pp. 29, 32–4, 135–6 & pl. 6.

Tissot painted several compositions on the theme of Goethe's Faust and Marguerite during 1860–1, most of which concentrate on the emotions of the latter, whose love affair with Faust led to her downfall, rather than on the substance of Goethe's story. The subject was an ideal vehicle for the use of historic costumes and settings like those which Tissot admired in the work of the Belgian painter, Henri Leys (see p. 64).

In this painting, Marguerite's spiritual crisis is emphasized by her physical separation from the devout family group on the left. Tissot painted a less stark variation (Cat. 2) and another composition on the same theme, *Marguerite à l'office* (Salon 1861 (2971), Wentworth 1984, pl. 5), where a pensive Marguerite sits with her back to a crucifix, a choir-screen literally separating her from the rest of the congregation.

Tissot had made his Salon début in 1859 with five pictures: two small portraits, two *peintures à cire* of family patron saints, and a rather tentative small Leysian composition, *Promenade dans la neige* (whereabouts unknown; Wentworth 1984, pl. 1).

2. *Marguerite à l'église* [Marguerite in Church]. *c*. 1861.

Dublin, National Gallery of Ireland.

Oil on canvas, $19\frac{3}{4} \times 29\frac{1}{2}$ (50.2 × 75.3). Signed in monogram b.l.: *J T*.

PROV.: Sir Alfred Chester Beatty Gift, 1950.

2

LIT.: Misfeldt 1971, p. 40 & fig. 12; Wentworth 1978, p. 36 & fig. 1f; NG of Ireland 1981, p. 164 (4280 CB); Wentworth 1984, pp. 28, 32–3, 136 & pl. 7.

A variation of Cat. 1. The pose and costume of Marguerite here are almost identical to those in *Marguerite au rempart*, 1861 (Wentworth 1984 pl. 8), with only the simple, spotted bodice in the latter substituted for a more elaborate one here. Wentworth points out that the pose of both Marguerites is copied from a figure in Leys's *Martin Luther enfant chantant dans les rues d'Eisenach*, 1859, which Tissot must have seen on a visit to the studio of Leys while in Antwerp during 1859.

3. *Marguerite à la fontaine* [Marguerite at the Well]. *c*. 1861.

Paris, Musée du Louvre, Cabinet des Dessins.

Watercolour on paper, $9\frac{1}{4} \times 7\frac{1}{8}$ (23.6 × 18.2).

PROV.: Bequeathed by Maciet, 1904; entered collections of Musée du Luxembourg 1912; transferred to Louvre 1930.

3

LIT.: Providence/Toronto 1968, note to (4); Misfeldt 1971, fig. 9a; Wentworth 1984, p. 22n.

A watercolour version of the painting, dated 1861, in the collection of Dr and Mrs Arthur C. Herrington (Wentworth 1984, pl. 4). It is an early example of Tissot's practice of making smaller-scale watercolour replicas of oil paintings, which was to become more common later in his career.

4. *Pendant l'office* [During the Service] (*Martin Luther's Doubts*). 1860.

Estate of Margaret E. Galbreaith, on loan to Art Gallery of Hamilton, Ontario.

Oil on panel, 34 × 26 (86.4 × 66). Signed & dated b.l.: *JAMES TISSOT 1860*.

PROV.: Charles Waring; Christie's 1886 as *Luther's Misgivings (style of Leys)*, bt. Manners for £84.

EXH.: Salon 1861 (2969) as *Pendant l'office*; Leeds 1868 (1315) as *Young Luther in Church*; Providence/Toronto 1968 (3) illus.

LIT.: Misfeldt 1971, pp. 44, 47–50 & fig. 20; Warner 1982, p. 2, monochrome pl.; Wentworth 1984, pp. 35, 199 & pl. 10.

Misfeldt identified this painting, published in an 1861 Bingham photograph as *Les Vêpres*, with *Pendant l'office* exhibited at the Salon of 1861. The titles connected with Luther accrued later and it is not known whether they were given by Tissot. However, the man at the right bears some resemblance to depictions of Luther in pictures by Leys and by Lucas Cranach the Elder which may have suggested the theme to Tissot. Physical separation from

the devout congregation by a column implies mental dissociation from them as with the choir-screen in *Marguerite à l'office* (see Cat. 1), while the symbols of time flying, death and the Devil on the candle-holder suggest the train of his thoughts.

4

5. *Le Retour de l'enfant prodigue* [The Return of the Prodigal Son]. 1862. (Fig. 25 and Colour Plate 2).

Manney collection.

Oil on canvas, $45\frac{1}{4} \times 80\frac{3}{4}$ (115.6 × 205.7). Signed & dated b.l.: *James Tissot 1862*.

PROV.: Private collection, Toulouse; Mr & Mrs Joseph M. Tanenbaum, Toronto.

EXH.: Salon 1863 (1803); Royal Society of British Artists 1864 (259).

LIT.: Misfeldt 1971, pp. 44–7, 52, 55–6 & fig. 18; Wentworth 1978, p. 245 & fig. 57a (incorrectly titled '*à Venise*'); Wentworth 1984, pp. 39–40, 199 & pl. 14.

Tissot exhibited two paintings at the Salon of 1863 on the theme of the Prodigal Son: *Le Départ de l'enfant prodigue à Venise* (1804; Wentworth 1984, pl. 16) and the picture shown here. The former, a brief and isolated excursion towards Italian Renaissance sources, employed poses and costumes derived from Carpaccio's paintings which Tissot had admired and studied on a visit to Venice sometime in 1862. The influence of Italian masters also briefly extended to his graphic work: three studies for the two paintings and one unrelated study of heads are drawn in pencil or crayon heightened with white wash or bodycolour on tinted paper, in emulation of fifteenth-century silverpoints. Strong criticism and ridicule

aimed at *Le Retour* for continuing to use Leysian models may have hastened a change of direction towards modern life painting. Tissot was later to return to the theme of the Prodigal Son with a series in modern dress and in two illustrations to the *Life of Christ*.

6. Tom Taylor. *Ballads and Songs of Brittany*, trans. from the 'Barsaz-Breiz' of Vicomte Hersart de la Villemarqué (London: Macmillan and Co.). 1865.
London, The National Art Library.
LIT.: Macrobert, T.M., *Fine Illustrations in Western European Printed Books*, V & A 1969 (93); Wentworth 1978, p. 347.
Tissot designed two illustrations for this volume, both in the style of his Leysian pictures. The frontispiece, 'The Murdered Lady, Child, Hound, and Horse, in a Breton Cemetery', from *The Clerk of Rohan*, re-used the pose of *Marguerite au rempart* and *Marguerite à l'église* (Cat. 2) in a stilted composition. The title page vignette shows a knight on horseback with his page and a shepherd with his flock in a seaside landscape with a castle.

7. *Tentative d'enlèvement* [The Attempted Abduction]. 1865.
New York, Elliott Galleries.
Oil on panel, $26\frac{3}{4} \times 37\frac{3}{4}$ (68 × 96). Signed & dated b.l.: *J.J. Tissot / 1865*.
PROV.: Goupil, bt. Knoedler May 1866; acquired by Elliott Galleries from private collection, New York.
EXH.: Salon 1865 (2075).

LIT.: Misfeldt 1971, pp. 44, 56–7 & fig. 15; Wentworth 1984, pp. 42–4, 199 & pl. 20.
Exhibited at the Salon of 1865 together with a modern life subject, *Le Printemps* (2074; Wentworth 1984, pl. 30), the *Tentative* drew much criticism of Tissot for regressing towards archaism rather than pursuing wholeheartedly the contemporary themes that he had begun exhibiting the previous year. It was to be the last 'medieval' dress picture shown by Tissot at a Salon, though he continued to paint them until the end of the decade.
A related composition, *Le Rendez-vous* (Fig. 26), shown at the Paris Exposition Universelle in 1867 (588), utilized the costumes, two main characters and setting of the *Tentative* (see p. 65). Another related picture, for which a contemporary title is not known, shows a more violent abduction (Nantes, Musée des Beaux-Arts; Wentworth 1984, pl. 21).

8. *Marie Goidet*. 1860.
Paris, Bibliothèque Nationale.
Etching, $5\frac{3}{8} \times 4$ (13.7 × 10.2), irregular plate. Inscribed t.l.: *MARIE ◊ GOIDET*; signed in monogram and dated b.r.: 厈 / *1860*
PROV.: Bequeathed by the artist, 1902.
EXH.: Minneapolis 1978 (1) illus.
LIT.: Misfeldt 1971, p. 58 & fig. 24; Wentworth 1978, pp. 34–9; Wentworth 1984, p. 46.
REF.: W. 1 (not in B. or T.).
Tissot began to experiment with etching in 1860, when the medium was enjoying a revival of interest among artists including

Tissot's friends, Degas and Whistler, whom he had met in 1859 and who could have introduced him to other etchers, particularly Manet, Bracquemond, Legros and Fantin-Latour. *Marie Goidet* and the following four catalogue entries are the only known etchings by Tissot of this period and were probably not intended for sale as very few impressions were made (*Marie Goidet* and *Un Prêtre* (Cat. 9) are unique). All five etchings are portraits, similar to contemporary drawings by Tissot but more fresh and spontaneous. The introspective moods of their sitters reflect the brooding quality of models in Tissot's *Faust* scenes (e.g. *Marguerite à l'église* (Cat. 1)).
Tissot was a skilled portraitist and is said to have supported himself when he first came to Paris by drawing small portraits of working-class people at forty francs each, none of which is known today.

8

9. *Un Prêtre* [A Priest]. 1860.
Paris, Bibliothèque Nationale.
Etching, $4\frac{5}{8} \times 3\frac{15}{16}$ (11.7 × 10), irregular plate. Signed in monogram above a cross and dated b.r.: 厈 / ✝ / *1860*; stamped with an early form of monogram b.l.
PROV.: Bequeathed by the artist, 1902.
EXH.: Minneapolis 1978 (2) illus.
LIT.: Misfeldt 1971, p. 58 & fig. 25; Wentworth 1978, pp. 40–1; Wentworth 1984, p. 46.
REF.: W. 2 (not in B. or T.).
See the previous entry.
The sitter for this unique etching is unknown, though the choice of subject is interesting in the light of Tissot's attitude towards his religion (see p. 89).

9

10. *Portrait de femme* [Portrait of a Woman]. *c.* 1860–1.
Private collection.
Etching, $8\frac{3}{4} \times 6\frac{1}{2}$ (22.2 × 16.5). Signed in monogram b.l.: 厈.
EXH.: Minneapolis 1978 (4) illus.
LIT.: Misfeldt 1971, p. 58 & fig. 23; Wentworth 1978, pp. 46–7; Wentworth 1984, p. 46 & pl. 23.
REF.: W. 4 (not in B. or T.).
See entry for *Marie Goidet* (Cat. 8).
This portrait of an unknown woman reflects a new, more open and relaxed attitude in Tissot's work during the early 1860s, which was to lead to the creation of his first masterpiece, *Mlle L.L . . .* in 1864. Only two impressions of this etching are known: the one exhibited here and one in the Bibliothèque Nationale, Paris.

10

11. *Louise*. 1861.
London, British Museum.
Etching, $7\frac{3}{4} \times 5\frac{3}{4}$ (19.7 × 14.6). Signed, dated & inscribed l.c.: *JAMES / TISSOT / 1861 / ✡*; inscribed c.r.: ◊ *Louise* ◊; inscribed across the bottom: *Ma bouche est un écrin meublé de perles fines / J'ai de grande yeux*

7

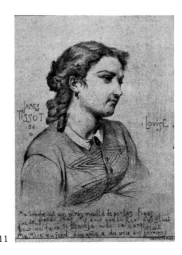

11

plus doux que la fleur d'un Bluet / Pour me faire si Blanche avec ce corps fluet / Ma Mère au fond d'un rêve a du voir des hermines / André Lemoyne.

PROV.: Acquired 1865.

LIT.: Providence/Toronto 1968 (60) illus.; Misfeldt 1971, pp. 58–9 & fig. 26; Wentworth 1978, pp. 42–5; Wentworth 1984, p. 46.

REF.: W. 3 (not in B. or T.).

See entry for Marie Goidet (Cat. 8).

This etching may be a portrait of the poetess, Louise Colet; the resemblance of the sitter to known portraits and photographs of Colet was suggested in the Providence/Toronto catalogue but no evidence has emerged that the painter and poetess knew each other. The verse was identified by Sybille Pantazzi as part of a poem by Camile-André Lemoyne, librarian of the École des Arts Décoratifs and a minor poet of distinction, which was entitled Baigneuse and first published in L'Artiste, 15 September 1860, with a dedication to Tissot. Thus, whether the etching is a portrait of Colet or not, it documents one of several friendships with members of the literary and music worlds. Tissot had taken a studio above the writer, Alphonse Daudet, in 1859 or 1860 and drew a small portrait of him (which he later gave to Mme Daudet when they renewed their friendship on Tissot's return to Paris in 1882) and another friendship, with the composer Ernest Chabrier, is documented in a portrait drawing of the latter dated 1861 (Misfeldt 1971, fig. 28; see also Wentworth 1984, p. 17).

This is one of four known impressions of the etching.

12. Portrait de Edgar Degas [Portrait of Edgar Degas]. c. 1860–1.

Paris, Bibliothèque Nationale.

Etching, $7\frac{3}{4} \times 5\frac{5}{8}$ (19.7 × 14.4), irregular plate.

Signed and inscribed b.l.: James Tissot / mon ami de Gas.

PROV.: Bequeathed by the artist, 1902.

LIT.: Misfeldt 1971, p. 58 & fig. 27; Wentworth 1978, pp. 48–51; Wentworth 1984, p. 46.

REF.: W. 5 (not in B. or T.).

Tissot's friendship with Degas, which began some time after Tissot's arrival in Paris during 1856 and lasted until about 1895, is discussed here by Wentworth, pp. 12–18, together with Degas's portrait of Tissot c. 1868 (Fig. 1).

The two artists were closely associated in the 1860s and their work and interests developed along similar lines, with considerable give and take on both sides. For perceptive analyses of crosscurrents in their art, see Reff 1976, pp. 101–10, 225–33, 314 and 331–2, and Wentworth 1984.

A second impression of this etching is in a private collection, Besançon.

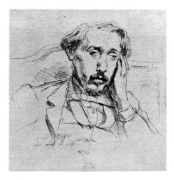

12

13. Portrait de Mlle L.L . . . (Jeune Femme en veste rouge) [Young Woman in a red jacket]. 1864. (Colour Plate 24).

Paris, Musée d'Orsay.

Oil on canvas, $48\frac{13}{16} \times 39\frac{3}{8}$ (124 × 100). Signed & dated b.r.: James Tissot fév. 1864.

PROV.: Musée du Luxembourg.

EXH.: Salon 1864 (1841); Providence/Toronto 1968 (7) illus.

LIT.: Misfeldt 1971, pp. 59–62 & fig. 22; Wentworth 1978, p. 46 & fig. 4a; Wentworth 1984, pp. 46–9, 59, 199 & pl. 26.

Both this painting and Les Deux Soeurs (Cat. 14) were presented

by Tissot as 'portraits' at the Salon of 1864 in order to attract lucrative portrait commissions, though neither was strictly a portrait as the same, no doubt professional, model appears in both and in later pictures, such as Le Printemps, c. 1865. The ploy was a very successful one, hardly surprising in the light of the masterful Mlle L.L Tissot's debt to Ingres is clear in the three-quarter pose and the use of a mirror as a compositional device. The two paintings were Tissot's first exhibited modern life subjects. Their success led to important portrait commissions from the Marquis de Miramon and the Parisian gentlemen's club, Le Cercle de la rue Royale (Wentworth 1984, pls. 38–40).

A pencil study for the painting is known (Musée du Louvre, Cabinet des Dessins; Misfeldt 1971, Fig. 22a) and a related half-length portrait, showing the same model seated in the Louis XV chair, is recorded in Tissot's photograph albums.

14. Les Deux Soeurs; portrait [The Two Sisters] (Portraits dans un parc). 1863. (Fig. 14).

Paris, Musée d'Orsay.

Oil on canvas, $82\frac{1}{2} \times 53\frac{1}{2}$ (209.6 × 137.2). Signed & dated b.r.: J.J. Tissot / 1863.

PROV.: Musée du Luxembourg.

EXH.: Salon 1864 (1860).

LIT.: Misfeldt 1971, pp. 61–3 & fig. 21; Wentworth 1984, pp. 47, 49–54, 56, 59, 106, 116, 199 & pl. 29.

This painting was criticized for its colour, which earned it the title 'Les Dames vertes', but was considered to be 'the very pattern of aristocratic propriety and high-toned simplicity' (Wentworth, p. 50). The composition owes much to contemporary

fashion plates (see p. 69), to Tissot's admiration for the work of the Pre-Raphaelites, and to the impact of Whistler's The White Girl (Fig. 13). In a slightly later composition, Le Printemps, c. 1865 (Wentworth 1984, pl. 30), directly inspired by Millais's Apple Blossoms (Lord Leverhulme), Tissot posed the older model from Les Deux Soeurs twice in the same dress and hairstyle and again in a different costume and the looser hairstyle of Mlle L.L . . . (Cat. 13) (see p. 69, n. 18).

15. Déjeuner sur l'herbe [A Picnic]. c. 1865–8.

The Goldschmidt family.

Oil on canvas, $12 \times 20\frac{1}{2}$ (30.5 × 52.1). Signed b.r.: J.J. Tissot.

PROV.: Leicester Galleries; A.R. MacWilliam Esq.; A.M.P. Goldschmidt Esq.

EXH.: Leicester Galleries 1937 (10); Sheffield 1955 (8); AC 1955 (7); Providence/Toronto 1968 (9) illus.

LIT.: Misfeldt 1971, pp. 72–4 & fig. 37; Isaacson, Joel, Monet : Le Déjeuner sur l'herbe, 1972, pp. 56, 110n. & fig. 29; Reff 1976, pp. 106, 314n. & fig. 74; Wentworth 1984, pp. 63–5 & pl. 43.

One of several genre scenes painted by Tissot, c. 1865–8, which include La Terrasse du jeu de paume (whereabouts unknown; Wentworth 1984, pl. 44) and La Retraite dans le jardin des Tuileries (Cat. 17). It has been suggested that this oil sketch records a picnic in the grounds of the Tissot family château near Besançon, whose outline and wooded surroundings are like those seen here in the background. Part of a similar painting is included in Degas's portrait of Tissot (Fig. 1) on the easel at the right.

15

16. *Le Confessional* [The Confessional] (*In Church*). 1865. (Fig. 41).
Southampton Art Gallery and Museums.
Oil on canvas, $45\frac{1}{2} \times 27\frac{1}{4}$ (115.4 × 69.2). Signed & dated b.l.: *J.J. Tissot / 1865*.
PROV.: ? Christie's 1880, *Leaving the Confessional*, sold Roberts, bt. in., £162.15s.0d; purchased, probably from the Leicester Galleries, 1936.
EXH.: Salon 1866 (1844); Leicester Galleries 1933 (19) as *Leaving the Confessional*.
LIT.: Providence/Toronto 1968 (42) on replica; Misfeldt 1971, pp. 81–3, 85–6 & fig. 40; Wentworth 1984, pp. 56, 65, 200 & pl. 32.

This painting is neither seriously moral nor religious, but simply a saleable 'keepsake' picture of a pretty woman in fashionable dress with fashionably affected piety. The subject is treated in similar vein for a later version, *c*. 1869 (Fig. 43 (Album, I/65)), where the composition is slightly wider, there are more figures, and the dress has changed, but the confessional is identical and the model's pose and muff, with tucked-in prayer-book and kerchief, are little altered.

Fig. 43. Untitled. Whereabouts unknown

Tissot made a watercolour replica of *Le Confessional*, which was probably commissioned by George A. Lucas for the collection of William T. Walters (Baltimore, Walters Art Gallery; Wentworth 1984, pl. 33). See p. 95, n. 10.

17. *La Retraite dans le jardin des Tuileries* [Beating the Retreat in the Tuileries Gardens]. 1867.
Besançon, private collection.
Oil on panel.

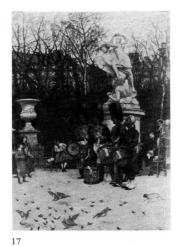

17

Signed & dated b.l.: *J. Tissot / 1867*.
PROV.: Purchased by the princesse Mathilde Bonaparte from the Salon, 1868, and in her collection until her death in 1904; her sale, Galerie Georges Petit, Paris 17–21 May 1904 (205).
EXH.: Salon 1868 (2390).
LIT.: Misfeldt 1971, pp. 72, 77–8 & fig. 35; Wentworth 1984, pp. 63–4, 200 & pl. 45.
A quartet of Imperial guardsmen, three hussars and a Greek Zouave, prepare to sound the evening retreat of colours in the Tuileries Gardens, a short distance from the palace and before Flamen's statue group of *The Abduction of Orithya* (1684–7; inside the Louvre since 1972). The frenetic subject of the sculpture contrasts effectively with the still figures of the soldiers. For once, the pretty women and children are relegated to the background. This is Tissot's most important modern life composition of the late 1860s. A detailed oil study for the Zouave drummer is known (Wentworth 1984, pl. 46). (Information for this entry kindly supplied by Willard Misfeldt.)

18. *Une veuve* [A Widow]. 1868. (Colour Plate 10).
Manney collection.
Oil on canvas, $27 \times 19\frac{1}{2}$ (68.5 × 49.5). Signed & dated b.l.: *J.J. Tissot / 1868*.
PROV.: Sotheby Parke Bernet, New York, 24 February 1983.
EXH.: Salon 1869 (2269).
LIT.: *Art at Auction: The Year at Sotheby's 1982–3*, 1983, p. 64, colour pl.; Wentworth 1984, pp. 66, 200 & pl. 51.

This '*veuve facile à consoler*' could be a modern dress illustration of La Fontaine's fable, *La Jeune Veuve*. Trapped in the claustrophobic tedium of formal mourning, watched over by mother and pestered by fidgeting daughter, she can only dream of future love as suggested by her glazed expression and the copy of Bouchardon's sculpture, *Cupid Stringing his Bow*, in the arbour behind her. The careful delineation of fussy items on the two tables heightens the feeling of claustrophobia.

The slightly daring show of ankle and petticoat is taken further in a picture of similar composition and date, *Un déjeuner* (A Luncheon, whereabouts unknown; Wentworth 1984, pl. 60) where, beneath a similar pergola, a late eighteenth-century '*merveilleuse*' sups tea and makes eyes at the man beside her, whom the widow can only imagine. Both models wear the same black net gloves.

19. *Le Goûter* [The Snack]. 1869.
Private collection.
Oil on canvas, $22\frac{1}{2} \times 15$ (56.6 × 39.1). Formerly signed & dated b.l.: *J.J. Tissot / 1869* (slight damage to area of signature formerly overpainted & new date & signature added, since removed; original inscription recorded in Goupil photograph, 1869).
PROV.: William H. Vanderbilt (before 1883); George W. Vanderbilt; Brigadier Cornelius Vanderbilt; Mrs Cornelius Vanderbilt; New York, Stair Sainty Fine Art Inc.
EXH.: On loan to Metropolitan Museum of Art, New York, 1902–7.
LIT.: Strahan, Edward, *Mr Vanderbilt's House and Collections*, 1883–4, vol. IV, p. 61, illus. between pp. 62–3; *Collection of W.H. Vanderbilt, 640 Fifth Avenue*, 1884, no. 198; Misfeldt 1971, p. 96 & fig. 53; Wentworth 1984, pp. 65–6, 162 & pl. 48.
Wentworth suggests that this painting is a variation of Alfred Stevens's *Fleurs d'automne*, shown at the Paris *Exposition Universelle* in 1867 (Wentworth 1984, pl. 49) and that the sitter may be the popular Parisian model, Emma Dobigny. The restricted autumn palette gives the picture a sombre mood, suggesting that perhaps the young

woman with red-rimmed eyes is a widow, and therefore makes interesting comparison with *Une veuve* (Cat. 18) or *Sans dot* (Cat. 167).

19

20. *Study of a Girl*. c. 1869. (Fig. 28).
Birmingham Museum and Art Gallery.
Pencil on coarse laid paper. $17\frac{7}{8} \times 9$ (45.5 × 23).
PROV.: Bequeathed by J.R. Holliday, 1927.
EXH.: Sheffield 1955 (51); AC 1955 (38).
LIT.: Misfeldt 1971, fig. 49a (shows verso).
This study from life does not relate to any known painting but

Fig. 44. Study for *Jeunes Femmes regardant des objets japonais*, verso of *Study of a Girl*. Birmingham Museum and Art Gallery

the costume appears in several works of *c.* 1869 (see pp. 69–70). On the verso (Fig. 44) is a study of a model in the same dress for *Jeunes Femmes regardant des objets japonais*, 1869 (Cincinnati, private collection; Wentworth 1984, pl. 59).

21. *Studies of a kneeling woman for 'Jeunes Femmes regardant des objets japonais'.* c. 1869–70.
London, Tate Gallery.
Pencil on paper, $12\frac{7}{8} \times 19\frac{1}{4}$ (33 × 48.8).
PROV.: ? Charles Fairfax Murray, London; J.R. Holliday, Birmingham; bequeathed by J.R. Holliday, 1927.
LIT.: Tate 1981, p. 719 (4292).
Tissot is known to have painted three versions of two women looking at Japanese objects, all posed in Tissot's house on the Avenue de l'Impératrice and admiring items from his renowned oriental collection. These studies are for an unlocated version (Fig. 45); a second version, dated 1869, and the one exhibited at the Salon of 1869 (2270) are illustrated in Wentworth 1984, pls. 59 and colour pl. II.

Tissot was among the earliest collectors of Japanese art in Paris in the early 1860s, together with Manet, Degas, Whistler, the Goncourts and Jacquemart (see Wentworth 1984, p. 69n). Rossetti, in a letter to his mother dated 12 November 1864, described how he went to a Japanese shop in Paris recommended by his brother, William, 'but found all the costumes were being snapped up by a French artist, Tissot, who it seems is doing three Japanese pictures, which the mistress of the shop described to me as the three won-

Fig. 45. *Jeunes Femmes regardant des objets japonais.* c. 1869. Whereabouts unknown

ders of the world, evidently in her opinion quite throwing Whistler into the shade.' *Japonaise au bain* (Dijon, Musée des Beaux Arts; Wentworth 1984, pl. 55) may have been one of these three paintings and is Tissot's largest known work in the genre. Another painting is known which uses a 'Japanese' model in a kimono (Wentworth 1984, pl. 56) and two still-lifes with Japanese objects are recorded in Tissot's albums.

22. *L'Escalier* [The Staircase]. 1869. (Colour Plate 3).
Private collection.
Oil on canvas, 20 × 14 (56.5 × 38.8). Signed & dated b.l.: *J.J. Tissot / 1869.*
PROV.: Christie's 17 May 1923, bt. Nicoll; M. Newman, 1962; New York, James Coats; Toronto, Mr and Mrs Joseph M. Tanenbaum.
EXH.: Providence/Toronto 1968 (11) illus; Ottawa 1978 (65) illus.

LIT.: Misfeldt 1971, pp. 90–1 & fig. 43; Reff 1976, pp. 231–2, 331n. & fig. 154; Wentworth 1984, pp. 20–30, 67–8, 95, 104, 162 & pl. 52.
Described by Wentworth as 'perhaps the most successful of Tissot's pictures of modern life in the sixties', *L'Escalier* shows the impact on Tissot of Whistler's *The White Girl* (Fig. 13) and Millais's portentous *Eve of Saint Agnes* (H.M. Queen Elizabeth the Queen Mother). It combines the single figure of a beautiful woman with a literal representation of the stained-glass window suggested by coloured light on the figure in Millais's painting. The setting is Tissot's house on the Avenue de l'Impératrice: the stained-glass window is seen from the inside of the room in *Jeunes Femmes regardant des objets japonais* (London, private collection; Wentworth 1984, colour pl. II), which could almost be a pendant to *L'Escalier*, and in another version of *Jeunes Femmes . . .* (Fig. 45). The white morning gown also appears in the London *Jeunes Femmes . . .* and several other pictures of *c.* 1869 (see pp. 69–70).

23. *Study for 'L'Escalier'.* c. 1869.
Mr and Mrs Allen Staley.
Pencil on paper, $16 \times 10\frac{1}{4}$ (40.6 × 26). Signed b.r. *J. James Tissot.*
PROV.: Purchased from Colnaghi's, c. 1963.
EXH.: Providence/Toronto 1968 (43) illus.
LIT.: Misfeldt 1971, fig. 43a; Wentworth 1984, pp. 64, 67 & pl. 53.

Tissot altered this study from life in his final painting, giving the figure a more expectant stance and adding a book and letter in her right hand, thereby suggesting that she is tensely awaiting a visitor or perhaps pining for an absent lover.

24. *At the Rifle Range.* 1869.
Wimpole, Cambridgeshire, The National Trust, Wimpole Hall.
Oil on canvas, $26\frac{1}{2} \times 18\frac{3}{4}$ (67.3 × 47.6). Signed & dated (on a contemporary photograph) b.l.: *J.J. Tissot / 69.*
PROV.: ? Christie's 1883, sold by Murietta as *The Crack Shot*, bt. in at £220.10s.0d.; Christie's 1934, sold by J. Beausire as *The Rifle Range*, bt. Tooth £52.10s.0d.; Leicester Galleries by 1936; purchased by Capt. Bambridge from Leicester Galleries, 1937.
EXH.: Leicester Galleries 1937 (3) illus.
LIT.: Laver 1936, pl. V; Wentworth 1984, p. 111 & pl. 96.

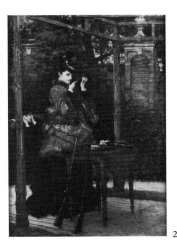

24

The setting here is thought to be the garden of Bowles's house at Cleeve Lodge, Hyde Park, where Tissot probably stayed during a visit to London in 1869–70 to work on Burnaby's portrait. It has similar elements to *Les Adieux* (Cat 42), on which Tissot would have worked while living at Cleeve Lodge following his flight to London after the fall of the Commune in May 1871. The seated man, partially hidden by the woman with a gun, may be a portrait of Bowles. A study for the woman with a gun is known (whereabouts unknown).

23

21

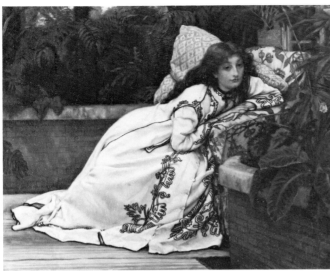

25

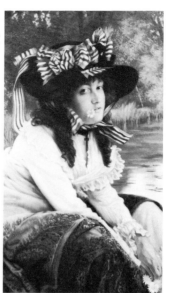

Fig. 47. *À la Rivière*. Whereabouts unknown

25. *A Girl in an Armchair* (*The Convalescent*). 1870.
Toronto, Art Gallery of Ontario.
Oil on panel, 14¾ × 18 (37.5 × 45.7). Signed & dated b.r.: *J.J. Tissot / 1870*.
PROV.: Donated by R.B.F. Barr, Esq., Q.C., 1966.
EXH.: Providence/Toronto 1968 (17) illus.
LIT.: Wentworth 1984, p. 112 & pl. 99.
This painting appears in the first of Tissot's photograph albums containing Parisian works of 1859–70. The dark piping on the morning gown is a very popular decoration of the 1860s, while the large cross on a velvet ribbon was also a fashionable accessory of that time and is seen in other French pictures by Tissot (e.g. *À la Rivière*, Fig. 47).

26. *A Tryst at a Riverside Café*. c. 1869.
Mr Ronald Lewis.
Oil on canvas, 16 × 21 (40.6 × 53.3). Signed b.l.: *J.J. Tissot*.
PROV.: In the owner's family for at least 50 years.
LIT.: Wentworth 1984, p. 73.
No contemporary title has been preserved for this painting, one of several eighteenth-century costume pieces on the theme of outdoor luncheons or picnics. The subject in all of them is light-hearted flirtation. Their suggestive tone was inspired by the works of Boilly, Debucourt and their late eighteenth-century contemporaries (see p. 66). Tissot was criticized for reverting to historical pastiche rather than keeping to modern life subjects,

but his 'eighteenth-century' pictures must have found a ready market for he continued to paint them until his departure from Paris.
A closely related work dated 1869 (Fig. 46 (Album, I/61)), for which a study of the girl is known (Los Angeles, private collection), shows the same couple seated on a bench before a trellis, the pug this time at the girl's feet. Both costumes appear in various other pictures (see p. 66).

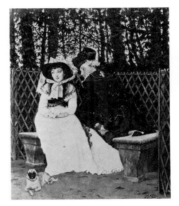

Fig. 46. Untitled. Whereabouts unknown

27. *Jeune Femme à l'éventail* [Girl with a Fan]. c. 1870–1.
San Antonio, Texas, private collection.
Oil on panel, 31 × 23 (78.7 × 58.4). Signed b.l.: *J.J. Tissot*.
PROV.: Martin Foster; Christie's 29 July 1977 (31); Sotheby's 23 March 1981 (66) as *Summer Dreams*.
LIT.: Wentworth 1978, p. 114 & fig. 24b; Wentworth 1984, p. 77 & pl. 65.

One of several 'keepsake' pictures in which a young woman in neo-eighteenth-century costume gazes languidly at the viewer (liked in *À la Rivière*, Fig. 47), The striped dress, hat and shawl appear in a number of other pictures (see p. 66).

28. *Alexander II, Tsar of Russia.* c. 1869.
London, National Portrait Gallery.
Watercolour on paper 11⅞ × 7⅛ (30.1 × 18.1). Signed b.r.: *Coïdé*.
PROV.: Sir Thomas Gibson Bowles, who sold the originals with *Vanity Fair* in 1889; Christie's 5–8 March 1912, *Vanity Fair* sale; purchased either from Maggs Bros., 1934, or from Hodgson & Co., 2 November 1938.
EXH.: Vanity Fair 1976 (37) & p. 8.
LIT.: Misfeldt 1971, p. 121; Wentworth 1978, p. 348; NPG 1981, pp. 8 (illus) & 683; Wentworth 1984, pp. 85–7.
Original cartoon for one of sixteen caricatures by Tissot, chiefly of European sovereigns and signed *Coïdé*, which were published as chromolithographs in *Vanity Fair*, 1869–71. These sixteen are rather political cartoons than caricatures, with their 'props' and pointed moral comments, and were probably drawn by Tissot before the Franco-

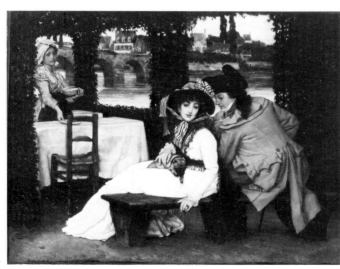

26

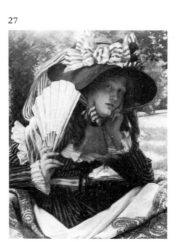

27

Prussian war and then sold as a group to Bowles. *Alexander II* appeared in *Vanity Fair* on 16 October 1869.

Tissot met Thomas Gibson Bowles some time in 1869 and the two shared lodgings during the siege of Paris (see entry for *The Defence of Paris*, Cat. 34). Bowles was owner-editor of the satirical magazine, *Vanity Fair*, which published full-page, coloured caricatures of different celebrities each week, accompanied by witty descriptions. Between 1871 and 1873, Tissot drew thirty-nine caricatures for the magazine, which brought useful income and helped him become established as

28

an artist in England and gain lucrative portrait commissions. A further eleven appeared between 1876 and 1877, by which time Tissot had established an English market for his pictures and no longer needed to rely on the steady income from *Vanity Fair*.

29. *Abdul Aziz, Sultan of Turkey.* c. 1869.
London, National Portrait Gallery.
Watercolour on paper, $11\frac{3}{4} \times 7\frac{1}{8}$ (29.8 × 18.1). Signed b.r.: *Coïdé.*
PROV.: As for the previous entry.
EXH.: Vanity Fair 1976, (38) & p. 8, illus p. 16.
LIT.: As for the previous entry, except NPG 1981, pp. 1 (illus) & 683.
See previous entry. This is the original cartoon for the chromolithograph published in *Vanity Fair*, 30 October 1869.

29

30. *Colonel Frederick Gustavus Burnaby.* 1870. (Colour Plate 11).
London, National Portrait Gallery.
Oil on panel, $19\frac{1}{2} \times 23\frac{1}{2}$ (49.5 × 59.7). Signed & dated b.l.: *J.J. Tissot / 70.*
PROV.: Thomas Gibson Bowles; G.F.S. Bowles (godson of the sitter); purchased from the latter, 1933.
EXH.: London, International Exhibition 1872 (1282) as *M. le Colonel * * **; Providence/Toronto 1968 (15) illus; Vanity Fair 1976 (15) & p. 5.
LIT.: Laver 1936, pl. III; Wentworth 1978, pp. 82, 85 & fig. 15d; Wentworth 1979–80, p. 8 & fig. 1; NPG 1981, p. 80, illus; Warner 1982, p. 8, colour pl.; Wentworth 1984, pp. 89–91, 100, 142, 207 & pl. 71.
Frederick Gustavus Burnaby (1842–85) was a veritable 'Boys Own' hero, a dashing cavalry officer, intrepid traveller, and a member of the Prince of Wales's set. He journeyed to South America, Spain, Morocco, South Russia and the Sudan, rode from Kazala to Khiva, and on another trip from Scutari to Armenia and thence to Batoum; he attended Valentine Baker's operations in the Russo-Turkish war of 1877, became a Lieutenant Colonel in 1880, commanded the 3rd Household Cavalry 1881–5 and was killed in action during an attempt to relieve Khartoum. Burnaby wrote several books on his adventures and contributed pieces to *Vanity Fair*, which he had helped Bowles to set up in 1868,

suggesting the title and contributing money to get the project started. Bowles commissioned this portrait from Tissot, who must have come to London during 1869–70 to paint it.

31. *Lady Mary Craven.* c. 1870.
London, private collection.
Pencil & watercolour on paper, $18\frac{1}{4} \times 12$ (46.4 × 30.5).
PROV.: Bought in Paris, 1923, by the previous owner.
EXH.: Leicester Galleries 1933 (3); Sheffield 1955 (54).
An unfinished study, possibly for an oil portrait. The costume is of about 1870 and this study may therefore have been made while Tissot was visiting London to paint Colonel Burnaby's portrait (see previous entry), or soon after his arrival in 1871. The sitter's name is that given when the picture was acquired in Paris.

31

32

32. *A French Soldier.* 1870.
The Duke of Devonshire..
Pencil on paper, 5 × 8 (12.7 × 20.3). Inscribed t.l.: *a la Malmaison / le 22 Oct 1870*; inscribed & dated b.l.: *a madame Millais / souvenir affecteux / James Tissot / le 19 juin 1871.*
LIT.: Wentworth 1978, pp. 94 & 96; Wentworth 1984, pp. 79–80.
Tissot made a number of pencil, watercolour and oil studies of soldiers during the siege of Paris, some of which were precisely identified with date and place, as here, or with the identity and regiment of the sitters. Part of this reportage formed the basis for his illustrations to Thomas Gibson Bowles's *Defence of Paris: Narrated as it was seen* (Cat. 34) and for a later series of etchings made between 1875 and 1878.

This drawing is of further interest because it documents Tissot's friendship with Millais (referred to, also, in letters from Degas to Tissot of the early 1870s: see Reff 1976, p. 232), and indicates that Tissot did not flee Paris empty-handed.

33. *A French Soldier.* c. 1870–1.
Julius S. Held collection.
Pencil and watercolour on paper, $6\frac{1}{4} \times 2\frac{1}{2}$ (15.9 × 6.5).
PROV.: Purchased on the New York art market in the mid 1960s.
EXH.: Providence/Toronto 1968 (46) illus.
LIT.: Wentworth 1978, pp. 82, 84 & fig. 15b; Wentworth 1984, p. 79.
See previous entry.
Although this work is unsigned, it relates closely to other

studies of soldiers made by Tissot during the siege, to his illustrations for Bowles's *Defence of Paris* (Cat. 34), and in particular to etchings like *Bastien Pradel* and *Sylvian Perier* (Cat. 35), which were themselves based on meticulous drawings.

34. Thomas Gibson Bowles, *The Defence of Paris: Narrated As It Was Seen* (London: Sampson, Low, Son, and Marston). 1871.
The British Library.
LIT.: Misfeldt 1971, pp. 110–11; Wentworth 1978, pp. 86–7, 19, 184 & 347; Wentworth 1984, p. 79.

Tissot and Bowles had met in 1869, when Bowles had commissioned Tissot to draw caricatures for *Vanity Fair* and to paint Colonel Burnaby's portrait. They met again by chance in 1870 during the siege of Paris, to which Bowles had been sent as a special correspondent by the *Morning Post*. Tissot, an active and brave soldier, was in the front line of fighting at Malmaison – La Jonchère in October 1870, and the two met after the sortie. They were thrown together again in January 1871 at Boulogne, where they spent a night with three other soldiers in an abandoned house, and subsequently met after the capitulation of the city. Bowles described these events among others in *The Defence of Paris*, and had seven of Tissot's drawings, made during the siege, engraved on wood to illustrate the book. The latter included two which Tissot later reproduced himself as etchings, *Sylvian Perier* (Cat. 35) and *Grand'garde* (Cat. 39).

35. *Sylvian Perier (Souvenir du siège de Paris)* (*Sylvian Perier (Souvenir of the Siege of Paris)*). 1875.
Private collection.
Etching, $7\frac{1}{2} \times 3\frac{7}{8}$ (19.2 × 9.8). Signed & dated b.r.: *J.J. Tissot / 1870*; inscribed t.l.: *Sylvian Perier / 159 de marche*.
EXH.: Minneapolis 1978 (16) illus.
LIT.: Wentworth 1978, pp. 86–5 & 347; Wentworth 1984, p. 79.
REF.: W. 16, B. 9, T. 9.

One of six prints, bearing the subtitle *Souvenir du siège de Paris*, which Tissot etched in 1876–8 after drawings made in Paris during the siege, some of which carefully note sitter's name and regi-

ment as here. A similar etching published in 1875, *Bastien Pradel* (W. 15), is also dated 1870. The drawing of Sylvian Perier was reproduced as a wood-engraved illustration in Bowles's *Defence of Paris* (Cat. 34), entitled *The French Linesman* (facing p. 150).

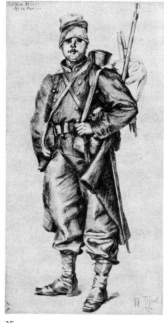

35

36. *Le Premier Homme tué que j'ai vu (Souvenir du siège de Paris)* (*The First Killed I Saw (Souvenir of the Siege of Paris)*). 1876.
Dr Frederick Mulder.
Drypoint.
a). Undescribed intermediate state between Wentworth's first and second states, with the plate cut down but before the addition of signature and drypoint alterations to rocks near upper plate edge. $9\frac{3}{4} \times 8\frac{9}{10}$ (24.8 × 22.6).

36a

b). Second state, with addition of drypoint and signature. $9\frac{3}{4} \times 8\frac{4}{5}$ (24.8 × 22.3). Signed b.r.: *J.J. Tissot*.
EXH.: Bury Street 1981 (2, a & b) illus.
LIT.: Wentworth 1978, pp. 94–7; Wentworth 1984, pp. 79–80.
REF.: W. 19, B. 12, T. 13 (second state).

See previous entry.

This drypoint may be based on Tissot's drawing of the dead sculptor, Joseph Cuvelier, killed during the sortie at Malmaison, which revolted Degas as Cuvelier had been a mutual friend (see Wentworth 1978, pp. 94–6 and 1984, p. 80). Two states of the drypoint were published, the second after the plate was cut down at the right, left and top edges.

36b

37. *Le Foyer de la Comédie-Française pendant le siège de Paris* (*The Green Room of the Theatre Français (Souvenir of the Siege of Paris)*). 1877.
Private collection.

37

Etching, $15 \times 10\frac{7}{8}$ (38.1 × 27.6). Signed on the bedclothes b.l.: *J.J. Tissot*.
EXH.: Minneapolis 1978 (27) illus.
LIT.: Providence/Toronto 1968 (67) illus; Wentworth 1978, pp. 126–9; Wentworth 1984, p. 79.
REF.: W. 27, B. 20, T. 21.

See entry for *Sylvian Perier* (Cat. 35).

During the siege of Paris, the public foyers of the Comédie-Française were converted into an emergency hospital, while a reduced programme of performances, recitals and patriotic lectures continued in the theatre.

38. *Le Campement, parc d'Issy (Souvenir du siège de Paris)* (*The Encampment, Parc d'Issy (Souvenir of the Siege of Paris)*). 1878.
Private collection.

38

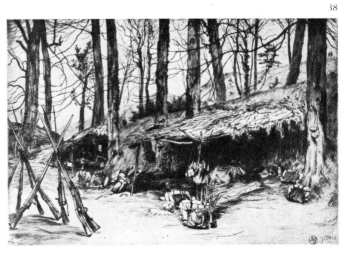

Etching & drypoint, $6\frac{1}{2} \times 9\frac{1}{4}$ (16.5 × 23.5). Signed & dated b.r.: *J.J. Tissot / 1871*.

EXH.: One such print at Dudley Gallery B/W 1878 (207), price £4.4s.0d.

LIT.: Providence/Toronto 1968 (73) illus; Wentworth 1978, pp. 182–3; Wentworth 1984, p. 79.

REF.: W. 41, B. 33, T. 37.

See entry for *Sylvian Perier* (Cat. 35).

Lying south of Paris, facing Versailles, Issy was an important defensive point and the location of one of several forts encircling Paris where severe fighting took place during the siege.

39. *Grand'garde (Souvenir du siège de Paris) (Grand'Garde (Souvenir of the Siege of Paris))*. 1878.

Private collection.

Etching & drypoint, $10\frac{5}{8} \times 7\frac{1}{2}$ (27 × 19). Signed & dated above title margin b.r.: *J.J. Tissot / 1878*.

LIT.: Wentworth 1978, pp. 184–5 & 347; Warner 1982, p. 9, monochrome illus.; Wentworth 1984, p. 79.

REF.: W. 42, B. 34, T. 38.

See entry for *Sylvian Perier* (Cat. 35).

The soldier on guard duty was reproduced as a wood-engraved illustration in Bowles's *Defence of Paris* (Cat. 34), without the background here, entitled *Out Post Duty* (facing p. 236).

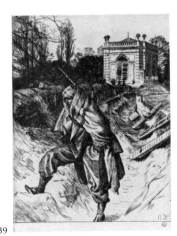

39

40. *Sir John Pender*. 1871.
London, National Portrait Gallery.
Watercolour on paper, $11\frac{7}{8} \times 7\frac{3}{8}$ (30.2 × 18.7).

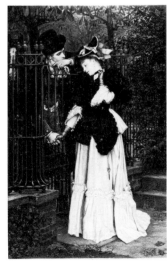

40

PROV.: Christie's 5–8 March 1912, *Vanity Fair* sale; purchased from Maggs Bros., 1934.

EXH.: Vanity Fair 1976 (46) illus.

LIT.: Wentworth 1978, p. 348; NPG 1981, p. 441 (2738) illus; Wentworth 1984, p. 86–8.

John Pender (1815–96) was a textile merchant, a pioneer of submarine telegraphy, and a Liberal MP. This caricature appeared as a coloured chromolithograph in *Vanity Fair*, 28 October 1871, as *Mr John Pender MP*. It is typical of Tissot's London caricatures, which are witty and flattering portraits rather than barbed or humorous distortions, presumably calculated so as not to offend those among whom Tissot sought patronage. Bowles notes that Tissot drew a number of his cartoons in outline on the lithographic stone and then added final details, colour and any necessary corrections to a trial proof (as here), which the printer then used as a guide. This was unusual, as it was common practice in England for artists to submit only finished coloured drawings to the printer, at most with traced outlines.

41. *Chichester Fortescue, later Lord Carlingford*. 1871.
University of Oxford, Examination Schools.
Oil on canvas, $74\frac{1}{2} \times 47\frac{1}{2}$ (189.2 × 120.7). Signed & dated b.l.: *J.J. Tissot 1871*.

PROV.: Subscribed for & presented to the sitter's wife by a group of 61 Irish MPs, bishops and peers to commemorate his term of office as Chief Secretary for Ireland. Given to the University of Oxford by his nephew, Francis Fortescue Urquart, *c*. 1904.

EXH.: RA *Portraits* 1956–57 (464); Nottingham *Victorian Painting* 1959 (68).

LIT.: Lane Poole, *Oxford Portraits*, I, 1912, p. 149; Hewett, O.W, *Strawberry Fair*, 1956, p. 228; Thomson 1979, p. 53–4, illus. p. 53; Wentworth 1984, pp. 90–1 & pl. 73.

Chichester Samuel Parkinson-Fortescue, Baron Carlingford (1823–98) was a Liberal MP and Chief Secretary for Ireland for 1865–66 and 1868–70, President of the Board of Trade for 1871–4, and went on to become Lord Privy Seal and Lord President of the Council. Such a prestigious commission reflects Tissot's swift rise to artistic and social fame through his *Vanity Fair* caricatures, his friendship with Bowles and the success of his portrait of Burnaby.

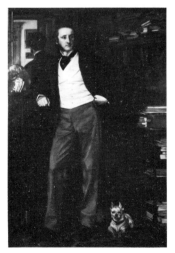

41

42. *Les Adieux*. 1871. (Fig. 12).
The City of Bristol Museum and Art Gallery.
Oil on canvas, $39\frac{1}{2} \times 24\frac{5}{8}$ (100.3 × 62.6). Signed & dated b.r.: *J.J. Tissot / 1871 Londres*.

PROV.: Charles Waring; Christie's 28 April 1888 (17), bt. Lt. Col. Walker's father; purchased from Lt. Col. P.L.E. Walker, 1955.

EXH.: RA 1872 (644); Sheffield 1955 (11); AC 1955 (9).

LIT.: Bell, Quentin, *The Listener*, 29 Oct. 1959, p. 728; Misfeldt 1971, pp. 136, 138, 140 & fig. 69; Bristol Art Gallery, *An Anthology of Victorian and Edwardian Paintings*, 1975, p. 18; Warner 1982, p. 6, colour pl.; Wentworth 1984, pp. 101–2, 106, 201, & pl. 76.

One of two pictures exhibited by Tissot at the Royal Academy in 1872, a year after his flight from Paris. Both *Les Adieux* and *An Interesting Story* (389; Melbourne, National Gallery of Victoria; Wentworth 1984, pl. 78) were eighteenth-century costume pieces, emulating British narrative paintings (see p. 68). A full-size replica is known for *Les Adieux* (Sotheby's, 24 Oct. 1978 (21), Providence/Toronto 1968 (49) illus.), which is a maquette for the steel engraving.

43. *Les Adieux*. 1873.
London, British Museum.
Steel engraving, $25\frac{3}{4} \times 16$ (65.5 × 40.5). Signed in title margin b.l.: *J. Tissot*, b.r.: *Ballin*.

PROV.: Acquired 1886.

EXH.: One such steel engraving was at London, International Exhibition, 1874 (4115); Paris, Galerie Sedelmeyer, 1885 (90).

LIT.: Misfeldt 1971, p. 139; Wentworth 1978, p. 349.

This steel engraving by John Ballin after Tissot's painting *Les Adieux* (Cat. 42) was published by Pilgeram and Lefèvre in 1873, indicating that Tissot's Royal Academy exhibit must have been as popular as it was well received by critics, for only favourites were commercially reproduced in this way.

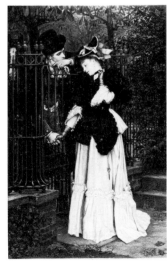

43

44. *Bad News (The Parting)*. 1872. (Colour Plate 26).
Cardiff, The National Museum of Wales.
Oil on canvas, 27 × 36 (68.6 × 91.4). Signed & dated b.r.: *J.J. Tissot / L.72*.
PROV.: A.B. Stewart; Christie's 9 May 1881 (134) as *The Parting*; William Menelaus, bequeathed by him to Cardiff Museum, 1882.
EXH.: London, International Exhibition 1872 (1181); Glasgow 1878 (244); Sheffield 1955 (13) illus. pl. I; AC 1955 (11).
LIT.: Providence/Toronto 1968 (16 & 50), illus. fig. 6; Brooke 1969 pp. 22–6, illus.; Misfeldt 1971, p. 138 & fig. 71; Wentworth 1984, pp. 100, 103, 207 & pl. 78.
Inspired by popular British narrative paintings in eighteenth-century dress, by the current fashions and by the works of Reynolds and his contemporaries, Tissot painted a number of costume pictures in the early 1870s that rearrange the same models, clothes and 'props' to tell different stories (see p. 68). The bay window setting, probably of a tavern on the Thames, looks on to a different riverscape in each picture: *Bad News* has a wooded landscape, unlike the other known paintings which show the port of London bristling with masts. Tissot later built a similar bay window in his studio (see Fig. 4).

The left side of the painting is repeated in a variant composition, *Le Thé* (New York, private collection) Wentworth 1984 pl. 79. The young woman in both is taken from a pencil study (see following entry).

45. *Young Lady Pouring Coffee. c. 1872.*
Tom Parr.
Pencil on buff paper, $17\frac{1}{2}$ × 12 (44.5 × 30.5), irregular. Signed & inscribed b.r.: *à mon ami Degas / J. Tissot / Londres*.
PROV.: Edgar Degas; Duke of Verdura, New York.
EXH.: Providence/Toronto 1968 (50) illus.
LIT.: Brooke 1969, p. 23 illus.; Misfeldt 1971, fig. 72a; Wentworth 1984, p. 103.
A study for the girl on the left in *Bad News* (Cat. 44), repeated on her own in a variant composition, *Le Thé* (see the previous entry). Though entitled 'Young Lady

Pouring Coffee', the girl in both paintings is decanting hot water from a tea urn into a teapot.

The verso has a compositional sketch for *(How We Read the) News of our Marriage* (Cat. 48), together with some notes in Tissot's handwriting, which appear to be framing instructions (illus. Providence/Toronto 1968, above fig. 6).

45

46. *Study after Reynolds's Portrait of Mrs Williams Hope. c. 1872.*
London, Tate Gallery.
Pencil on paper, $4\frac{3}{4}$ × $2\frac{5}{8}$ (12.1 × 6.7).
PROV.: ? Charles Fairfax Murray, London; J.R. Holliday, Birmingham; bequeathed by J.R. Holliday, 1927.
LIT: Tate 1981, p. 718 (4294).
Tissot would have been already familiar with Reynolds's paintings before he came to London through the medium of reproductive engravings, which he may have collected. His interest in Reynolds was perhaps fostered by his friend Millais, who preferred the more romantic and 'timeless' dress of Reynolds's pictures and whose *Hearts are Trumps*, painted as a pendant to Reynolds's *The Ladies Waldegrave*, was exhibited at the Royal Academy in 1872 (see p. 68 and n. 12). Both of them no doubt visited the Reynolds exhibition held at the Royal Academy that year. Tissot would have made numerous studies like this one (which is after Reynolds's Royal Academy picture of 1787), recording useful information about dress, which could later serve for making up items like the mob-cap.

46

47. *Study of a Girl in a Mob-Cap. c. 1872.*
London, Tate Gallery.
Pencil on paper, $12\frac{1}{4}$ × $8\frac{1}{8}$ (32.4 × 20.6).
PROV.: As for previous entry.
LIT.: Brooke 1969, p. 25 illus.; Tate 1981, p. 719 (4293).
No finished painting is known at present that directly uses this life study, but the drawing is clearly related to Tissot's London eighteenth-century costume pictures. The mob-cap, kerchief, petticoat and polonaise skirt appear in varied combinations in all the pictures (see p. 68) and the armchair, clearly matching the 'Rossetti' chairs in *Bad News* (Cat. 44), appears in *News of Our Marriage* (Cat. 48). A small oil study related to these pictures is known, showing a girl reading (Fig. 48), wearing eighteenth-

47

century costume 'props' and the large mob-cap, and seated on the 'Rossetti' armchair in a bay window (Christie's 24 June 1983 (87)).

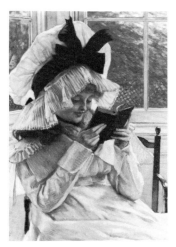

Fig. 48. *Reading a Book. c. 1872.* Whereabouts unknown

48. *(How We Read the) News of our Marriage. 1874.*
London, British Museum.
Steel engraving, $24\frac{3}{5}$ × $17\frac{9}{10}$ (62.5 × 45.5). Signed in the plate b.r.: *J.J. Tissot / L / 1872* and in the title margin b.l.: *James Tissot*.
PROV.: Acquired 1886.
EXH.: One such steel engraving was at London, International Exhibition, 1874 (4121); Paris, Galerie Sedelmeyer, 1885 (91).
LIT.: Brooke 1969, p. 25 illus.; Misfeldt 1971, p. 140; Wentworth 1978, p. 349
This was the second of Tissot's pictures to be reproduced commercially as a steel engraving (see *Les Adieux*, Cat. 43). The original

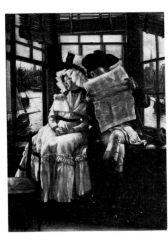

48

painting for this steel engraving by W.H. Simmonds is presently unlocated, but must have been very popular when shown in London to warrant the publication of this print by Pilgeram and Lefèvre in 1874. Costumes, models and setting appear in a number of other pictures and, as in Tissot's other early London works, the narrative element is strong.

A small oil study (Fig. 49; possibly *The Tryst, Greenwich*, exhibited Sheffield 1955 (14)) has the same familiar elements re-arranged in a variant composition (Sotheby Parke Bernet, New York, 28 October 1982 (39)).

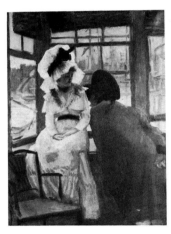

Fig. 49. *The Tryst, Greenwich*. Whereabouts unknown

49. *Histoire ennuyeuse* (*An Uninteresting Story*). 1878.
London, British Museum.
Etching and drypoint, $12\frac{3}{8} \times 8$ (31.4 × 20.3). Signed & dated t.r.: *J.J. Tissot / 1878*.
PROV.: Acquired 1923.
EXH.: One such etching at Grosvenor Gallery 1878 (157), as *The Bow Window*.
LIT.: Wentworth 1978, pp. 146–9.
REF.: W. 32, B. 25, T. 28.
An etching in the same direction after an oil painting, which presumably once had the same title (New York, private collection; Wentworth 1984, pl. 80). Tissot's eighteenth-century costume pieces of the early 1870s were very popular, yet he only later reproduced one as an etching himself, perhaps because the market was satisfied by the two commercially-produced steel engravings (*Les Adieux* and *News of our Marriage*, Cats. 43 and 48).

Histoire ennuyeuse repeats the theme of *An Interesting Story* (see entry for *Bad News*, Cat. 44), though this time the title does not belie the obvious boredom of the young woman with the battle reminiscences of the old soldier and his maps.

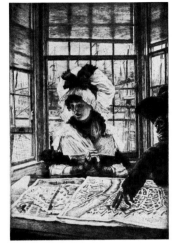

49

50. *Le Châpeau Rubens* (*The Rubens Hat*). 1875.
London, British Museum.
Etching, $10 \times 6\frac{3}{8}$ (25.4 × 16.2). Signed b.l.: *J.J. Tissot*.
PROV.: Acquired 1923.
LIT.: Wentworth 1978, pp. 60–3.
REF.: W. 8, B. 2, T. 2. .
No related paintings are known for this etching and Cat. 51. The 'Rubens' hat worn in both is an item of fashionable dress copied from Rubens's full-length portrait of *Hélène Fourment* (Lisbon, Calouste Gulbenkian Foundation),

50

which inspired several generations of 'Rubens' fancy dress, and the smaller *Châpeau de Paille* (London, National Gallery) which had created a sensation in London in the 1820s and 1830s. The revival of interest in eighteenth-century dress brought with it renewed interest in the Rubens and Van Dyke fashions copied at that time, and watered-down or disjointed elements like the Rubens hat crept into current fashion.

51. *A la Fenêtre* (*By the Window*). 1875.
Charles Jerdein.
Drypoint and etching, $7\frac{1}{2} \times 4\frac{1}{4}$ (19.0 × 10.8). Signed & dated t.r.: *J. Tissot / 1875*.
EXH.: One such print at Dudley Gallery B/W 1876 (337).*
LIT.: Wentworth 1978, pp. 64–7.
REF.: W. 9, B. 3, T. 3.

51

See previous entry.

Tissot was fond of placing figures against the light, as here, giving bold silhouettes and striking contrasts of light and dark areas. The cropping and geometric division reflect Tissot's interests in Japanese prints and in photography. A number of later prints use the same compositional elements (e.g. *Mavourneen*, Cat. 98).

* I am indebted to Harley Preston for bringing the Dudley Gallery 'Black and White' exhibitions to my attention.

52. *Frederick, Lord Leighton*. 1872.
Museum of London.
Watercolour & bodycolour on paper, 12 × 7½ (30.3 × 18.8).
PROV.: Acquired from Charles Davis, 1912.
LIT.: Wentworth 1978, pp. 348–9; Wentworth 1984, pp. 87–8.
See entry for *Sir John Pender* (Cat. 40).

Tissot's caricature of *Mr Frederick Leighton, ARA*, languishing against a door jamb at a social gathering, appeared in *Vanity Fair* on 29 June 1872, subtitled 'A Sacrifice to the Graces'. Unusually, the composition of this watercolour is reversed in the print.

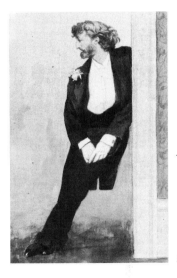

52

53. *The Earl of Harrington*. 1873.
John Franks collection.
Pencil, watercolour & bodycolour on paper, 12 × 7¼ (30.5 × 18.4). Inscribed on original *Vanity Fair* mount: *The Earl of Harrington / October 25 1873*.
PROV.: Sir Thomas Gibson Bowles, who sold the originals with *Vanity Fair* in 1889; Christie's 5–8 March 1912, *Vanity Fair* sale (355); Phillips' at Jolly's of Bath 10 Oct. 1983.
LIT.: As for previous entry.
See entry for *Sir John Pender* (Cat. 40). *Vanity Fair* said of Lord Harrington: 'an unexpected earl ... although become a Statesman by accident, is not a politician by practice, for he greatly prefers Music and Seafaring to Public Affairs, and his house at Cowes is the chosen centre for chamber-practice and nautical conver-

sation. He is now sixty-four years of age and still delights in the Sea and the Fiddle.'

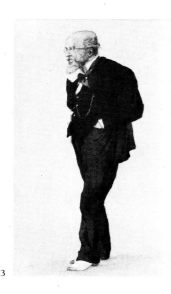

53

54. *Miss Annie Wells. c.* 1873.
Private collection.
Pencil on paper, 12 × 9½ (30.5 × 24.1). Signed and inscribed b.r.: *Londres. J. Tissot*; inscribed t.r.: *Miss Annie Wells.*
PROV.: Christian Humann; Stair Sainty Fine Art Inc., New York.
This small portrait study was probably drawn in Tissot's studio, perhaps in his newly-bought house at 17 Grove End Road, for the armchair is the one with zigzag patterned fabric which appears in a number of Tissot's later pictures (e.g. *Woman Fainting*, Cat. 144).

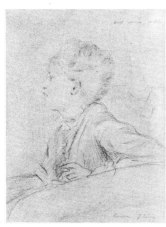

54

55. *The Last Evening.* 1873. (Colour Plate 14).
London, Guildhall Art Gallery.
Oil on canvas, 28½ × 40½ (72.4 × 102.8). Signed & dated b.l.: *L.1873 J.J. Tissot.*
PROV.: Acquired from the artist by Agnew's, from whom purchased by Charles Gassiot 10 Feb. 1873 for £1,000; bequeathed by Charles Gassiot, 1902.
EXH.: RA 1873 (121); Leicester Galleries 1933 (10); Sheffield 1955 (15) illus. pl. II; AC 1955 (13).
LIT.: Laver 1936, pl. VIII; Providence/Toronto 1968 (51) illus.; Misfeldt 1971, pp. 140–3 & fig. 74; Wentworth 1979–80, p. 23 fig. 15; Warner 1982, p. 10, colour pl.; Barbican 1984, (42) colour pl.; Wentworth 1984, pp. 102–3, 105–6, 113, 147, 201 & pl. 84.
One of three modern life pictures exhibited at the Royal Academy in 1873, the others being *The Captain's Daughter* (Cat. 57) and *Too Early* (Cat. 65). All three were a popular and critical success. Their appeal was as much due to the stories that could be woven around their content as to their meticulous finish and detail. *The Last Evening* and *The Captain's Daughter* are among a number of Thames-side subjects painted by Tissot *c.* 1872–6, in which the same models and garments reappear in ever-changing variations (see p. 73). The first of these pictures was *The Thames* (London, private collection), shown by Tissot at the London International Exhibition in 1872 (1176). Several were painted aboard the *Carisbrooke Castle* and *Arundel Castle* whose captain, John Freebody, had befriended Tissot soon after the latter's arrival in London. The captain's wife, Margaret Kennedy, and her brother, Captain Lumley Kennedy, served as models for some of the Thames-side pictures: brother and sister are the pair on the right in *The Last Evening.*
A gouache study is known for the woman in the rocking chair, with a slight variation of facial expression (Fig. 29 and following entry).
NOTE: The family of Captain John Freebody had six contemporary photographs after paintings by Tissot in their possession – *The Last Evening, The Ball on Shipboard, The Captain's Daughter, The Captain and the Mate, Emigrants* and *Boarding the Yacht* – which were marked on the back, in what appears to be Captain Freebody's handwriting, with the names of sitters (information supplied by Philip Bailey, Captain Freebody's grandson). John Freebody (b. 1834) was the master of the *Warwick Castle,* 1870–2, the *Arundel Castle,* 1872–3, and the *Carisbrooke Castle,* 1874–80, while Lumley Kennedy (b. 1819) was a mate on the *Cintra* in 1870 and master of the *Aphrodite,* 1872. It is feasible that Tissot met the Freebodys and Captain Kennedy soon after his arrival in London, as figures similar to Margaret Freebody, née Kennedy, and her sister appear in *The Thames* of 1872. He probably made pencil and gouache studies of the ships, similar to his study of the *Falcon Tavern, Gravesend* (Cat. 112), during the short periods when the ships were in dock, 1872–4, which were later used as backgrounds in paintings together with studio-posed studies of the figures, like the gouaches for *The Captain and the Mate* (Cats. 62, 63).

56. *Study of a woman for 'The Last Evening'. c.* 1873. (Fig. 29).
Northampton, Mass., USA, Smith College Museum of Art.
Gouache and watercolour over pencil on blue-toned paper, 9⅞ × 15½ (25.1 × 39.4). Signed b.l.: *J. Tissot.*
PROV.: Purchased from Gropper Art Gallery, Cambridge, Mass., 1966.
EXH.: Providence/Toronto 1968 (51) as *Young Lady in a Rocking Chair*; Sterling and Francine Clark Art Institute, Williamstown, Mass., *Tissot's Paintings and Drawings from New England Collections,* 1978 (adjunct to *Prints* exhibition, Minneapolis 1978).
LIT.: Misfeldt 1971, fig. 74a; Wentworth 1984, pp. 105, 159 & pl. 85.
Tissot made a number of gouache studies like this in the early 1870s, perhaps choosing the medium for its proximity in effect to the surface of his paintings. These studies include two for *Too Early* (see entry for Cat. 65); one for *The Captain's Daughter* (Cat. 57); a study of a woman with a bobble-fringed shawl and lap rug, for which a related painting is not known at present (Sydney, Art Gallery of New South Wales); and a study of a sleeping woman (Cat. 69). They have an attractive freshness which is lacking in Tissot's later watercolour replicas. This is the only known study for the painting *The Last Evening.*

57. *The Captain's Daughter.* 1873. (Colour Plate 8).
Southampton Art Gallery and Museums.
Oil on canvas, 28½ × 41¼ (72.4 × 104.8). Signed & dated b.l.: *J.J. Tissot / L. 73.*
PROV.: Sold by Branch and Lees, 1903; The French Gallery, 11 Berkeley Square; Leicester Galleries by 1933; acquired through Smith fund, 1934.
EXH.: RA 1873 (108); Leicester Galleries 1933 (21) illus.; Sheffield 1955 (16); AC 1955 (14).
LIT.: Laver 1936, pl. IX; Brooke 1969, p. 26 illus; Misfeldt 1971, pp. 140–2 & fig. 73; Wentworth 1978, pp. 134, 139 & fig. 29b; Wentworth 1984, pp. 95, 103–6, 113, 131, 147, 201 & pl. 81.
See entry for *The Last Evening* (Cat. 55).
The female model is again Margaret Kennedy; an unlocated gouache study of her for this picture is known. Tissot reworked the composition for the etching *L'Auberge des Trois Corbeaux* (W. 29), published as the frontispiece to a portfolio of ten etchings, 1876–7, and possibly taken from a finished painting for which an oil sketch is known (see the following entry). He also later repeated *The Captain's Daughter,* without the figure of the woman and with minor variations in background and foreground, in a watercolour, *La Tamise à Gravesend, c.* 1882–5, exhibited at the *Société d'Aquarellistes* in 1886 (4) and recorded in Tissot's albums (IV/2).

58. *The Three Crows Inn, Gravesend* (*L'Auberge des Trois Corbeaux*). *c.* 1873–6.
Dublin, National Gallery of Ireland.
Oil on canvas, 24½ × 36 (62.2 × 91.4).
PROV.: Purchased from Leicester Galleries, 1943.
LIT.: Wentworth 1978, pp. 134–9 & fig. 29a; NG Ireland 1981, p. 163 (1105) illus.; Wentworth 1984, p. 104 & pl. 82.

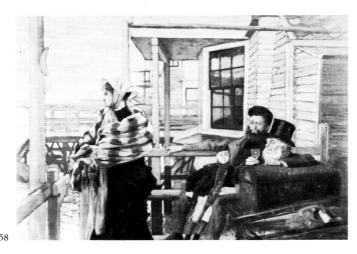

58

This oil sketch is probably a study for a finished painting, as yet unknown, which was repeated by Tissot in the print *L'Auberge des Trois Corbeaux* (see the previous entry).

59. *Disembarking on the Thames.* c. 1872–4.
Gavin Graham Gallery.
Oil on panel, $8\frac{1}{4} \times 6\frac{1}{2}$ (21 × 16.5). Signed b.r.: *J.J. Tissot*; inscribed on a label on the back: *Un débarcadère sur la Tamise*.
PROV.: Madame des Pourmet Fitzgerald, Paris; Edward Speelman, Esq., by 1955; Leicester Galleries by 1962; Sotheby's 23 Nov. 1982 (169) as *Un débarcadère sur la Tamise*.
EXH.: Sheffield 1955 (12) as *Coming Ashore*; AC 1955 (10).
No larger finished painting is known at present for this small oil sketch, though it is clearly related to Tissot's Thames-side scenes of c. 1872–4. The woman wears a red check shawl which is probably

the one frequently used by Tissot and seen for example in *The Last Evening* (Cat. 55) and *Waiting for the Ferry* (Cat. 111).

60. *The Return from the Boating Trip.* 1873. (Colour Plate 4).
Private collection.
Oil on panel, 24 × 17 (61 × 43.2). Signed & dated b.l.: *J.J. Tissot / 73 / L.*
PROV.: Christie's 26 Nov. 1982 (306); Gerald Ratner, London.
The model is probably Margaret Kennedy (see Cat. 55) or her sister, and the setting has been identified by Ian Thomson as the Thames below Maidenhead Bridge. Michael Wentworth has suggested that this picture may have formed part of a projected series of '*la belle anglaise*' caught at her various typical occupations and amusements' together with pictures like *Waiting for the Train, Willesden Junction* (Wentworth 1984, pl. 98), an early, English version of *La Femme à Paris*.
There is a gouache study for the young woman in a private collection, Boston, Mass.

61. *The Captain and the Mate.* 1873. (Colour Plate 13).
Private collection.
Oil on canvas, 21 × 30 (53.3 × 76.2). Signed & dated b.l.: *J.J. Tissot / L.1873.*
EXH.: Leicester Galleries 1933 (22) illus.
LIT.: Laver 1936, pl. VII; Wentworth 1984, pp. 31, 107 & colour pl. III.
See entry for *The Last Evening.*
Margaret Kennedy is seated on the left and her brother, Captain Lumley Kennedy, sits on the side

of the ship. The title is apt, as the latter was a Mate at that time. There are gouache studies for both of the women (see Cats. 62 and 63). Tissot displays a masterful and detailed knowledge of rigging and ships' fittings in these Thames-side subjects, which he must have acquired as a boy in the sea port of Nantes.

62. *Study of a Seated Woman for 'The Captain and the Mate'.* c. 1873.
Oxford, The Ashmolean Museum.
Gouache over black chalk on blue paper, $9 \times 11\frac{1}{2}$ (22.8 × 29.1).
PROV.: C.F. Slodt, London; purchased by Ashmolean Museum, 1942.
EXH.: Sheffield 1955 (48) as *Figure Study: Seated Woman*; AC 1955 (35).
LIT.: Ashmolean Annual Report 1942 p. 23; Warner 1982, back cover, monochrome pl.; Wentworth 1984, p. 105n.
This and the following work are the only known studies for *The Captain and the Mate* (Cat. 61). Tissot made a number of similar gouache studies of single figures in the early 1870s, most of which relate to known pictures (see entry for *The Last Evening*, Cat. 55).

63. *Study of a Standing Woman for 'The Captain and the Mate'.* c. 1873.
Oxford, The Ashmolean Museum.
Gouache over black chalk on blue paper, $16\frac{1}{2} \times 10\frac{1}{8}$ (41.7 × 25.7). Signed b.r.: *J. Tissot.*
PROV.: Purchased by Ashmolean Museum, 1942.

EXH.: Sheffield 1955 (47) as *Figure Study: standing woman*; AC 1955 (34).
LIT.: Ashmolean Annual Report 1942 p. 23; Wentworth 1984, p. 105 & pl. 86.
See previous entry.

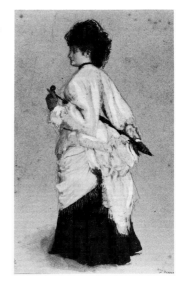

63

64. *Boarding the Yacht.* 1873. (Colour Plate 9).
The Hon. P.M. Samuel.
Oil on canvas, 28 × 21 (71 × 53.4). Signed & dated b.r.: *J.J. Tissot / Londres 1873.*
PROV.: Leicester Galleries by 1936; Viscount Bearsted by 1937.
EXH.: Leicester Galleries 1937 (8) illus.; Sheffield 1955 (18) as *Coming Aboard*, AC 1955 (16) illus. pl. I.

59

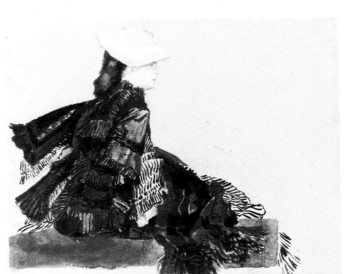

62

LIT.: Laver 1936, pl. I; Maas, Jeremy, *Victorian Painters*, 1969, p. 255, colour pl.; Misfeldt 1971, p. 143 & fig. 75; Warner 1982, p. 11, colour pl.; Wentworth 1984, pp. 107, 131, 139, 142, & pl. 88.

See entry for *The Last Evening* (Cat. 55).

The two young women are boarding the *Carisbrooke Castle*, Margaret Kennedy again the model for the woman on the right, her sister the woman on the left. The theme of a man and two women, rich with innuendo, is repeated in pictures like *Portsmouth Dockyard* (Cat. 83) and *The Thames* (Cat. 81), where the suggestive nature of the scene was frowned upon by critics.

65. *Too Early.* 1873. (Colour Plate 7).
London, Guildhall Art Gallery.
Oil on canvas, 28 × 40 (71.2 × 101.6). Signed & dated b.l.: *J. Tissot 1873*.
PROV.: Bt. from the artist by Agnew's, from whom purchased by Charles Gassiot 20 March 1873 for £1,155; bequeathed by Charles Gassiot, 1902.
EXH.: RA 1873 (914); Sheffield 1955 (17); Providence/Toronto 1968 (18) illus.
LIT.: Laver 1936, pl. VI; Reynolds 1953, pl. 98; Misfeldt 1971, pp. 143–4 & fig. 77; Wood 1976, pp. 28, 30 & pl. 17; Warner 1982, p. 12, colour pl.; Barbican 1984, (41, colour pl.); Wentworth 1984, pp. 96, 103, 113–17, 163, 201 & pl. 101.

The first of Tissot's more ambitious social conversation pieces, *Too Early* caused a 'great sensation' among the public when shown at the Royal Academy in 1873, where Tissot 'fairly out-Tissoted himself in his studies of character and expression' (the *Builder*, 3 May 1873). The picture had been bought by Agnew's and immediately sold to Charles Gassiot before its exhibition at the Royal Academy. The subject may well have been inspired by engraved illustrations of society functions and fashions in English popular magazines, and was a departure from Tissot's earlier work. Describing *Too Early*, the critic in the *Builder* went on to compare the 'truthfulness and delicate perception of the humour of the ''situation''' to that found 'in the novels of Jane Austen, the great painter of the humour of

''polite society'''. *Too Early*'s popular success led Tissot to paint *The Ball on Shipboard* (Cat. 66) and *Hush!* (Cat. 70).

Two gouache studies are known for *Too Early*, one for the young woman to the left of the central group, looking out of the picture (New York, Mrs Vincent Astor) and one for the young woman leaning against the door jamb (whereabouts unknown).

66. *The Ball on Shipboard.* c. 1874. (Colour Plate 25).
London, Tate Gallery.
Oil on canvas, 33⅛ × 51 (84 × 130). Signed b.r.: *J.J. Tissot*.
PROV.: Bt. by Agnew's from the artist 1874; H. Philipson, 1874; Mrs Roland Philipson; Leicester Galleries, London; Sir Alfred Munnings, London, 1937; purchased by Chantrey Trustees, 1937.
EXH.: RA 1874 (690); Leicester Galleries 1937 (15) as *The Ball on Shipboard, Cowes*.
LIT.: Sitwell 1937, pp. 92–3, 118 & pl. 129; Misfeldt 1971, pp. 144–7, 149–51 & fig. 78; Wood 1976, pp. 30–1 & colour pl. 18; Ottawa 1978, (66) illus. fig. 5; Tate 1981, pp. 719–20 (4892) illus; Warner 1982, p. 14, colour pl.; Thomson 1982, p. 328, fig. 1; Wentworth 1984, pp. 4–5, 31, 50, 96, 106, 109, 114–16, 118–19, 139, 141–2, 201 & pl. 102.

This is Tissot's most ambitious English picture, successfully incorporating a large number of figures and balancing complex groups with empty space. Though some later critics have suggested that the picture records a particular event, *The Ball on Shipboard* is largely a studio 'mock-up': Misfeldt notes that Tissot had similar flags to those shown here among his studio 'props' at the Château de Buillon, while the chair and costumes are also 'props' which appear in numerous other paintings (see p. 76). The large variety of new costumes in this painting no doubt reflects Tissot's growing wealth, as evidenced by the larger house he had bought in 1873 at 17 Grove End Road, St. John's Wood. The young woman facing the viewer on the left is probably a friend and frequent model of the early 1870s, Margaret Kennedy (see entry for *The Last Evening,* Cat. 55).

67. *Study for 'The Ball on Shipboard'.* c. 1874.
Toronto, Mr & Mrs Joseph M. Tanenbaum.
Oil on canvas, 37¼ × 26 (94.5 × 66).
PROV.: Paul Séguin Bertault, Paris; Count François de Vallombreuse, Paris; Sotheby's 25 Oct. 1977 (174); acquired Oct. 1977.
EXH.: Providence/Toronto 1968 (20) illus.; Ottawa 1978 (66), illus.
LIT.: Misfeldt 1971, & fig. 78a.

The composition of this large oil study is related to the centre left section of *The Ball on Shipboard* (Cat. 66), but there are many differences in number and pose of figures.

67

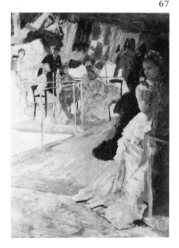

68. *Reading the News.* c. 1874. (Colour Plate 1).
New York, private collection.
Oil on canvas, 34 × 20½ (86.4 × 52). Signed b.r.: *J.J. Tissot*.

PROV.: Lady Duveen; Christie's 25 July 1947, bt. Newman; T.H. Farr; Christie's 18 March 1983 (118).
EXH.: Sheffield 1955 (21).
LIT.: Wentworth 1978, pp. 64, 67 & fig. 9c; Wentworth 1984, p. 119 & pl. 108.

The setting for this picture is the bay window in Tissot's studio (see Fig. 4). The young woman wears a dress which appears twice in the centre of *The Ball on Shipboard* (Cat. 66), with a summer hat that is one of Tissot's favourites (see p. 76).

69. *Woman Asleep.* c. 1873–6.
Oxford, The Ashmolean Museum.
Gouache over black chalk on blue-grey paper, 8⅗ × 11⅓ (21.9 × 28.8). Signed b.r.: *J.J. Tissot*.
PROV.: Purchased by Ashmolean Museum, 1951.
EXH.: Sheffield 1955 (49) as *Figure Study: Reclining woman*; AC 1955 (36).
LIT.: Annual Report 1951 p. 63; Wentworth 1978, p. 88 & fig. 17a; Wentworth 1984, p. 105n.

The model wears the dress seen in *The Captain's Daughter* (Cat. 57) with a different skirt and hat. The composition is related to the drypoint, *La Dormeuse* (Cat. 89), but is not a study for any known oil painting. See also the entry for *The Last Evening* (Cat. 55).

70. *Hush!* (*The Concert*). c. 1875. (Colour Plate 6).
Manchester City Art Galleries.
Oil on canvas, 29 × 44¾₁₆ (73.7 × 112.2). Signed b.r.: *J.J. Tissot*.

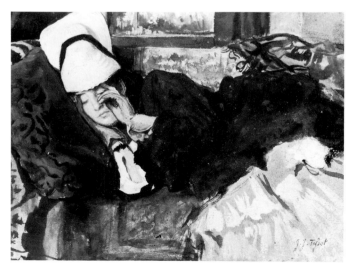

PROV.: Bt. by Agnew's from the artist for 1,200 guineas; Leicester Galleries by 1933; purchased by Manchester City Art Gallery, 1933.

EXH.: RA 1875 (1233) as *Hush!*; Leicester Galleries 1933 (13) illus; Sheffield 1955 (32); AC 1955 (24).

LIT.: Laver 1936, pl. XIV; Reynolds 1953, pl. 99; Misfeldt 1971, pp. 144–5, 152–5 & fig. 79; Wood 1976, pp. 30–1 & fig. 18; Warner 1982, p. 13, colour pl.; Manchester City Art Gallery, *A Century of Collecting 1882–1982*, 1983 (143) illus. p. 135; Wentworth 1984, pp. 16, 88, 114–19, 144, 201 & pl. 103.

Criticism of the lack of intelligible meaning in his pictures may have led Tissot to incorporate some portraits of known personalities in this, the third of his ambitious social scenes, though he also got friends to model people in the crowd (see p. 45; the young woman with a fan on the left may be Margaret Kennedy – see entry for *The Last Evening*, Cat. 55). The subject was probably inspired by a party that Tissot attended at the Coopes, where the lady violinist, Neruda, played (Laver, pp. 33–4; Wentworth, p. 117n). The colour, texture of paint and brushwork are very different to Tissot's smooth and meticulous earlier works, which culminate in *The Ball on Shipboard* (Cat. 66), and look forward to the more painterly approach in Tissot's later work.

71. *The Empress Eugénie and the Prince Impérial in the Grounds of Camden Palace, Chislehurst.* c. 1874.

Compiègne, Musée Nationale du Château.

Oil on canvas, 50 × 60 (106.6 × 152.4). Signed b.r.: *J.J Tissot.*

PROV.: Fosters, Pall Mall; Leicester Galleries; purchased by Musée du Louvre, 1934.

EXH.: Leicester Galleries 1933 (23) illus.

LIT.: Laver 1936, pl. XV; Misfeldt 1971, pp. 155–6 & fig. 82; Wentworth 1984, pp. 119–20 & pl. 112.

This portrait of the exiled Empress of France and her son was commissioned in 1874, either to mark Prince Louis Napoleon's twenty-first birthday in March, or his passing out of Woolwich at the end of that year: he wears the uniform of a Woolwich cadet. The painting confirms Tissot's standing as a portraitist and, in its sensitive treatment, dispels any possibility of strong anti-Bonapartist feelings on Tissot's part.

72. *Mr Lionel Lawson.* 1876.
Private collection.

Watercolour, pencil & body-colour on paper, 16 × 10 (40.6 × 25.4). Signed b.l.: *J.J. Tissot.*

PROV.: Christie's 26 March 1982 (102).

LIT.: As for *Lord Leighton* (Cat. 52).

See entry for *Sir John Pender* (Cat. 40).

Lionel (Levi) Lawson (1824–79) was a financier and man-about-town. He owned a printing-ink factory in France and lived mainly in Paris. He later became the principal proprietor of the *Daily Telegraph.*

72

73. *Sir Henry Keppel.* 1876.
London, National Portrait Gallery.

Watercolour, pencil & body-colour on paper, 12¼ × 7¼ (31.1 × 18.4). Signed in monogram b.r.: ꟷ; inscribed and dated on original *Vanity Fair* mount: *Admiral Sir Hon. H. KEPPEL G.C.B. | April 22, 1876.*

PROV.: Acquired 1983.

LIT.: As for *Lord Leighton* (Cat. 52).

See entry for *Sir John Pender* (Cat. 40).

Sir Henry Keppel (1809–1904) was Admiral of the Fleet and commanded the naval brigade in the Crimean War and British naval forces in China in 1857 and 1867–70. He was also a director of the North Borneo Company.

73

74. *Portrait de M...B...* (*Portrait of Mrs B...*). 1876.
Paris, Bibliothèque Nationale.

Etching, 10¹⁵⁄₁₆ × 7½ (27.8 × 19.1). Signed & dated t.l.: *J.J. Tissot / 1876.*

EXH.: Minneapolis 1978 (21) illus.

LIT.: Wentworth 1978, pp. 104–5.

REF.: W. 21, B.14, T. 15.

A portrait of Jessica Bowles, née Gordon (1852–87), wife of Thomas Gibson Bowles.

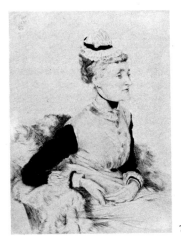

74

75 *Portrait de Miss L...*, *ou Il faut qu'une porte soit ouverte* (*Portrait of Miss L..., or A Door Must Be Either Open or Shut*). 1876.
Private collection.

Drypoint, 14¼ × 7¼ (36.2 × 18.4). Signed & dated on curtain b.l.: *J.J. Tissot / 1876.*

EXH.: One such print at Dudley Gallery B/W 1877 (507).

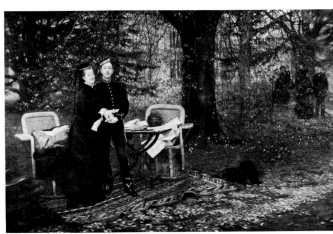

71

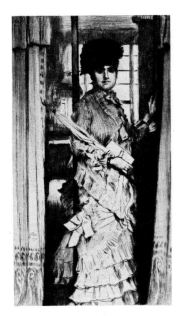

75

LIT.: Wentworth 1978, pp. 110–13; Wentworth 1984, pp. 135, 142 & 202 (on the painting).

REF.: W. 23, B. 16, T. 17.

Drypoint, in reverse and with minor variations, after the painting exhibited at the Grosvenor Gallery in 1877 (18) as *A Portrait* (London, Tate Gallery; Fig. 15). The sitter for the print is identified as a Miss Lloyd in the Vente Tissot. The dress is a 'prop', and like other portrait 'specimens' (e.g., *Spring* (Cat. 101) and *Mlle L.L...* (Cat. 13)) the painting was no doubt intended to attract portrait commissions.

76. *Algernon Moses Marsden.* 1877.

Private collection.

Oil on canvas, $19\frac{1}{2} \times 29$ (49.5 × 73.5). Signed & dated b.r.: *J.J. Tissot / 1877.*

PROV.: By descent through the Marsden family; Christie's 25 Nov. 1983 (64).

LIT.: Wentworth 1979–80, p. 10 & fig. 4; Wentworth 1984, pp. 142–3 & pl. 128.

Algernon Moses Marsden (1848–1921) was a successful art dealer (see p. 44). The portrait's setting was once thought to be Marsden's study but is clearly Tissot's studio: the tiger skin, blue and white china and furniture appear in a number of other pictures, notably *Hide and Seek* (Washington, National Gallery of Art; Wentworth 1984, pl. 160).

77. *Room Overlooking the Harbour.* c. 1876–8. (Colour Plate 21).

London, private collection.

Oil on canvas, 10 × 13 (25.4 × 33).

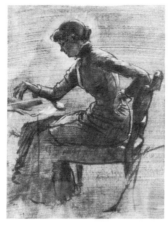

Fig. 50. Study of Kathleen Newton. Dijon, Musée Magnin

EXH.: Leicester Galleries 1933 (II); Sheffield 1955 (41); AC 1955 (30) illus. pl. III.

LIT.: Laver 1936, pl. XXVII; Providence/Toronto 1968 (27); Wentworth 1978, pp. 106, 108 & fig. 22b; Wentworth 1984, p. 131.

This painting is based on a pen and ink study of a room in Ramsgate overlooking the harbour, which Tissot used for another painting, *A Passing Storm*, c. 1876 (Fredericton, New Brunswick, Beaverbrook Art Gallery; Wentworth 1984, pl. 116), and for the drypoint *Ramsgate* (Cat. 79). Unlike the latter two, which re-use the drawing with only minor changes, Tissot substitutes the small round table and easy chair for a gate-leg dinner table and upright chair in *Room Overlooking the Harbour*. The figure of Kathleen Newton is taken from a grisaille oil sketch of her playing chess (Fig. 50), on the

reverse of which is a similar sketch for the man at the right in *Richmond Bridge* (Cat. 110).

78. *Ramsgate.* c. 1876.

London, Tate Gallery.

Pen & ink on blue-grey paper, $9\frac{3}{4} \times 13\frac{7}{8}$ (24.8 × 35.2).

PROV.: ? Charles Fairfax Murray, London; J.R. Holliday, Birmingham; bequeathed by J.R. Holliday, 1927.

LIT.: Providence/Toronto 1968 (27); Wentworth 1978, pp. 106, 108 & fig. 22a; Thomson 1982, p. 328, fig. 2.

Preparatory study for a drypoint and two paintings: see previous and following entries. The setting has been identified as a room in Goldsmid Place, now called Harbour Parade, Ramsgate (Providence/Toronto).

79. *Ramsgate.* 1876.

Private collection.

Drypoint, $9\frac{7}{8} \times 13\frac{3}{4}$ (25 × 35). Signed & dated b.r.: *J.J. Tissot / 1876.*

EXH.: Minneapolis 1978 (22) illus.

LIT.: Wentworth 1978, pp. 106–9; Wentworth 1984, pp. 99, 130 & pl. 117.

REF.: W. 22, B. 15, T. 16.

Drypoint after a pen and ink study, reversing the latter's composition. The woman in the centre wears a white muslin dress with lemon ribbons, which appears in numerous contemporary paintings by Tissot (e.g. *Holiday* (Cat. 96) and *Spring* (Cat. 101); see also p. 73).

80. *La Galerie du 'Calcutta' (Souvenir d'un bal à bord)* (*The Gallery of HMS Calcutta (Souvenir of a Ball on Shipboard)*). 1876.

Private collection.

Drypoint, $10\frac{1}{4} \times 14\frac{1}{8}$ (26 × 35.9). Signed & dated t.r.: *J.J. Tissot / 1876.*

LIT.: Wentworth 1978, pp. 118–21; Wentworth 1984, pp. 108, 135, 139–41 & 202 (on the painting).

REF.: W. 25, B. 18, T. 19.

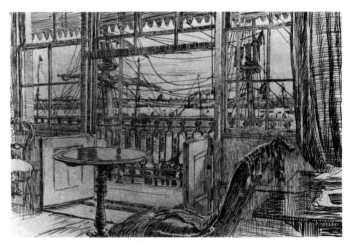

78

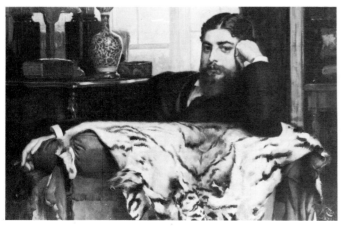

76

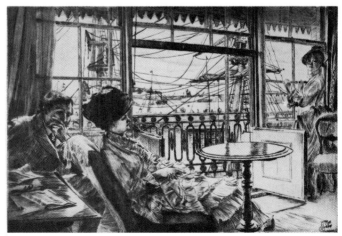

79

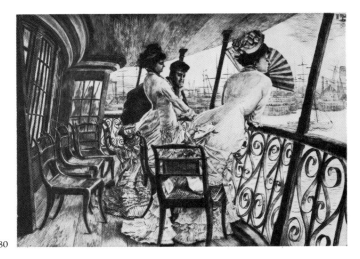

80

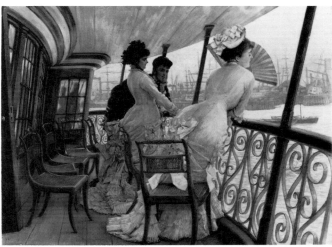

Fig. 51. *The Gallery of HMS Calcutta (Portsmouth)*. London, Tate Gallery

Drypoint after the oil painting, *The Gallery of HMS 'Calcutta' (Portsmouth)* (Fig. 51), exhibited at the Grosvenor Gallery in 1877 (19). The pose of the young woman in the foreground may reflect a French pun on the word 'Calcutta', *quel cul tu as*.

81. *The Thames*. 1876. (Colour Plate 15).
Wakefield Art Gallery and Museums.
Oil on canvas, 28½ × 46½ (72.5 × 118). Signed b.r.: *J.J. Tissot*.
PROV.: Mrs Newton (née Stella Mary Pearce), London, from whom purchased by the Wakefield Corporation, September 1938.
EXH.: RA 1876 (113); Sheffield 1955 (30) as *'How Happy could I be with either'* or *'On the Thames'*; AC 1955 (22); National Maritime 1977 (83).

LIT.: Providence/Toronto 1968 (64); Misfeldt 1971, pp. 158–9, 161–2 & fig. 83; Wentworth 1978, pp. 98–101 & fig. 20b; Thomson 1982, p. 329, fig. 4; Wentworth 1984, pp. 88, 94, 107–9, 120, 131, 134, 141, 201 & pl. 115.
With its grey smoky atmosphere, evocative of nineteenth-century London, and its striking composition, *The Thames* is today felt to be one of Tissot's best paintings. But when it was shown at the Royal Academy in 1876, it attracted a furore of criticism, which did considerable long-term damage to the critical reception of Tissot's paintings in England. *The Times* found it 'questionable material', the *Athenaeum* 'thoroughly and willfully vulgar' with 'ugly and low-bred women' who were described by the *Spectator* as 'undeniably Parisian ladies', while even the *Graphic* found it 'hardly

nice in its suggestions. More French, shall we say, than English?'. Tissot made an etching after the painting, with which it was exhibited at the Royal Academy in 1876.

82. *La Tamise* (*The Thames*). 1876.
London, National Maritime Museum.
Drypoint & etching, 9¼ × 14¼ (23.5 × 36.2). Signed & dated b.l.: *J.J. Tissot / 1876*.
EXH.: RA 1876 (1098).
LIT.: Providence/Toronto 1968 (64); Misfeldt 1971, p. 162 & fig. 84; Wentworth 1978, pp. 98–101; Wentworth 1984, pp. 121 & 200–01.
REF.: W. 20, B. 13, T. 14.

Etching, in the same direction, after the oil painting *The Thames* (Cat. 81) with which it was exhibited at the Royal Academy in 1876. See previous entry.

83. *Portsmouth Dockyard*. c. 1877. (Colour Plate 16).
London, Tate Gallery.
Oil on canvas, 15 × 21½ (38 × 54.5). Signed b.r.: *J.J. Tissot*.
PROV.: Henry Jump, Gateacre, Lancs.; James Jump, Ipswich; Capt. Henry Jump, Heytesbury; Christie's 26 April 1937 (44) as *Divided Attention*, bt. Leicester Galleries; Sir Hugh Walpole, London; bequeathed by Sir Hugh Walpole, 1941.
EXH.: Grosvenor Gallery 1877 (25); Leicester Galleries, *Victorian Life*, 1937 (106) as *Entre les deux mon coeur balance*, illus.

LIT.: Sitwell 1937, pp. 92, 118 & pl. 131; Misfeldt 1971, pp. 172–4 & fig. 94; Wentworth 1978, p. 140 & fig. 30a; Tate 1981, pp. 723–4 (5302) illus.; Warner 1982, p. 7, colour pl.; Thomson 1982, p. 329, fig. 5; Wentworth 1984, pp. 108, 141, 202 & pl. 125.
Following severe criticism of the unsavoury nature of *The Thames* (Cat. 81), Tissot painted this more acceptable version of the subject (as he was to do again with *The Hammock* (Cat. 123)). The theme of a man choosing between two pretty women had appeared in earlier pictures like *Boarding the Yacht* (Cat. 64), and the use of a soldier and of a recognizable naval setting, with Nelson's *Victory* in the background, was no doubt

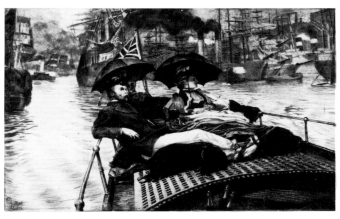

82

calculated to ensure that this painting received a better critical and public reception than *The Thames*. Tissot published an etching after the painting, entitled *Entre les deux mon coeur balance (How Happy I could be with Either)* (W. 30), and the painting was known by the French title until Misfeldt identified it with the *Portsmouth Dockyard* exhibited at the Grosvenor Gallery in 1877.

84. *Henley Regatta*. c. 1877.
Henley-on-Thames, Oxfordshire, The Leander Club.
Oil on canvas, 18¼ × 37¼ (46.5 × 94.5). Inscribed on a label on the stretcher: *J.J. TISSOT à Mrs GEBHARD*.
PROV.: Mrs Gebhard; N.C. Beechman Esq. by 1933; Mrs Emily Beechman by 1934; Walter Hutchinson, National Gallery of British Sports and Pastimes, by 1949; acquired by Leander Club, July 1951.

84

EXH.: Leicester Galleries 1933 (17); Henley-on-Thames Festival, *The Thames in Art*, 1967 (38); National Maritime 1977 (84).

LIT.: Laver 1936, pl. XVII; Roberts, Keith, *Painters of Light: The World of Impressionism*, 1978, p. 48 & pls. 42 & 43; Thomson 1979, p. 56 (illus.); Warner 1982, p. 20, colour pl.; Wentworth 1984, p. 129 & pl. 136.

This painting is a unique venture, among Tissot's larger works, into impressionist technique and a landscape rather than narrative subject. Tissot's only known oil studies of landscape are smaller, while a freer technique is restricted to studies for larger, more finished works. But this painting reflects Tissot's interest in human activity, and rowers later appear in the background of *Richmond Bridge* (Cat. 110), in *On the Thames* (or *The Return from Henley*, Newark Museum, USA; Warner 1982, p. 21, colour pl.), and in *The Prodigal Son in Modern Life: The Fatted Calf* (Cat. 153e and j).

An engraving after a later version of this painting by Frederic Vezin was published in 1886. The relationship between the two paintings has yet to be determined.

85. *The Triumph of Will: The Challenge*. c. 1877.
Besançon, private collection.
Oil on canvas. Signed.
PROV.: The artist, until his death in 1902; Mlle Jeanne Tissot, until her death in 1964; her sale, Château de Buillon 8–9 Nov. 1964.

EXH.: Grosvenor Gallery 1877 (22).

LIT.: Misfeldt 1971, pp. 168–70; Wentworth 1984, pp. 136–8, 140–1, 175 & 202.

Tissot's exhibits at the opening exhibition of the Grosvenor Gallery in 1877 included the first in an unfinished didactic series entitled *The Triumph of Will*. The *Challenge* foreshadows Tissot's later mystical and religious concerns and, in mood, relates to his bronze and *cloisonné* enamel fountain design, *Fortune* (Fig. 32) of 1882 (see p. 78). Will is shown as a fair woman with sword and armour, attended by Daring and Reserve, and striding over Vice who is half fair woman and half tiger. The scutcheon on the trees bears the motto, *Audere, volle, tacere*. (Information kindly supplied by Willard Misfeldt.)

This was the only Tissot painting in the exhibition to be praised by Ruskin, who dismissed his other exhibits as 'unhappily, mere coloured photographs of vulgar society', while praising their meticulous technique.

The heroic subject matter of *The Triumph of Will* was a rare departure on Tissot's part and was perhaps an attempt to reverse criticism of the 'trivial' nature of his work. However, despite being a prolific and fast painter, he never finished the series (which was to include *The Temptation*, *The Rescue*, *The Victory* and *The Reward*), perhaps because of the cool critical reception of *The Challenge*.

A study is known for the figure wearing a tiger-skin, representing Daring (private collection, Wentworth 1978, Fig. 83a), and a related painting, presently titled *La Femme préhistorique* (Besançon, private collection, *L'Oeil* Nov. 1974, p. VI) showing a woman in a wooded landscape wearing a tiger-skin and carrying a staff, with another similar figure by the banks of the river in the distance.

86. *Deuxième frontispice (Assise sur le globe)* (*Second Frontispiece (Sitting on the Globe)*). 1875.
Private collection.

Drypoint, $9\frac{15}{16} \times 6\frac{3}{8}$ (25.2 × 16.2). Signed & dated b.l.: *J.J. Tissot / 1875*.
EXH.: Minneapolis 1978 (11) illus.
LIT.: Wentworth 1978, pp. 72–3 & 68–71, 74–5.
REF.: W. 11, B. 5, T. 5.

Throughout his career, Tissot painted and etched very few nudes, and his understanding of anatomy was none too good. This print is one of three drypoints of nude young women, crowned

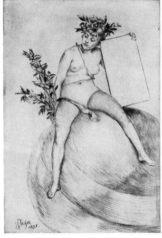

86

with laurel leaves, holding large plaques, which were trials for a frontispiece to Tissot's portfolio of ten etchings, published 1876–7; the artist finally settled on a different subject for the frontispiece, *L'Auberge des Trois Corbeaux* (W. 29). For the other two figural frontispieces, see Wentworth 1978, Cats. 10 and 12.

87. *Une Convalescente* [A Convalescent]. 1875.

Paris, Bibliothèque Nationale.
Drypoint & etching, $10\frac{7}{8} \times 14\frac{5}{8}$ (27.6 × 37.2). Signed & dated b.r.: *J.J. Tissot / 1875*.
PROV.: Bequeathed by the artist, 1902.
EXH.: Minneapolis 1978 (6) illus.
LIT.: Wentworth 1978, pp. 52–5.
REF.: W. 6 (not in B. or T.).

This is the only known impression of Tissot's first known London print. It repeats, in reverse, the young woman on the right in the painting *A Convalescent* (Cat. 95), exhibited at the Royal Academy in 1876, and therefore appears to be the first instance where Tissot re-uses a painting for a print (see p. 57). The theme of convalescence was to recur in Tissot's work throughout his London career.

88. *La Convalescente* (*The Convalescent*). 1875.
Charles Jerdein.
Drypoint & etching, $8\frac{3}{16} \times 6\frac{5}{16}$ (22.5 × 16.2). Signed & with monogram b.l.: *JJT / J.J. Tissot*.

88

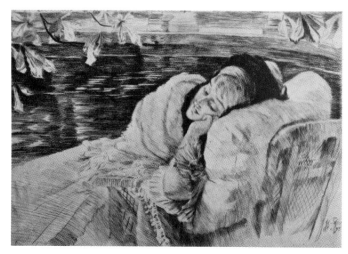

87

EXH.: Minneapolis 1978 (7) illus.
LIT.: Wentworth 1978, pp. 56–9.
REF.: W. 7, B. 1, T. 1.
Tissot's first published print, exhibited several times throughout his career and probably included in the small number of etchings which Tissot showed at Durand-Ruel's in Paris at the *Exposition des ouvrages noir et blanc*, 1876. No related painting is known at present.

89. *La Dormeuse* (*Sleeping*). 1876.
Private collection.
Drypoint, $4\frac{1}{4} \times 7\frac{5}{8}$ (10.8 × 19.4).
 Signed b.r.: *J.J. Tissot*.
LIT.: Wentworth, Michael, 'Tissot's "La Dormeuse"', *Currier Gallery of Art Bulletin*, Jan–March 1970 n.p.; Wentworth 1978, pp. 88–9.
REF.: W. 17, B. 10, T. 10.
Though Wentworth links the costume in this drypoint with that in some of Tissot's neo-eighteenth-century pictures, the model in fact wears fashionable dress and the hat is a favourite one of Tissot's, which appears in numerous modern-dress paintings. The composition and subject are related to a gouache, *Woman Asleep* (Cat. 69), though no related oil painting is known.

90. *Matinée de printemps* (*Spring Morning*). 1875. (Fig. 24).
Private collection.
Drypoint, $19\frac{15}{16} \times 11$ (50.6 × 27.9).
 Signed & dated b.r.: *J.J. Tissot / 1875*.
EXH.: One such print at Dudley Gallery B/W 1876 (56).
LIT.: Providence/Toronto 1968 (67); Wentworth 1978, pp. 76–9; Wentworth 1984, p. 138n.
REF.: W. 13, B. 7, T. 7.
A drypoint with minor variations after an oil painting (private col-

lection, Fig. 23), see pp. 56–7. The costume and hat are repeated in several other pictures (see p. 73), while the setting is re-worked in *Le Veuf* (Cat. 93).

91. *Femme à la fenêtre* (*Woman at a Window*). c. 1875.
Paris, Bibliothèque Nationale.
Etching, touched with ink, $21\frac{3}{4} \times 13\frac{3}{4}$ (55.4 × 35).
EXH.: Minneapolis 1978 (14) illus.
LIT.: Wentworth 1978, pp. 80–1.
REF.: W. 14 (not in B. or T.).
This trial proof is the only known impression of this print; the re-use of the costume seen in *Matinée de printemps* (Cat. 90) suggests a similar date. The bent-wood rocking chair and wicker armchair appear in many other pictures and are among Tissot's favourite studio 'props', while a painted oriental screen, like those which Tissot had in his Parisian collection, can be seen at the right. No related painting by Tissot is known for this print.

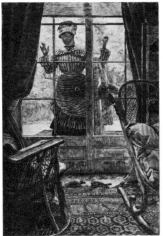

91

92. *Querelle d'amoureux* (*Quarrelling*). 1876.
Lady Abdy.
Etching & drypoint, $11\frac{7}{8} \times 7\frac{1}{8}$ (30.2 × 18.1). Signed & dated b.l.: *J.J. Tissot / 1876*.
LIT.: Providence/Toronto 1968 (63); Wentworth 1978, pp. 90–3.
REF.: W. 18, B. 11, T. 11.
This etching of a couple, posed beside the colonnade and pool that Tissot built in his garden at 17 Grove End Road, is taken directly from a painting of the same title (private collection; Wentworth 1984, pl. 97). The woman is dressed in some of Tissot's costume 'props' of c. 1875–6. The subject of the picture is underlined by the composition, the column physically separating the couple and hiding the man's face as the woman gazes into the pool and toys with her skirt. Tissot was fond of equating physical separation with spiritual or emotional distance (see Cats. 1 & 2), and also used weather as a metaphor of emotion – winter snow in *Promenade dans la neige*, 1858 (whereabouts unknown; Wentworth 1984, pl. 1) and a summer shower in *A Passing Storm*, c. 1876 (Fredericton, New Brunswick, Beaverbrook Art Gallery; Wentworth 1984, pl. 116).

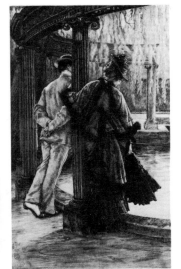

92

93. *Le Veuf* (*The Widower*). 1877.
Private collection.
Etching & drypoint, $13\frac{7}{8} \times 9$ (35.2 × 22.9). Signed & dated b.r.: *J.J. Tissot / 1877*.

EXH.: One such print at Dudley Gallery B/W 1877 (174), price £12.
LIT.: Providence/Toronto 1968 (68); Misfeldt 1971, pp. 170–1 & fig. 90; Wentworth 1978, pp. 130–3.
REF.: W. 28, B. 21, T. 22.
Etching, in the same direction, after the oil painting *The Widower* (Sydney, Art Gallery of New South Wales; Wentworth 1984, pl. 122) exhibited at the Grosvenor Gallery in 1877 (20), of which a smaller oil replica is known (British Rail Pension Fund, on loan to Detroit Museum of Fine Arts). The composition is similar to *Matinée de printemps* (Cat. 90; see p. 57) and the theme was to be repeated in *L'Orpheline*. (Cat. 122).

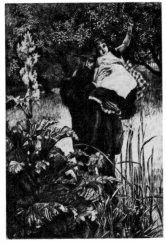

93

94. *Mon jardin à S.-John's Wood* (*My Garden in St. John's Wood*). 1878.
Lady Abdy.
Etching and drypoint, $7\frac{3}{8} \times 4\frac{1}{2}$ (18.7 × 11.4). Signed and dated b.l.: *1878 / J.J. Tissot*.
EXH.: One such print at Dudley Gallery B/W 1878 (242) as *A Colonnade*, price £3.3s. 0d; Grosvenor Gallery 1879 as *A Garden*.
LIT.: Eyre, Alan Montgomery, *Saint John's Wood: Its history, its houses, its haunts and its celebrities*, London: Chapman & Hall Ltd., 1913, illus. opp. p. 259 as *The Tissot colonnade*; Wentworth 1978, pp. 176–7.
REF.: W. 39, B. 35, T. 35.
One of the few pure landscapes in Tissot's oeuvre, showing the Hadrian's villa-type pool and colonnade (the latter similar to one in the Parc Monceau, Paris) which Tissot built in the large

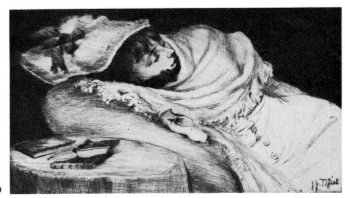

89

garden of his house at 17 (now 43) Grove End Road, St. John's Wood. The colonnade particularly appealed to the next occupant of the house, Alma-Tadema, but was pulled down in the 1940s to make room for garages. Though this etching is not directly related to any known painting, the pool and colonnade appear in many of Tissot's pictures c. 1875 onwards (e.g. *A Convalescent* (Cat. 95), *Querelle d'Amoureux* (Cat. 92), and *Holyday* (Cat. 96)).

94

95. *A Convalescent. c. 1875–6.* (Plate 19).
Sheffield City Art Galleries.
Oil on canvas, $30\frac{1}{4} \times 39\frac{1}{4}$ (74.9 × 97.8). Signed b.l.: *J.J. Tissot.*
PROV.: Christie's 21 Jan. 1949, bt. Fine Art Society.
EXH.: RA 1876 (530); Sheffield 1955 (27) illus. pl. III; AC 1955 (20).
LIT.: Providence/Toronto 1968 (26); Misfeldt 1971, pp. 160–1; Wentworth 1978, pp. 52, 54 & fig. 6a; Wentworth 1984, pp. 94, 112, 120, 128, 130, 139, 162, 167, 201 & pl. 113.
The young convalescent and her chaperone are posed beneath the chestnut trees, beside the pool and colonnade in Tissot's Grove End Road garden. A hat and cane on the left-hand wicker chair suggest the temporary absence of a male companion. This painting was shown at the Royal Academy in 1876 and could almost be a pendant to one of Tissot's Grosvenor Gallery exhibits of the following year, *Holyday* (Cat. 96), which uses the same setting from a slightly different viewpoint,

the two pictures depicting sickness and rude health respectively. Tissot's first London etching, *Une convalescente* (Cat. 87), 1875, reuses the figure of the young convalescent in reverse and is the first instance of Tissot's later frequent derivation of etchings from his own paintings.

96. *Holyday (The Picnic). c. 1876.* London, Tate Gallery.
Oil on canvas, $30 \times 39\frac{1}{8}$ (76.5 × 99.5). Signed b.r.: *J.J. Tissot.*
PROV.: James Taylor; with or through Thos. McLean Ltd., London; purchased from Thos. McLean Ltd. (Clarke Fund), 1928.
EXH.: Grosvenor Gallery 1877 (23); Sheffield 1955 (24) as *The Picnic*; AC 1955 (25); Providence/Toronto 1968 (26) illus.
LIT.: Laver 1936, pl. XXIII; Misfeldt, 1971 pp. 171–2 & fig. 91; Wood 1976, p. 179 & pl. 191; Tate 1981, pp. 722–3 (4413) illus.; Warner 1982, p. 17, colour pl.; Wentworth 1984, pp. 120, 130, 139, 202 & pl. 123.
Holyday was among ten pictures exhibited by Tissot at the first Grosvenor Gallery exhibition in 1877. Set in the garden of his Grove End Road house like *A Convalescent*, to which it could almost be a pendant, friends and professional models are posed in a variety of costume 'props' from Tissot's studio wardrobe, enjoying a summer picnic. Oscar Wilde described them as 'over-dressed, common-looking people' and be-

96

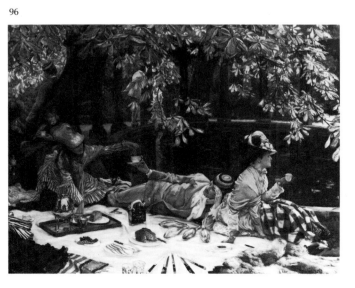

wailed the 'ugly, painfully accurate representation of modern soda water bottles', while a critic in the *Yorkshire Post and Leeds Intelligencer*, 9 May 1877, commented on the 'unhealthy looking pool and luxuriant vegetation'. The cricketers in striped caps are members of the I Zingari cricket club: Tissot's house was very near to Lord's cricket ground.

A picture exhibited at the Leicester Galleries 1937 (4) was described as a study for the Tate Gallery *Picnic*, but may well have been related to a later painting of the same theme (see *Déjeuner sur l'herbe*; Cat. 131); the appearance and present whereabouts of the study are unknown.

97. *The Letter (La Lettre). c. 1876–8.* (Colour Plate 18).
Ottawa, The National Gallery of Canada.
Oil on canvas, $28\frac{1}{4} \times 42\frac{1}{4}$ (71.8 × 107.3). Signed & indistinctly dated on base of urn at right: *J.J. Tissot 18(78)?*.
PROV.: The Hon. Mrs Basil Ionides; Sotheby's 29 May 1963 (170); acquired by National Gallery of Canada, 1964.
EXH.: Sheffield 1955 (34); Providence/Toronto 1968 (29) illus.
LIT.: Reynolds 1953, pl. 100; Wentworth 1984, pp. 20, 111, 130, 139, 141 & pl. 114.
The setting is probably Tissot's garden and the servant may well be the one described sarcastically by Goncourt as 'a footman in silk stockings brushing and shining

the shrubbery leaves' (see p. 14). The young woman wears clothes also seen in *Querelle d'amoureux* (Cat. 92) and worn by the old lady in *A Convalescent* (Cat. 95).

Letters were a favourite theme among nineteenth-century painters, as they are full of narrative implication. Tissot had added a letter in *L'Escalier* (Cat. 22), suggesting the absence or imminent arrival of a loved one.

98. *Mavourneen.* 1877.
Private collection.
Etching and drypoint, $14\frac{3}{4} \times 8$ (37.5 × 20.3). Signed and dated b.r.: *J.J. Tissot / 1877.*
EXH.: Minneapolis 1978 (31) illus.
LIT.: Providence/Toronto 1968 (69); Wentworth 1978, pp. 142–5; Wentworth 1984, pp. 143, 202, & pl. 129.
REF.: W. 31, B. 24, T. 27.
This etching was based on an oil portrait of Kathleen Newton (whereabouts unknown, Sotheby's 14 Nov. 1973 (36); Wentworth 1978, fig. 31c) and the title of the print was taken from a popular Victorian song, *Kathleen Mavourneen.* Mrs Newton wears the same embroidered jacket as in *October* (Cats. 99, 100) and the print *Portrait de M.N.* (W. 26). She is posed against the light before a window in Tissot's studio, a compositional device seen in the earlier print, *À la Fenêtre* (Cat. 51). A reduced heliogravure of the plate was published by the Galerie Georges Petit in the 1880s.

98

99. *October.* 1877. (Frontispiece).
The Montreal Museum of Fine Arts.
Oil on canvas, $85\frac{1}{4} \times 42\frac{1}{8}$ (216.5 × 108.7). Signed & dated b.l.: *J.J. Tissot / 1877.*
PROV.: London (?) McLean; Christie's 20 May 1882, bt. Polak for £139.13s.; William Lee, London; Christie's 22–23 June 1888 as *Autumn*, bt. Koekkoek, Holland; Lord Strathcona (Donald Smith), Montreal, to 1914; donated to Montreal Museum of Fine Arts by Lord Strathcona & family, 1927.
EXH.: Providence/Toronto 1968 (ex. cat.).
LIT.: Misfeldt 1971, fig. 100; Wentworth 1978, pp. 150, 152, & fig. 33a; Wentworth 1984, pp. 143–4.
This is one of Tissot's largest paintings. It shows Kathleen Newton, caught in motion with a swish of frothy pleats and petticoats revealing a 'well-turned ankle', inviting the spectator to follow her into the picture. The 'Japanese' composition of a single, silhouetted figure is particularly effective where dark clothes are set off by a colourful sunlit background, as here and in *La Dame à l'ombrelle.*

The composition was reproduced in an etching and a small oil replica of the painting is known (whereabouts unknown, Wentworth 1984, pl. 130).

100. *Octobre* (*October*). 1878.
Lady Abdy.

100

Etching & drypoint, $21\frac{9}{16} \times 10\frac{15}{16}$ (54.8 × 27.8). Signed & dated t.r.: *J.J. Tissot / 1878.*
EXH.: One such print at Grosvenor Gallery 1878 (155); Dudley Gallery B/W 1879 (179).
LIT.: Wentworth 1978, pp. 150–3; Wentworth 1984, pp. 143 & 202.
REF.: W. 33, B. 26, T. 29.
The relative size of this etching reflects the size of the original painting, *October* (Cat. 99), one of Tissot's largest pictures. Both painting and etching were exhibited at the Grosvenor Gallery in 1878, together with the etching *Mavourneen* (Cat. 98), in which Kathleen Newton wears the same jacket and hat.

101

101. *Spring (Specimen of a Portrait). c.* 1878.
Private collection.
Oil on paper, laid down on panel, $24 \times 9\frac{1}{2}$ (60.96 × 24.13). Signed b.r.: *J.J. Tissot.*
PROV.: Robert Frank; Mr and Mrs G.D. Sacher; Christie's 29 Feb. 1980 (175); New York, Stair Sainty Fine Art Inc.
EXH.: ? Grosvenor Gallery 1878 (31); London, Redfern Gallery, *Plaisirs de l'epoque 1900*, 1954

(8); Sheffield 1955 (25) as *La Femme à la robe blanche.*
LIT.: Wentworth 1978, pp. 154–7 (on the etching after the painting); Wentworth 1984, pp. 138, 142–4, 202 & pl. 131.
This is either the painting exhibited at the Grosvenor Gallery in 1878 or a smaller replica (another version of the subject is not known at present). The composition was repeated in an etching, which was shown along with the painting at the Grosvenor Gallery exhibition. The white muslin dress with lemon ribbons was a favourite costume 'prop' of Tissot's and had appeared several times in earlier works before Kathleen Newton posed in it for this painting.

102. *Printemps* (*Spring*). 1878.
Lady Abdy.
Etching & drypoint, $15 \times 5\frac{5}{16}$ (38.1 × 13.5). Signed t.r.: *J.J. Tissot.*
EXH.: One such print at Grosvenor Gallery 1878 (158).
LIT.: Wentworth 1978, pp. 154–7; Wentworth 1984, pp. 144 & 203.

102

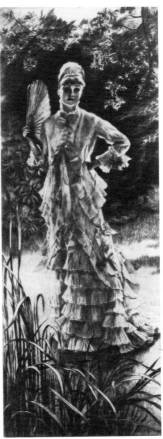

REF.: W. 34, B. 27, T. 30.
Etching after the painting, *Spring (Specimen of a Portrait)* (Cat. 101), with which it was exhibited at the Grosvenor Gallery in 1878. Tissot's experimentation with long, narrow formats, inspired by Japanese *hashira-e* prints, is seen likewise in *Au Bord de la mer* (Cat. 120), *La Dame à l'ombrelle* (Cat. 103) and a painted variant of *La Soeur aînée* (Fig. 58). See also entry for *October* (Cat. 99).

103. *La Dame à l'ombrelle, Mme Newton* [Woman with a parasol, Mrs Newton]. *c.* 1878. (Colour Plate 17).
Gray, Musée Baron Martin.
Oil on canvas, $56 \times 18\frac{3}{4}$ (142 × 54).
PROV.: Edmond Pigalle; bequeathed by Edmond Pigalle to the Musée Baron Martin, 1921.
EXH.: Tokyo/Osaka/Fukuoka 1979–80 (15) illus., colour pl. p. 177; Gray etc. 1983–4 (75) illus.
LIT.: Wentworth 1978, pp. 186, 188 & fig. 43a; Wentworth 1984, p. 147 & pl. 140.
This striking portrait of Mrs Newton with a parasol, for which no contemporary title has been preserved, is the most oriental of Tissot's oil paintings. Her slim, black-clad figure, relieved only by the splash of a red posy, is set off against the bright yellows and greens of an abstract, sunlit garden background, the open parasol framing her head and shoulders. Tissot was very familiar with Japanese prints and paintings, where figures with crisp, sinuous outlines were silhouetted against plain or decorative backgrounds thus gaining greater impact, though he did not use this knowledge fully in his art until the late 1870s. It is seen at its best in this painting, and also in *October* (Cat. 99). The figure of Kathleen Newton with a parasol was re-used in *The Gardener* (Fig. 68) and the head, shoulders and upper torso, silhouetted against the open parasol, was the basis for the etching *L'Été* (Cat. 104).

104. *L'Été* (*Summer*). 1878.
London, British Museum.
Etching & drypoint, $14\frac{13}{16} \times 8\frac{3}{16}$ (37.6 × 20.8). Signed & dated b.r.: *J.J. Tissot / 1878.*
EXH.: One such print at Grosvenor Gallery 1879 (282); Dudley Gallery B/W 1879 (309).

LIT.: Wentworth 1978, pp. 186–9; Wentworth 1984, pp. 147 & 203.

REF.: W. 43, B. 35, T. 39.

No painting is known at present that directly corresponds to this etching, though two related paintings are known that show Kathleen Newton in the same dress, with head and shoulders silhouetted against an open parasol: *La Dame à l'ombrelle* (Cat. 103) and *The Gardener* (Fig. 68). The dress appears in a number of other contemporary paintings and prints. Personification of the seasons as in *L'Été* and *Printemps* (Cat. 102) was a favourite theme among artists on both sides of the Channel.

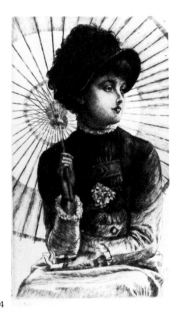

104

105. *Juillet* (*July*). *c*. 1878.
Paris, Bibliothèque Nationale.
Etching, $13\frac{15}{16} \times 9$ (35.3 × 22.8).
EXH.: Minneapolis 1978 (35) illus.
LIT.: Wentworth 1978, pp. 158–61; Wentworth 1984, p. 144n.
REF.: W. 35 (not in B. or T.).
This trial proof is the only known impression of this print after the oil painting *July (Specimen of a Portrait)* (New York, private collection; Wentworth 1984, pl. 132), which was exhibited at the Grosvenor Gallery in 1878 (34) and also had the title *Seaside*. A replica of the painting, with minor variations and subsequently altered hairstyle, is also known (Ohio, private collection; Wentworth 1978, fig. 35b).

105

106. *Evening* (*Le Bal*). *c*. 1878.
Paris, Musée d'Orsay.
Oil on canvas, $35\frac{1}{4} \times 19\frac{1}{4}$ (90.2 × 50.2). Signed b.r. *J.J. Tissot*.
PROV.: Musée du Luxembourg.
EXH.: Grosvenor Gallery 1878 (33); Manchester, Royal Institution, 1878.
LIT.: Misfeldt 1971, pp. 178 & 185–7; Wentworth 1984, pp. 143, 162 & 202.
Misfeldt has identified this painting with the work exhibited by Tissot at the Grosvenor Gallery in 1878 (33) entitled *Evening*, from contemporary reviews. A critic in *The Times* described the scene as a 'west-end *soirée*' and noted the 'daring "arrangement"' of the young woman in the foreground, 'in which yellow predominates in head-gear, fan, and dress, all of

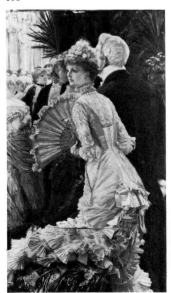

106

the most pronounced fashion of modern millinery, a figure worthy of Worth' (2 May 1878). Tissot later re-used the composition for *L'Ambitieuse* (Cat. 165), one of the *Femme à Paris* series of paintings, substituting a different model for Kathleen Newton and changing the yellow dress for a similar pink one.

107. *The Warrior's Daughter* (*The Convalescent*). *c*. 1878.
City of Manchester Art Galleries.
Oil on panel, $14\frac{1}{4} \times 8\frac{11}{16}$ (36.2 × 21.8). Signed b.r.: *J.J. Tissot*.
PROV.: Purchased from the Leicester Galleries, 1925.
EXH.: ? Dudley Gallery 1879 (191), price £125; Sheffield 1955 (28); David Carrit Ltd., *Some Masterpieces from Manchester City Art Gallery*, 1983 (27) illus.

107

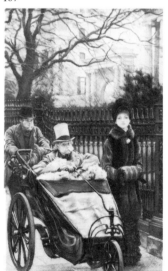

LIT.: Misfeldt 1971, fig. 86; Wentworth 1978, pp. 172, 174 & fig. 38a; Warner 1982, p. 18, colour pl.; Wentworth 1984, pp. 133–4 & pl. 152.

Previously called *The Convalescent*, this painting was identified by Julian Treuhertz with a picture exhibited at the Dudley Gallery in 1879, described in the *Athenaeum*, 27 November, as 'a battered old officer riding in a bathchair and attended by a young lady who is not always under her father's eye'. A second, slightly smaller autograph version is known (Christie's 25 May 1979 (242) illus.; Laver 1936, pl. XIX) and it is not clear which of the two was exhibited at the Dudley Gallery. A further replica is also known (whereabouts unknown, illus. *Connoisseur*, December 1977, p. 89).

108. *Cumberland Terrace, Regent's Park*. *c*. 1878.
London, Bury Street Gallery.
Oil on canvas, $12\frac{1}{2} \times 17\frac{1}{4}$ (31.8 × 43.9). Signed t.l.: *J. Tissot*.
PROV.: Sotheby's 3 April 1968 (102); H. Shickman Gallery, New York; Christie's 26 March 1982 (101).
LIT.: Wentworth 1978, pp. 172, 175 & fig. 38b; Wentworth 1984, p. 133 & pl. 153.

This is a study for the background of the painting *The Warrior's Daughter* (Cat. 107). Regents Park was no doubt a favourite haunt of Tissot's, being not far from his house in St. John's Wood; another Regency terrace appears in *Le Joueur d'orgue* (Cat. 109).

108

109. *Le Joueur d'orgue* (*The Organ Grinder*). 1878.
London, Bury Street Gallery.
Etching & drypoint, $10\frac{3}{8} \times 6\frac{1}{2}$ (263 × 165). Signed & dated b.l.: *J.J. Tissot / 1878*.
LIT.: Wentworth 1978, pp. 172–5.
REF.: W. 38, B. 30, T. 34.
EXH.: One such print at Dudley Gallery B/W 1878 (240), price £4.4s.0d.
Similar Regency architecture appears in the background of *The Warrior's Daughter* (Cat. 107), for which an oil study is known (Cat. 108).

109

110. *Richmond Bridge. c.* 1878. (Colour Plate 5).
Private collection.
Oil on canvas, $14\frac{1}{2} \times 9\frac{1}{4}$ (37 × 23.5). Signed b.l.: *J.J. Tissot.*
PROV.: Phillips, New York 16 Feb. 1982 (164) as *Mrs Newton beside the Thames at Richmond*; Stair Sainty Fine Art Inc., New York.
LIT.: Phillips, *The Auction Year 1982/3*, colour pl., n.p.; Wentworth 1984, p. 133.
This is one of several pictures featuring Kathleen Newton in various outdoor locations. She is seen here in the outdoor toilette she wears in *The Warrior's Daughter* (Cat. 107), sitting beside a man on a bank near Richmond Bridge. There is a grisaille oil sketch (Fig. 52) for the figure of the man, perhaps Frederick Kelly (see *Uncle Fred*, Cat. 133), on the reverse of which is a grisaille sketch of Kathleen Newton used for *Room Overlooking the Harbour* (Cat. 77). The composition may have been based on photographs: a similar Thames-side picture,

Fig. 52. *Study of a man.* Dijon, Musée Magnin

The Artist, Mrs Newton and her Niece, Lilian Hervey, by the Thames at Richmond (whereabouts unknown, Warner 1982, p. 19, colour pl.), which shows a man, perhaps Frederick Kelly, writing 'I love you' on the ground, takes the figure of Lilian Hervey from the photographs posed in Tissot's garden (Cats. 145d, 146c). A contemporary picture, *Kew Gardens* (Fig. 53 (Album, III/6), gouache replica sold Kennedy Wolfenden & Co. Ltd. at Dunadry Inn Hotel, Co. Antrim, 15 May 1984 (114)), shows Kathleen

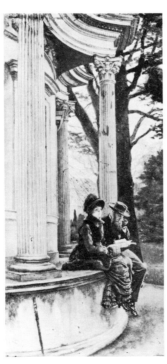

Fig. 53. *Kew Gardens.* Whereabouts unknown

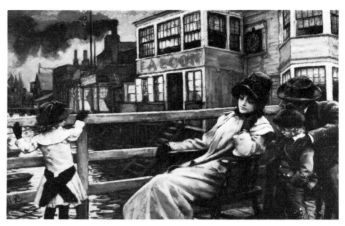

Fig. 54. *Waiting for the Ferry.* Brussels, private collection

Newton sitting on the podium of Chambers's Temple of the Sun beside the bearded man who appears in several other paintings (e.g. *A Convalescent*, Cat. 95).

111. *Waiting for the Ferry. c.* 1878. (Colour Plate 20).
Samuel A. McLean.
Oil on panel, 10 × 14 (26.7 × 35.6). Signed b.l.: *J.J. Tissot.*
PROV.: Leicester Galleries by 1936, again until *c.* 1953; Mr Alec Guinness *c.* 1955; Christie's 13 May 1977 (173) as *Waiting for the Boat at Greenwich*, bt. Owen Edgar Gallery; Roy Miles Fine Paintings.
EXH.: Leicester Galleries 1937 (1) as *Waiting for the Boat at Greenwich*, illus.; Sheffield 1955 (39).
LIT.: Laver 1936, pl. XX; Providence/Toronto 1968 (31); Wentworth 1984, pp. 131, 133–4 & pl. 118.
Tissot painted three versions of this subject: one, *c.* 1874, shows

a woman in the vertical-striped tunic of *The Ball on Shipboard*, with a bearded man and child (Louisville, J.B. Speed Museum; Wentworth 1984, pl. 111); the second (Fig. 54), based on photographs posed in Tissot's garden (Cats. 145d, 146c), depicts a tired Kathleen Newton with her son, Cecil George, niece, Lilian Hervey, and a man, perhaps Frederick Kelly. In this third version, Kathleen sits alert beside the same man, wearing the caped coat and travelling veil which appear in other Tissot pictures on the theme of travel, her baggage ready with the favourite red check shawl on top. The figures were probably based on photographs, as in Fig. 55, and the setting was taken from a pencil and gouache study made on the spot, perhaps at the time of the first version (see the following entry).

112. *The Falcon Tavern, Gravesend. c.* 1874–8.
Museum of London.

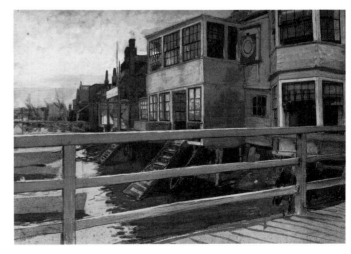

112

Pencil & watercolour with body-colour, 15 × 21 (38 × 53).

PROV.: In the artist's possession until his death, 1902; the artist's niece, Jeanne Tissot, until her death in 1964; Château de Buillon sale, 8–10 Nov. 1964; Sotheby's 15 June 1982 (71).

A study of the tavern and riverside, used as a background for three oil paintings c. 1874–8 (see the previous entry). The Falcon Inn, first mentioned in 1622, was situated in East Street and was timber fronted, with bay windows reaching over the river and with a balcony and bridge between them. During a serious gale in 1881, the wooden front was washed away and in 1888 the inn was rebuilt in red brick, that building being demolished in 1961. A second gouache study, showing the inside of the tavern (private collection, Sotheby's 15 June 1982 (72) illus.) was the basis for a watercolour, *L'Auberge du Falçon à Gravesend*, exhibited by Tissot at the Société d'Aquarellistes, Paris, in 1886 (recorded in Tissot's albums, IV/I).

113. *Trafalgar Tavern, Greenwich.* 1878.

Charles Jerdein.

Etching & drypoint, $13\frac{7}{8} \times 9\frac{5}{8}$ (35.2 × 24.4). Signed & dated b.l.: *J.J. Tissot / 1878*.

a). First published state, with the sky blank.

b). Second published state, with the addition of storm clouds with rays of light breaking through.

PROV.: b). One of a set of prints kept by the artist and displayed in the long gallery of the Château between his collection of Roman portrait busts; the artist's niece, Jeanne Tissot, until her death in 1964; Sotheby's 17 June 1982 (281).

EXH.: One such print at Grosvenor Gallery 1879 (281); Dudley Gallery B/W 1879 (35) price £5.5s.0d.

LIT.: Providence/Toronto 1968 (71); Wentworth 1978, pp. 162–7.

REF.: W. 36, B. 28, T. 31. (first state), 32 (second state).

First and second states of the etching based on a pen and ink drawing in the collections of the Fogg Art Museum, Harvard University (Wentworth 1978, fig. 36c). The tavern was also used as the setting for an oil painting,

The Terrace of the Trafalgar Tavern, Greenwich (whereabouts unknown, Wentworth 1984, pl. 121).

114. *Le Portique de la Galerie Nationale à Londres (The portico of the National Gallery, London).* 1878.

Charles Jerdein.

Etching and drypoint, $14\frac{7}{8} \times 8\frac{1}{4}$ (37.8 × 20.9). Signed and dated on the step b.r.: *1878 J.J. Tissot*.

EXH.: One such print at Grosvenor Gallery 1879 (283); Dudley Gallery B/W 1879 (352) as *A portion of the National Gallery*, price £6.6s.0d.

LIT.: Providence/Toronto 1968 (72); Misfeldt 1971, fig. 105; Wentworth 1978, pp. 178–81; Wentworth 1984, pp. 117n, 133–4n & 203.

REF.: W. 40, B. 32, T. 36.

This etching is based on one of Tissot's most striking compositions, *London Visitors*, 1874 (Toledo, Ohio, Museum of Art;

113a

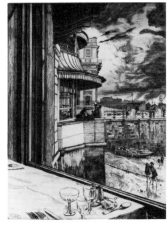

113b

Wentworth 1984, pl. 106) for which a replica is known (Milwaukee Art Center, Layton Art Gallery; Wentworth 1978, fig. 40c). The composition is narrower and taken from a slightly lower viewpoint, but the architecture refrains from being dominant because of the prominent figure of Kathleen Newton in the foreground. One of the background groups of figures in the portico has been retained from the painting, though the pose of both figures and the woman's dress have been altered.

114

115. *Going to Business (Going to the City).* c. 1879.

The Edmund J. and Suzanne McCormick Collection.

Oil on panel, $17\frac{1}{4} \times 10$ (43.8 × 25.4). Signed on kerb b.r.: *J.J. Tissot*.

PROV.: ? Sir J. Gomer Berry, Bart.; The Rt. Hon. The Viscount Kemsley; Sotheby's 9 March 1976 (50) as *Going to the City*, bt. Alexander Gallery; Christopher Wood Gallery, from whom bt. 1977.

EXH.: ? Grosvenor Gallery 1879 (98) as *Going to Business*; ? Tooth's 1879 (37) as *Going to the City*; ? Leicester Galleries 1933 (14), lent by Sir J. Gomer Berry, Bart., illus.; Sheffield 1955 (36); Guildhall Art Gallery, *London and the Greater Painters*, 1971 (33); Alexander Gallery, *Victorian Panorama*, 1976 (24); Yale Center for British Art, *The Edmund J. and Suzanne McCormick Collection*, 1984 (38) illus.

LIT.: Laver 1936, pl. XXV; Wentworth 1984, pp. 132, 148, 203 & pl. 151.

This painting reflects Tissot's penchant for monumental architectural backgrounds and for the theme of travel. He used several different London locations for a number of pictures, including Gravesend, Greenwich, Kew and Regents Park, and St. Paul's Cathedral appears in the background of *The Lord Mayor's Show* (Cat. 116). When shown at the Grosvenor Gallery in 1879 together with *A Quiet Afternoon* and *The Hammock*, a *Punch* critic could not resist wickedly renaming the former *The Naughty Old Man; or, I'll tell your Wife how you spend your Afternoons in Fair Rosamund's Bower-Villa, N.W.*, and tagging *Going to Business* with the ditty 'Drive on, Cabby! / Ah! is she good, / She of the Abbey / Road, St. John's Wood?'

It is not clear whether the exhibited painting is that shown at the Grosvenor Gallery, or a replica.

115

116. *The Lord Mayor's Show.* c. 1879.

London, Guildhall Art Gallery.

Oil on canvas, $84\frac{1}{2} \times 43$ (214.6 × 109.2).

PROV.: Given by the artist to the Curator of the Musée du Luxembourg; by descent to the latter's grand-daughter, Mme Léonce Bénédite, from whom it was purchased by the Corporation of London through S.C. L'Expertise, Paris, in 1972. This painting of a civic procession shows what appear to be the Master of a Livery Company and a Prime Warden in a carriage, a Beadle marching beside, followed by a military police escort and the Lord Mayor's state coach coming down Ludgate Hill, with St. Martin's Church and St. Paul's Cathedral in the distance. The proliferation of flags echoes their decorative use by Tissot in other paintings (see Cat. 66). It is not known whether this was a specific commission, which might warrant its comparatively large size.

117

Tissot painted several variants of this theme, based on studies made during a visit to Paris with Kathleen Newton in 1879, no doubt one of several such visits. One variant of this composition was narrower, with only two people (Fig. 55 (Album, III/48), Sedelmeyer Sale, Paris 1907 (99)). A grisaille oil study for the figure of Kathleen Newton in the exhibited picture is known (Melbourne, private collection; Christie's New York 26 May 1977 (47) illus.).

A watercolour version, with a larger group of figures in a different part of the Louvre, was exhibited at the Société d'Aquarellistes Français in 1883 (see the following entry).

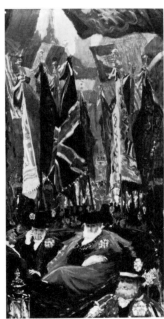

116

117. *Visiteurs étrangers au Louvre* [Foreign Visitors to the Louvre]. c. 1880.
New York, private collection.
Oil on canvas, 14½ × 10½ (36.9 × 26.7). Signed b.l.: *J.J. Tissot.*
PROV.: Sotheby's 10 July 1973 (62) as *Visiting the Louvre*; H. Shickman Gallery, New York.
EXH.: ? Liverpool, Walker Art Gallery, 10th Autumn Exhibition of Modern Pictures, 1880 (1720).
LIT.: Misfeldt 1971, p. 182; Wentworth 1984, p. 163 & pl. 195.

Fig. 55. *Visiteurs étrangers au Louvre.* Whereabouts unknown

118. *Au Louvre (Visiteurs étrangers au Louvre)* [Foreign Visitors to the Louvre]. c. 1879–80.
London, private collection.
Watercolour, 16¼ × 8¾ (41.3 × 22.2). Signed b.l.: *J.J. Tissot.* Old exhibition label on back marked *Au Louvre.*
PROV.: The artist, until his death in 1902; Mlle Jeanne Tissot, the artist's niece, until her death, 1964; her sale, Château de Buillon, 8–9, 14–15, 21–2 (57); Martyn Gregory.
EXH.: Paris, Société d'Aquarellistes Français, 1883 (3).
LIT.: Wentworth 1984, p. 163.
This watercolour is more probably the one exhibited at the Société d'Aquarellistes than the one illustrated in Wentworth 1984, pl. 194. An unlocated oil version is known (Wentworth 1984, p. 163n) and there is an oil study for the setting without people (Paris, Musée d'Orsay), similar to an oil study of a different part of the Louvre used in *L'Esthetique* (Cat. 173), both of which are mentioned in a letter written by Tissot in 1879 (information from Willard Misfeldt).

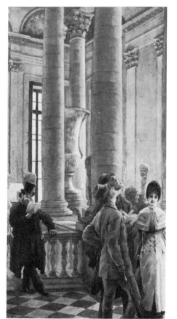

118

119. *Promenade dans la neige (A Winter's Walk).* 1880.
Private collection.
Etching & drypoint, 22⅜ × 10⅜ (56.8 × 26.3). Signed & dated b.r.: *J.J. Tissot / 1880.*

LIT.: Wentworth 1978, pp. 204–13.
REF.: W. 48, B. 47, T. 43 (first state).
The exhibited print is the first of three published states, before the addition of a text from Keats in the title margin: 'She will bring in spite of frost / Beauties that the earth hath lost.' The etching is taken directly from a portrait of Kathleen Newton (whereabouts unknown, Christie's 22 January 1965, bt. Leger Galleries; Wentworth 1978, fig. 48f). A large number of trial proofs are known (Wentworth 1978, 48a–e and Bury St. 1981 (11a)). This is one of several personifications of Kathleen Newton as one of the months or seasons (see, for example, *Spring* (Cat. 101), *July* (Cat. 105) and *October* (Cat. 99)).

119

120. *Au Bord de la mer (At the Sea Side).* 1880.
Charles Jerdein.
Etching & drypoint, 14¹⁵⁄₁₆ × 5⁷⁄₁₆ (37.9 × 13.7). Signed & dated on panel below the window b.l.: *J.J. Tissot / 1880.*
EXH.: One such print at Dudley Gallery B/W 1880 (122) as *Seaside*, price £7.7s.0d.
LIT.: Wentworth 1978, pp. 202–3.
REF.: W. 47, B. 38, T. 42.
Etching in the same direction after an oil painting (Fig. 56) recorded in Tissot's albums (III/7). Despite the masts and lighthouse, the setting is the bay

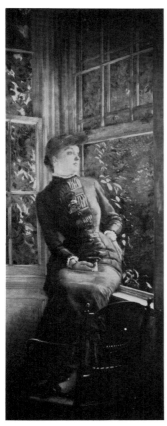

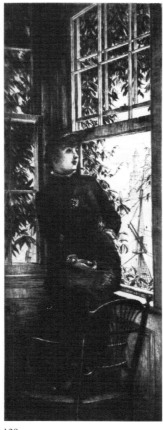

Fig. 56. *Au bord de la mer.* Whereabouts unknown

120

girls were re-used on three sides of a quadrilateral *cloisonné* enamel vase, the pair of girls being repeated on two opposite facets (Colour Plate 30, and Fig. 37), Kathleen Newton with a parasol from *The Gardener* (Fig. 68) making up of the fourth side. There is a gouache replica of *Croquet* in the Museum of Art, Rhode Island School of Design (Wentworth 1984, pl. 143). The composition is repeated in an etching of 1878 (W. 37).

122. *L'Orpheline* (*Orphan*). c. 1879.
Paris, Bibliothèque Nationale.
Etching, $21\frac{1}{2} \times 10\frac{15}{16}$ (54.8 × 28.7), irregular plate.
a). Trial proof with some shading added to chestnut leaves and bullrushes, lily pads and shadows added in the water (W. 44b).
b). Trial proof with added shading, sloping bank and numerous chestnut leaves behind the figures, the child's arms and face partially removed by burnishing (W. 44c).
LIT.: Wentworth 1978, pp. 190–3.
REF.: W. 44 (not in B. or T.).
Only three trial proofs are known for this etching, which apparently remained unfinished. The composition is taken directly from the oil painting, *Orphan* (private collection; Wentworth 1984, pl. 138), exhibited at the Grosvenor Gallery in 1879 (96), for which at least one oil replica is known. The

122b

subject is related to *Le Veuf* (Cat. 93) and the use of a dark-clad Kathleen Newton, silhouetted against a richly coloured background, is similar to *October* (Cat. 99) and *La Dame à l'ombrelle* (Cat 103).

123. *Le Hamac* (*The Hammock*). 1880.
a). Charles Jerdein.
b). Lady Abdy.
Etching & drypoint, $10\frac{5}{16} \times 7\frac{1}{4}$ (27.8 × 18.4). Signed & dated in the title margin b.l.: *J.J. Tissot / 1880.*
a). Trial proof, before the addition of fully delineated features and further shading (mentioned but not illustrated in Wentworth 1978).
b). Published proof.

window in Tissot's studio at Grove End Road (see Fig. 4) and the 'Rossetti' armchair appears in some of Tissot's first London works (like *News of Our Marriage* (Cat. 48)). Kathleen Newton wears the favourite black dress seen in numerous contemporary pictures, with the ever-present posy tucked in at the breast.

121. *Croquet.* c. 1878.
Ontario, Art Gallery of Hamilton.
Oil on canvas, $35\frac{3}{8} \times 20$ (89.8 × 50.9).
PROV.: Laing Galleries, Toronto, Ontario; donated by Dr and Mrs Basil Bowman in memory of their daughter, Suzanne, 1965.
EXH.: Grosvenor Gallery 1878 (32); Providence/Toronto 1968 (29) illus.
LIT.: Brooke, David S., 'James Tissot and the ''Ravissante Irlandaise'': Reflections on an Exhibition at the Art Gallery of Ontario', *Connoisseur*, May 1968, p. 58, illus.; Misfeldt, pp. 187–8 & fig. 99; Wentworth 1978, pp. 168, 170 & fig. 37a;

Warner 1982, p. 16, colour pl.; Wentworth 1984, pp. 147, 151, 165, 202 & pl. 142.
This painting is set in Tissot's garden, with the familiar pool and colonnade visible in the distance. The figures of the three

121

122a

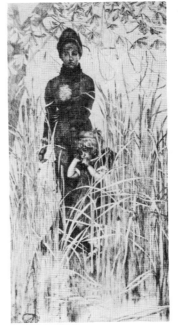

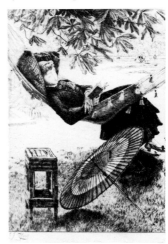

123a

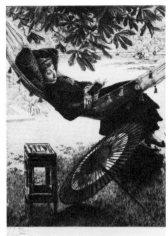

123b

EXH.: Probably a published proof at Dudley Gallery B/W 1880 (21) as *The Hammock*, price £6.6s.0d.

LIT.: Wentworth 1978, pp. 46–7; Wentworth 1984, pp. 145n, 147 & 203.

REF.: W. 46, B. 37, T. 41.

This etching is directly after a painting, presumably of the same title, recorded in Tissot's albums (IV/5). The composition is a 'censored' re-working of Tissot's Grosvenor Gallery picture of 1878, *The Hammock* (Fig. 57),

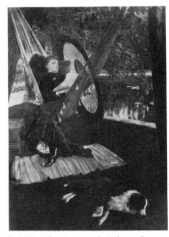

Fig. 57. *The Hammock*. Whereabouts unknown

which, together with *A Quiet Afternoon* (private collection; Wentworth 1984, pl. 144) and *Going to Business* (Cat. 115), attracted a fury of disgusted comment. A critic in the *Spectator* summed up the former as 'ladies in hammocks, showing a very unnecessary amount of petticoat and stocking, and remarkable for little save their indolence and insolence' (31 May 1879), while

Punch, giving a suggestive alternative title to *A Quiet Afternoon* and linking it with *Going to Business* (see Cat. 115), thought that *The Web* might be a more appropriate title for *The Hammock*: 'Will you walk into my Garden? / Said the Spider to the Fly. / 'Tis the prettiest little garden / That ever you did spy. / The grass a sly dog plays on; / A hammock I have got; / Neat ankles you shall gaze on, / Talk – *à propos de bottes*. / *Elle est bien botté alors*. Is it so? 'Tis so.' *The Hammock*'s composition showed the view which would have been seen by the old man in *A Quiet Afternoon*.

Tissot was probably surprised by this reception of his works as 'unsavoury' and quickly sought to remedy the situation through a new composition, without the 'unnecessary amount of petticoat and stocking' and the dog. This revised painting may have been the one exhibited by Tissot at the Glasgow Institute of Fine Arts in 1880 (225), though this is described by the Magazine of Art as the picture exhibited at the Grosvenor Gallery two years before.

124. *La Soeur aînée* (*The Elder Sister*). c. 1881. (Colour Plate 12).

D.C. Dueck.

Oil on panel, $17\frac{1}{2} \times 8$ (44.5 × 20.3). Signed b.r.: *J.J. Tissot*.

PROV.: Sotheby's 20 June 1972 (96); Carpenter-Deforge, Paris; Sotheby's 22 Nov. 1983 (60); Stair Sainty Fine Art, Inc..

LIT.: Wentworth 1978, pp. 230, 233 & fig. 53c; Wentworth 1984, p. 152 & pl. 163.

This is one of three known oil versions of the subject (Figs. 30 and 58 (Album, III/24) being the other two), based on photographs taken of Kathleen Newton (Cat. 145b) sitting on the steps below Tissot's studio and conservatory with her niece, Lilian Hervey. The bay window of the studio is clearly visible in the background of this painting. The viewpoint and poses are different to those in the other two compositions.

125. *La Soeur aînée* (*The Elder Sister*). 1881.
a). Paris, Bibliothèque Nationale.
b). Lady Abdy.
Etching & drypoint, $11\frac{3}{8} \times 6$ (28.9 × 15.2). Signed & dated t.c.: *J.J. Tissot / 1881*.

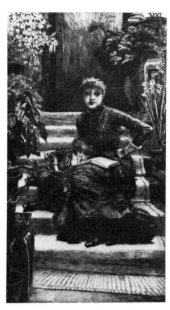

Fig. 58. *La Soeur aînée*. Whereabouts unknown

125a

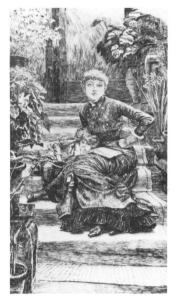

a). Trial proof, without drypoint additions.
b). Published state.
LIT.: Providence/Toronto 1968 (79); Misfeldt 1971, fig. 106; Wentworth 1978, pp. 230–3.
REF.: W. 53, B. 44, T. 53.
This etching is directly after one of three known painted versions of the subject (Fig. 30), which was based on a photograph of Kathleen Newton (Cat. 145b) and

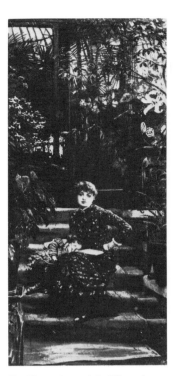

125b

her niece, Lilian Hervey. A second variant of the composition (Fig. 58) was taller and included more of the conservatory, with fuchsias substituted among the plants on the left. One of these two paintings was probably that exhibited at the Dudley Gallery in 1882 (6) as *The Elder Sister* (Cat. 124). The third known version is taken from a different angle and the poses are slightly altered.

126. *Rêverie* (*In the Garden*). c. 1880–1.
Private collection.
Oil on panel, $14\frac{1}{2} \times 7\frac{7}{8}$ (36.8 × 20.3). Signed b.r.: *Tissot*.

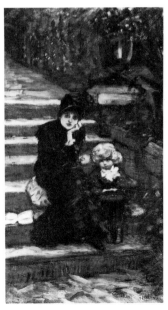

126

PROV.: Christie's 5 Dec. 1941; Weingraf collection; Redfern Gallery; Humphrey Brooke; Sotheby's 18 Nov. 1970 (125); Christie's 24 June 1983 (81).

EXH.: Sheffield 1955 (44); AC 1955 (44).

LIT.: Wentworth 1978, pp. 226, 229 & fig. 52c; Wentworth 1984, p. 152 & pl. 162.

An oil study for a presently unknown painting, probably related to the etching. The composition is based on a photograph of Kathleen Newton (Cat. 145a), which Lilian Hervey recalled had served for a painting called *The First Cloud*, though the steps in this oil study are within the garden, not below Tissot's studio as in the print (Cat. 127) and photograph.

127. *Rêverie.* 1881.
London, British Museum.
Etching, $9 \times 4\frac{7}{16}$ (22.9 × 11.4). Signed & dated t.r.: *J.J. Tissot / 1880.* Signed in title margin b.l.: *J.J. Tissot.*
a). Trial proof, before the addition of considerable shading.
b). Published proof.

EXH.: One such print at Dudley Gallery B/W 1881 (574) as *Deep in Thought*, price £4.4s.0d.

LIT.: Wentworth 1978, pp. 226–9; Wentworth 1984, p. 152.

REF.: W. 52, B. 43, T. 52.

Etching, presumably after a painting of the same title, based

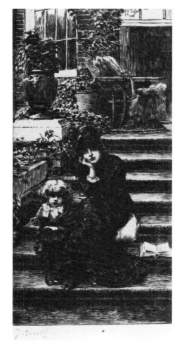

127b

on a photograph of Kathleen Newton (Cat. 145a) on the steps below Tissot's studio, like that used for *La Soeur aînée* (Cats. 124, 125), whose theme and setting it repeats.

128. *'Garden-party' d'enfants* (*A Children's Garden Party*). 1880.
Private collection.
Drypoint, $10 \times 6\frac{1}{4}$ (25.4 × 15.9). Signed b.r.: *J.J. Tissot.*

EXH.: One such print at Dudley Gallery B/W 1881 (109) as *Children's Party*, price £5.5s.0d.; Minneapolis 1978 (49 i) illus.

128

LIT.: Wentworth 1978, pp. 214–7.

REF.: W. 49, B. 40, T. 46 (first state).

One of several pictures showing Kathleen Newton, her sister, Mary Hervey, and their children relaxing in the garden at Grove End Road. No related oil painting is known at present for this particular drypoint, though a work entitled *Children's Party* was exhibited at the Dudley Gallery in 1882 (11). The composition is probably based on one or more photographs, like *Sur l'herbe* (Cat. 129) and *Déjeuner sur l'herbe* (Cat. 131). The exhibited print is the first of two published states, before the addition of much shading on the trees, figures and foreground, and additional hatching on the grass.

129. *Sur l'herbe* (*On the Grass*). 1880.
Lady Abdy.
Etching & drypoint, $7\frac{3}{4} \times 10\frac{5}{8}$ (19.7 × 27). Signed & dated b.r.: *J.J. Tissot / 1880.*

EXH.: One such print at Dudley Gallery B/W 1881 (141) price £4.4s.0d.

LIT.: Wentworth 1978, pp. 218–21.

REF.: W. 50, B. 41, T. 49 (second state).

See previous entry. Again, no related oil painting is known at present for this etching. The exhibited print is the second of two published states, with the addition of much hatching, particularly in the area of grass.

130. *Sa première culotte* (*His First Breeches*). 1880.
Paris, Bibliothèque Nationale.

Drypoint, 7×3 (17.7 × 7.6). Signed & dated b.l.: *J.J. Tissot / 1880.*

EXH.: One such print at Dudley Gallery B/W 1881 (595) as *First Breeches*, price £3.3s.0d.; Minneapolis 1978 (51 i) illus.

LIT.: Wentworth 1978, pp. 222–5.

REF.: W. 51, B. 42, T. 50 (first state).

The exhibited print is the first of two published states, the second having much additional shading

130

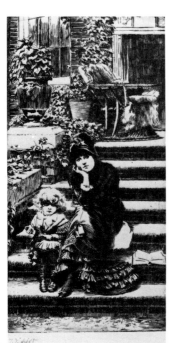

127a

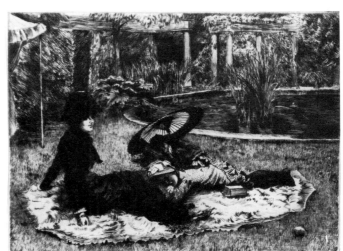

129

(see Wentworth 1978). The figure is that of Cecil George Newton, based either on group photographs like the two described later (Cats. 145d, 146c), or on a separate photograph taken at the same sitting. Cecil George appears in the same suit in a number of contemporary paintings and prints (see the two previous and two following entries).

131. *Déjeuner sur l'herbe* [The Picnic]. *c.* 1881–2.
Dijon, Musée des Beaux-Arts.
Oil on panel, $8\frac{1}{5} \times 12\frac{4}{5}$ (20.8 × 32.7). Signed b.r.: *J.J. Tissot.*
PROV.: Bequeathed by A. Bichet, 1920.
EXH.: ? Dudley Gallery 1882 (12) as *Children's Picnic* ($7\frac{1}{4} \times 10\frac{3}{4}$ in).

132

133

LIT.: Dijon, Musée des Beaux-Arts, *Catalogue des peintures françaises* 1968, p. 156 (874); Wentworth 1978, p. 292 & fig. 75b; Wentworth 1984, pp. 152, 203 & pl. 166.

This picnic scene in the garden at Grove End Road has a 'snap-shot' quality and must have been based on photographs, as a presently unlocated variant (Fig. 59) shows the same group around the picnic cloth from a different viewpoint. (The latter painting, recorded in Tissot's albums, III/32, is reproduced in Laver 1936, pl. X, erroneously given as belonging to the Tate Gallery; exh. Sheffield 1955 (19).) This is a more homely and intimate picnic than *Holyday* (Cat. 96), reflecting the relaxed lifestyle at Grove End Road *c.* 1880–2, which is recorded in several contemporary pictures showing Kathleen Newton, her sister, Mary Hervey, and their

Fig. 59. *Déjeuner sur l'herbe.* Whereabouts unknown

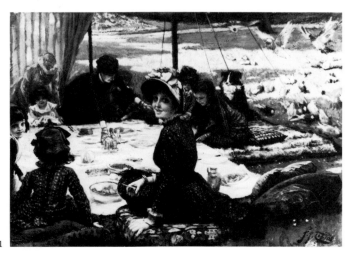

131

children (see previous three and following entry). Either the exhibited painting or Fig. 60 may be the work exhibited by Tissot at the Grosvenor Gallery in 1882 (12) as *Children's Picnic.*

132. *En plein soleil* (*In the Sunlight*). 1881.
London, British Museum.
Etching & drypoint, $7\frac{1}{2} \times 11\frac{11}{16}$ (19.0 × 29.7). Signed b.l.: *J.J. Tissot.*
LIT.: Wentworth 1978, pp. 234–5; Wentworth 1984, pp. 151–3 (on the painting).
REF.: W. 54, B. 45, T. 54.
The etching is based on a small oil painting of the same title (New York, private collection; Wentworth 1984, colour pl. IV). The composition is reversed and slightly altered for the etching: the figures of the woman seated on the wall and Cecil George are reduced, the footpath with black cat is replaced by shrubbery, the cushions in the foreground are rearranged and a scattering of toys added. The seated figure of Kathleen Newton in the straw hat

is based on a photograph (Cat. 145c) and both painting and etching were probably composites of several such photographs.

133. *Uncle Fred. c.* 1879.
Besançon, private collection.
Oil on panel, $8\frac{3}{5} \times 12\frac{1}{2}$ (22 × 32). Inscribed on old exhibition label on reverse, with Grove End Road address, *Uncle Fred / £100.*
PROV.: The artist, until his death in 1902; Mlle Jeanne Tissot, the artist's niece, until her death in 1964; her sale, Château de Buillon 8–9, 14–15 & 21–2 Nov. 1964.
EXH.: Glasgow, Institute of Fine Arts, *19th Exhibition of Works by Modern Artists*, 1880 (517); Liverpool, Walker Art Gallery, *10th Autumn Exhibition of Modern Pictures*, 1880 (159); Manchester, Royal Institution, *Exhibition of Works of Modern Artists* 1881, (1190).
LIT.: Misfeldt 1971, pp. 197–8 & fig. 118.
F. Kelly, presumably Kathleen's brother Frederick, signed as a

witness at her wedding in India in 1871. In this charming small painting, set in Tissot's garden at Grove End Road, Uncle Fred faces his niece, Lilian Hervey, in an apparent depiction of an actual family relationship, unlike the *Soeur aînée* paintings (Cats. 124, 125). He is the reddish-blond young man shown in other paintings of this period, such as those of visitors to the Louvre (*c*. 1879), and frequently misidentified as Tissot (*Richmond Bridge* (Cat. 110) and *Waiting for the Ferry* (Cat. 111)) because in one instance the photographic model is Tissot himself. (Information for this entry kindly supplied by Willard Misfeldt.)

134. *Quiet. c.* 1881.
Private collection.
Oil on canvas, 27 × 36 (68.9 × 91.4). Signed in monogram b.r.: ⅏; exhibition label on stretcher, in Tissot's own hand, gives the title *Quiet*.
EXH.: R.A. 1881 (561); Providence/Toronto 1968 (34) illus.
LIT.: Misfeldt 1971, p. 196 & fig. 112; Wentworth 1984, pp. 66, 130, 144n, 148, 153, 201 & pl. 169.
Kathleen Newton, her niece, Lilian Hervey, and the notorious dog from *The Hammock* (Fig. 56), are depicted on a bench covered with the fur rug seen in *Le Banc de jardin* (Cat. 148), beneath a chestnut tree in Tissot's Grove End Road garden. A watercolour replica of the painting is known (London, Hon. James Tennant; Laver 1936, pl. XXVI) and the figure of Kathleen Newton with a book is repeated in a vertical composition, *La Lecture dans le*

parc (Dijon, Musée des Beaux-Arts; Misfeldt 1971, fig. 114).

135. *Mrs Newton Resting on a Chaise-longue. c.* 1881–2.
Gray, Musée Baron Martin.
Oil on canvas, 35½ × 26¾ (90.2 × 68.3).
PROV.: Edmond Pigalle; bequeathed by Edmond Pigalle to Musée Baron Martin, 1921.
EXH.: Gray etc. 1983–4 (76) illus.
LIT.: Misfeldt 1971, p. 197 & fig. 116; Wentworth 1978, pp. 240, 243 & fig. 56b; Wentworth 1984 p. 153 & pl. 171.
Kathleen Newton was fragile and died of consumption at the age of 28. Though consumptives could look quite healthy, she must have had bouts of illness as recorded here. A similar, probably earlier, composition in which Kathleen Newton sleeps propped up on pillows in a wicker armchair (as here), an open book on her lap, was sold Christie's 24 June 1983 (82 illus.) as *A Lady Asleep in an Armchair*.

135

Fig. 60. *Soirée d'été*. Paris, Musée d'Orsay

136

136. *Soirée d'été* (*Summer Evening*). 1882.
Charles Jerdein.
Etching & drypoint, 9⅛ × 15⅝ (23.2 × 39.7). Signed & dated b.l.: *J.J. Tissot / 1881*.
LIT.: Wentworth 1978, pp. 240–3; Wentworth 1984, pp. 153 & 204 (on the painting).
REF.: W. 56, B. 47, T. 57 (second state).
Second of two published states, after the addition of much shading. The etching is after an oil painting of the same title exhibited at the Dudley Gallery in 1882 (5) and now in the Musée d'Orsay, Paris (Fig. 60), of which an unlocated watercolour replica is known. See also previous entry.

LIT.: Wentworth 1978, pp. 194–9; Wentworth 1984, pp. 104 & 146.
REF.: W. 45, B. 36, T. 40.

137. *Emigrants*. 1880.
London, National Maritime Museum.
Etching & drypoint, 13¾ × 6¼ (34.9 × 15.9). Signed on the rail at the left: *J.J. Tissot*; signed and inscribed in title margin b.l.: *J. Tissot* ¹/₉₇ₚ.
EXH.: One such print at Dudley Gallery B/W 1880 (141) as *The Emigrants*, price £7.7s.0d.

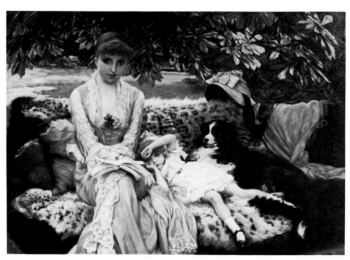
134

137

Fig. 61. *Emigrants*. New York, private collection

Etching in the same direction after the oil painting (or replica) exhibited at the Grosvenor Gallery in 1879 (93) and probably dating back to the early 1870s, the subject relating to Tissot's Thames-side themes. The original painting was once in the collection of the Montreal Museum of Fine Arts and is known to have been damaged and cut down (Wentworth 1978, fig. 45e) but is now unlocated; the replica is in a private collection, New York (Fig. 61).

It has been suggested that Margaret Kennedy is also the model for this painting and etching (see note to *The Last Evening*, Cat. 55). Captain John Freebody's ships took emigrants to America and this may have suggested the subject to Tissot, considering his penchant for poignant scenes of parting. The distinctive flags of the Castle line can be seen on the *Carisbrooke Castle* in the distance.

138. *By Water* (*Waiting at Dockside*). c. 1881–2.
Owen Edgar Gallery.
Watercolour heightened with white, 20 × 10¾ (50.8 × 27.3). Signed b.l.: *J.J. Tissot*; and twice in monogram on crates t.r.: ᵢ𝕀ᵢ.

PROV.: Leicester Galleries, London; N. Ronald Esq.; Sotheby's 16 Nov. 1976 (251) as *Waiting for the Boat*; Christopher Wood.
LIT.: Wentworth 1984, pp. 132, 159, 204 & pl. 149.

Fig. 62. Study for *By Water*. Wimpole Hall, near Cambridge, National Trust

Tissot painted a number of compositions c. 1879–82 on the theme of travel and parting, featuring Kathleen Newton. This is a gouache replica of *By Water*, a companion piece to *By Land* (for which an oil sketch is known, Wentworth 1984, pl. 150, and a gouache replica, entitled *Victoria Station*, Laver 1936, pl. XXI). The two oil paintings were exhibited at the Dudley Gallery in 1882 (8 and 7 respectively, both 25 × 11 in) and are recorded in Tissot's photograph albums (III/30 and

138

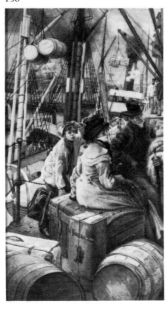

III/29). A grisaille oil study for the figure of Kathleen Newton in *By Water* is known (Fig. 62), where the pose of head and details of neckline and umbrella are slightly different to the finished work. Other related pictures are *Goodbye, On the Mersey* (Cat. 139), *The Ferry* and *Crossing the Channel*, c. 1879 (Wentworth 1984, pls. 145 & 146), and the unlocated *Leaving Old England* (*Gravesend*) exhibited at the Dudley Gallery in 1882 (10).

139. *Goodbye, On the Mersey*. c. 1881.
New York, The Forbes Magazine Collection.
Oil on canvas, 33 × 21 (83.8 × 53.3). Signed b.r.: *J.J. Tissot*.
PROV.: Christie's 10 July 1970 (151).

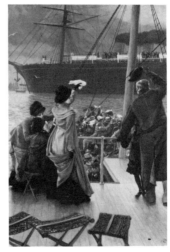

139

EXH.: RA 1881 (981); Glasgow Institute of Fine Arts, 1881 (910), for sale at £85; Leicester Galleries, *Victorian Life*, 1937 (118) as *Départ du Paquebot*; New York, Metropolitan Museum of Art, and Princeton University, Art Museum, *The Royal Academy (1837–1901) Revisited*, 1975 (64) illus.
LIT.: Providence/Toronto 1968 (33); Misfeldt 1971, pp. 196, 198–9 & fig. 113; Wentworth 1978, pp. 236, 238 & fig. 55b; Wentworth 1984, pp. 105, 116, 132, 148, 155, 201 & pl. 147.
See previous entry.

The theme of parting frequently recurs in Tissot's work throughout his career, e.g. *Bad News* (Cat. 44), *The Last Evening* (Cat. 55) and *Les Deux Amis*

(Cat. 140). Sadness is eloquently stressed here through muted colours and grey atmosphere. A gouache replica of the painting was exhibited at the Leicester Galleries in 1933 (18) as *Departure of the Steamer*, and an oil replica is known (Christie's 12 Dec. 1969 (77A) illus.).

140. *Les Deux Amis* (*Two Friends*). c. 1882.
Rhode Island School of Design, Museum of Art.
Oil on canvas, 44½ × 20 (113 × 50.8). Signed on railing b.r.: *J.J. Tissot*.
PROV.: Acquired 1959.
EXH.: London, Arthur Jeffress Gallery, *Etchings by J.J. Tissot*, 1959, unnumbered; Providence/Toronto 1968 (33) illus.
LIT.: Gourley, Hugh J., 'Tissots in the Museum's collection', *Bulletin of the Rhode Island School of Design*, 50 no. 3. (March 1964), pp. 1–4; Misfeldt 1971, p. 199 & fig. 120; Wentworth 1978, pp. 236, 238 & fig. 55a; Wentworth 1984, pp. 105, 132 & pl. 148.

This is a study for a presently unlocated painting, whose title is known from the etching after it. The theme of parting and travel is treated in a number of pictures, c. 1879–82 (see entry for *By Water*, Cat. 138) which include Kathleen Newton in a caped coat, as seen in the lower left of this study.

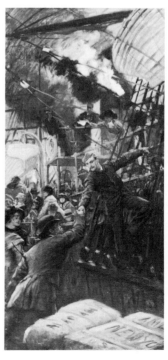

140

141. *Les Deux Amis* (*Two Friends*). 1882.
London, National Maritime Museum.
Etching & drypoint, $23\frac{1}{4} \times 10\frac{1}{8}$ (59 × 25.7). Signed & dated in title margin b.r.: *J.J. Tissot 1881*; with American and British flags inscribed in the title margin, left and right, here coloured by hand.
EXH.: Liverpool, Walker Art Gallery, *12th Autumn Exhibition of Modern Pictures*, 1882 (1429) as *Two Friends*.
LIT.: Misfeldt 1971, p. 199 & fig. 121; Wentworth 1978, pp. 236–9; Wentworth 1984, p. 132.
REF.: W. 55, B. 46, T. 55.

141

Etching after an unlocated painting of the same title for which an oil study is known (Cat. 140). There are several refinements in the etching: the lifeboat has been marked *Old England* (which the ship is presumably leaving), the package and crate on the right have been marked *New York* and *Alabama* respectively, and the American and British flags have been added to left and right in the title margin.

142. Edmond et Jules de Goncourt, '*Renée Mauperin: édition ornée de dix compositions*

à l'eau-forte par James Tissot (Paris: G. Charpentier et Cie) [Renée Mauperin: illustrated edition with ten etchings by James Tissot]. 1884.
Private collection.
LIT.: Providence/Toronto 1968 (79); Misfeldt 1971, pp. 181–2 & 204–5; Wentworth 1978, pp. 256–77; Wentworth 1984, pp. 133, 135, 153, 155, & pl. 172; Preston 1984, pp. 442–4.
REF.: W. 62–71, B. 53–62, T. 64–73.
Tissot's illustrations for *Renée Mauperin* were completed in 1882, shortly before Kathleen Newton's death. They are based on photographs (Cats. 145e, 146a & b) and probably on composite oil studies made from the latter (see Cat. 143). The novel had appeared in 1875, at about the time that Tissot met Kathleen Newton, who came to live with him c. 1876 and whose illness and death parallel those of the novel's heroine, such that Edmond de Goncourt refers to Mrs Newton as 'la Mauperin anglaise'. The plates were also published separately and several such prints are exhibited here.

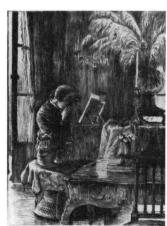

c). Renée Sitting at the Piano, Crying. (W. 65).

143. *Study for 'M. and Mme. Mauperin in Egypt'. c.* 1882.
London, private collection.
Oil on paper on panel, $11\frac{1}{2} \times 15\frac{1}{2}$ (29.3 × 39.6).
PROV.: Paris art trade; with Jane Abdy, London, by 1981.
EXH.: Bury Street 1981 (22) illus.
LIT.: Wentworth 1978, pp. 276–7 (on the etching); Preston 1984, pp. 442–4, fig. 1.

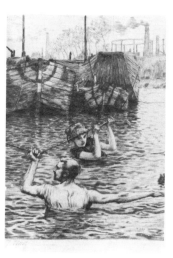

a). Renée and Reverchon Swimming in the Seine. (W. 62).

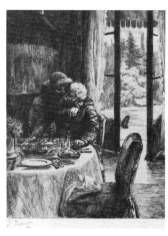

b). Renée Hugging her Father as He comes in to Breakfast. (W. 63).

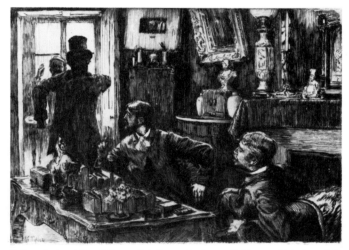

d). Denoisel and Henri Mauperin's Rooms in the rue Taitbout as Bois Jorand de Villacourt Enters to Challenge Him to a Duel. (W. 66).

e). Henri Mauperin Wounded After the Duel with Bois Jorand de Villacourt. (W. 67).

f). M. Mauperin Sitting in a Public Garden in Paris. (W. 69).

This oil sketch, presumably adapting in oils photographs of Tissot, Kathleen Newton, and the pylons and 'Kiosk of Trajan' of the temples at Philae in Upper Egypt, was reproduced by Tissot in the etching *M. and Mme. Mauperin in Egypt* (W. 71, Fig 63), the tenth and final illustration to the novel *Renée Mauperin* by Edmond and Jules de Goncourt (see Cat. 142). The composition was reversed in the printing of the etched plate. The illustration shows the bereaved parents of the dead Renée Mauperin on their ceaseless world travels.

Similar oil sketches are known for *Renée and Reverchon Swimming in the Seine* (W. 62) and *Denoisel Reading in the Garden, Renée Approaching* (W. 64) (See Preston, note 10).

144. *Woman Fainting (Abandoned* or *The Convalescent). c. 1881–2.*
Samuel A. McLean.
Oil on panel, $12\frac{1}{2} \times 20\frac{1}{2}$ (31.7 × 52.1). Signed t.l.: *J.J. Tissot.*
PROV.: Sotheby's 18 Feb. 1970 (93); H. Shickman Gallery, New York, as *Abandoned*; Dr and Mrs John P. Bradbury by 1975; Roy Miles Fine Paintings.
LIT.: Wentworth 1978, p. 270 & fig. 68a; Preston 1984, p. 444n.
EXH.: Shepherd Gallery, New York, *The Figure in French Art 1800–1870*, 1975 (139) as *Woman lying in Front of a Fire.*
This composition is similar to one of Tissot's illustrations for Renée Mauperin showing *Renée Fainting after her Brother's Death in the Duel* (W. 68, Fig. 64) and was

144

Fig. 64. *Renée Mauperin: Renée Fainting after Hearing of her Brother's Death in the Duel*

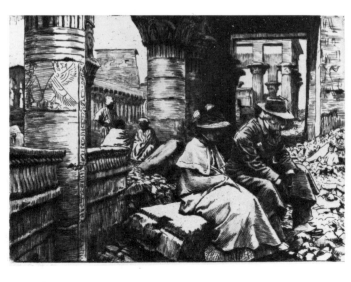

143

145a

Fig. 63. *Renée Mauperin: M and Mme Mauperin in Egypt*

possibly inspired by the latter, but is an independent variation and not a study for the etching. Kathleen Newton is posed in Tissot's studio beside the arm-chair which appears in numerous other paintings.

145. *Five photographs of Kathleen Newton, Tissot and children* (copies). *c.* 1878–82.
PROV.: Lilian Hervey, Kathleen Newton's niece; Marita Ross; originals now lost.
LIT.: Providence/Toronto 1968, figs. 1, 3, 2, 5 & 4; Wentworth 1978, pp. 222, 225–6, 229–30, 233–4, 257, 274 & figs. 52b, 53b, 54a, 51a & 70a; Warner 1982, p. 19, illus.; Wentworth 1984, pp. 126, 131, 149, 151–3, 182 & pls. 161, 164, 165, 120 & 173.
a). Kathleen Newton seated on the steps below Tissot's studio and conservatory, an unidentified man (perhaps Frederick Kelly: see *Uncle Fred*, Cat. 133) on the terrace behind. The photograph

was said by Lilian Hervey to have been used for a painting called *The First Cloud*. A related oil study and etching are known (Cats. 126, 127).
b). Kathleen Newton seated on the steps below Tissot's studio and conservatory with her niece,

145b

145c

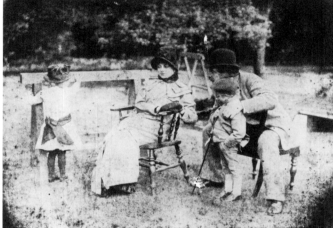

145d

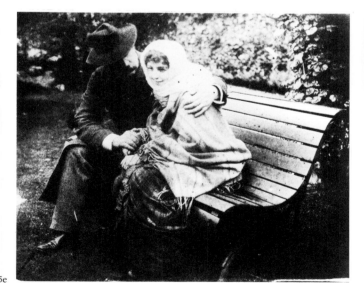

145e

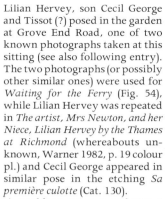

Lilian Hervey, son Cecil George and Tissot (?) posed in the garden at Grove End Road, one of two known photographs taken at this sitting (see also following entry). The two photographs (or possibly other similar ones) were used for *Waiting for the Ferry* (Fig. 54), while Lilian Hervey was repeated in *The artist, Mrs Newton, and her Niece, Lilian Hervey by the Thames at Richmond* (whereabouts unknown, Warner 1982, p. 19 colour pl.) and Cecil George appeared in similar pose in the etching *Sa première culotte* (Cat. 130).

e). Kathleen Newton and Tissot (?) seated on a garden bench. Re-used for the etching *Renée and her Father in the Porch of the Church at Morimond*, 1882 (W. 70, Fig. 65), the ninth illustration to the novel, *Renée Mauperin* (see Cat. 142).

146. *Three photographs of Kathleen Newton, Tissot and children. c.* 1878–82.

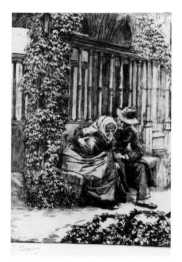

Fig. 65. *Renée Mauperin: Renée and her Father Sitting in the Porch of the Church at Morimond*

Boston, Mass., James A. Bergquist.

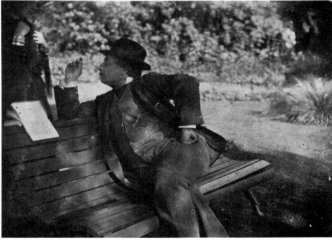

146a

Fig. 66. *Renée Mauperin: Denoisel Reading in the Garden, Renée Approaching*

Lilian Hervey, and an unidentified woman (perhaps Kathleen's sister, Mary Hervey) on the terrace behind. Used for the oil painting and etching *La Soeur aînée* (Cats. 124, 125).

c). Kathleen Newton seated on the grass. Used for the painting and etching *En plein soleil* (Cat. 132) and related to her pose in *Déjeuner sur l'herbe* (Cat. 131).

d). Kathleen Newton, her niece,

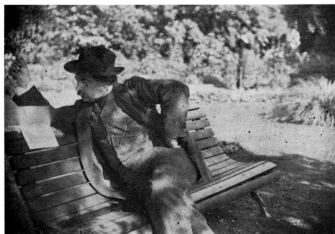

146b

146c

PROV.: The artist until his death in 1902; Mlle. Jeanne Tissot, the artist's niece, until her death in 1964; her sale, Château de Buillon 8–9 Nov. 1964; Sotheby's 17 June 1982 (270 a & b).

LIT.: Preston 1984, pp. 442–4 & figs. 3 & 4.

a). Tissot (or Frederick Kelly) seated on a bench in the garden at Grove End Road, with Kathleen Newton standing behind the bench. Elements used together with b). for the etching *Denoisel Reading in the Garden, Renée Approaching*, 1882 (W. 64, Fig. 66), Tissot's third illustration to the novel *Renée Mauperin*. The figure of Kathleen is omitted in the etching.

b). A variant of a), closer to the final etching.

c). A variant of Cat. 145 d), with Kathleen Newton and Cecil George in slightly different poses.

147. *Le Petit Nemrod* (*A Little Nimrod*). c. 1882. (Colour Plate 23).

Besançon, Musée des Beaux-Arts.
Oil on canvas, $43\frac{1}{2} \times 55\frac{3}{5}$ (110.5 × 141.3). Signed b.l.: *J.J. Tissot*.

PROV.: Bequeathed by A. Bichet, 1920.

EXH.: ? Paris, Palais de l'Industrie 1883 (6) as *Un Nemrod*; ? Paris, Galerie Sedelmeyer 1885 (24); Gray etc. 1983–4 (74) illus. p. 59.

LIT.: Wentworth 1978, pp. 330–2.
This painting relates to the pictures of Kathleen Newton's and Mary Hervey's children in the garden at Grove End Road and shows them playing in a park similar to that in *Repos dans le parc* (whereabouts unknown, Wentworth 1978, fig. 50a). Probably one of the last works to be painted in London, it was reproduced by Tissot in a mezzo-

tint of 1886, in the same direction (W. 83). *Le Petit Nemrod* is similar in style, content and iconography of child worship to *Le Banc de jardin* (Cat. 148), though Kathleen Newton is absent and the colour range of the two paintings is quite different, the former autumnal and melancholy, the latter vibrant with the bright colours of early summer.

148. *Le Banc de jardin* (*The Garden Bench*). c. 1882. (Colour Plate 22).

Private collection
Oil on canvas, 39 × 56 (99.1 × 142.3). Signed b.l.: *J.J. Tissot*.

PROV.: The artist until his death in 1902; Mlle Jeanne Tissot, the artist's niece, until her death in 1964; her sale, Château de Buillon 8–9 Nov. 1964; Christie's 24 June 1983 (103).

EXH.: Paris, Palais de l'Industrie 1883 (8); Paris, Galerie Sedelmeyer 1885 (20); Christopher Wood Gallery, *Victorian Fanfare*, 1983 (29) illus. colour pl. and also in colour on the cover.

LIT.: Wentworth 1978, pp. 290–3; Christie's *Review of the Season, 1983* p. 53 colour illus.
See previous entry.

The bright colour and liveliness of this painting belie the probable state of Kathleen Newton's health at the time this work was painted, either shortly before or following Tissot's return to Paris after her death. An oil study for the painting is known (Fig. 67), which could have been made before Kathleen was too ill to pose, and formed the basis for the painting, together with photographs. Tissot reproduced the painting as a mezzotint (Cat. 149) soon after his return to Paris.

149. *Le Banc de jardin* (*The Garden Bench*). 1883.
London, Bury Street Gallery.
Mezzotint, $16\frac{1}{2} \times 22\frac{1}{8}$ (41.9 × 56.2). Signed in title margin b.l.: *J.J. Tissot*.

LIT.: Providence/Toronto 1968 (81); Misfeldt, Willard E., 'A Tissot Mezzotint in the MSV Collection', *Kresge Art Center*

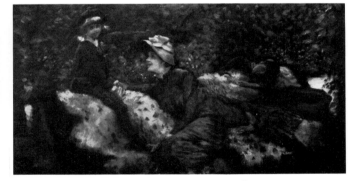

Fig. 67. Sketch for *Le Banc de Jardin*. Whereabouts unknown

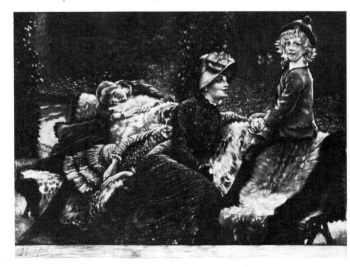

Bulletin 5, no. 3 (Dec. 1971), n.p.; Wentworth 1978, pp. 290–3; Bury Street 1981 (16) illus.; Wentworth 1984, p. 152 & pl. 168.

REF.: W. 75, B. 66, T. 77 (first state).

Mezzotint after the oil painting of the same title (Cat. 148), in reverse. One of only four known mezzotints by Tissot, made after his return to Paris (the others being *L'Apparition Médiunimique*, W. 82 and W. 83). Tissot may have used the medium, known in France as the *Manière anglaise*, to suit his pose as a *Londonien de Paris* and to give his works a fashionable English appearance. The waxen quality of mezzotint also reflects the quality of pigment and technique in Tissot's paintings at this time and the fixed, doll-like features foreshadow those of models in the *Femme à Paris* series.

The exhibited print is the first of two published states, before the addition of letters.

150. Entry omitted.

151. *L'Apparition médiunimique (The Apparition)*. 1885.
Private collection.
Mezzotint, printed in dark blue ink, $19\frac{1}{4} \times 13\frac{1}{2}$ (48.8 × 34.2). Signed, dated & inscribed in title margin b.l.: *J.J. Tissot*; b.c.: *Apparition Médiunimique*; b.r.: *Dark seance d'Eglinton / du 20 May 1885 / Londres*.
LIT.: Wentworth 1978, pp. 294–9; Wentworth 1984, pp. 177, 189 & pl. 197, pp. 177–8, 186, 196 (on the painting).
Following a 'successful' seance with William Eglinton, Tissot recorded the spiritual vision of

Kathleen Newton he had seen in an oil painting and a mezzotint (see pp. 24, 52 and 84).

152a

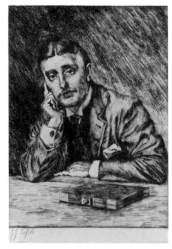

152b

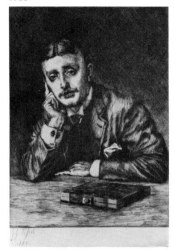

152. *William Eglinton*. 1885.
Dr Frederick Mulder.
Etching, $6\frac{1}{4} \times 4$ (15.9 × 10.2). Signed & dated in title margin b.l.: *J.J. Tissot / 1885*.
a). Undescribed first state or trial proof, before the addition of cross-hatching on the lapel and sleeves, and in the background.
b). Published state.
LIT.: Wentworth 1978, pp. 334–4; Wentworth 1984, p. 176n.
REF.: W. 84 (not in B. or T.)
The published etching appeared as the frontispiece to John S. Farmer's *Twixt Two Worlds: A Narrative of the Life and Work of William Eglinton* (London: The Psychological Press) 1886. Eglinton was a well-known medium (see pp. 50–2). The box on the

table is a double slate with a Bramah-lock, used to obtain 'irrefutable' psychographic writing. Tissot's portrait appears to have been a rather flattering one, contemporary photographs showing Eglinton as rather more podgy.

153. *L'Enfant prodigue (The Prodigal Son)*. 1882.
a–e: Dr Frederick Mulder; f–j: London, Guildhall Library.
Etching. $12\frac{1}{4} \times 14\frac{3}{4}$ (31.1 × 37.5).
PROV.: Providence/Toronto 1968 (75–8) illus.; Misfeldt 1971, pp. 200–4 & figs. 126–9; Wentworth 1978, pp. 244–55; Bury Street 1981 (12) illus.; Wentworth 1984, pp. 148–9, 208 & pls. 154–6.
REF.: W. 57–61, B. 48–52, T. 58–62 (first state), T. 63 (all five prints second state).
Five prints, consisting of *Frontispice (Frontispiece)*, *Le Départ (The Departure)*, *En pays étranger*, (*In Foreign Climes*), *Le Retour (The Return)* and *Le Veau gras (The Fatted Calf)*, a–e the first published state, f–j the second published state, after the addition of text. The prints were based on a series of four paintings showing the four stages of the narrative (the original oil paintings (Wentworth 1978, figs. 58a, 59a, 60a & 61a), exhibited at the Dudley Gallery 1882 (1–4), Paris Exposition Universelle 1889 (1310–13) and Chicago, World's Columbian Exhibition 1893 (703–4) are now in the Musée des Beaux-Arts, Nantes, but are at present undergoing extensive restoration following severe damage). A set of watercolour replicas is known (private collection, France), which was exhibited with the oil versions at the Dudley Gallery in 1882 (1–4, see Wentworth 1984, p. 204) and oil studies for the first three paintings of the

153a

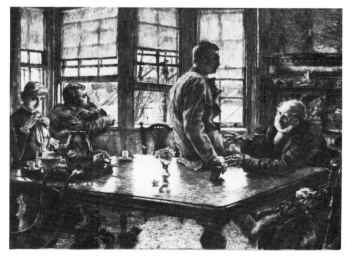

153b

151

series are also known (Sotheby's 22 Nov. 1983 (63–5)).

Tissot had painted two subjects on the Prodigal Son theme in *c.* 1862–3 (Cat. 5), in historic dress, and was clearly attracted by its narrative possibilities and didactic content. The story is also treated among his illustrations to the *Life of Christ.*

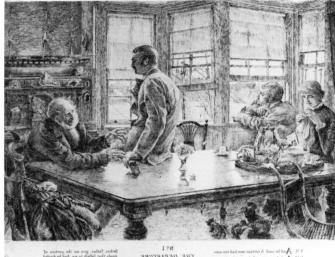

154a

153c

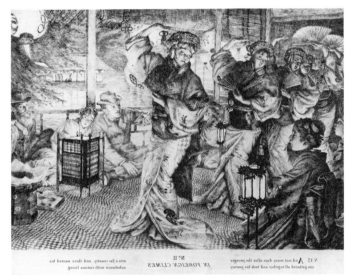

154b

153d

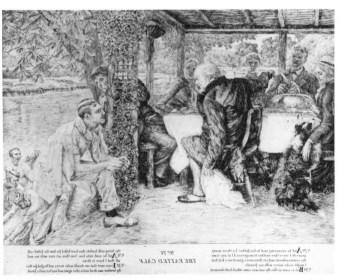

154d

153e

154. *L'Enfant prodigue* (*The Prodigal Son*). 1882.
Dr Frederick Mulder.
Etched copper plates, $13\frac{7}{8} \times 17\frac{3}{4}$ (35.1 × 45).
Original plates for the etchings *L'Enfant prodigue*, second state after the addition of texts (see previous entry, f–j).
a). *Le Départ*.
b). *En Pays étranger*.
c). *Le Retour*.
d). *Le Veau gras*.

155. *Pillar Vase – Black Serpents on a yellow ground, supported by Bronze Serpents entwining human figures*. c. 1882.
Besançon, private collection.
Cloisonné enamel on copper with bronze base, vase $23\frac{3}{5} \times 4\frac{7}{10}$ (60 × 12), base $7\frac{4}{5} \times 5\frac{9}{10}$ (20 × 15).
PROV.: As for *Uncle Fred* (Cat. 133).
EXH.: Dudley Gallery 1882 (72); Paris, Palais de l'Industrie 1883; Paris, Galerie Sedelmeyer 1885.
LIT.: Wentworth 1984, pp. 137–8.
Tissot's activity as an enamellist was unusual at this time and represented a new direction for him: his work in *cloisonné* enamel is fully explored in Chapter 7. The design of this vase is of black serpents on a yellow scale-patterned ground; the base consists of intertwined serpents and writhing female figures. The motifs relate to the painting, *The Triumph of Will: The Challenge* (Cat. 85) and to the fountain design of *Fortune* (see pp. 78–9). Tissot appears to have continued enamelling after his return to Paris, into the 1890s. (Information for this and for the following entry kindly supplied by Willard Misfeldt.)

155

156. *Pillar Vase – Turquoise-blue, supported by Bronze Serpents entwining human figures*. c. 1882.
Besançon, private collection.
Cloisonné enamel on copper with bronze base, dimensions as for Cat. 155.
PROV.: As for *Uncle Fred* (Cat. 133).
EXH.: Dudley Gallery 1882 (73); Paris, Palais de l'Industrie 1883; Paris, Galerie Sedelmeyer 1885.
A similar vase to the yellow *Pillar Vase* (see previous entry), here without the serpents and with *cloisonné* enamel scales in two shades of turquoise blue.

156

157. *An Oval Jardinière – Lake and Sea. Bronze-mounted with female figures kneeling on monsters' heads*. c. 1882. (Colour Plate 179 and Fig. 36).
Brighton, The Royal Pavilion, Art Gallery & Museums.
Cloisonné enamel on copper, mounted on gilt bronze base with feet of rock crystal, $9\frac{1}{2} \times 24\frac{1}{2} \times 12\frac{1}{5}$ (24 × 62 × 31). Impressed: *J.J.T.*.
PROV.: As for *Uncle Fred*; Sotheby's Monte Carlo 15 June 1982 (833); Bury Street Gallery, London.
EXH.: Dudley Gallery 1882 (74); Paris, Palais de l'Industrie 1883; Paris, Galerie Sedelmeyer 1885.
LIT.: Wentworth 1984, p. 138.
This *jardinière* is one of Tissot's most ambitious pieces in *cloisonné* enamel. It is fully discussed pp. 79–80.

Fig. 68. *The Gardener*. Whereabouts unknown

158. *Vase 'en gaine' – Children in a Garden*. c. 1882. (Colour Plate 30 and Fig. 33).
Paris, Musée des Arts Décoratifs.
Cloisonné enamel on copper, $9\frac{4}{5} \times 4$ (25 × 10).
PROV.: The artist, until his death in 1902; his studio sale, Hôtel Drouot 9–10 July 1903, purchased by Musée du Petit Palais.
EXH.: Dudley Gallery 1882 (78); Paris, Palais de l'Industrie 1883; Paris, Galerie Sedelmeyer 1885.
LIT.: Misfeldt 1971, p. 188 & fig. 103 a & b; Wentworth 1984, p. 138 & pl. 141.
Tissot made several *cloisonné* enamels with figural scenes. The images used here are based on two paintings of c. 1878, *Croquet* (Cat. 121) and *The Gardener* (Fig. 68 (Album, III/10)). See p. 79.

159. *Patterned quadrilateral vase*. c. 1882. (Fig. 34).
Paris, Musée des Arts Décoratifs.
Cloisonné enamel on copper, $9\frac{4}{5} \times 4$ (25 × 10).
PROV.: As for previous entry.
LIT.: Misfeldt 1971, fig. 104.

This is a less ambitious vase than *Children in a Garden* (Cat. 158) and is decorated with simple tear shapes.

160. *Teapot*. c. 1882. (Fig. 35).
Besançon, private collection.
Cloisonné enamel on gilded metal, $3\frac{1}{2}$ (9) high. Signed in monogram on spout: *J.J.T.*
PROV.: As for *Uncle Fred*; Sotheby's Monte Carlo 15 June 1982 (835 or 836).
EXH.: ? Dudley Gallery 1882 (? 81–5); Paris, Palais de l'Industrie 1883; Paris, Galerie Sedelmeyer 1885.
One of several teapots made by Tissot, using the same shape of base with varied arrangement of colour and pattern.

161. *Plaque with swags*. c. 1886.
Besançon, private collection.
Cloisonné enamel on copper, $6\frac{7}{10} \times 18\frac{1}{2}$ (17 × 47).
EXH.:? Dudley Gallery, 1882 (89) as *Slab, for a chimney piece*.
PROV.: As for *Uncle Fred*; Sotheby's Monte Carlo 15 June 1982 (834).
This plaque may have formed part of a *cloisonné* enamel mantelpiece which Tissot was working on after his return to Paris (see pp. 40–1 and 84).

162. *Le Journal* (*The Newspaper*). 1882–3.
Paris, Musée du Petit Palais.
Pastel on paper, $25\frac{1}{3} \times 19\frac{3}{4}$ (64.3 × 50.2).
EXH.: Paris, Palais de l'Industrie 1883 (17); Paris, Galerie Sedelmeyer 1885 (33).
LIT.: Providence/Toronto 1968 (80); Misfeldt 1971, p. 219 & fig. 132; Wentworth 1978, pp. 282, 285 & fig. 73e; Wentworth 1984, p. 156 & pl. 174.
Tissot made numerous pastel portraits during the 1880s and 1890s, most of which are unlocated today. The sitter here appears in other works recorded in Tissot's

161

albums, including one together with 'Berthe' (Fig. 69 (Album, III/44)). The pastel was the basis for an etching (W. 73) published in 1883.

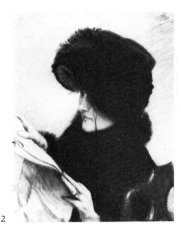

162

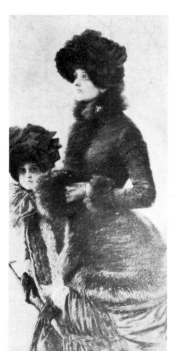

Fig. 69. Untitled. Whereabouts unknown

163. *Berthe*. 1882–3.
Paris, Musée du Petit Palais.
Pastel on paper, $28\frac{1}{2} \times 23\frac{1}{3}$ (72.4 × 59.3).
EXH.: Paris, Galerie Sedelmeyer 1885 (36).
LIT.: Misfeldt 1971, p. 219 & fig. 133; Wentworth 1978, pp. 286–9 & fig. 74a; Wentworth 1984, p. 158 & pl. 175.

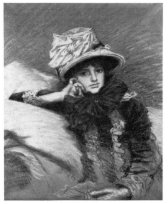

163

See Cat. 162. The young girl, presumably called Berthe, appears with the sitter of *Le Journal* (Cat. 162) in at least one other work (Fig. 69) and is the model for *Le Dimanche Matin* (Cat. 164).

164. *Le Dimanche Matin* (*Sunday Morning*). 1883.
Charles Jerdein.
Etching & drypoint, $15\frac{3}{4} \times 7\frac{1}{2}$ (40 × 19). Signed & dated b.r.: *J.J. Tissot / 1883*.
LIT.: Wentworth 1978, pp. 278–81.
REF.: W. 72, B. 63, T. 74.
Etching after an unlocated pastel of the same title (Fig. 70, recorded in Tissot's albums, III/43) which was exhibited at the Palais de l'Industrie in 1883 (16). See previous entry.

164

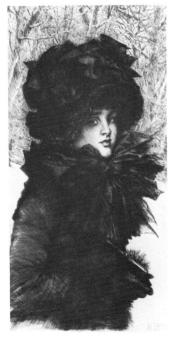

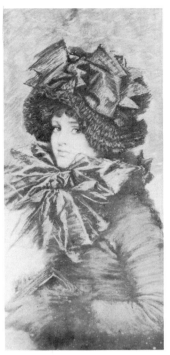

Fig. 70. *Le Dimanche matin.*
Whereabouts unknown

165–172. *La Femme à Paris* (*Pictures of Parisian Life*). 1883–5.
After his return to Paris in November 1882, Tissot worked for about three years on a series of fifteen large canvases depicting Parisian women, *La Femme à Paris*, and on a similar, incomplete series of foreign women to be called *L'Étrangère*. The canvases were shown, together with other work, at the Galerie Sedelmeyer, Paris, in 1885, entitled *Exposition J.-J. Tissot: Quinze Tableaux sur la Femme à Paris*, and the following year at Arthur Tooth and Sons, London, as *Pictures of Parisian Life by J.J. Tissot*, where the sequence was altered, one picture was left out and two were added.

In scale, technique and subject matter, the works parallel current preoccupations among leading artists in Paris. Wentworth also compares Tissot's Parisian 'goddesses of modern life' with the shop girls, society ladies, *demi-monde* and circus performers of Manet and Degas, modern-life paintings which sought to vie with the monumentality of the highest art form – history painting. The series was not a critical success in Paris or London.

Tissot planned to etch the whole series and issue three sets of five prints each in December 1885 and in May and December 1886, in editions of five hundred, each print to be accompanied by a short story written by a leading author. But he only made etchings of the first five of the series and these were never issued, perhaps because Tissot's energies were by then re-directed towards religious illustration.

For a full discussion of the series and its critical reception, see Wentworth 1984, chapter VI; the paintings are listed with Sedelmeyer and Tooth exhibition numbers, authors for the projected literary texts, and present locations, p. 205, and all except *Musique sacrée* are illustrated, pls. 178–91.

Titles given here are the Sedelmeyer titles followed by Tooth titles in brackets.

165. *L'Ambitieuse* (*The Political Woman*). 1883–5. (Colour Plate 28).
Buffalo, New York, Albright-Knox Art Gallery.
Oil on canvas, 56 × 40 (142.24 × 101.6). Signed b.r.: *J. Tissot*.
PROV.: Gift of William M. Chase, 1909.
EXH.: Sedelmeyer 1885 (1); Tooth 1886 (3).
LIT.: Providence/Toronto 1968 (35); Misfeldt 1971, fig. 139; Wentworth 1978, pp. 302–4 & fig. 77g; Wentworth 1984, pp. 162, 165–6, 168, 205 & pl. 178.
For this first painting of the *Femme à Paris* series, Tissot virtually copied an earlier picture, *Evening c.* 1878 (Cat. 106), modifying hairstyle and dress while retaining his beloved froth of pleats and nipped-in waist. The dress was rather untypical for evening wear and certainly not the height of fashion in 1885; one critic snidely remarked that the woman did not include elegance among her ambitions (see p. 76–7).

Tissot made an etching after the painting (W. 77), for which Jules Claretie was to write a text when the etchings were published.

166. *Ces Dames des chars* (*The Ladies of the Cars*). 1885.
Private collection.
Etching and drypoint, $15\frac{3}{4} \times 10$ (40 × 25.4). Signed in the title margin, b.l.: *J.J. Tissot*.
LIT.: Providence/Toronto 1968 (36) (on the painting); Misfeldt 1971, p. 226; Wentworth 1978,

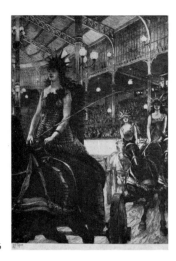

166

pp. 308–13; Wentworth 1984 (on the painting) pp. 162, 165–6, 168, 170, 205 & pl. 179.
REF.: W. 78, B. 69, T. 83.
See note before Cat. 165.

Etching after the painting now in the Museum of Art, Rhode Island School of Design, Providence. Wentworth and Misfeldt have suggested that the subject is taken from passages in Alphonse Daudet's *Sappho*, published in 1884, which is based on Daudet's youthful affair with Marie Rieu. Tissot probably saw the text before publication and may well have been aware of the story at first hand as he and Daudet lived above one another in the 1860s. There is direct correspondence between passages in the novel and Tissot's painting, although Théodore de Banville is given by the *New York Times* as the proposed author of the text to accompany the print. Tissot and Daudet were close friends and the latter took an active part in the literary side of the *Femme à Paris* publishing venture (see Wentworth 1984, pp. 169–70).

167. *Sans dot* (*Without Dowry*). 1883–5.
Toronto, Mr and Mrs Joseph M. Tanenbaum.
Oil on canvas. 57 × 40 (147.1 × 105). Signed b.l. *J.J. Tissot.*
PROV.: Christie's 4 Oct. 1973 (231) as *Sunday in the Luxembourg Gardens*; H. Shickman Gallery, New York, from whom acquired Feb. 1975.
EXH.: Sedelmeyer 1885 (3); Tooth 1886 (2); Ottawa 1978 (67) illus.

LIT.: Providence/Toronto 1968 (35); Wentworth 1978, pp. 314–17 & fig. 79d; Wentworth 1984, pp. 66, 162, 166, 168, 171, 205 & pl. 180.
See note before Cat. 165.

In this painting, as in several earlier works (e.g. *The Letter*, Cat. 97), Tissot equates autumn and falling leaves with the passage of time and fading of hope. The young woman dressed in mourning, without dowry or prospects of marriage and ignored by the dapper soldiers, sits contemplating her bleak future. Unlike the widow of *Une veuve* (Cat. 18) who has brighter prospects of future love and is itching for the obligatory time of mourning to pass, she is sadly resigned to her fate, while the impassive chaperone in both pictures reads on.

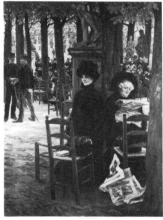

167

Tissot made an etching after the painting, to which Georges Ohnet wrote a text which was published in *Les Lettres et les arts*, 1888, with an illustration by August Loustanou (which is a pale imitation of Tissot's composition; see Wentworth 1978, fig. 79e). In Ohnet's story, the young woman is left dowerless after the death of her father, a colonel, and spends the autumn with her mother listening to music at Versailles. Love ultimately triumphs over material concerns and the story ends with her engagement. Misfeldt has identified the setting of the picture as the gardens in Versailles near the staircase to the Pool of Latona, which can be seen in the distance to the left.

168. *La Mystérieuse* (*The Mystery*). 1885.
Charles Jerdein.

Etching and drypoint, 15⅜ × 9⅞ (39.7 × 25.1). Signed in title margin b.r.: *J.J. Tissot.*
LIT.: Wentworth 1978, pp. 318–21; Wentworth 1984, (on the painting) pp. 162, 166, 168, 170, 205 & pl. 181.
REF.: W. 80, B. 71, T. 85.
See note before Cat. 165.

Etching after an unlocated painting, recorded in Tissot's albums (Wentworth 1984, pl. 181), for which an oil sketch is also known (Wentworth 1978, fig. 80c). Wentworth has noted that the subject appears to have been taken from a novel by Ouida, *Moths*, published in 1880, where the hero sees the mysterious Anglo-Russian Princess Zouroff while riding in the Bois de Boulogne: 'As he returned two hours later, he saw her walking in one of the *allées des piétons*; she was in black, with some old white laces about her throat; before her were her dogs and behind her was a Russian servant.'

Critics were quick to point out that there was little mystery or allure in Tissot's picture. The model's open, outward stare, intended to involve the spectator more closely in the picture (see Cats. 169, 170, & 172), detracts from any haunting speculation.

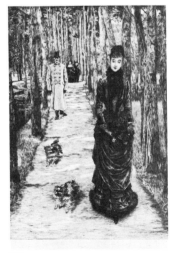

168

169. *La Plus Jolie Femme de Paris* (*The Fashionable Beauty*). 1885.
Private collection.
Etching and drypoint, 15¾ × 10 (40 × 25.4). Signed in the title margin b.l.: *J.J. Tissot.*
LIT.: Wentworth 1978, pp. 322–5; Wentworth 1984, (on the painting) pp. 162, 164, 166–8, 171, 205 & pl. 182.
REF.: W. 81, B. 72, T. 86.

See note before Cat. 165.

Etching after the painting in a Swiss private collection (Wentworth 1984, pl. 182) for which an oil study is known (Sotheby's 23 Feb. 1977 (57)). The print was to be accompanied on publication by a story written by Ludovic Halévy, which Wentworth notes is probably the one later published in *Parisian Points of View* as 'The Most Beautiful Woman in Paris'. This describes the brief fame of Mme Derline, the wife of a Parisian lawyer, who is hailed as 'the prettiest woman in Paris' one night at a performance of Ernest Rayer's *Sigurd* at the Opéra, only to see that title pass to a musical comedy actress the following evening.

169

170. *La Mondaine* (*The Woman of Fashion*). 1883–5.
Toronto, Mr and Mrs Joseph M. Tanenbaum.
Oil on canvas, 57 × 39 (148.3 × 103). Signed b.r.: *J.J. Tissot.*
PROV.: ? Detroit Institute of Art; H. Shickman Gallery, New York, Jan. 1970, from whom acquired Nov. 1970.
EXH.: Sedelmeyer 1885 (8); Tooth 1886 (6); Ottawa 1978 (68) colour pl.
LIT.: Providence/Toronto 1968 (35); Misfeldt 1971, fig. 141; Wentworth 1984, pp. 162, 164, 166, 168–9, 205 & pl. 185.
See note before Cat. 165.

By making some of his models look out from the canvas directly at the spectator, Tissot sought to involve people more closely in the subject of his pictures. Here, we are made to feel like someone

with whom the young woman is flirting while her elderly husband is busy attending to her coat.

An oil sketch for the painting is known (private collection, New York, mentioned in Christie's sales catalogue, 25 Nov 1983 (99)).

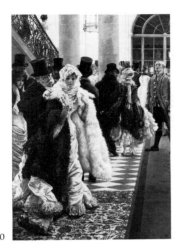

170

171. *La Demoiselle d'honneur* (*The Bridesmaid*). 1883–5.
Leeds City Art Galleries.
Oil on canvas, 58 × 40 (147.3 × 101.6). Signed b.r.: *J.J. Tissot*.
PROV.: Christie's 1889 £69.5s.0d., bt. Live; given to Leeds City Art Gallery by R.R. King, 1897.
EXH.: Sedelmeyer 1885 (9); Tooth 1886 (13); Leeds City Art Gallery Inaugural Exhibition 1888 (19); Sheffield 1955 (46).
LIT.: Providence/Toronto 1968 (35); Misfeldt 1971, fig. 140; Budge, Adrian, 'A Note on "The Bridesmaid" by James J. Tissot', *Leeds Arts Calendar* 1982, no. 91, pp. 28–30; Warner 1982, p. 22, colour pl.; Wright, Christopher, 'Renoir and Tissot: A neglected Masterpiece and a Masterpiece to Neglect', *Art and Artists*, November 1982, p. 25; Wentworth 1984, pp. 162, 164–7, 205 & pl. 186.
See note before Cat. 165.

A small oil sketch for the painting (Fig. 71) was sold at Sotheby's 19 June 1984 (76). Its general lines are similar to the final composition, though the pose of the groom and angle of the bridesmaid's head are slightly different. More significantly, the messenger boy on the left, who cheers the couple, looks out at us in the sketch, indicating that Tissot at first intended to engage the ob-

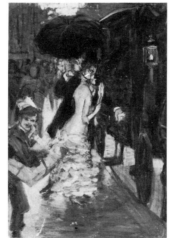

171

server directly, as in *La Mondaine* (Cat. 170), *La Demoiselle de magasin* (Cat. 172), and other paintings of the *Femme à Paris* series.

Fig. 71. Study for *The Bridesmaid*. Whereabouts unknown

172. *La Demoiselle de magasin* (*The 'Young Lady' of the Shop*). 1883–5.
Toronto, Art Gallery of Ontario.
Oil on canvas, 57½ × 40 (146.1 × 101.6). Signed b.r.: *J.J. Tissot*.
PROV.: Christie's 1889 £52.10s.0d, bt. King; property of Leicester Galleries 1936; H. de Vere Clifton; Christie's 22 Jan. 1965 (55) as *The Milliner's Shop*, bt. Leger; given to Art Gallery of Ontario through Corporation's Subscription Fund, 1968.
EXH.: Sedelmeyer 1885 (14); Tooth 1886 (5); Leicester Galleries 1937 (11) as *L'Article de Paris*; Providence/Toronto (39) illus.

LIT.: Laver 1936, pl. XXIX; Providence/Toronto 1968 (35); Misfeldt 1971, fig. 134; Wentworth 1984, pp. 163, 166, 169, 205 & pl. 191.
See note before Cat. 165.

As in *La Mondaine* (Cat. 170), the central character here demands our attention and makes us feel as if we are part of the scene depicted, in this case perhaps leaving the milliner's shop with our newly-bought 'confections'.

There is an oil sketch for the painting in the Art Museum of the Socialist Republic of Romania, Bucharest.

172

173. *L'Esthetique* (*In the Louvre*). c. 1883–5. (Colour Plate 27).
Owen Edgar Gallery.
Oil on canvas, 25½ × 17½ (65 × 44.5). Signed b.r.: *J.J. Tissot*.
PROV.: Charles Sedelmeyer, Paris; his sale, Paris, 1907 (100).
EXH.: Paris Exposition Universelle 1900 (781).
LIT.: Wentworth 1984, pp. 163, 206 & pl. 193.
This painting is a small replica of a work exhibited with the *Femme à Paris* series in 1885 and 1886 at the Galerie Sedelmeyer (21) and Tooth's (4), and now in the Museo de Arte de Ponce, Puerto Rico. *L'Esthetique* was the second of a projected series, *L'Étrangère*, which was to show 'the foreign woman' at her various pursuits in the same way that the *Femme à Paris* series depicted the *parisienne*, but was never completed. There is an oil study for the setting in the Museum of Art, Rhode Island School of Design (Sheffield 1955 (6) and Providence/Toronto

1968 (37) illus.), which Tissot made in 1879 at the same time as the study for *Visiteurs étrangers au Louvre*. The window looks out onto the Pavilion Sully, and the large vase is '*La Rotonde de Mars*'. The choice of aesthetic dress is suited to the subject (see p. 77).

174. *Study of a Seated Woman*. c. 1886–90.
Private collection.
Pencil on paper, 22 × 11 (56 × 28). Signed, inscribed & dated t.r.: *1891 / James Tissot à mon / amical voisin C. Grault*.
PROV.: Jeremy Maas, London; Benjamin Sonnenburg, New York; Sotheby's 16 June 1982 (271) bt. Frost and Reed, London.
This study of a woman, reminiscent of Kathleen Newton, was used in a presently unlocated painting (Fig. 72 (Album, IV/27))

174

within the setting of Tissot's garden at Grove End Road, the familiar pool and colonnade in the distance, which appears to have been painted from memory. The woman wears an 'aesthetic' dress, with ruffled fall collar and gathered sleeves and waist, the fullness of the loose skirt tucked beneath her. Kathleen Newton was not given to wearing aesthetic dress, but the painting has the feel of 'Kathleen Newton and St. John's Wood revisited'.

Fig. 72. Untitled. Whereabouts unknown

175. *Letter L, with Hats. c.* 1885.
Lady Abdy.
Etching, $3\frac{7}{8} \times 3\frac{15}{16}$ (8.7 × 8.4).
 Signed in monogram b.r.: ᴊᵀᵗ.
LIT.: Wentworth 1978, pp. 340–1.
REF.: W. 86 (not in B. or T.).
One of three known impressions of this print (the other two are in the collections of A.E. Gotlieb and the Bibliothèque Nationale, Paris).
 Wentworth suggests that this and the following print may well be associated with the planned publication of etchings after the *Femme à Paris* series, where the texts which were to accompany the etchings could have incorporated decorated initial letters and vignettes like these. The subject of a musicians' cloakroom would have been ideally suited to decorate Halévy's *La plus jolie femme de Paris*, set at the Paris Opéra.

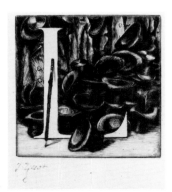

176. *A Cloakroom. c.* 1885.
Paris, Bibliothèque Nationale.
Etching, $3 \times 11\frac{9}{16}$ (7.6 × 29.3).
 Signed in monogram on a cloakroom tag l.c.: ᴊᵀᵗ.
LIT.: Wentworth 1978, pp. 342–3.
REF.: W. 87 (not in B. or T.).
See previous entry.
 The only known impression of this etching, which depicts a musicians' cloakroom.

177. Paul Helleu: *Le Peintre Tissot chez la princesse de Polignac. c.* 1895. (Fig. 5).
Private collection.
Drypoint, $14\frac{4}{5} \times 14\frac{1}{4}$ (37.8 × 36.2).
This drypoint indicates that Tissot was not entirely a recluse while working on his Bible illustrations. Helleu, to whom Tissot left his diamond point (see pp. 21 and 60), was soon to become a fashionable and much sought-after portraitist of the *Belle Époque*.

178. *Château de Buillon.* Late 1880s.
Private collection.
Oil on board, 20 × 14 (51 × 35.5).
PROV.: The artist, until his death in 1902; Mlle Jeanne Tissot, the artist's niece, until her death in 1964; her sale Château de Buillon 8–9 Nov. 1964; Sotheby's 16 June 1982 (272).
LIT.: The *Builder*, 15 June 1895, pp. 452–3 & illus.; the *Builder*, 1 May 1897, pp. 390–0 & illus.; the *Builder*, 1 June 1901, p. 540; Misfeldt 1984, pp. 24–9.
Tissot inherited the Château de Buillon after his father's death (15 March 1888) and subsequently divided his time between Paris and the Château. He made extensive alterations to the Château and grounds *c.* 1895–7 using the same English architect who had designed the studio at his Grove End Road house in 1873, John Brydon (1840–1901; see Fig. 4 and note 16 to chapter 2). The work was carried out by a local contractor, Monsieur Patou, under the supervision of a resident architect, Monsieur Vielle of Besançon. Drawings of the studio and the front were exhibited at the Royal Academy in 1895 and 1897, and were illustrated in the *Builder*. A description of Tissot's additions to the Château is given in Misfeldt 1984.

176

178

179

179. *The Château Buildings at Buillon. c.* 1895–1900.
Besançon, Private collection.
Oil on canvas, $23\frac{1}{5} \times 27\frac{1}{2}$ (59 × 70).
PROV.: Acquired by the late son of the present owner in Paris *c.* 1980.
See previous entry.
 Pure landscapes are rare in Tissot's oeuvre. There exist a few landscape sketches done in the area of the Château de Buillon, Tissot's country retreat on the site of a ruined Cistercian monastery, which he inherited from his father. This painting seems to be based on a photograph. In the foreground we see the green-house and studio building (re-

modelled from the old *logis d'abbé*) and, beyond that, the Château. Besides the subject, the painting is notable for its fresh, clean colours. (Information for this entry was kindly supplied by Willard Misfeldt.)

180. *Three photographs of the Château de Buillon and Park*
Boston, Mass., James A. Berg-quist.
PROV.: The artist, until his death in 1902; Mlle Jeanne Tissot, the artist's niece, until her death in 1964; her sale, 8–9, 14–15 & 21–2 Nov. 1964; Sotheby's 17 June 1982 (270c).
LIT.: Misfeldt 1984, pp. 24–9.
a). The Château de Buillon and grounds from across the river, with possibly Père Bichet, the brother of Tissot's sister-in-law, Claire Bichet (widow of Marcel-Africani), on the right. The 'English' mill can be seen in the middle distance.
b). The grounds of the Château de

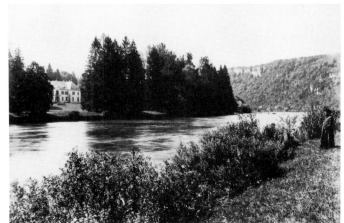

Buillon from across the river. The studio and greenhouse(?) can be seen in the centre right background.

c). Père Bichet with his and Tissot's nieces in the grounds of the Château de Buillon.

180b

180c

181. *The Life of Our Lord Jesus Christ* (Lemercier et Cie, Paris, and Sampson Low, Marston & Co., London) 1897–8 (2 vols.). Translated by Mrs Arthur Bell.
London, Guildhall Library.
LIT.: Providence/Toronto 1968 (56–9); Misfeldt 1971, pp. 246–79 & figs. 145–53; Wentworth 1978, p. 347; Arts Council of Great Britain, *Great Victorian Pictures*, 1978 (58); Warner 1982, p. 24; Jewish Museum 1982; Wentworth 1984, pp. 36, 136, 148–9, 157–8, 174–97 & pls. 198, 200–4.

Following a mystic vision while working on one of the *Femme à Paris* series, which he recorded in the painting *The Ruins* (Wentworth 1984, pl. 196), Tissot decided to embark on illustrating the life of Christ (see pp. 21–3 and 91–3). He made two trips to Palestine in 1886–7 and 1889 to study the locations at first hand, believing that little had changed since the time of Christ. On the basis of numerous studies and photographs, he made 365 drawings, which were exhibited in London and Paris in 1896 and 1897, the first 270 having been exhibited at the Salon du Champ de Mars, Paris, in 1894. The pictures made a considerable impact in Paris: visitors 'entered the gallery of the Louvre, where the pictures were exhibited, as though performing a religious ceremony – many on their knees – and spent hours praying and sobbing before each scene represented' (Bryant, Lorinda, *French Pictures and their Painters*, 1923, p. 259). English visitors to the London exhibition were more restrained: 'Every day the Lemercier Gallery is crowded, and the procession of the solemn-visaged who go through the rooms is almost devotional. At first you hear criticisms of the art; but presently that . . . is forgotten . . . and as the last scene of the Divine Tragedy is approached, you see the tender-hearted trying to hide their emotion' (*Western Morning News*, 1896). The gouache illustrations then toured North America in 1898–9, bringing Tissot a reputed $100,000 in entrance fees, and were acquired by the Brooklyn Museum in 1900 for $60,000, Tissot offering to paint a large head of Christ as a focus to the display.

The drawings were published by Mame et fils, of Tours, in 1896–7, together with selected Bible texts chosen by Tissot, which described events from the life of Christ relevant to the drawings. Tissot was paid one million francs for the reproduction rights. English and American editions followed, and a range of editions was available from *de luxe* facsimile in a wooden box to cheap editions on poor paper. The exhibited volumes fall somewhere in the middle of the range.

182. *Five illustrations for 'The Life of Our Lord Jesus Christ'*. c. 1886–96.
New York, The Brooklyn Museum. Watercolour and bodycolour on paperboard. Signed b.r.: *J.J. Tissot*.
PROV.: Purchased from the artist, 1900.

182a

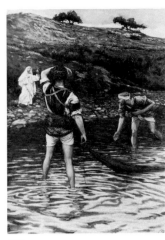

182b

EXH.: Paris, Société Nationale des Beaux-Arts, Champ de Mars, 1894; London, Lemercier Gallery, 1895; Paris, Société Nationale des Beaux-Arts, Champ de Mars, 1897; Brooklyn, New York 1899 & 1900; St. Louis Exposition 1900.
LIT.: As for previous entry.
a). *St. Joseph Seeks a Lodging in Bethlehem*. $10\frac{7}{16} \times 6\frac{5}{8}$ (26.5 × 16.8).
b). *The Calling of St. Peter and St. Andrew*. $10\frac{7}{16} \times 6\frac{5}{8}$ (26.5 × 16.8).
c). *Jesus Healing the Lame and the Blind on the Mountain*. $6\frac{11}{16} \times 9\frac{1}{8}$ (17 × 23.2).
d). *Christ Driving out Them that Sold and Bought in the Temple*. $7\frac{9}{16} \times 10\frac{7}{16}$ (19.2 × 26.5).
e). *The Tribute Money*. $7\frac{1}{4} \times 11\frac{9}{16}$ (18.4 × 29.4).

183. *The Sojourn in Egypt*. c. 1886–94.
Dublin, National Gallery of Ireland.
Oil on canvas, $27\frac{1}{4} \times 33\frac{1}{2}$ (69.2 × 85.4) Signed b.l.: *J.J. Tissot*.
PROV.: Presented by Sir Alfred Chester Beatty, 1954.
LIT.: Misfeldt 1971, p. 327; NG of Ireland 1981, p. 163 (1275) illus.; Wentworth 1984, p. 188 & pl. 199.

Tissot is known to have made several oil replicas of his gouache illustrations to the *Life of Christ* like this one (three are noted in the sale of his studio contents, l'Hôtel Drouot, Paris, 1903, lots 7, 8 and 9, and Misfeldt, citing Tissot's will, suggests the existence of at least seven). Only

183

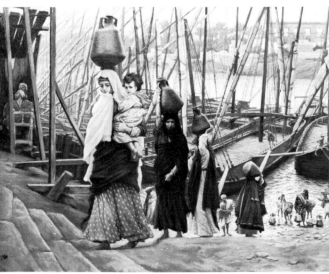

three are known today: the exhibited work, *Journey of the Magi* (The Minneapolis Institute of Arts; Wentworth 1984, colour pl. VI) and *Christ before Pilate* (Besançon, private collection).

184. *The Old Testament: Three Hundred and Ninety-Six Compositions Illustrating the Old Testament*, (Maurice de Brunoff) 1904 (2 vols).
London, Guildhall Library.
LIT.: As for *The Life of Christ*.
Following the success of the *Life of Christ*, Tissot decided to illustrate the Old Testament. He made a third trip to Palestine in 1896, to gather more material, and had completed ninety-five illustrations by 1901, when they were shown at the Salon du Champ de Mars. He died in 1902 without finishing the work, and it was left to six studio assistants to complete the project. The illustrations were published in 1904, together with texts, in French, English and American editions.

185. *Six illustrations for 'The Old Testament'. c.* 1889–1901.
New York, The Jewish Museum.
Watercolour and bodycolour on paper.
PROV.: Purchased by the New York Public Library, following a tour of the United States, and transferred to the Jewish Museum in 1952.
EXH.: Paris, Société Nationale des Beaux-Arts, Champ de Mars, 1901 (95 illustrations).
LIT.: As for *The Life of Christ*.
See previous entry.
Tissot did not manage to complete the series before his death and a large body of illustrations were carried out by assistants, following sketches and photographs compiled by Tissot. The exhibited illustrations are probably all in Tissot's hand, as he is known to have completed the first ninety-five illustrations.
a). *Abraham's Servant Meeteth Rebecca.* $10\frac{15}{16} \times 7\frac{13}{16}$ (27.8 × 19.8).
b). *Jacob's Dream.* $12\frac{3}{16} \times 5\frac{7}{8}$ (31 × 14.9).
c). *Rachel and Leah.* $6\frac{7}{8} \times 10\frac{7}{8}$ (17.5 × 27.6).
d). *Moses Laid Amid the Flags.* $9\frac{15}{16} \times 4\frac{7}{8}$ (25.2 × 12.2).
e). *The Plague of Locusts.* $7\frac{3}{4} \times 9\frac{3}{8}$ (19.7 × 23.8).
f). *The Camp before Sinai.* $10\frac{5}{8} \times 7\frac{3}{4}$ (27 × 19.7).

185a

185b

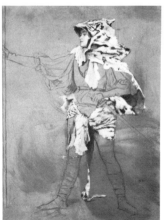

185d

185f

185e

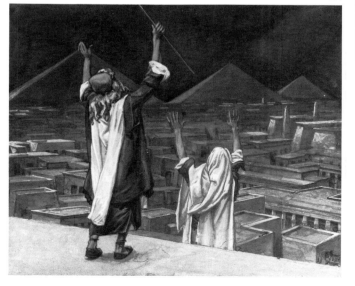

Additional entry
Study for 'The Triumph of Will: The Challenge'. c. 1877.
Private collection.
Brush drawing in grey, with bodycolour over black chalk on blue paper, $21\frac{1}{4} \times 15\frac{1}{2}$ (54.7 × 39.9). Signed b.r.: *James Tissot*.
PROV.: P. and D. Colnaghi and Co. Ltd. by 1970; Mr and Mrs Eliot Hodgkin; Christie's 26 Oct. 1982 (75) as *A Young Nimrod*; Christopher Wood Gallery.
EXH.: P. and D. Colnaghi and Co. Ltd., *Exhibition of Nineteenth-Century Drawings by European Artists*, 1970 (26) as *A Boy Wearing a Tiger Skin*.
LIT.: Wentworth 1978, pp. 330, 333, and Fig. 83A.
This study was previously thought to be related to the painting *Le Petit Nemrod* (Cat. 147) and it was even suggested that the model was Cecil George, Kathleen Newton's son. The young model wears one of Tissot's studio 'props', first used *c.* 1862 – a tunic with billowing ribbon-cut sleeves (see p. 64 and Colour Plate 2). The tiger skin is like that with which the children play in *Le Petit Nemrod* and which appears in numerous other pictures (e.g. *Algernon Moses Marsden*, Cat. 76). Its use here, and the stance of the model with a staff, is similar to that in a related painting, presently titled *La Femme Préhistorique* (Besançon, private collection, *L'Oeil*, Nov. 1974, p. VI).

Bibliography

AC 1955 The Arts Council, *Paintings Drawings and Etchings by James Tissot 1836–1902*, a touring exhibition selected from that arranged by the Graves Art Gallery, Sheffield. 1955.

BARBICAN 1984 Barbican Art Gallery, *The City's Pictures. A Selection of Paintings from the Collection of the Corporation of London*. 1984.

BÉRALDI Béraldi, Henri, *Les graveurs du dix-neuvième siècle: guide de l'amateur d'estampes modernes*. 12 vols. Paris 1885–92.

BROOKE 1969 Brooke, David S., 'Tissot's "The Parting"', *Amgueddfa: Bulletin of the National Museum of Wales*, 2 (summer–autumn 1969) pp. 22–6.

BURY STREET 1981 Mulder, Frederick, in association with Abdy, Jane, Bury Street Gallery, *J.J. Tissot. Etchings, drypoints and mezzotints*. 1981.

DUDLEY GALLERY B/W Dudley Gallery, *Exhibition of Works of Art in Black and White*. 1876–81.

GRAY ETC. 1983–4 L'Association des Conservateurs de Franche Comté, *Peinture et Société 1870–1914. A travers des collections des Musées de Franche Comté*. Touring exhibition to Gray and other venues, 1983–4.

JEWISH MUSEUM 1982 The Jewish Museum, New York City, *J. James Tissot. Biblical Paintings*. With essays by Yochanan Muffs and Gert Schiff and a Chronology by Michael Wentworth and David Brooke. 1982.

LAVER 1936 Laver, James, *Vulgar Society: The Romantic Career of James Tissot*. 1936.

LEICESTER GALLERIES 1933 The Leicester Galleries, *In the Seventies. Catalogue of an exhibition of paintings by James Tissot*. With an Introduction by Edward Knoblock. 1933.

LEICESTER GALLERIES 1937 The Leicester Galleries, *Catalogue of the Second James Tissot Exhibition*. 1937.

MINNEAPOLIS 1978 see Wentworth 1978.

MISFELDT 1971 Misfeldt, Willard Erwin, *James Jacques Joseph Tissot: A Bio-critical Study*. PhD Dissertation, Washington University Dept. of Art & Archaeology. 1971. (University Microfilms.)

MISFELDT 1984 Misfeldt, Willard Erwin, 'James Tissot's Abbaye de Buillon', *Apollo* January 1984, pp. 24–9.

NG OF IRELAND 1981 Dublin, National Gallery of Ireland, *Illustrated Summary Catalogue of Paintings*. 1981.

NATIONAL MARITIME 1977 National Maritime Museum, *London and The Thames. Paintings of Three Centuries*. Selected and Catalogued by Harley Preston. 1977.

NPG 1981 National Portrait Gallery, *Complete Illustrated Catalogue 1856–1979*. Compiled by K.K. Yung. 1981.

OTTAWA 1978 d'Argencourt, Louise and Druick, Douglas, *The Other Nineteenth Century: Paintings and Sculpture in the Collection of Mr and Mrs Joseph M. Tanenbaum*. Ottawa, National Gallery of Canada. 1978. Biography and catalogue entries on Tissot by Willard Erwin Misfeldt. pp. 184–7.

PRESTON 1984 Preston, Harley, 'Tissot and "Renée Mauperin"', *Apollo*, June 1984. pp. 442–4.

PROVIDENCE/TORONTO 1968 Providence, Museum of Art, Rhode Island School of Design, and Toronto, Art Gallery of Ontario, *James Jacques Joseph Tissot: A Retrospective Exhibition*. 1968. With introduction by Henri Zerner and entries by David Brooke, Michael Wentworth and Henri Zerner.

REFF 1976 Reff, Theodore, *Degas: The Artist's Mind*. 1976. Reprint of articles which appeared in various magazines. Ch. III.: 'The Pictures Within Degas's Pictures', from *Metropolitan Museum Journal*, I (1968); Ch. V.: 'Degas's "Tableau de Genre"', from *Art Bulletin*, 45 (summer 1972).

REYNOLDS 1953 Reynolds, Graham, *Painters of the Victorian Scene*. 1953.

RA Royal Academy, 1864, 1872–6 & 1881.

SHEFFIELD 1955 Sheffield, Graves Art Gallery, *James Tissot (1836–1902). An Exhibition of Paintings, Drawings and Etchings*. 1955.

SITWELL 1937 Sitwell, Sacheverell, *Narrative Pictures: A Survey of English Genre and its Painters*, 1937.

TATE 1981 Alley, Ronald, *Catalogue of The Tate Gallery's Collection of Modern Art other than works by British Artists*. 1981.

THOMSON 1979 Thomson, Ian, 'Tissot and Oxford', *Oxford Art Journal*, no. 2 (April 1979) pp. 53–6.

THOMSON 1982 Thomson, Ian, 'A Study in Leisure. James Tissot's Paintings', *Country Life*, 29 July 1982, pp. 328–9.

TISSOT Yriarte, Charles, introd., *J.-J. Tissot: Eaux-Fortes, manière noire, pointes-sèches*. Paris 1886.

TISSOT ALBUMS Tissot, James, *The Complete Collection of the Artist's Works, Reproduced in a Series of Photographs*. Vol. I: Paris, 1859–70; Vol. II: London, 1871–77 (missing); Vol. III: London and Paris 1878–85; Vol. IV: Paris 1886 onwards. First three volumes exhibited at Dudley Gallery 1882, dated 1859–70, 1870–76 and 1876–82, the latter added to after the exhibition and ending with the 1885 Sedelmeyer exhibition. Fourth album postdates this. Now in private collection, USA. Numbering given here refers to album and location therein. (Information kindly supplied by Michael Wentworth.) The albums have been published by Willard Misfeldt (Bowling Green University Popular Press, 1982) but the sequence of images for one of the albums is incorrect.

TOKYO/OSAKA/FUKUOKA 1979–80 *Japonisme in Art*, travelling exhibition to Tokyo, Osaka and Fukuoka, 1979–80.

VANITY FAIR 1976 National Portrait Gallery, *Vanity Fair, an exhibition of original cartoons*. Introduction by Eileen Harris, catalogue by Richard Ormond. 1976.

WARNER 1982 Warner, Malcolm, *Tissot*. The Medici Society Ltd. 1982.

WENTWORTH 1978 Wentworth, Michael, *James Tissot: Catalogue Raisonné of his Prints*. Minneapolis Institute of Arts, 1978. Also catalogue of exhibition shown at Minneapolis and the Sterling and Francine Clark Art Institute, Williamstown, Mass.

WENTWORTH 1979–80 Wentworth, Michael, 'Energized Punctuality: James Tissot's "Gentleman in a Railway Carriage"', *Journal of the Worcester Art Museum*, 3 (1979–80) pp. 8–27.

WENTWORTH 1984 Wentworth, Michael, *James Tissot*. 1984. Contains full bibliography up to 1982.

WOOD 1976 Wood, Christopher, *Victorian Panorama. Paintings of Victorian Life*. 1976.

SEE ALSO

Lumley Cazalet Ltd., *J.J. Tissot. Etchings, drypoints and mezzotints*. (Exhibition organized in association with Jane Abdy who wrote the catalogue). 1978.

Lenders

Besançon: Musée des Beaux-Arts et d'Archéologie, 147; Birmingham: Museum and Art Gallery, 20; Brighton: Pavilion, Art Gallery and Museums, 157; Bristol: City Museum and Art Gallery, 42; Buffalo, New York: Albright-Knox Art Gallery, 165; Cardiff: National Museum of Wales, 44; Compiègne: Musée Nationale du Château, 71; Dijon: Musée des Beaux-Arts, 131; Dublin: National Gallery of Ireland, 2, 58, 183; Gray: Musée Baron Martin, 103, 135; Hamilton, Ontario: Art Gallery, 121; Henley-on-Thames: The Leander Club, 84; Leeds: City Art Galleries, 171; London: The British Library, 34, The Trustees of The British Museum, 11, 43, 48, 49, 50, 104, 127, 132, Corporation of London, Guildhall Art Gallery

55, 65, 116, Corporation of London, Guildhall Library 153 (f)–(j), 181, 184, Museum of London, 52, 112, National Art Library, 6, National Maritime Museum, 82, 137, 141, National Portrait Gallery, 28, 29, 30, 40, 73, The Trustees of the Tate Gallery, 21, 46, 47, 66, 78, 83, 96; Manchester: City Art Galleries, 70, 107; Montreal: Museum of Fine Arts, 99; New York: The Brooklyn Museum, 182, The Jewish Museum, 185; Northampton, Mass.: Smith College Museum of Art, 56; Ottawa: National Gallery of Canada, 97; Oxford: The Visitors of the Ashmolean Museum, 62, 63, 69, University Examination Schools, 41; Paris: Bibliothèque Nationale, 8, 9, 12, 74, 87, 91, 105, 122, 125(a), 130, 176, Musée des Art Décoratifs, 158, 159, Musée du Louvre, Cabinet des Dessins, 3, Musée du Petit Palais, 162, 163, Musée d'Orsay, 13, 14, 106; Providence: Museum of Art, Rhode Island School of Design, 140; Sheffield: City Art Galleries, 85; Southampton: Art Gallery and Museums, 16, 57; Toronto: Art Gallery of Ontario, 25, 172; Wakefield: Art Gallery and Museums, 81; Wimpole: The National Trust, Wimpole Hall, 24.

Lady Abdy, 92, 94, 100, 102, 123(b), 125(b), 129, 175; James A. Bergquist, 146, 180; Bury Street Gallery, 108, 109, 149; Duke of Devonshire, 32; D.C. Dueck, 124; Owen Edgar Gallery, 138, 173; Elliott Galleries, New York, 7; The Forbes Magazine Collection, 139; John Franks Collection, 53; Estate of Margaret E. Galbreaith, 4; Major Martin Gibbs, 1;

Goldschmidt Family, 15; Gavin Graham Gallery, 59; Julius S. Held, 33; Charles Jerdein, 51, 88, 113, 120, 123(a), 136, 164, 168, 180; Ronald Lewis, 26; Manney Collection, 5, 18; The Edward J. and Suzanne McCormick Collection, 115; Samuel A. McLean, 111, 144; Dr Frederick Mulder, 36, 152, 153 (a)–(e), 154; Tom Parr, 45; Private Collections, 10, 17, 19, 22, 27, 31, 35, 37, 38, 39, 54, 60, 61, 68, 72, 75, 76, 77, 79, 80, 85, 86, 89, 90, 93, 98, 101, 110, 117, 118, 119, 126, 128, 133, 134, 142, 143, 148, 150, 151, 155, 156, 160, 161, 166, 169, 174, 177, 178, 179; The Hon. P.M. Samuel, 64; Mr and Mrs Allen Staley, 23; Mr and Mrs Joseph M. Tanenbaum, Toronto, 67, 167, 170.

Photographic Acknowledgements

We would like to thank the above named, and also the following, for supplying photographs and for allowing us to reproduce them: the Bridgeman Art Library; The British Architectural Library RIBA, London; Christie's, London; the Courtauld Institute of Art; the Metropolitan Museum of Art, New York; the National Gallery, London; Oxford University Press; Réunion des Musées Nationaux, Paris; the Royal Academy; The California Palace of the Legion of Honor, San Francisco; Sotheby's, London; Sotheby Parke Bernet, Monte Carlo; Rick Stafford, Fogg Art Museum Photographic Service; and Michael Wentworth for supplying photographs from Tissot's albums and for allowing us to reproduce them here.

Index